THE SOLITUDE
OF
PASSION

A NOVEL

ADDISON MOORE

Books by Addison Moore:

New Adult Romance

Someone to Love (Someone to Love 1)
Someone Like You (Someone to Love 2)
Someone For Me (Someone to Love 3)
3:AM Kisses (3:AM Kisses 1)
Winter Kisses (3:AM Kisses 2)
Sugar Kisses (3:AM Kisses 3)
Whiskey Kisses (3:AM Kisses 4)
Rock Candy Kisses (3:AM Kisses 5, 2014)
Beautiful Oblivion
Beautiful Illusions (Beautiful Oblivion)
The Solitude of Passion
Burning Through Gravity
Perfect Love (A Celestra Novella)
Celestra Forever After
The Dragon and the Rose (Celestra Forever After)

Young Adult Romance

Ethereal (Celestra Series Book 1)
Tremble (Celestra Series Book 2)
Burn (Celestra Series Book 3)
Wicked (Celestra Series Book 4)
Vex (Celestra Series Book 5)
Expel (Celestra Series Book 6)
Toxic Part One (Celestra Series Book 7)
Toxic Part Two (Celestra Series Book 7.5)
Elysian (Celestra Series Book 8)
Ephemeral (The Countenance Trilogy 1)
Evanescent (The Countenance Trilogy 2)

Entropy (The Countenance Trilogy 3)
Ethereal Knights (Celestra Knights)

When old love and new love collide—impossibility is born.

Prologue

It's hard to know what's real and what isn't when you're trying to pick the pieces of your heart off the ground. But the order of the universe reversed itself—it took my heartbreak and exchanged it for something far more palatable. I swallowed the delusion whole and traded agony for this strange new reality. Now, there was a choice to be made—a decision that would prove impossible.

I was walking barefoot on the edge of a very sharp knife, the blade already slicing me to ribbons, but I was oblivious to its infliction. The pain was sublime. I was the lucky one, even when the torment shaved me to the bone.

It was a season in my life, born of confusion, all consuming lust, passion that could fuel jet planes—intoxicating, rich and heated as lava.

A fire brewed in my heart, too magnificent to ignore, I could never deny it, never insist it disappear. I want to drink it down, let it erode me from the inside like a white-hot flame—intoxicating myself with ecstasy—ignoring the misery. A dream had materialized from the darkest part of my being. I had pulled everyone into my fantasy, and it was only fair that no one suffer but me.

Mitch gazes at me with those hungry eyes, his body glowing like burnished bronze.

"Lee," my name streams from his lips like a poem. Mitch meets me with his mouth, diving over me with a kiss that tastes like eternity branding itself from his soul to mine. "I'm going to love you," he whispers, gliding down my body and burying a

string of kisses over my stomach, trailing lower until he presses my knees apart.

Mitch peels off his jeans and rises above me like a phoenix. He crashes his lips over mine and kisses me through a lust-driven smile. I open up for him like a flower—Mitch is the sun I've craved for so long. He pushes into me with a pronounced thrust, and a small cry escapes me that's been building for the last five years. Mitch pushes in, deeper still and fills me with all of his carnal affection—a hard-won groan wrenches from his gut.

"God, I love you," he pants hot into my ear.

"I love you, too, Mitch."

There's not another person in the universe who exists right now.

It's just Mitch and me, lost in our love as his body moves in rhythm to mine.

But Max hovers over us like a ghost.

And, now, nothing will ever be the same.

The Departure

Lee

It's a dangerous game when nobody knows how to surrender. If only it were a simple game.

The ground quakes beneath them. You could hear their primal grunting, feel the wind of their bodies cutting across the court. This was no ordinary match, no friendly round of balls—it was a battering. They want to beat each other, cross the net, and shove the optic yellow sphere down one another's throats. This is years' worth of pent-up aggression—the I'll-see-you-in-hell kind of drama played out in fields of war, gang infested alleyways—prison.

Katrice and I huddle on a bench under the eaves and watch Mitch and Max play tennis in a warlike fashion. The California sun scorches across the sky, searing down over the four of us as if there could be casualties. My eyes wander to a bone-dry acacia that threatens to ignite like a birthday candle under the oppressive heat.

A night from long ago hedges in my mind, and I can't fight it. I can still feel Max's strong body pressing into mine, still see the flexing of his chest—hear his steady groans.

"You ever think of that party back in high school?" Kat asks. She doesn't even know she's chiding me, that it feels more like a taunt than something genuinely inquisitive.

I slept with Max—just once, that night at the party.

Katrice bows her lashes, trying to hide a smile. She's the only living soul that knows what happened that night. Not even Mitch knows about that explosive night I shared with his self-proclaimed enemy. Of course, back then they were anything but—they were the best of friends.

"You ever tell Mitch?" she whispers.

"I'd die before I told him."

Those two were closer than brothers until Mitch's father and Max's mother flaunted their infidelity for the world to see. It was treason in both the bedroom and boardroom. It split two families in half and reduced their friendship to cinders.

"*Lee*," Max shouts, waving his racket. His black hair gleams in the light. He's so cuttingly handsome, but it's Mitch who's my golden Adonis. "You see that? Your husband cheats!"

I wasn't paying attention, so I just shake my head and round my hand over the curve of my swollen belly. I'm hardly five months, and already I've lost my toned stomach, exchanged it for a beautiful bump, oval and hard as stone.

"Leave him." Max grins before serving the ball with bionic force. "I'll help you raise the baby."

"*Leave* him?" Kat whispers. Her face pricks with mockery. "I'll help you *raise the baby*? He is so still in love with you."

"Shut up. He's not in love with me. He's in love with making Mitch miserable."

"Heard his divorce is final," Kat practically sings the words. I can tell she's enjoying this.

He was married less than six months to Vivienne—*Viv*. A girl he's dated on and off forever.

"Well, I'm never getting divorced, so he's out of luck." I hold out my wedding ring and examine the stones as they

shimmer under the harsh supervision of the sun. One of the diamonds pierces me with a glare—its brilliance lingers in my mind long after I put my hand down. It's been a year for Mitch and me. Our baby is due in October.

A biplane gets my attention as it whirs in the sky. It heads off toward the beach, hauling a tattered sign with a picture of a faded beer can. Living on the coast you see a lot of these. You lose interest in what they're trying to sell and just enjoy it for the spectacle it is. Mono Bay magic—that's what the tourists call it. Mono Bay, where the vineyards reach the shore. Not quite, but what do tourists know? Mono is famous for its vineyards with two of the most prominent belonging to the gladiators on the tennis court.

My stomach sours as the biplane purrs toward the horizon.

God—Mitch is going on an impromptu trip overseas, and I hate the thought of it. I hate the thought of him being away from me for one second, especially now with the baby. He wouldn't be going anywhere if it wasn't for Colton and his hidden talent of rolling off rooftops.

"So, Colt broke his leg," I whisper. Kat already knows this, but I'll say anything to change the subject from my one-night stand with Max, so I go with it. "They really need a general contractor, someone who knows what they're doing." A tight knot builds in my throat, choking off the rest of the words.

Colton. I'm so pissed he broke his leg. I'd like to break the other one, too—hell, all four limbs.

"Don't tell me Mitch is going in his place?" Kat's features harden. "So it's official? It's his job to keep bailing out his loser brother?" Her hair whips around her face and conforms to her sarcastic smile like parentheses.

"Bailing out Colt is Mitch's third job." Right after the vineyard and his new side business of construction.

I push into Kat playfully with my shoulder. Our matching long hair is straight as bones and pale as paper. You can tell

11

we're sisters in so many other ways, but it's the hair that confuses people, makes us look more like twins even though Kat likes to remind me I'm *older*—twenty-four to her twenty-three. My mother called us her Irish twins until the day she died.

"Besides, he'll be in and out," I say, trying to believe it myself. The truth is, it's going to be two long weeks in China. They had a team of six people, and three have already bailed. If it wasn't a community outreach, he'd probably reconsider. It should be great PR for Townsend Construction, the company Mitch and Colt started once the vineyard tanked, but I'm not sure it'll do anything to drum up business. "Colton volunteered to cover material expenses and promised to heft the bulk of the responsibility." I make a face at my sister because we both know damn well that Colt is allergic to responsibility.

"And the real story?" Kat is the last to buy Colt's special brand of bullshit.

"Apparently, a hot brunette committed to go, and Colt's dick wanted to salute the effort." A small groan escapes me because now it's my handsome husband who's stuck traveling abroad with a *hot brunette*. "Anyway, so much for altruism. Mitch is going to supervise construction, so he's pretty crucial to the team. They'd have to cancel the trip without him."

"And the vineyard?" Kat lends her gaze to the battlefield as two gorgeous men swelter in the citrine sun—even though I'd never admit it, I could watch this twenty-four seven. The truth is, I miss Max in our lives. We grew up together. I knew what each of his smiles meant. I miss those infectious dimples that would greet me, those cobalt eyes that washed the day anew with their glory. But, once the divorce bombs went off between their parents, lines were drawn, and I was already with Mitch at that point. Although, unlike Mitch, I never considered Max an enemy, not by a long shot.

"The vineyard?" I consider Kat's question. "Colt has two weeks to run it into the ground." I give a wry smile.

"Considering he doesn't have far to go, I'd say he can do it in one." It's the truth. Kat and I both know it.

Unfortunately the Townsend label doesn't have great distribution, so the construction business helps keep the financial cogs spinning. Max, on the other hand, has turned his father's vineyard into a global conglomerate. You'd think they were selling the fountain of youth the way bottles of Shepherd wine fly off the shelves. It's been served to royalty. And, poor Mitch—nine out of ten derelicts prefer Townsend wine across the country.

"Weird they're playing together," Kat muses, never taking her eyes off the sultans of soon-to-be third degree sunburns.

"So strange," I whisper. Max wasn't even invited to our wedding.

It was me who was playing with Mitch before I started to sway in the heat. Kat works at the club, so she brought me lemonade. Max came out with her and challenged Mitch to a quick match. "Wouldn't it be great if they could be friends again?"

"Mitch-the-Bitch and Maxi-Pad?" She balks at the insanity of it all.

Clearly I've stunned her.

Those were the monikers of choice they used for one another in school after the "incident."

Maxi-Pad. That's what Mitch called him for years, still does sometimes. It's hard to let go of all that misplaced anger. It was his dad he really wanted to strangle for having the affair with Max's town-harlot of a mother. But, both of their fathers are long since dead. You'd think it would have brought them closer together, but under the circumstances it created a division as wide as the sea and made them captains of industry far too soon. It set them up at the helm their fathers abandoned and led them to turn their livelihoods into a bitter rivalry.

"Mitch feels like he's always on the losing end of the stick." It's an unmitigated truth never before spoken, but it

13

ADDISON MOORE

hangs in the air like a ghost every time we read of another Shepherd victory.

"He said that?" Kat's mouth rounds out as if I've just dispensed a juicy bit of Mono gossip.

"Not those exact words, but it comes out in other ways."

"Oh, come on." Kat's eyes roll back a moment. "He's got *you*, Lee. He won the war. Who cares about battles fought with toothpicks when he's already holding the gilded trophy?"

I look over at Kat. Her play on words amuse me. Ironic if you think about it. Mitch and Max, those hardwired rackets nothing more than glorified toothpicks. What are they fighting for so ferociously, anyway?

A dull laugh settles in my chest.

Mitch really wants the win, and Max doesn't know how to lose.

Max catches the ball with his bare hand and howls out a laugh. He belts the ball into the sky as if it were Mitch himself.

"You *suck*, Townsend," he shouts, rounding out the gate and blowing me a kiss.

Mitch tosses his racket across the empty court like a machete, and it fractures into a thousand splintered shards.

So many pieces to pick up after those two.

I don't know why this always surprises me.

ဆာင်္က

Mitch drives us past the vineyard on the way home, and I roll down the window, inhaling the sharp bite of soil. Up ahead, a tall wooden arch rises into the pristine sky with a crooked sign reading, *Townsend Fields*.

"I've been meaning to fix that." Mitch presses his lips together and eyes the sign as if it might crash over the roof of the car as we drive beneath it.

I gaze out at the fields with the earth plowed in rows of deep russet-colored soil. The flat leaves of the vines are as wide as my hand, and the grapes gleam, hidden in the branches like tiny black gemstones.

Mitch and I get out of the car and walk over to the ridge, an overlook where you can see the entire vineyard, acre after luscious acre, nothing but rolling rows of verdant beauty.

"I'm going to turn this ship around." Mitch wraps his arm around my waist and presses a kiss into my neck as he leads us down into the field.

"I know you will." I give a peck to his cheek and rub my lips over the sandpaper like stubble. "I'm proud of how you handled yourself out there today, you know, with Max." Strange, his name hasn't passed through my lips in so long that it actually sounds foreign, downright illegal.

Mitch pulls back a dull smile. He's so unreasonably handsome with his chiseled features, his glowing jade eyes. He still makes my stomach squeeze tight with nothing more than a stolen glance.

"Shepherd has balls to talk to you the way he did."

"What?" I pull him in by the arm and hug him. "You're hysterical, Townsend. He was kidding. Only in his wildest dreams would I ever leave you and let him raise the baby." I brand a kiss over his lips and linger. "Besides, it's too late." I stop him from moving ahead and wrap my arms secure over his waist. "I love *you*. You're my husband. The only one I'd ever want." I push another kiss off his lips. "You're my everything. You're perfect."

Mitch presses out a gentle smile, never taking those lawn-green eyes off me. He reaches over and plucks a grape off the vine and sets it in his teeth before feeding it to me by way of his mouth. He cups my face as we share the sharp bite of fruit with his sweet tongue dancing over mine. Mitch is a master of achingly soft kisses—kisses that wrench a cry from the deepest part of me, kisses that give birth to moans that have the ability

to stretch out for weeks. My hands ride into the lip of his jeans, and I pull him in until his body is pressed against mine. The baby protrudes just enough to create a barrier.

He trails his mouth up to my neck and bites down gently over my earlobe.

"You're my perfect wife, Lee. And nobody, not even Max Shepherd, can take you away from me. I'd move heaven and earth to make sure that didn't happen. In fact, I already did." He gives my ribs a quick tickle, and my elbows swoop to my sides as I give a violent laugh.

"Oh"—I reach down and scoop a handful of clay— "tickling, huh? So you want to play dirty?"

"Is that where this is going?" He tilts his head with that wicked gleam in his eye, looking hotter than hell in the process. "Because it looks like you're the one who wants to play dirty." Mitch takes a slow step in, and I jump back, laughing. "Come here and nobody gets hurt," he gravels it out sultry and demanding.

"Oh, no, you don't." I try to make a break for it, but Mitch scoops me up in his arms and lands us both in a soft pile of Townsend soil, laying my head to rest in an orange cloud. "Thanks a lot," I tease. "I'll be washing dirt out of my hair for weeks."

His brows twitch. Then, quick as it came, his playful demeanor dissipates. His eyes grow serious as death as he takes me in.

"God, you're so beautiful, Lee." He swallows hard as he runs his gaze over my features. "I always want to remember you like this."

"Hey"—I reach up and touch his face, pulling him down by the chin—"I'm not going anywhere. You couldn't get rid of me if you tried."

He gives a quick glance around at the vineyard with its dilapidated sign, its dwindling crops, and gives a wry smile.

"Sometimes I think that's the only thing I've done right"—his eyes squint out a smile born of pain—"having you in my life."

"It's you and me 'til the end, Mitch." I pull him in until he's just a breath away.

"You and me 'til the end." He crashes his lips over mine and we detonate in a vat of passion, nothing but limbs and sublime kisses right here over a warm bed of Townsend soil.

Mitch said he would move heaven and earth for me.

I believe him.

Mitch

A seam of early morning light streams into the room from the slit in the curtains.

The clock reads 5:54—a full minute before the alarm is set to go off. I seem to do that on a regular basis—beat the buzzer, and I'm not sure why. It's a gift, I guess, but as far as gifts go, I'd like to put in for something different. Something a little more useful that actually has the potential to produce a paper-like substance traded as currency.

I dot the back of Lee's head with a kiss and take in her scent as she lies folded in my arms, still and quiet—so beautiful, and I fight back tears. Of all the times for my brother to maim himself, and he chooses now while Lee houses the evidence of our love deep in her belly. The thought of leaving Lee makes me sick to my stomach, but I would never tell her that. I don't want her to worry. I've been making it sound like no big deal, but Colt would have caused less pain in my life if he skinned my balls and used them for batting practice.

Lee relaxes into me, still lost in a silent slumber, and I memorize the way her skin sears up against mine, her silken hair soft against my cheek.

I close my eyes and beg God to take care of Lee, our baby, the business. Protect all three from my idiot brother—and deliver us from Max. I throw in that last part about Max just for fun. Can't get him out of my head since last week. I don't like the way it happened—the way it felt too coincidental. My father's self-prescribed doctrine comes back to me—that there are no coincidences in life. It's never bugged me before, but now, with Max showing up out of the blue and saying the things he did, I hate the concept.

The plane ride floats through my mind, and I can't help but envision an aerial cartwheel, followed by a ball of flames and nothing but the blue Pacific as we nosedive into the sea.

Wish I could shake this feeling of outright foreboding. Then again, I don't travel much. Maybe this is how you're supposed to feel seven hours before an international flight—maybe it's just self-preservation kicking in—a little something called "fight the flight."

I slip out of bed and head downstairs to make breakfast while trying to blow off the negativity.

It's probably just Lee's hormones rubbing off on me, and any minute now I'll be bawling like a schoolgirl, craving pickles and ice cream.

I hit the bottom step and my foot lands on the bare plywood that spans the downstairs. I meant to take Lee into town to pick out flooring. We never should have moved in without installing a proper floor of all things. Now there's furniture to move—heavy, cumbersome furniture that I'm pretty damn sure is lined with lead. Originally we had travertine planned, but at the last minute Lee changed her mind, and we moved in anyway. So plywood it is. The truth is, I'd love our home no matter what the floor was—because it's just that, *our* home—the one Lee and I designed ourselves. The one I built with Colt as a starter project for our new side business—Townsend Construction.

It hasn't fallen over yet, so we must have done something right.

"Morning." Lee comes up from behind and wraps her arms around me. I turn and bury my face in her neck, taking in her scent—not showered and perfumed, just natural Lee. This is how I want to remember her. The sweet scent of her skin is going to get me through the next two weeks. I dig my face into her hair and inhale sharply—saving it all for later.

"Morning beautiful." My stomach pinches with grief at the thought of boarding that plane without her. I wish she could go, but with the baby I don't want to take any chances.

The more I think about this situation, the more I want to smack my idiot brother. I've never been away from my wife for more than a day, and I sure as hell didn't plan to go on some foreign relations excursion while Lee is pregnant with our first child.

"Don't go," her voice dips into its lower register when she says it, sounding sexy as hell in the process.

I give her a minute to see if she's going to back it up with some nightmare she had of a plane crash, then for sure I wouldn't go. When Lee was six, she dreamed her parents were in a horrible crash the night before they were killed in a car accident. It's never happened again, the dream thing, but if she said it, I wouldn't go.

"I'll be back before you know it. Besides, hundreds of disabled orphans are counting on me." I throw in that last part with a lopsided smile—amused she might actually believe this.

"I know." Lee sags as she sweeps the floor with her gaze.

"Come here." I pull her in tight. "Stupid Colt," I whisper into her hair.

"Stupid Colt." Her chest rumbles over mine.

"I may have to kill him before leaving the country," I tease, rubbing her back, and she lets out a moan of approval. "Of course, I'll have to make it look like an accident. Maybe I can run his head over with my back tire at the airport. People are always in such a damn hurry in those kinds of places." A soft laugh rumbles from my chest.

Lee pulls back and makes a face. "No killing, Colt."

"You're right. Screw it. I'm sure he'll have some new mutation of the clap before Christmas—and I won't have to worry about doing the dirty work—*flesh*-eating clap."

Lee belts out a laugh. "Rumor has it, there's going to be a beautiful brunette on call in the event you get lonely." She bites

down on her lip, her teeth white as milk. "I think I'd better give you something to remember me by." She hops up on the barstool and rocks back with the curve of a naughty smile, crossing her legs, slow and seductive. Her skin glows from underneath her nightshirt, revealing the fact she's not wearing any underwear.

I give a slow spreading grin. "I can eat on the plane."

"Eat on the plane?" She runs her tongue over the rim of her lips. "Whatever will you do with all this time on your hands?" She slides her foot over her knee exposing a dark triangle tucked between her thighs, and my hard-on ticks to life.

"Oh, I don't know." I lean in and wrap my arms around her waist. "Maybe you can help find something to keep me busy." I trace the pattern of her brows, her high cheekbone before dipping down and feathering my finger over her lips.

Lee runs her hands along the elastic of my boxers before expanding their girth and sailing them to a puddle at my feet.

"Really?" I hold back a smile while my fingers work the buttons on her nightshirt. Technically it's my dress shirt, but it's been a longstanding habit of hers to utilize my wardrobe as her nighttime accouterments. "I'm naked in the kitchen. You're limiting my options of what I can do."

She bubbles with laughter as I fumble with the buttons just over her belly.

"Why don't you make us some eggs?" She teases. "You could be the naked chef."

"You're funny." I peel the shirt off her shoulders, and my insides pinch seeing her like this. Lee has perfect breasts, round as melons, but her stomach stops me cold. I hadn't seen her in the light in a while. I've felt her stomach firming, seen her rounding out in her T-shirts, but seeing her stomach mound like a half moon scares the hell out of me. Lee has transformed into a full-fledged goddess, a creature of beauty too magnificent to comprehend.

"Lee," I whisper, touching my hand over our growing child. "What the hell am I doing leaving you?"

"*Hey.*" She pulls me down to her mouth and tucks her legs over my hips. "It'll be over before we know it. I promise you, this baby and I will both be waiting, right here, naked on this stool until you get back."

A dry laugh rolls through me. "I like the imagery." My hand slips between her thighs, and her chest expands with a breath. "I'd think I'd better leave you with something to remember me by—something that might hold you over for the next two weeks." God knows I'm not going to be able to breathe without her.

She reaches down and guides me in. Lee lets out a groan that sears me straight to the bone. I push in and watch as her head slips back, her eyes close just enough while she bites down on her cherry-stained lip. I push in deeper before gliding out, and I'm already about to lose it. I don't close my eyes once. I savor every moment with Lee, lost in ecstasy, and wonder if I'll ever get to see this again.

I run my fingers over her slick and bring her right there with me until the world, the universe, feels like a bomb ready to detonate.

"Oh shit." I pull her in and tremble over her as she pants wild in my ear.

"God, I love you, Mitch." She grazes her teeth over my ear as she says it. "Come back to me."

"I will. I promise."

That heavy feeling takes over again.

Please God, let me keep my promise.

<p style="text-align:center">ഇൗൽ</p>

Lee and Mom sob all the way to the airport as if it were my funeral.

I cut a hard look to Colt. He almost had surgery. They wanted to pin his stupid leg then decided he wasn't worth the effort. I'm going to tear into him as soon as Lee and Mom are out of earshot—pin him to a wall with a hunting knife if I get the chance.

LAX roars with the hustle and bustle of bodies readying themselves to drift to the four corners of the earth—with China being the most distal point.

We park and the three of them come to the ticket counter with me to give a "proper farewell" as Mom put it. Hate to break it to her but this proper farewell has all of the charm of an Irish wake.

Colt leans against the wall, sizing up a blonde in an airline uniform as she whizzes by.

"Dude, come here," it huffs from me, annoyed as hell. I nod him over to the counter while Lee and Mom huddle in misery.

"What's up?" His hair is neatly combed back. He's showered, but his eyes look as if someone poured in vinegar. I'm afraid to ask whether or not a couple of blunts played a role in the breakdown of his blood vessels, but I'd most likely say, yes. We'd look identical if I spent more time at the gym and he spent less time everywhere but the vineyard.

"You don't take your eyes off Lee, got it?" I meant for it to come out harsher than it did. I'm so close to tears I force myself to take a deep breath and down the rest of my water before continuing. I'll let it all out on the plane—emasculate myself in front of dozens of strangers minus the people on the outreach team I don't know anyway.

"Okay." He salutes me. "She might not like it when she's taking a shower, but I'll follow orders."

"Right." I grip him by the arm and dig in. "Listen to me, you little shit. My wife is having our baby. If she feels the need for ice cream at midnight, she's going to call you. Pretend you're an adult for five minutes. I left the vineyard on autopilot.

Just show up. It might actually give people the impression someone's in charge."

"So you're just using me for my pretty face. Can I push all the shiny buttons?"

"The only buttons you ever push are mine." I blink a smile and offer a half-hug. "If anything happens, man, take care of Lee for me, 'kay?"

He pulls back, slaps me on the shoulder. "Dude, nothing's gonna happen. But if it does"—he mock shoots me—"I'll continue with family tradition and procreate with the girl in question."

Lee swoops in and shoos Colt away. Her face is blotched and her eyes stained with large, dark rings from crying. It's a haunting image that sears itself into my mind before I can stop it.

"Love you." I press a kiss into her, deep and lingering, as if we were alone. I don't usually make it a practice to kiss Lee so passionately in front of my mother, but this is an exception. I fight the urge to start breaking all sorts of carnal rules like taking off her clothes—having her right here at the baggage check in. "I love you deeper than the ocean, Lee Townsend." The first time I told her I loved her was at the beach, and those were the exact words I used.

She tries to smile but it fails to initiate. "I can't do this without you." It strangles out of her, broken in pieces, as she glides her hand over her stomach.

My heart breaks witnessing all of the misery I'm causing, and I haven't even stepped on the plane. I sweep my thumb over her cheek and press a kiss into her forehead.

"I'll be right back." Made it sound like I was going to the refrigerator.

"What if you're not?" Her eyes are on fire with grief, her lips quiver with fear; although, I'd like to think it was the kiss I just delivered that was making her tremble.

We hadn't entertained the theory of anything tragic happening until now. Something tells me it's too late to explore the concept, so I nip it.

"But I will be," I whisper. "I promise you. I'll be okay. Don't fall in love with Colt while I'm gone."

She shakes her head like a frightened schoolgirl. I want to add, *if I don't come back, it's okay to fall in love with Colt.* Something tells me to say it, but I don't.

I crash my lips into hers instead.

Max

Oversized X's, the size of cereal boxes, are keyed into all four doors of my truck—a bittersweet memento from Viv. Hell, it's all bitter. There's not one sweet bone in that woman's body. I'm over her, though. Although, I can't say I'm not freshly offended each time I'm forced to admire her artwork. It's more of a performance piece I guess you could say. Just like Viv—all performance. And cutting that drama out of my life was like excising cancer. The best thing we ever did in our relationship was sign the divorce papers. I assumed the position and took it up the ass while she got the house, two cars, and the condo in Tahoe. Thank God for the prenup, or everything my father worked for would be boxed and buried right alongside him. Talk about a watertight lesson. Might just leave those X's to remind me of what lies ahead the next time I entertain the idea of unholy matrimony.

I pull into Hudson's expansive, massively *expensive*, yet somehow doggedly showy, crap-filled yard and hop on out.

Hudson. Leave it to my ex-con slash wannabe biker of a brother to turn the best real estate in Mono into an automobile carcass warehouse. You name it, rusted out Chevys, skeleton Fords by the mile, burnt out crap, too. Anything and everything that once held the promise of a roadside maneuver litters the landscape as far as the eye can see. He lifts a beer in my honor as he makes his way over.

"What the hell?" Hudson stumbles forward, looking far more horrified at Viv's extension of her vagina than I did when I first saw it. I slam the door and survey the damage right alongside him.

"Love letter. If you're lucky, you'll get one someday." I push him in the arm, and nearly knock the beer out of his hand.

"Sooner than you think." The lines around his eyes harden. "Jackie's leaving me."

"Serious?" A quick pulse of alarm tracks through me. Hudson and Jackie have been married for over three years. They happen to own my favorite nephew, Josh—my only nephew.

"Serious." He yanks at his baseball cap and downs the rest of his beer before discarding the bottle into the bushes. "Moved out a week ago."

Hudson glances up at me. His watery eyes shine like green stones. He'd be a good-looking guy if he hadn't let himself fall to shit. Long scraggly hair—a Fu Manchu that scares the hell out of little children including his own—not that Jackie's a prize with that razor blade she calls a tongue. I've seen her greet her own mother with a blunt *fuck off* on at least a dozen occasions, and half of those were holidays.

Hudson heads toward his massive enclave of garages, and I follow suit hoping to escape the harsh sting of the sun. An entire herd of his lackeys are busy twisting over the open hood of a bright yellow kit car. In addition to pilfering the vineyard, Hudson runs a sweatshop on the side. Although, I believe the term he prefers is "automotive restoration lab."

"That's too bad about you and Jackie," I say before we head into the protective shelter of his overgrown man-cave. Can't say the breakup was entirely unexpected the way my brother likes to keep track of the local strippers—the way he earns frequent flyer miles by purchasing drinks at the bar.

"Don't feel too bad." He offers a conciliatory slap to the back of my neck. "I don't miss her. Besides, now I get to hang with the boys." He pats a burly looking linebacker on the shoulder.

"That's the problem," I'm quick to assess. "You never stopped hanging with the boys."

"You come to lecture me on what it takes to keep a woman around?" He bucks out a laugh and plucks another beer

from the cooler. "Or are you just playing show-and-tell with the new masterpiece scribbled on your truck?"

"That's what I'm doing." I shake my head. Viv made sure I became a road show for her new career as an emasculation artist. I'm sure she calls this piece *the ex-husband ode to Blue Balls*. "I came by to see Josh and to tell you there's a shareholders meeting next Tuesday. Play dress up in a monkey suit, will you? Brush your teeth, and I'll throw in a six pack."

"Got it." Hudson looks impressed with the promise of malt liquor.

A white truck pulls up with a cheap metal sign slapped on the door that reads *Townsend Construction*.

"Here's my man, Colt." Hudson raises the bottle in his honor. "He's gonna give me a bid for the new garage." Hudson plucks his jeans up by the belt-loops before meeting him halfway. They exchange high fives and bark out a laugh over something. Probably how they've got their brothers snowed into doing the lion's share of work while they sit around titty bars and collect checks like Halloween candy.

Colt's sporting a thigh-high cast with a dozen different signatures scrawled over the front. There's a drawing of a naked woman upside down that he probably penned himself with his dick.

"What happened to your leg?" I don't bother with hello.

"Fell off a roof two weeks ago." He presses out a dull grin, and I see Mitch hiding behind his face like a ghost. "Glad it wasn't my neck."

"Yeah, well, better luck next time." I yank on my baseball cap. "Aim head down. You'll get it right eventually. Where's your brother? Rolling around with a broken back somewhere?"

"China. Building homes for orphans." He runs his fingers through his hair. Girls used to fall over themselves trying to get Colt into bed. They thought he was some god who was going to rule their world with his pearly smile and cut abs. Now look at him. Tumbling off roofs, barely able to keep the family business

afloat. They can't save Townsend. Hell, not even I could save Townsend. There's not enough alcohol in the world to pull off that miraculous feat.

"Sounds like Mitch is a real hero," I say.

Colt and Hudson somehow managed to stay friends after my mother devoured their father like an anaconda. The blame should probably be the other way around. Young widow, fragile mindset, vulnerable, but it was *my* mother in question, and the word vulnerable is nowhere near her lexicon, let alone her person—not after my father died—not a moment before. Everything she does is calculated, and if she wanted to bag a very married Townsend, then, by God, that's just what was going to happen. And it did, for a good long while until he died of a heart attack right there tucked between her legs.

Hudson and Colt could let it go, but not Mitch. He acted like I personally plunged a knife in his back when he wasn't looking. He was already with Lee at that point. First she dated Colton. That's when I hooked up with her at a party. She was mad as hell at Colt. Best night of my life, even if I was drunk out of my mind. So was she, which isn't like her, and that probably explains the sleeping with me part. Soon after, she broke up with Colt, and it's not too hard to understand why. I spent the summer with relatives on the East Coast, and when I came back she was with Mitch—missed my chance. I always wondered what would have been different if I had stayed. I don't believe Mitch Townsend was ever Lee's destiny, mostly because I don't believe in that destiny crap unless it concerns Lee and me. Nope. Mitch Townsend wasn't Mr. Right, just Mr. Right Place at The Right Time. Lee got comfortable that's all. She's loyal—doesn't know when to quit. I know this because every now and then I'll look at her, and sparks fly. You can't deny chemistry like that. Lee might, but I never said she wasn't above lying.

"Say a prayer for him." Colton's lips keep flapping like anybody cares. "He's gonna need it."

"Will do." *Dear God, please let Mitch drop dead in China, preferably between the legs of another. Either gender will do. Ah heck, make it a big hairy woman.*

I blink a smile over at Colt. "Just sent one up."

Missing You

Lee

My limbs swim over the bed in search of a tactile response—for arms or legs. There's a mental hiccup just after I wake and instinctually I reach for him. For a brief moment I believe he's still here, close enough to touch, then it all comes back to me, Colt and his broken leg—Mitch on the other side of the planet. Not even the tiny being that flutters in my belly can comfort me. The void he left eats through the darkness. It drills into my soul with a weight as heavy as the sea.

Eleven days without my husband and I'm starting to forget how to breathe. I can't see past the permanent lens of tears anymore. Eleven days without contact. No phone, no email. He said, worst case, there'll be no phone coverage and you won't hear from me. It's been eleven days, and it's worst case. Nothing—not one damn word.

The alarm on the nightstand blinks in a panic—two o' eight. There's no point in trying to pretend to sleep, so I call Colton and coerce him into coming over.

I scuttle downstairs in the dark, waiting for the trail of headlights to illuminate the night as I nestle on the couch. It's soupy out as a dense fog pushes over the landscape thick as batting unfurling in bolts. I glance up at the three-quarter

moon spraying its beams over the haze. It ignites the neighborhood with its glittering magic. A part of me is convinced I can walk through that precipitous bloom and land on the other side of the world—touch Mitch.

I've never been afraid of the dark. Contrary to popular opinion I rather enjoy it. I like to sit and bask in its stillness, take in the world robed in its midnight splendor. There's something relaxing about a room void of any ocular energy. I like the way the air shifts and takes on a strange heft—the way its weight presses against you like a body. The dark can comfort you far more than the light can if you let it. The light magnifies all the flaws in the universe, but the darkness lends a certain magic to the world. That's the reality I'd much rather live in.

Katrice and her husband, Steve, live a half block away. They've only been married a couple months, but I don't have the balls to ask her to come over this late. Colton is another story. Him I'd ask to dig in the sand until he found diamonds at this late hour. He owes me. He owes *Mitch*.

Twin lamps light up the street like a flare before landing harsh in the driveway.

When I called, he didn't sound the least bit tired. He sounded irritated more than he did roused from a hard-earned slumber. The only thing he likely abandoned for me tonight was his hard-on.

I watch as he jogs up the walkway. Same broad shoulders, same flame of golden hair as his brother and for a second I let myself believe it's Mitch—that he's come home early to surprise me. Then Colt comes in clear with his schoolboy swagger, that get-in-my-bed grin—nope, definitely not Mitch.

I push out a tiny smile and hold the door open. A crisp breeze whistles in and inflates my nightgown like a flower before I tighten Mitch's cashmere robe over me.

"You've got timing, you know that?" He gives a mild look of irritation as he steps inside.

Truth is, my eyes were ready to close off the world, heavy as anchors just before he pulled in. I could have gone to bed, but I promised Mitch I'd make Colt lose sleep at least once, and tonight seemed as good as any. I'm sure Mitch will dream up some supreme punishment later that involves manual labor and long hours, both of which Colt is spectacularly allergic to.

I lock my arms around him tight and take in his scent—musk and beer, a woman's perfume lingers on his neck like a poltergeist. The girth of his body against mine, feeds me on some level. For years people thought Colt and Mitch were twins, and tonight they could be. I pull back and inspect him for signs of my husband. I see him there in the cheeks, the perpetual smile in his eyes, those perfect bowtie lips.

"Were you closing a deal?" I ask.

"Negotiating." His brows dip as he frowns.

Colton is in the business of using women, not to be misconstrued as a player. These women demand to be utilized in the most sexually degrading manner possible. They line up for his dominance, desire him—worship at his feet until he points his unholy crutch in their direction.

"Shall we?" I tease, leading him up the twisted stairwell that leads through the attic until we emerge in a bath of dense salt-air. It was Mitch's idea to add a rooftop patio—that way we could see the moon dance over the water, he explained. He said we wouldn't want to miss it. And tonight the moon shimmers its spell over the Pacific like a song. It spells out *I love you* over the ocean like a poem written in the waves. Mitch was right— we wouldn't want to miss this.

Colton takes a seat next to me on the glider. He hikes his cast up on the small rattan table and groans.

It's so beautiful here. The beach house was Mitch's gift to me, to us. And it's times like this when I take in the grand scope of the sea—glittering and black—that I realize it's one gift that will never stop giving.

"I miss him," I whisper, pulling Colt's arms over my shoulders to keep from shivering. The ocean shouts as it detonates over the shore. It demands our attention at this late hour, filling our ears with its rushing fervor. There's something magical about hearing the consistency of the waves as they crash, listening to them whisper an apology to the shore after the harsh beating.

Colt leans in and singes a hot breath in my ear. "He misses you, too," he says it muffled through a yawn.

"I bet you never planned on going. Bet you broke your stupid leg on purpose." God knows he's done more creative things to escape an honest day's work.

"Stupid, huh? I get it," he moans with his lids half-shut. "You dragged me out here to tell me how much you hate me." He rubs the sleep from his eye with his palm. "You want to push me off the balcony?"

"Only if you let me." I let out a little laugh and expire it in a sigh. "I'm sorry." I nuzzle into him and trace the pocket on his T-shirt. "Calling you was a mistake." I strum my fingers just under his neck as if I were plucking the strings on a guitar. I thought Colt and I could make music once. But it was Mitch who made me sing. "I should have gone to bed—washed my hair in tears." It comes out low, morose. After my parents died, tears were the only constant in my life. Not even Kat could cure the pain. But this is an altogether different kind of misery. The pain of missing Mitch has multiplied, blossomed into a thing—a monster—I can't see past the heartache anymore.

"I don't want to feel like this." I let the tears burn hot tracks down my cheeks. They roll into the seam of my lips, and I taste the salt and the pain—nothing but a hot wash of agony I could drink by the gallon.

"Hang in there kid. Just three more days." Colt shakes my knee trying to snap me out of my hormone-inspired stupor. "We'll head to the airport, bright and early. We can hold up a

big fat sign that says, *Don't even think of pulling this shit again, Mitch.*"

I stifle a laugh. "You miss him?"

"Of course, I miss him." Colt sinks down and wraps an arm around my waist. "He's my little bro. Annoying as hell, but I need him. He's pretty good at keeping the funds fresh in my bank account—keeps me out of trouble, mostly—and he took you off my hands didn't he?"

It was Colton I dated first, then Mitch. Really I was using Colt to get to Mitch, but he grew on me, and we dated three solid months.

"This could have been our baby," I tease, placing his hand high over my stomach.

Colton is a far cry from his brother. He couldn't sustain a wife or child on his best day, at least not one set of each. That would be like a tiger living under water, it couldn't happen.

"Believe me, Lee. You'll have my baby someday. I'm just having Mitch train you." He digs a smile in his cheek. "When you're good and ready, I'll come around and take back what's mine."

"And Mitch?" I'm completely amused.

"He can be our cabana boy. He'll run around—cook our meals, do the laundry."

"You know what would be fun?" I reach up and pinch his ear. "If *you* were the cabana boy. Of course, you'll have to change diapers and give baths."

"Mitch can change diapers." He dips down and plants a warm kiss over the top of my head. "I'll give you a bath—you can sit on my lap while I do it."

"Stop." Typical Colt—all innuendo and nowhere to go.

He tightens his grip around my shoulder. "What do you think Mitch would do if he knew we were sitting in the dark entertaining the idea of bathing together?"

"Nobody is entertaining that idea but you." The sky brightens with a sliver of lightning. It cuts through the navy sky like a sword in some intergalactic declaration of war.

A storm rolls in on the crest of ominous clouds. I've never been one to romanticize the notion of a summer storm. My parents died on a night like tonight, leaving my uncle to raise Kat and me. He passed away my last semester in college.

Clouds gather thick and full in strange hues of pinks and grey while the moon cleverly amplifies itself from behind. The night lights up like a broken chandelier, followed by a primal growl. I pull Colton's arms tight around me and pretend he's Mitch. "Thank you for coming home," I whisper in secret.

He brushes a quick kiss over my ear. "You know I love you."

Mitch

A crowded room filled with the pungent scent of body odor, distracts me from the fact I damn near broke my back digging in soil that could double as concrete.

Bodies swarm around the tiny room, hot and sticky. The humidity in the air bites through my nostrils like a toxic stew. They talk in whispers while I sit against the wall, trying to keep my eyelids from closing permanently. I can't remember the last time my muscles ached like this. Swear to God, I'll never complain about losing a day in the vineyard again. Townsend field has nothing on China.

I steal a quick glance around the room for a sign of the clowns I'm here with. It only took four days for each of them to crawl under my skin, and now two weeks have drifted by and I'm ready to start breaking more than a few legs. It was my idea to head back to the place we're staying at and crash, but I was outvoted by the group and forced to attend a "house meeting"— a glorified Bible study that has all the appeal, and legality of a mafia meeting. It's not quite a house we're in, either. It feels more like a bunker, a dimly lit canal with no beginning and no end. We've crammed ourselves in a hideaway out in the country to hold this meet and greet after a blistering day slaving over parched earth. If I knew the soil would be so damn hard to penetrate, I would never have agreed to the job in the first place. On second thought, if Colt had come like he should have, I would have applauded the soil for being so damn stubborn.

A man, draped in a shawl that loosely resembles a potato sack, stands with his hands spread wide. He dispenses all things truth and light with minimal animation to a spellbound community of what feels like hundreds, sardined in this tiny space. He flexes in and out of broken English before diving into

Chinese. I manage to catch a word or two before growing sleepy from the Ping Pong effect of it all. You would think we smuggled in illegal contraband and distributed it to unsuspecting villagers the way we dug in like moles. Nevertheless, a healthy number has joined the militia-type group. It all feels so rogue—sneaking around, covering the windows with blankets. Turns out, the good book is covert ops in this part of the country. It's surreal to me. Lee and I must have half a dozen Bibles lying around. At least one of those is swimming around on the floor of my truck with discarded fast food wrappers. We walk into church like heading to the mall, no worse for wear. Not a fear in the world that we'll find ourselves staring down the barrel of a machine gun or a prison term.

I force myself to keep my eyes open and take in the scenery. When I replay the scene for Colt, I want him to realize this wasn't the romantic getaway he sold himself on. It's panning out to be a tinderbox of heartache with too much suffering I don't have the cure for and not enough Lee.

The women look beat and tired. Everyone's so hungry to hear what the man with the plan has to offer. As much as their muscles crave protein, their hearts crave hope. It's a miracle they believe in anything—that they even care to after the desolate living conditions I've witnessed. It's heartbreaking on a whole new level.

Lee. God I miss her. She wafts over me like a cool breeze.

Three more days until I see her. Everything here is in Lee time. Hours until Lee, sunsets until Lee, dreams until Lee. I see her everywhere, her beautiful face in the hills, the clouds take her shape—I watch her in the sky as she laughs and holds her hands over our unborn child. Even the stars converge to spell out her name. Lee is her own consolation, her own divine universe.

I'm so sick without her, I think I could actually die if I wanted. There's not another good deed in the world that would

make me leave her again. I'd break my own damn leg if it came down to it.

I glance around at the room full of somber expressions. You could hear the wind blow, the crickets layered beneath the silence. Not even the sound of human breathing exists within these four cloistered walls, just some underground cleric reciting red-letter promises. He strings them out like a lullaby until the world vanishes, and Lee meets me in my dreams with a smile.

<p style="text-align:center">ॐ</p>

A hard thump jolts me out of my slumber.

"Shit," I hiss, waking with a start.

A loud crash detonates to my left, and my eardrums vibrate from the assault.

I give several hard blinks and startle to a jumble of confusion—legs snake their way around the vicinity in a panic, a blur of bodies switch back and forth until the room begins to drain. Total disorientation sets in, and for a second I forget where the hell I am and what the fuck I'm doing here.

A gunshot goes off.

I hit the floor in time to see a pair of brown leather shoes stomp in this direction and one of them crushes my knuckles.

I snatch back my hand as I try to digest what the hell is happening.

A voice shouts something loud and aggressive in a dialect I've never heard, sounds like a rubber band warbling in and out of tune.

It all comes back, China, God—the man in the potato sack.

Shit.

The brief training we received in the "event things went south" jags through my mind. And here I thought the team

captain of this junior expedition was offering comic relief as we disembarked from a twelve-hour flight.

Bodies fly over chairs and dart out every exit at once, nothing but limbs scrambling, women screaming.

A small army of men suited up in black fatigues fill the room, each armed with his own personal assault rifle. They kick and shout at the elderly that were unable to make a quick escape and herd them toward the exit, pushing and yelling as if they were lining them up for the firing squad.

I glance around for a weapon, but the place is so damn bare there's nothing shy of a rug on the floor. I pat my jeans for my hunting knife before remembering it's in my backpack which I stupidly left it in the trunk of the car. It houses my passport and a picture of Lee, and suddenly I want nothing more than to get to that picture because clearly logic isn't invited into the equation.

"Please God, let me see Lee again," I whisper below a breath. "Just let me hold her one more time."

I bolt up and run out the back as a barrage of gunfire explodes from behind.

Outside, clouds lay in strips over a sodden sky. The sun melts over the horizon, still affording enough light to amplify the landscape. I dart up through the bushes until I hit the main road, and my heart lurches when I spot the car I arrived in sputtering down the street without me. It's teeming with bodies, struggling in low gear as it tries to barrel up the hillside.

"Shit," I grunt as I try to flag it down.

A barrage of uniformed officers pour into the street, corroding the landscape like wolves on the prowl. They fire an errant round of shots, inspiring me to take cover in an overgrown bush.

It all happens so fast. An entire band of men come in, clad in black, shouting and screaming like human megaphones. I peer out at them as they collect themselves in a group. The one with the thick neck and short arms appears to be in charge. He

carries the appeal of a death ninja as he barks out commands, and the men break out into groups of two and three in an attempt to fulfill their mission.

The guy in charge levels his weapon to his eye and manages to blow out the windows of the tiny car as it hits the crest of the road.

Oh God, no. The faces of the outreach team flash through my mind. They're good people. They don't deserve this.

All hellfire opens up on the car as the small sedan slows to a crawl, curving until it gently butts into a tree.

Three of his apostles take off for the wreckage. Not a window survived the ambush, a shower of red sprays what remains of the shattered glass.

One of the officers tosses in a softball-sized flame through the windshield, and the entire cab ignites like a bonfire.

Not one body moves inside, just slumped figures igniting like torches.

"*Shit*," I stare out in disbelief.

The bastard in charge gives a victorious shout as the unmistakable sound of glee swims from his voice. He fires a celebratory round into the air. This was his party, his deadly rules in play. The innocent beings that lost their lives were simply his prey.

The fire in the car dulls down to embers. Those people had families, wives, children waiting for them at home, and now they were gone in the most horrific way possible.

I get up and stagger backward as the stench of smoke sears itself in my nostrils. This is all too surreal, one minute I'm dreaming of Lee, and the next I've entered a nightmare. This is the stuff you read about—watch on the news, for sure not something I ever imagined myself caught up in.

A stream of officers jog into the street. They shout into the night as they circle the area. They smell blood, and they want it all. Still thirsty, unsatisfied from the mass slaughter they just pulled.

My heart tries to stomp its way out of my chest. I'd bet good money I'm about to have a cardiac episode—reenact my father's death in the least romantic way possible.

Something solid cracks over my skull, and a blast of agony splits through my body.

My face plants itself in the soil as the world fades in and out of existence.

A boot introduces itself to my thigh by way of a solid kick, and for a moment I'm thankful my balls were nowhere in the vicinity.

The angry boot rains down an assault of both the verbal and physical variety until pain ricochets through my skull like a boomerang on fire.

Two men with loose smiles stare down at me. They look happy to have me, a toy of their very own to torment.

Lee flashes through my mind, and I can't think straight.

He shakes his weapon at me, and I get on my knees—hold up my hands for good measure. The shorter one kicks my legs apart until the seam in my jeans threatens to burst.

"You spy?" He squawks it out so quick it sounds like the whoop of a police car, and for a moment I'm hopeful. "Say, you spy." He glances back at the amassing crowd of his comrades in arms. They share a laugh while settling in for the show. "You say spy, you live."

Doesn't sound like a bad alternative, so I nod into the idea.

"I'm a spy," I volunteer a little too eager.

Another round of barking laughter lights up the night. One of them helps me up, pats my back like we're old friends. A long scar decorates his face from his ear to his lip and I wonder if that's what waits for me on the other side of this incarceration.

A shorter man steps forward and butts his weapon into my ribs, forcing me onto the road and into a balloon-shaped patrol car that looks straight out of a cartoon.

They motion for my hands behind my back and throw on a pair of zip-tie handcuffs before shoving me in. Two of the guys hop up front, and we take off into the country, past the car still glowing with bodies, past the potato sack wearing cleric lying prone in the street with a bullet through his forehead, past a small child watching dazed from the side of the road. Hovels float by, then nothing but stretches of dry, flat fields.

The sun finally sets, and I wonder if all my hope of ever seeing Lee again has set right along with it.

Max
Two weeks later

I've prayed on a few occasions. Although, I'm pretty sure this is the only one that's ever been answered—and I was joking at that.

Mitch's funeral.

Memorial. Whatever. Here we are with the weeping, the gnashing of teeth commencing, and I can't take another damn minute. All the glory of pulling down his curtain is gut wrenching. Any moment now I'm about to show all of Mono that Max Fucking Shepherd has a heart—once the waterworks start.

I glance at his oversized picture, framed and mounted, and I fight hard to stop the tears. Mitch gleams a brilliant smile. He looks like he's advertising dental floss, not his untimely demise. Instead, the black and white pictorial adorns the altar as a final reminder of his effigy. Another picture sits to its right—one of him and Lee. Wedding picture. It was the best day of his life, marrying Lee, I'm sure of it—would have been mine if that were me.

You never know when you're smiling for the camera, which shot might make the pamphlet at your funeral. Maybe we should all pose for a funeral pic. Leave the guesswork out of every other picture we ever take. No more macabre thoughts running through your mind as the photographer counts to three.

I glance over at Lee. I've got a clear shot of her huddled between Janice and Colton. She's beyond miserable, zombie-like with a steady river of tears tracking over her cheeks. I glance down at the neat, glossy brochure folded in my hands

with Mitch's countenance on the front like a slap in the face. I skim the timeline of events planned for the service. She's not in the lineup. I can't imagine she'd want to speak today. It's standing room only in the back. It's quite a turnout with everyone in tears—nothing but heartbreak city.

Colton steps up to the microphone and gives a loud warbling sigh. "I never imagined I would have to do this." He reevaluates the crumpled paper in his hand before stuffing it in his pocket. It's eerie to look at him. He's all but a double for his brother. I bet it kills Lee to see him. "Mitch was a great guy. If you knew him for five minutes you figured out pretty easy how genuine he was. He'd give you the shirt off his back if you asked. Well maybe not his favorite Townsend T-shirt riddled with holes, but I'm sure if you asked real nice he'd give you that one, too."

A low rumble of laughter circles the room.

This is good—break up the atmosphere a little—take the edge off all the heart wrenching sorrow everyone's drinking down to the dregs.

"Once, when we were kids, Mitch and I thought it'd be a great idea to take our dad's golf clubs and hit a few balls in the backyard. Since he was younger and less likely to get in trouble, I made Mitch promise he would say it was all his idea if we got busted. We tried hitting some balls but discovered it was much more fun to pitch the clubs into the next field—see how far we could fling 'em. About halfway through the irons, Mitch launched a big Bertha like it was a missile, only this time it didn't go into the next field, it went over the roof of the garage and planted itself in a windshield. Turns out Dad came home a little early for dinner." Another round of titters. "Mitch took the blame." Colton looks remorseful. "He always kept his word." His eyes meet up with Lee before she dips her nose back into a wad of tissue. "Fast forward about five years. We're both sitting on the beach, and a beautiful blonde struts by. Mitch took one look at her and said 'That's the girl I'm going to marry.'" He

nods toward her. "That was Lee. Again, Mitch kept his word. Whether he made a promise to someone else or to himself, Mitch was a man of his word. It was an honor to be his brother." He pushes his palm into his eye. "Mitch, I'm gonna miss you," he chokes out the words before heading to his seat.

Impressive. Colton actually managed to string whole thoughts together to create a cohesive eulogy.

I glance over at Hudson. I wonder what Hud would say about me if it were my memorial service? He'd probably accuse me of being too damn uptight. He reminds me of this at least twice a week—thinks I'm digging an early grave by diving into the books everyday, keeping tabs on input and output. What he fails to realize is that if I didn't run the ship with both hands on the wheel, we would have capsized long ago. My father may have dreamed of this empire, but I built it, just like Mitch deconstructed his father's good intentions with a few select boneheaded moves.

Mitch could have listened to me. I mean, it's not like I didn't reach out to the guy. My door was always open. I even offered to take him to lunch and go over marketing strategies a couple of years ago, but he couldn't see past his pride. The fact he had a dead weight brother, one that rivals my own, didn't add to the situation.

The room darkens. A video presentation starts out with Mitch as a baby.

Baby. That's the elephant in the room—Lee's growing middle. Now what? Stand by and watch Colton, the bumbling uncle, swap the baby bottle with a beer bottle? Lee isn't even cognizant of what could happen with too much Colt around an innocent child. She's too blindsided with grief. Nope. Not letting that take place—not going back East this time. I'm not letting Lee out of my sight. I'll wait until she's ready. She will be eventually.

Mitch lights up the room with an enormous smile. There's something piercing about the way he looks out into the crowd.

He inspires the waterworks to take off exponentially, and I swallow hard, fighting not to give in. It takes everything in me not to blubber like a baby. It's a wrestling match of the highest order to keep my emotions in check, but the lights come back, and I let out a breath—I win.

My heart breaks for Mitch. I still consider him a brother even if he went to his grave filled with hatred over something I had nothing to do with. The truth is, I cared about him. And if it wasn't me who could have Lee, it might as well have been him. Doubtful he would feel the same now that the roles are reversed. In fact, I'd better get ready to dodge some serious lightning bolts if he has anything to say about it.

<p style="text-align:center">⁎⁎⁎</p>

After the service, a line snakes around the room as people offer up their condolences to the family. It takes an hour before I even reach the front, Colton first.

"Sorry man. He was a good guy." I pat my way past him and let Lee fold into my arms. She smells good, roses and raw earth. I breathe in the scent of her hair, feel her soft skin against mine and close my eyes a moment. I'm still so thirsty for Lee. All of those wasted Vivienne years when all I wanted was something I couldn't have.

My arms remain locked as I wait for her to let go first.

"Thanks for coming." She pulls back, holding onto my hands with her iced fingers. My eyes fall to her waist. It looks like she tucked a basketball under her shirt, and it makes her even more beautiful.

"I'm sorry there was anything to come to," I say it low, and my voice breaks for the first time.

"He liked you," she whispers through tears. "He just didn't know how to handle it all. I'm sure if Mitch had more time he would have welcomed you back into his life." Her left

eye twitches when she says it as if she had spilled some long-guarded secret, and she just might have.

"I'd like to think so." I warm her hands with mine. "If you need anything at all, call me."

"I will." She says it, but it feels obligatory.

"Janice." I pull his mother into a tight embrace. I miss Janice. She was more of a mother to me than my own could ever hope to be. Her hair is shorter, darker than it was when I logged all those hours at the Townsend house back in high school.

"Max." Her entire face glows with a broken smile. "How have you been?" There's a genuine sweetness in her voice like she means it.

"I'm fine. Listen, if you want me to take care of anything at the vineyard—even if it's just paying a few bills. I'm your man."

Lee reaches over and clasps my forearm. "Would you? He did everything by himself, and I've been trying to figure things out, but I'm afraid I've missed something."

"Yes." My heart thumps like a racehorse as I cover her hand with mine. "Don't worry about a thing. I'll come by tomorrow and straighten everything out."

I'll be happy to put myself front and center.

By the time she's ready to move on, I'll be all she sees.

3

A Grievous Kind of Love

Lee
Two months later

When I was a child I adored my mother. Her hair was spun gold, and her teeth illuminated like stars. My father was a tall man with a twinkle in his eye just for me, and I worshiped at his feet. Katrice and I would stand at the window like puppies until he came home from his job at the advertising agency. He brought colorful paperclips and discarded office supplies that delighted my sister and me. They were our treasures. Then God saw that my heart was full and removed my parents from the landscape of my life.

Mitch.

He filled my being with his goodness. His heart was pure, and he loved me infinitely more than my parents were ever capable. God saw that this too was good, and He took Mitch. It's days that my heart highlights this realization that I feel like a celestial toy—nothing more than a mortal burden to those I love.

In a tragic sense, my sweet baby will enter this world without two parents. One of them removed from the planet by fire and the other removed by emotional paralysis—with

nothing left to offer but a soul caged in barbed wired—a heart of ice.

Time is drifting. Minutes, hours—*days* bleed by. Time flows like some unstoppable torrent. It knocks me off balance with no proper way to navigate its force field. The day and night die, then resurrect themselves as something new, but I see it for the sham it really is—just a string of yesterdays that pile up in the end, the hopeful tomorrow dangled before us that never comes.

It's killing me fast, this death cloud with its intangible stranglehold.

I'm paralyzed. I've become my own rotting corpse with the hand of God crooked around my neck, dragging me into each new day by force. I'm choking, all alone in my misery. There isn't enough time to devote, collapsed in front of Mitch's pictures, pleading with God for some new resolution to this madness. I'm nothing more than a speck in the universe. I've become a master of my nothingness.

I play with the curtains while peering out the window. My heart pulsates with anticipation because Max is on his way to the house to comb through some loose ends in the office. Max has gone by Townsend vineyard every single day for the past eight weeks. He's reassigned distributors, and production has nearly doubled under his steady supervision. But today he'll be here, on sacred grounds, and I'm afraid of what Mitch would think. It's strange. The only other man I've had at the house is Colton, and now, out of all the penile-wielding people on earth, it's Max who will darken these halls. It feels entirely septic bringing him here. I try to tuck away the anger Mitch felt toward him. Mitch would rather eat buckets of broken glass and swim through sewage than have Max here under any circumstance.

His truck pulls in low on the driveway as if he were unsure himself whether or not this were a good move. I rush over to the door before he has a chance to knock, excited to see

him, excited to see anybody who has the power to soothe this constant bite of pain, and Max definitely holds that power. Max has become a strange salve in Mitch's absence.

He strides up the walk with the beginnings of a smile playing on his lips. His dark hair stains the blue sky with just the right amount of saving grace my heart needs.

"Hey," he says it shy, wide-eyed with a slight grin just for me. His dimples dig in deep, happy to see me. His eyes steal the color from the sky and make it their own. It's a wonder I didn't bow down to his glory long before that fated night in high school.

He's lost the suit in exchange for jeans and a green T-shirt with faded letters that read, *Ireland*. The soft scent of musk and sandalwood mixes through the air, and I take him in, inhale him by the vat-full. I miss the clean scent of a man, the layer of testosterone just beneath. It makes me dizzy, makes it feel as though the altitude in the room has shifted.

"Hey, yourself." I wrap my arms around him and pull him inside.

Our eyes lock, and something quickens in me. I don't think I've felt him through anything but his wool suit, his crisp dress shirts, and now here I was with my hand over his warm arm, his muscles rock solid as if he were carved from granite. I take in a breath and pull away. Max has always had the power to move me on primal level, but I belong to Mitch. Mitch is my everything. His death is just another obstacle we'll have to overcome on our way to happily ever after, and a heartsick part of me accepts this impossibility.

"What's this?" He runs his shoe over the raw plywood and creates the shape of a rainbow in the dust.

"My fault. I couldn't decide what I wanted, and now I have nothing." Just like it's my fault I let Mitch go. I should have pulled the wife card—the new *mom* card—and I would have, but I swore I'd never be one of those women.

His serious eyes flex at the sight, and I marvel at the unblemished sky he holds in them. When we were kids I could stare at them for hours. Even before my hormones kicked in I had a place in my heart for Max. But I can tell he's judging Mitch for letting us move in like this, even if it was me who pushed for it.

"So what are you leaning toward? Are you thinking stone—hardwood?" He presses his hand into the small of my back as I lead him toward the office, and an electrical charge springs from his touch. It travels up my spine and proliferates its branches over my arms, down my legs, quickening between my thighs. Max is infiltrating, rooting himself in my existence even if he's not aware of it.

There's a sweetness to Max. If I let him, I'm sure he'd solve every problem on the planet for me, including my spousal deficiency. But he can't bring back Mitch. He can't *be* Mitch. Some problems are just too big.

"Wood, for sure." I blink back tears. "We were going to put in stone, but then I thought wood last minute." I thought it'd be better with the baby, but I leave that part out. Instead, I run my hand over the high crest of my stomach. The only piece of Mitch left in the world sits right here inside me. The whole universe had reduced itself to a thimble. It was so big and beautiful with Mitch in it. His love buoyed me, soft and light, like helium. I don't think this baby could take his place, but I long to see Mitch's face when I hold it. I crave to see his smile again in our child, hear his laugh through another set of vocal cords.

When I come to, Max is penetrating me with his gaze. He doesn't ask for explanation when I go away like that, just simply waits for me to return.

"Sorry," I say, leading him into the stifling office. "It's an oven in here. No A.C.—Colt's fault." I'm quick to point out. "Colt was in charge of ductwork and screwed up—now it's a

furnace. For this reason alone Mitch didn't spend anymore more time in here than needed."

We both take a seat, right here, in Mitch's office, and yet today it feels more like a chamber of his heart.

Max lets out a soft laugh at Colt's oversight. "I'm shocked he didn't install a stripper pole in the middle of the living room." His eyes widen with a slight look of mortification. "I meant Colt, not Mitch."

"Of course you meant Colt. And, it was me who ixnayed the stripper pole from the blueprints." I give a little laugh. That small tremor stirred something inside me. I haven't laughed since before Mitch left—forgot that I was capable. "Here's the stuff." I pulled all the papers I thought Max might have to look at and fanned them out like a tapestry of financial destruction.

I watch over his shoulder as he studies each one individually—Max with all his assurances. With Mitch there were always questions when it came to the business, and with Max there are only solutions.

"So what's going on with our favorite strip club patron anyway?" He glances up, and the dimple on the left side of his cheek goes off with a wink.

"Why? Is he siphoning funds?" I lean in closer until my cheek rubs against his shoulder. I can feel the warmth radiating off his body, and a selfish part of me craves to touch him, wrap myself around him like a vine and forget about all this dizzying pain.

Max turns into me, resettling the paperwork in his hands. He inspects me in earnest before giving the hint of a devilish smile.

"Do I detect a hint of mistrust?" He looks alien in this world that Mitch built, gorgeous yet obtrusive.

"I don't know." I avert my eyes at the thought. "I'd trust Colt with my life. My finances—not so sure."

He reverts back to the paperwork a moment. "I'll do a little digging. How's he handling things? You know..." He ticks

ﾃﾃﾃ

his head toward a picture of Mitch, reducing him to a bodily gesture without meaning to. Max asks me that same question every day regarding my own sanity or lack thereof. He's been so wonderful, holding me up emotionally like a suspension bridge that's desperate for the plunge because he knows that drowning in grief is a real possibility. "I mean, usually he's poking around Hudson's, but since the funeral he's been M.I.A." He winces as though he regrets his word choice.

"No, it's okay." I have Mitch's blackened wedding ring, his charred passport. All but two bodies were identified with dental records. Two of them didn't have anything left to ID due to the fact they had their heads blown off. But they had enough bags stashed in the trunk to account for each person, and those were left untouched for the most part. "Colton is being Colton, drinking, losing himself in front of the television. Sleeping with everything that's not nailed down. That should numb the pain for a while."

"How's Janice?"

"She's lost." It's like a tidal wave came and washed everything we knew away from underneath us. And now we're drifting, looking for something solid to hold onto. "I wish Colt would step up. I think he's so immersed in guilt he can't see straight. He was supposed to go but broke his leg."

"Sounds like he's self-medicating." Max presses his gaze over me as if he were taking inventory of my features, memorizing them as individual attributes. He leans in as if he were about to confess he was self-medicating, too, still high on the memory I gave him at that fateful party long ago—medicating on our short jaunt into fornication. Although alcohol inspired, I still wanted it. It still makes me blush to think about.

I can feel his open wanting, and I don't shy from it. I think Mitch should have known better than to leave me, and now look where it landed us? With him dead in a ditch and Max Shepherd trying to fill his void. Maybe it's not fair of me to be

so pissed off at my dearly departed husband, but the anger feels so much more powerful, far more productive than pain ever could.

"I'll talk to Colt," he offers.

"Better not," I say. He chewed me out in a drunken tirade last week at the mention of Max's name. "I think he just needs more time."

"It's been over two months, and I haven't seen him at Townsend once. Does he honestly expect you to run everything on your own? Lee, he doesn't give a rat's ass about this business—you and I both know it."

A deep sigh expels from my chest at those potent truths. Max's words are like a bloodlet, like a weight rolling off my shoulders lightening the load so I can breathe again.

"I thought the same thing last night, but I don't dare mention it," it comes out low, catatonic. "I feel like I need to walk on eggshells around him. He blows up if we even get near the subject of Mitch—to Colt the vineyard *is* Mitch."

Something solidifies in Max. His eyes harden for a moment as if he were ready to send Colt off to say hello to his brother in the great beyond.

"I'm going to help you, Lee," he says it surefooted and finite. The deep baritone of his voice comforts me, repairs the suture of Mitch's death just enough for me to catch my breath. "Believe me, it's my pleasure. But I can't wrap my head around Colton flipping out, going off the deep end like this. Sounds like he needs some serious help or a good old-fashioned ass kicking. I'll make sure he gets both." He blinks a smile, and his dimples go off. It sends an uninvited quiver through my stomach and makes me uneasy. I'm not ready to have those feelings again, *ever* perhaps, but my hormones have taken my body hostage, and I'm quivering for Max at the drop of his dimples.

"I don't know what I'd do without you." My voice breaks as I say it. "I would have lost everything he worked so hard to keep. I can't lose the business." I choke the words out. "I know

for a fact he'd want our baby to have it. As for Colt, I'm not entirely opposed to the ass kicking." I try to force a laugh, but I mean it. In truth, Colt should have had that beating years ago, administered personally by Mitch.

The baby starts in on its daily aerobics routine, and my shirt jumps like there's a frog beneath it.

"Whoa, I saw that." His whole face lights up as his eyes settle on the bulge beneath my chest.

"Here." I take his hand and place it over the sharp protrusion. It gives another hard kick like it's trying to bat him away, and I bite down a smile. This baby is Mitch, through and through.

Max pulls me in with those watery eyes, there's sadness there, but they smile for me anyway.

Mitch's picture snags my attention—Mitch and I on our honeymoon in St. Lucia. We smile for the camera as the clear blue Caribbean spreads wide and innocent behind us like a bird in flight.

And now here I am, holding Max Shepherd's hand over our child, an act I'm sure Mitch would have found borderline sacrilegious. Perhaps he should have entertained this theory before boarding that plane. He should have weighed the consequences before he volunteered himself on a life-threatening mission like he was some infallible superhero. He should have thought about Max Shepherd taking his place in his business, sitting comfortable in his seven hundred dollar leather chair—Mitch who keeps his "word." He promised he'd come back. *Be right back,* he said—nothing but an empty promise. Colton had it wrong at the funeral. Mitch doesn't always keep his words.

I break down and cry, right there in the office, with Max's hand still firm on my belly.

"Hey, come here." Max envelops me with his strong embrace, his warm skin pressed against mine. I close my eyes and dig my nails into his arms as if impaling myself into him

were the only way to keep from sinking under the weight of Mitch and his nonexistent casket. I can't take this pain all by myself anymore. I want to give it all away—squeeze into Max until my fingers dig into muscle, and sinew, and bone.

"I'm so glad you're here. I couldn't do this without you." I whisper.

I glance over at Mitch, encapsulated behind a curtain of glass, and give a sharp look.

I hope he heard every damn word.

Mitch

My feet are bound with threadbare rope, strong as steel, while my hands are pulled apart, secured with leather straps at an uncomfortable trajectory. A stout man with sunken jowls beats over my flesh at regular intervals with rusted, iron tongs. If he derives any pleasure from the experience, he sure as hell doesn't emote it.

I'm not sure how long it's been since the last time I slept, but I'm pretty sure that's the point—keep me awake until I lose my fucking mind. Little did they know my sanity left right along with my hope of seeing Lee.

Hard, powerful blows ignite over the top of my head, my chest, my back.

Shouting—bright lights.

They want something from me because they think I'm a spy. It's the joke of the century. I can't give them what they want: names, places, dates. My head reverberates until I can't make out their broken English anymore. Dogs barking—they all sound like rabid dogs.

Another sharp blow to my temple—the skull cracker. A trickle of blood runs down the side of my head, and I lap it up. Taste the salt. I'm so hungry, so thirsty. I'd drink my blood by the bucket if they let me.

The room warps, and with unrequited mercy, the world fades to grey.

❧❦

A fresh slap on the face draws me out of a drug-like slumber. I give a series of rapid-fire blinks, reaffirming my

worst nightmare. I'm still here in the same dungeon-like cell. My eyes struggle to open as the sharp blows persist. I try to break free from the new configuration they've set my limbs to with my hands fettered together, my feet still bound at the ankles.

A stocky woman, with a dark eyetooth, drums harsh jagged words from her lips, subtle as pounding a hammer. She taps my mouth with her fingers before producing a heaping spoon of rice.

My jaw widens lazily, and I let her feed me like a child.

The unmistakable harsh bite of salt explodes over my tongue, and I spit it out onto my chest. Someone got the recipe wrong—or not.

A rattle of angry words escape her before she produces another heaping spoonful. She shovels it in with a slight look of frustration—clamps one hand over my mouth, pinches my nose shut with the other. She force-feeds me ten more not-so-loving spoonfuls until the salt races through my veins, amps my blood, and spikes through my skull at unnatural levels.

If I didn't get the message before, I'm getting it now—loud and clear—no fucking sleep. Not one long blink or they beat the shit out of you. I struggle to keep my eyes from closing on a permanent basis. Think of Lee. Beautiful Lee—our baby so close to arriving. Or maybe it's already here? I've lost track of time. It might have been years, feels like decades, one long bad dream.

A man walks into the sparse concrete room. I've been under the watchful eye of two rail-thin men and the poisonous chef for as long as I can remember, and now he's something new. He steadies a bucket in his hands, and they take turns spitting in it. He steps forward and dowses me full in the face—cold, sweet water. If I knew, I would have opened my mouth, drown in its beauty. My body craves another dowsing, and I beg for a reprisal.

Hours pass.

He comes in with his beautiful bucket and baptizes me with its offerings. This time I take in a mouthful, choking on what I manage to aspirate. It takes a while for me to catch onto the fact this is an ongoing process. Rinse, lather, repeat—rinse, rice, beat.

A vaguely familiar figure peers from the shadows. His tall, menacing stature lingers like a stain against the wall.

He steps into the light, and I take him in. His smile, those sad eyes, I recognize him from so long ago. My father.

"Am I going to die?"

"Not today, Mitch." He steps from the murky fog and places a hand on my bare shoulder. I can feel him—*feel* him.

"Get me out of here. Untie me." I'm panicked and thrilled at the sight of him. My adrenaline shoots through the roof at the prospect of returning to Lee—of becoming a ghost like my father.

"I can't do that." He pats me on the back like he used to when I was child. A forlorn expression is locked on his face and that always meant no.

"Why the fuck *not*?" I pulse in agitation. "Where's God? Why isn't there anybody here to help me?" I bellow it out in an aggressive roar, motivating the bucket man to pour his affection over me again.

"I'm here, Mitch." My father bleats from behind.

"Help."

"Your time here is a gift," he says. "You're one of the lucky ones."

Another splash ices my body, sends a shiver through me, so strong, it nearly rocks me off the chair like a seizure. The woman with the poisoned rice leaves the room, as does the man with the iron fist. A changing of the guards takes place, and everyone is shiny and new. Two men enter, one with a rubber tube. He introduces himself by way of a swift strike just below my neck with what looks like a rubber pipe. A spray of sand escapes the instrument of destruction, and I'm quickly apprised

of what gives it such great heft. A series of pressured blows rain down over me, one after another. The grand finale lands over the top of my skull and makes me bite down on my tongue without warning. It sends a blinding pain through me—numbing—so distracting with its horrific sting, I don't feel anything else.

I've transcended fear with this new reality.

Another man steps up to the plate, fresh and ready for his chance at bat. He holds something up for me to see, but my vision blurs with a warm trickle. It takes a moment to recognize the strange crimson glow filling my eyes. Blood drips down my chest, my thigh, right onto the floor, pouring from me like oil.

A long, thin rope with jagged edges unfurls from his palm. He whips it across the room without moving. It pulsates in his hand like a demonic snake—a giant rat's tail embellished with knives. It strikes against my hip, catches on my flesh before he commands it back with the flex of his wrist. It digs into my skin, taking bits of me with it.

I'm so unbelievably tired, so unnaturally dazed from this long string of horror. I let out a deafening cry to reward him for his efforts. But there's no satisfaction with my displeasure. He scrapes his barbed leash along my chest, creating railroad tracks of blood—all of the work I put into life, the vineyard, my marriage, my marrow—in the end it was for nothing.

He doesn't deviate from his position across the room. He's the requisite conductor unmoved by the melody—completely underwhelmed by my cries for mercy. He's seen it all before, been here, done this. It is his sole reason for existing.

A static charge builds around me. It fills my ears with its incessant buzzing. Voices escape from the walls—the ceiling. An entire human choir hums in the vicinity, and I can distinctly hear Lee. Her trail of laughter, the coolness of her voice, she's most definitely saying something, and I can't make out a single word.

"*Lee!*" I cry out.

The voices escalate in agitation. I can hear God, my father, the entire universe speaking in tongues. It's so damn beautiful, I collapse under its glory.

Then, in a moment of resplendence, I see her.

She snatches around the room like an apparition. So perfect, so frightened. She points at my wounds and laughs her wonderful laugh. She tells me to come to her.

"I can't get up, Lee."

She walks over, slow and seductive. Her robe opens up in the front. She's naked underneath—the round of her belly so close I can touch it.

A wall of water christens me, and Lee disintegrates, quick as a vapor.

It's so quiet again, nothing but a man with an empty bucket staring back at me.

Max

"Here." I spread the concept designs across the table as Lee and Janice lean in to inspect them. Last week, I had the art department print up new labels for Townsend. I'm shocked Mitch kept the old crap as long as he did.

We sit nestled in Janice's kitchen, a room I haven't been in since I was seventeen. I forget how many meals I had eaten here up until then—how many days I spent in this house. I miss those carefree days when Mitch and I used to shoot BB guns all night, knocking out foxes and chickens that had a habit of straying from the ranch next door.

"God, these are gorgeous." Lee's eyes widen. Her lips press together, and I watch as they turn white then pink from the effort. "Mom, what do you think?"

"I like it." Janice is slower to praise my work. Her dark hair is tinted with a magenta patina, greying at the roots like it's time for a touchup. I remember when she had it long. She wore sundresses and never left the kitchen, always baking something for *her boys* to eat. She included me in that number once, and it felt good. "It's change, though, and I'm not sure how much more I can take." She plucks off her glasses and rubs her tired eyes.

The old Townsend label is archaic and not in any good, nostalgic way. It looks dated like someone printed up the labels using ancient software. A seventh grader with a basic home printer could do a better job.

"I checked the books." I try to sound as benign as possible. The last thing I want is to come across like some arrogant asshole who wants to destroy everything her son built, or—more to the point—demolished. "You're already paying for a premium label. For the price you're getting, I can have a gold-

embossed vineyard on the front and the company name in a nice script font. I can get three colors—two of them in foil."

Lee glances over at Janice. "I really want Townsend to crawl out of this den of mediocrity. I think we *need* change."

Footsteps migrate over from the entrance. Colton barrels in and almost passes the three of us up before stopping in his tracks—glowering at us like we were busy drowning kittens.

"What the hell's going on?" He huffs, just this side of a rage.

It's clear my presence offends him, and he doesn't bother to hide it. He's honest. I'll give him that.

"Nothing." Lee sounds almost defensive.

"Doesn't look like nothing." You can practically see his brain spasm, he's that pissed.

God, he's wearing Mitch's face like a Halloween mask. I don't know how Lee and Janice can stand to look at him without weeping.

"Colt." Janice beckons him over to see the labels, but he resists the offer. "Oh come on, it's not like we're having some secret family meeting without you. Max is showing us some new stuff." She says it curt, spitting the words out like rancid fat.

Colt huffs a laugh. "I know you're not having a family meeting because he's not family." His voice raises an octave. "Lee, can I see you a minute?"

Lee pushes her seat back, struggles to get up before following him into the dining room.

"He's not my biggest fan," I lament while pulling out a different set of samples and laying them over the table. Truthfully, I don't give a flying fuck that Colt can't stand the sight of me. The feeling is mutual these days.

"He wouldn't be in this predicament if he showed the slightest interest in the working end of the business." Janice forces herself to pick up the labels and inspect them. "If it wasn't for Lee and the baby, I'd get rid of the company." Her

chest expands as she forces out a breath. "Lee wants this"—
Janice looks up at me from over her glasses, her expression as
serious as death—"and I want to see Lee happy." Her eyes
linger a moment like she's speaking in code—saying all of the
things she could never bring herself to verbalize.

"I want to see Lee happy, too." I fix my gaze on hers. It
feels awkward. Maybe I'm reading too much into this. As much
as I'd like to think Janice were handing me Lee on a silver
platter, the truth is, she just wants the damn vineyard to drive a
straight line without the wheels falling off for once.

Janice mulls over the samples. It's hard to believe she
buried a son just months ago. Her expression, her clothes, the
house, everything looks so ordinary as if Mitch might be the
next one to walk through the door pissed at what he's seeing.
But he's not. He's dead, and the world scoots by like it doesn't
even matter.

Lee reappears, agitated from whatever garbage Colton
spewed at her. She caresses her oversized belly with a motherly
affection before taking a seat.

"Okay." Janice slaps her hands on the table and nods over
at Colt lurking in the doorway. "Have you eaten yet?" Her tone
softens as she inspects her son. He's disheveled from a wild
night's romp, in sweats and barefoot.

He shakes his head, too filled with rage to speak. I hope
he gags on all that anger and ruins his digestive system for
being such an idiot.

"Good, you can be my lunch date," Janice offers, rising
from the table. "Max, Lee, if you'll excuse me, I'll leave the
designs entirely up to you. Just show me what you decide
before it goes to print."

Janice and Colton make their way out of the kitchen,
erupting in murmurs once they hit the hall. You can practically
hear the crackle of hatred electrifying the air. But there's a
definite atmospheric cleanse once Colton is out of sight. He
perverts the area just being here with all that hostility.

"You could bottle all that tension," I say. "If he could rein in his anger and use it as fuel to get his brother's company out of the gutter, he might actually get someplace in life."

"You mean his father's company." Lee pulls her cheek up as though I gifted Mitch with the honor.

"I mean his brother's. I think Mitch took it farther than his dad ever did." The potential, anyway. "What's got Colt so uptight?" Not that I need an explanation. Don't even know why I went there.

"You." She flashes a smile—first honest one I've seen since the funeral.

"Thought so." I can imagine the bullshit he's filled her head with. "Don't believe a thing he tells you." I don't really need the specifics.

I mop the debris off the table, leaving the labels in a neat stack for them to riffle through later.

"He said you want to get in my pants." There's a dare in her voice, but her eyes are wide at the concept. "And I laughed because someone's already in them." She strums over her belly.

"Very funny." I blink into the empty doorway. Of course he's right, just not now. "Lee?"

"Yes?" She leans in with a warm smile on her lips, and it's all for me.

"You want to go for a ride?"

<div align="center">∞⁣℃</div>

I promise to take her to lunch after one quick detour. We pull into a flooring warehouse downtown and walk through the side entrance into acres of hardwood samples. The air is thick with the scent of lacquer, and an inch of sawdust decorates the floor. A man with a clipboard asks if he can help us, but I let him know we're just looking.

"Wood is great for a young family," he insists. "If you need me, here's my card." He stuffs a small stack in my hand before disappearing.

I glance over at Lee with apprehension.

He thought we were a family—Lee and me. Her discomfort spreads a mile wide as she raises her shoulders and holds them by her neck. I take a step back trying to increase the proximity between us—send the signal I'm simply a contractor showing a client the options out there.

"What kind of wood were you thinking?" I say it low and steady, trying to get her to focus on the sound of my voice rather than drifting back to China where I'm sure she strangles Mitch nightly. "Do you want a dark stain or something natural?" I'd die to have a family with Lee—for that baby tucked in her belly to have been derived from me.

"Dark." She gravitates toward a black high polished sample, and I hold it up for her.

"You'll see footprints on this one." Dust too, but I don't want to imply she's not capable of maintaining it.

"Something dull, then." She runs the pad of her hand over it before studying her reflection in the veneer. "Less of a shine."

"There's some nice stuff toward the back." I replace the sample and start leading her over. Her fingers feather over my hand, and she clasps on for the ride.

"I can't keep up with you," she says it out of breath as she waddles by my side, but right now I'm just fixated on the fact she took up my hand and interlaced her fingers with mine. "I'm sorry." She slips out of my grasp as though it were an oversight. "I guess I need to be pulled."

"No, it's okay." I retrieve her hand and press gently into the small of her back with the other. "I keep thinking you're the same Lee who beat me swimming when we were kids."

"That's right, and don't forget it." She pinches a smile. "I could hold my breath longer than you, too."

Miss those days, back when nobody dated anybody, and the Mono kids all hung out on the beach together. There's a fierce ache in my gut for that magic to return to our lives, to rewind the past and rewrite it. I wanted Lee—fell in love with her as soon as my hormones kicked into gear. I fantasized about being with her so damn much until one amazing night it actually happened. I still remember the way she felt against me, soft and smooth, the sweet groans she pushed in my ear—her legs wrapped around my back like a dream.

"Brazilian walnut." I take a breath and pull out a sample. "It's naturally dark, so you could sand it if you had to without having it refinished. There's no stain on this wood at all, just its God-given glory. Hardest wood on the planet." I give a strong knock as if that proves anything.

Lee goes away a moment—emotionally withdraws from her account—leaving a big empty space where her heart was a moment ago.

"Max?" It comes out a broken whisper—her eyes fixed on some invisible horizon.

"I'm right here." I place the sample back, readying myself for the hurricane of grief that's trying to escape her heart.

"Do you think Mitch is still alive?" She blinks into me with those ashen eyes. Her face bleaches out all color. "Please tell me—because whatever you say I'm going to believe." A lone tear rides down her cheek, catches the light, and falls like a star.

Whatever I say she's going to believe. What the hell am I going to say? There wasn't a stitch of DNA.

"Everyone was accounted for in the car." I let out a breath. "Three outreach workers, the owner of the orphanage, and Mitch—five people," I whisper as I step in close. "Backpacks belonging to each of them were in the trunk." Just the facts. I don't have anything else to give her.

"So he's gone." She looks past me, lost in a vegetative state.

"He's gone, Lee," I whisper, pulling her in. "Mitch is gone."

Lee folds into me and pushes her face into my shirt. I can feel her hot breath as her tears bleed through to my skin. Mitch and all of his good intentions. Wish it didn't go down like this. Wish I could go back and figure out why the hell he blamed me for something my mother did.

Truth is, I miss Mitch. I hate that he died. If I could, I would have boarded that plane for him just to give him back to Lee—so her heart wouldn't hurt like hell right now.

Tears spring to the surface. I fight to hold them back, then one by one they trickle down, and I rain all of my sorrow into Lee's beautiful hair.

We hold each other, right here in the warehouse, pouring out all our grief over the person I once loved like a brother.

The Kiss

Lee
Three months later

I drive out to Townsend field early on a crisp morning once the sky is washed crystalline from an unseasonable shower. Under the masterful guise of Max's supervision, Townsend is blooming like a cherry blossom in springtime. Deep inside I always knew it was capable, then Max came and worked his magic, simply lifted his fingers, and the surprise of color enlivened our world.

First, he made sure the vineyard received a much-needed fertilization. He had the fields aerated and pruned last week until the vines, the branches, all breathed a sigh of relief. Max, in all his wisdom is meticulous to detail, and Townsend is reaping the benefits.

The noxious fumes from the compost penetrate my nostrils. It burns my lungs as I stare out over the speckled green and brown rows of Mitch's blood, sweat, and tears. The dark, rusted soil has always captivated me. I've never thought of it as dirt, or like the soot you find in the yard. This was nourishing, life-giving soil, raw earth at its finest—warm and moist, every bit the clay that God formed man from. Now, Mitch himself has become a part of the earth, and all I want to

do is bury myself in its moist clay and join him on the other side.

The baby gives a viral kick, and I snap out of my Mitch-inspired stupor. I'd better get home before I hurt his only living heir with the viral scent of manure that Max laid out.

I take the long way back to the house, watching the acacia's sway in the breeze. The marigolds light up the border gardens with their manes turned toward heaven as if they too were waiting for Mitch to come home. I hope Mitch has a flower garden wherever he is. I hope when he sees a tree sway in the wind it makes him smile as he thinks of me. Mitch always pointed out the beauty that existed outside the windshield when he drove. He couldn't get past the glory life had to offer, and all I could ever see were the potential hazards—the potholes, the wreckage on the side of the road.

I get home and sigh into the silent doorway, tossing my purse down as I head over to the couch. I've had mild cramps all morning, just below my pelvic bone, hard, long lasting episodes, one of which evoked a spontaneous groan. It sounded sexual, and it made me miss everything about a man.

It's not until I hit the sofa that a wild squeeze grips my abdomen like a punishment.

"Shit." I drop to my knees and fumble for my purse. I'm going to kill Mitch for doing this to me.

A tiny laugh rumbles through my chest as I victoriously snatch my phone and call Kat.

"What?" She doesn't bother with the niceties.

"I just threatened to kill Mitch," I pant. Of course it was all in my head, but the thought amuses me on some level.

"Well if you see him, tell him I'm in the mood to commit a few felonies myself." She breathes into the receiver. "What'd he do now?"

"He impregnated me and left the country. Now I'm dying in pain."

"I'm there."

71

It takes less than five minutes for Kat to burst through the door. I've yet to regret my decision to gift her with a key, and today for sure I'm glad because I'm too busy writhing in pain to crawl to the door.

"What the hell's wrong?" Her face is rife with worry. And I can't help notice her lips are rioting for attention, stained a bright fuchsia pink. It distracts me just enough to ebb the pain, and I'm grateful for her cosmetics-based misstep. "You just sitting here by yourself?"

"You're observant." I'd readjust myself, but I'm too afraid my belly will go off like a grenade. "What did your lips ever do to you?"

She makes a face. "I was playing."

"Don't play. It's not Halloween. It's scary. And, yes, I'm sitting here by myself. Who'd you think was going to be here? Mitch?"

"Lee, this is serious." She wipes her mouth over her jacket and leaves an indelible smudge over the denim.

"It's nice to see you've evolved past the seventh grade." Wish it *was* the seventh grade—any grade when I wasn't knocked up for that matter.

"We need to call Colt and Janice." She fumbles for her phone and spastically jabs at the screen.

"No thanks." I snatch the phone from her and hang up on Colt. "I'm not calling them until I get to the hospital. This is probably just a false alarm. I don't want to worry anybody."

She eyes the swollen peak of my belly with a look of longing. Kat is dying for a swollen peak of her own. She and Steve have been trying to conceive since before he proposed.

"How about Max?" Her forehead wrinkles with concern. "Should we call him?" She's so frightened for me like I might be dying.

"Max?" I'd be lying if I hadn't thought of calling him. In fact, it takes everything in me *not* to call Max. We've logged so many hours together getting Townsend up and running again,

it feels unnatural not to have him here. And he cares. He would want to know—hell, I want him to know. "I'm okay. I have you. You're all I need." I bite down on the lie. I desperately need Max. I don't know why, I just do.

I look out the window at the plain butter sky stretched like a crisp sheet. A car drives up the street, unassuming and banal. Dew beads over the calla lilies sitting beneath the window as their phallic protrusions nestle proud in their white cocoons—the bleeding hearts with their curled pink tails dangle in rows. I want to galvanize this moment into my memory—the last of our world that Mitch knew—the one without the baby. I seize the scene, logging random events into an imaginary file that falls in the timeline after Mitch's death. My whole world is rearranging without my husband by my side. Not even the house will look the same once the baby is born. It never looked the same without Mitch, and now he's coming back to me in the form of a child—a phantom with his face. I don't know if I can bear it. How can I have Mitch's beautiful eyes, his perfect structure, staring at me day after day? It's nothing short of genetic cruelty. At least with Colt, his personality offsets the startling resemblance. He's always been Colton, the wild donkey of a brother, but the baby might be Mitch through and through, and it scares me.

Another hard pull of pressure erupts at my waist.

Maybe I should pretend it's Colton's baby. That would make it easier for sure. I could harness all of my pain into anger at Colt for impregnating me. God knows I have enough rage stored in me to deliver ten babies at least.

A gush of liquid warms my thighs and floats up around my bottom.

I look up at Kat and blink into a smile. "I think we'd better get to the hospital."

"*Dry birth*." The nurse squints into me with the face of a beetle.

I shrink in the bed with my bare bottom cool against the sheet, the thin hospital gown rising in all sorts of unflattering directions.

"Dry birth?" I look to Kat in a panic. I need to get out of here—as in out of my body.

I make wild eyes at Kat, signaling her to do something.

"It doesn't sound comfortable." She shakes her head, devoid of her smartass superpowers at the moment.

This is all affecting me on a disturbingly horrific level. It's all real—there's no turning back. This baby has to pass through my so-called birth canal, i.e. my very narrow vagina. It's no wonder television portrays birth like some scene out of a horror movie with nothing but blood curdling screams and bodily fluids soaking the sheets—because it happens to be factual. I do want the screaming and the blood, but I want all of it to belong to Mitch. Suddenly knocking me up seems like a horrible act of cruelty, and he's responsible in the worst way.

"I changed my mind," I say it so cool it almost sounds plausible. "I'm not doing this."

Kat and the beetle share a laugh in light of my newfound misfortune.

"You're going to do fine," Kat squawks with no real evidence. "You're not in pain *now* are you?" It comes out accusatory, and I suddenly feel the need to shove her face in the urine filled bedpan.

I glare at her.

Kat is mistakenly convinced I can do this without the aid of high power pharmaceuticals. She's gone over the ramifications of a drug-induced delivery at least a dozen times these past few months and twice on the way to the hospital. Of course, I foolishly agreed before I was enlightened to the magnificent amount of torture my body was capable of

inflicting. And, now, I rather look forward to having a blessed-by-narcotics birthing experience. If anything, this builds a strong case for Colton and his self-medicating. I might join him in the effort should I survive the trauma.

"Here comes another one." The beetle tracks her finger over the tiny monitor in an upward motion.

My entire person seizes with panic.

"I think I need something to take the edge off." Like a bullet, but I decide to leave assault weapons out of the equation for now.

"I'll get you some water." Kat springs up trying to escape the room, but I snatch her by the wrist.

"What did you say?" That Kat even thinks for a minute something as docile as *water* could cure this misery proves how useless she's going to be through this entire experience. "You are not leaving." My stomach tightens at an accelerated rate. "Drugs!" It rips from my lungs like a battle cry. "*Strong* fucking drugs!"

Kat lets out a little laugh, and I sear her with a look. I haven't taken slitting her throat off the table just yet.

"Oh God." I squeeze her hand as though the ceiling were about to crash in. It's like a vise is tightening around my waist at Mach five. "I can't do this." I scream, high and shrill like a whistle.

"Breathe!" she commands.

Breathing. Panting. Surreal moments stroke by filled with delirium. Finally it gives, and I'm filled with dread at the thought of having another one. I wish I could go back in time and smack Mitch at the thought of ever pointing his penis in my direction.

A visual of Mitch writhing over me infiltrates my thoughts, warms my heart, heals the emotional and physical pain like liniment if only for a moment.

"Will they get much harder?" I ask the nurse as she thumbs through my chart. Her wiry hair sprays out every which way.

"Could be." She purses her lips, doesn't bother to look up. "You're only at three centimeters. This is just the beginning."

"*Three?*" I sit up in horror. "That's like seven away from ten." It's a bad time to prove I'm good at simple math. "I need to see somebody about an epidural." I spit it out so fast I can practically see the words dart around the room.

"You need to be at four to have one." She strides to the door. "I'll send someone in about an hour or two."

"What?" I dig my fingernails into the fleshy part of Kat's hand. "I can't deal with this for another hour. Get my phone."

"You want me to get your drug dealer on the line?" She mocks.

"Yes," I hiss, reaching past her and diving into my purse.

"Whoa, whoa, whoa!" She holds up her hands and backs away. "Who you gonna call? Vagina busters?"

"You are a real fucking comedian, you know that?" I fumble until I manage to dial Colt.

"I'm at the hospital," I pant into the phone with disregard for hello. "I'm having the *baby*." I say "baby" like it's a disease. "Bring whatever illegal shit you have and get the hell down here now. I'm dying, Colt. I'm going to die if you don't do this for me." I take in a controlled breath trying to stave off the tears. "If you ever loved Mitch, you will do this—"

Kat snatches the phone away before I have a chance to threaten his life appropriately. "She's not dying. They're giving her drugs."

"In an *hour!*" I shout in distress.

Kat drops my cell in her pocket safely out of reach.

"You are going to have a baby one day." I fix a venomous look at my sister who I suddenly hate with all of my mortality. "It is going to hurt like hellfire. You will beg for something to

make it all go away. And I'll make damn sure you don't get so much as an aspirin."

Kat belts out a laugh. "We'll see about that." She points to the needle rising on the monitor. "Now breathe."

Time warbles by in a delirious pain-induced frenzy—a haze of polemic cramps— the tearing and burning of muscles and tissue—the splitting of my entire existence. I close my eyes and try to will myself out of my body—beg for God to take me. I have no desire to see this through. A current of agony rails over me, unrivaled by anything I've ever felt before. My entire body is in revolt. This was the pain Mitch put me through when he died, and just when I thought he was incapable of giving me more, here I am.

Voices ignite in the room. A flash of white uniforms, Kat appears, then disappears.

Mitch strides over. He leans in and tries to comfort me.

"*Mitch.*" I take his hand. It's so cold. I pull it over my forehead and hold it there. "Help me. Help me die," I give it in a fevered whisper. I pull him down until his face is over mine, securing him by the back of the neck and cry out in pain.

"It's okay. The nurse is here," he whispers as his hot breath rakes across my face. "She wants to check you. I'll be right back."

"No! You're not leaving." I wrangle him closer and whimper. "Please, God, don't leave."

"Lee, it's me, Colt." He pulls away so I can see his face, but all I can see is the outline of the man I love, the one that put the baby in me to begin with.

"Colt?" I don't bother hiding my disappointment.

Someone props my legs back and a cool hand tracks up my thighs.

The pain ratchets up again. Molten lava burns through my belly. Every nerve inside me is so horrifically alive, it's sublime on a hysterical level.

I pull him in hard and sob into his neck like the night I lost my parents, the night I lost Mitch.

"Don't die, Colt," I whisper.

"I'm good." He picks up my hands and threads our fingers—bumps his nose against mine until the nurse extricates her hand from my bowels.

"You're at nine!" She gives a single clap. "You've been working very hard, young lady."

"When's the anesthesiologist coming?" No sense in flooding myself with temporary relief.

I see the needle on the monitor shoot up again.

Temporary relief, my ass.

"Oh, hon." She comes around and lays the cool of her hand across my forehead. "It's too late for that."

"What?" I bat her arm away.

"We don't administer epidurals this late in the game. I'll be back in five minutes. I'm going to call the doctor."

Janice waves from the corner of the room, and I shoot her a hard look. She gave birth to Mitch who was attached to the reproductive organ which got me into this mess to begin with, so I'm livid with her by proxy.

A sharp blinding pain ignites. It immobilizes my thoughts, paralyzes my body, my vocal cords. I gouge into Colton's hand and squeeze my eyes shut.

I hate you, Mitch.

I hate you, Mitch *Townsend*.

Lights burst overhead like a nuclear explosion. An entire herd of people sweep into the room. My feet are strapped into position, and my gown lay open down the front exposing my breasts, my wide girth just below.

I can't see the show over the round of my belly. Kat must sense this. She mobilizes and adjusts the pillows until I'm propped up. I catch Dr. Kines in snatches, seated at the base of the bed. The cold shock of her hand inspires another heartfelt contraction from Satan himself, and I give a harrowing cry with

wild abandon. I scream so loud I'm sure I've rattled Mitch's bones at the cemetery where they've buried his questionable remains. I want him to feel my agony—I hope it interrupts his harp lessons or his rotation on the spit. *See all the pain you've caused?* I want to roar until I'm seated next to him in oblivion.

"Push with the next one," she instructs.

It takes four steady pushes before I feel a bustle of pressure unlock, and a baby slithers out covered in a coat of blood and slime, landing safe in the waiting doctor's arms. She places the startled being onto my chest, and it turns beet red while letting out a bloodcurdling cry, makes me feel like an amateur at the lingual effort I put in only moments before.

"It's a girl!" Colton shouts. He leans in and delivers a hot kiss to my forehead.

A girl.

She's so sweet—a little bleating lamb, perfect in every way.

And I start to cry.

<center>߂ං౮</center>

The nurse bathes my brand new baby girl and hands her back swaddled like a cloud with nothing but her tiny face blinking in confusion. Janice and Kat each take turns holding her before passing her back to me.

I'm so sore. No stitches. It just feels like a semi backed into my hind-end.

I unwrap her from the blanket and take in her perfect form, touch her fingers, her toes. She's so light I hardly notice her heft as she lies in my arms. I gaze at her tiny features—a drop of a nose, dark navy eyes. It feels good to bathe in her beauty.

A tall figure moves in the doorway. Max.

My heart sings at the sight of him. I wish it were him beside me—not Kat—not Colt with his impossible reflection of Mitch.

"We don't want any," Colton quips.

"Yes, we do." I bite down a grin and wave him in. "Look what I did." I position her toward him.

Colt sticks his chest into Max. "Dude, we're fucking having a family moment."

"Hey!" Janice crosses her hands like a referee. "Do not use that language in front of my granddaughter. You got that? Max is welcome, as long as Lee says so."

"Janice," I whisper above the sleeping angel in my arms, "why don't you take Colton downstairs to get something to eat." I shoot Kat a look that demands she join the involuntary feast.

Janice and Kat drift out of the room without prompting, but Colt remains in a hard stance with his arms crossed tight like an ape waiting to pounce. I'm sure Mitch would be proud—cheer him on even.

"Colton please," I beg. "I'm so exhausted I can't do this with you."

"I'll be around," he says storming out the door, good and pissed for Mitch.

"I'm so sorry." My voice breaks as I motion Max to my side. "You're more than welcome to be here." Tears blur my vision. Damn hormones. I wipe my face into my shoulder before continuing. "I want you here." I confess as he presses a quick kiss to the top of my head.

"Congratulations," he says, not taking his eyes off her. "She's absolutely gorgeous." He marvels.

"I wanted to call you." I let the tears fall this time in lieu of an apology.

"It's okay." He leans in and continues to take in the beautiful pink being glowing between us. "I've been here a couple of hours." His dimples depress as he takes her in. "I hung out in the waiting room. Good news travels fast." He

offers a heartfelt smile that says I love you more than words could ever say. "Look at her, Lee. You have a real angel on your hands."

"You want to hold her?" I offer her up to his waiting arms and he takes her, precious as blown glass.

"God—she's light as a feather." He presses a kiss to her nose. "Hey you—what's your name?"

"She doesn't have one." My heart sinks for a moment at my first failure as a parent. She's been here almost an hour with no moniker to call her own.

"You've gotta name her. Everyone's got a name." Max blinks over at me with those solid steel eyes.

I pushed this moment so far out of my mind. Even when I tried to think up names I couldn't.

"I thought maybe if it was a boy..." I stop short of saying Mitch out loud. It's too painful to even go there. "I guess I wasn't really expecting a girl." Lame, but true.

"Hmm." He looks down at her in earnest. "She doesn't quite look like a Mitch." Max leans in against my shoulder and holds her between us like an offering. "How about Stella?"

"Stella?"

"Yeah, you know, from the play."

In high school Mitch and I were in *A Street Car Named Desire*. He called me Stella for months. The entire school did.

"Stella—I like it." A spike of enthusiasm fills me. I'm in love with the idea of gifting her such a special name. "Hello, Stella," I say as he cradles her close to me.

"Hello, beautiful Stella," he whispers.

I pull him in by the neck and touch my cheek to his. Max feels good, warm and comforting—safe. We watch this precious alien being together, and it feels like we're forming a family.

Mitch

Isolation—a dark cave-like dwelling with a four-by-six-inch window near the ceiling. No bed. A hole in the floor emits a raucous odor. Every evening a small tray of rice along with a bed of loose noodles makes its way under the door—water in a bowl like a dog.

Doubt I would tell Lee if I could. I'm not really interested in sharing the subhuman creature I've become.

My father used to say, no matter what you're doing, bring passion to the table. A dull laugh rattles from me at my father's advice, his back of the cereal box motto. I wonder if he meant here, too. Bring the passion to the isolation chamber—marinate in the solitude of it all.

I shake all thoughts of my father away. Instead, I dream of Mono Bay—the entire hillside charred and smoking. I look for Lee, my mother, my brother, but they're all gone—nothing but ashes raining from a kettle-black sky.

Each night greets me with blinding darkness—the kind that makes you squeeze your lids tight just to see a burst of red firing off in your skull. I miss the colors, the vibrancy of life. I lose myself for hours imagining life with Lee as though time had never stopped for us. I imagine her giving birth—her face lost in tears and sweat. A beautiful baby comes, but I don't know what gender it is. I don't know its name.

Sometimes I pretend it's a boy, other times a girl. Sometimes I splice it in two entities, one of each. Lee and I are so happy in our Technicolor world. I make love to Lee night after night—such a wonderful, rich, full life. I wonder who's living it. Has Colton manned up? She was with Colt for a while. She felt something once. She could do it again. I try not to make a habit of imagining Lee with my older, less cerebrally inclined

brother, but it comes to me in jags—them holding hands, sharing a stolen kiss, the delivery room, their wedding day—him rolling on top of her in bed—that one I can't turn off. Like some bad pornographic nightmare, images of Lee with her legs hiked over his shoulders hack away at my subconscious.

I punch my fist into the concrete.

A burst of tears come to the pity party.

I hate Colton.

I love Colton. It's me I hate for being so damn stupid.

Max Shepherd's face pops up uninvited—his sharpened canines, his brimming wide smile.

Colton is welcome to Lee as long as it's not Max.

There's no way in hell Colton would let Max weasel his way into her life. If there's one thing I can count on, it's that.

Max
Two Months later

The sky is washed a lavender blue as I pull in behind Lee's car and head on up the walk. Mitch's truck is parked high on the driveway, collecting enough dust to qualify as a self-burial. You'd think Colt would take it, *sell* it—do something so it doesn't sit here like some morbid reminder that the owner is never coming back.

I worked all day at Townsend, sweating it out in the fields with the ranch hands just to give them the feel that someone is actually in charge. I've had Shepherd on autopilot for the last few weeks, and its still pounding Townsend in the profit department.

I give a gentle knock. Lee knows I'm coming over, but I hate the thought of waking the baby.

The door flies open, and Lee's beautiful face brims with a smile. Her hair whips around, glassy and pale as milk.

"Flowers!" She beams. Lee always beams. Her hair is long and flowing with a mirror shine. Her smile radiates a glow that could outfit a nuclear warhead.

"They're not for you." I pull them back playfully. "Its Stella's two month birthday."

"Should've figured." She makes a face before batting her lashes at me. "It's Stella's world, I'm just living in it." Lee takes the bouquet and offers a quick embrace. Her hand leaves a hot impression over my shoulder as I inhale her scent. Lee holds the fragrance of lilacs all on her own.

We cross over the dark walnut floors I had installed a couple months ago as a gift. I gave her some commemoration-of-Mitch and out-of-friendship bullshit because I knew she

wouldn't accept me paying for it on my own. I meant it, though. Mitch didn't deserve to die like that, and I'm sure he's spitting nails in hell, or wherever he's landed, knowing I'm here hovering over Lee like a shadow. I can't stop, though. I love her and Stella as if they were my own family.

Lee runs water into a vase and plops the flowers inside, plastic wrap and all. Stacks of mail create mini skyscrapers all over the dining room table, along with various baby toys, diapers, and blankets that lie strewn about like pastel confetti. A week ago I offered to hire someone to come and help out, but she wouldn't hear it—said she doesn't like the idea of strangers in her home. Can't say I blame her.

"Where's the princess?"

"I'd say right here, but I doubt you're talking about me." Lee gives a quick wink as she takes me by the hand. The kitchen opens up to the family room, and she leads me over to the U shape couch with a bassinette situated on the far end.

"Wake up, angel," she sings, hitching her hair behind her ear, looking desperately beautiful in the process. "We've got company."

"How did it go last night? Catch some Z's?"

"Are you kidding? This child doesn't believe in sleep. If you lie to me and tell me you can't see the dark circles under my eyes, I'll never speak to you again, Shepherd."

A soft laugh rolls through me. Of course, I can't see them. Lee is immaculate, but I hear report, day after day, that Stella is a bit of a night owl—sleeps just fine during daylight hours apparently.

Lee picks up the baby and presents her to me like a trophy. She nestles in my arms for a moment before curling into me. Stella doesn't bother to open her eyes, just squirms a bit and lets out a muffled grunt. Her fine blonde hair blows like feathers with the slightest movement, her cheeks each their own splash of pink.

"She smells like heaven," I say, lifting her slightly toward my face—baby powder and fabric softener with a touch of her own special sweetness.

Lee and I get comfortable on the couch, same routine every single night for the past two months. Lee doesn't seem to mind. She hasn't evoked the restraining order yet, so I keep coming. She places her head on my shoulder and looks down at Stella while I kick off my shoes and stretch out my legs across the giant ottoman.

"Why don't you go upstairs and take a nap," I whisper. "I'll hang out with Stella. We'll watch a movie."

"Trying to get rid of me?" Lee coils her arms around mine and gives a squeeze. "I'm not leaving. I'd never fall asleep, what with all the partying going on down here." She clicks on the television, and some old comedy I didn't care for the first time around greets us. "Nothing good is ever on," she whispers, relaxing her curves into me. I can feel her chest cushion against my arm and close my eyes a moment, memorizing how it feels. "I guess that means you'll have to entertain me." She dots my nose with her finger.

"I got a group of investors to look into Townsend for you." I give the beginning of a wicked grin. Lee has wanted to get investors involved for a while, and for whatever reason, Mitch held back. She asked me to look into it a few weeks ago, and I've been dying to surprise her all afternoon as soon as I got confirmation.

"You did?" Her face explodes with wonder like a kid on Christmas morning, and it warms me that I was able to supply the gift. I'd gift the world to Lee if she let me.

"I'll put together a proposal for you," I offer. "It'll take a few months before they want to meet with the board. You might want to groom Colton for the occasion. Tell him there's a six pack involved if he behaves—maybe throw in a stripper just to be safe."

"I wish Colt was more into the working end of the business." She pulls in tight and snuggles up to my shoulder. "Speaking of which, Mom and I just had a long conversation. She wants to be a silent partner. She said when I'm ready, she's making me the president of Townsend Enterprises."

Her cheeks fill in a deep shade of burgundy, her eyes electrify a clear sky-washed blue.

"Well, hello, Ms. President." I lock my gaze over hers. "You have all the fire you need to do this. I believe in you, Lee. You're going to make Townsend the name it was meant to be."

"Thanks"—she lowers her lashes—"but without you, I couldn't have paid the electric bill." She wraps a long finger around a loose strand of her hair. "I still feel bad I'm cannibalizing so much of your time."

There's something honest and humble about Lee. Deep inside I know she believes in herself. Life just caught her off guard, that's all.

I pat her on the knee. "Go to sleep. I'm going to take care of Stella for you tonight."

"You're spending the night?" She looks amused, but the color in her face deepens as if maybe she wants this on some level. I wish I knew. I wish I could read Lee like a book, turn the page and see what the future holds for us. Either way, I plan on being there for her as a friend.

"Right here on the couch." I hold up a hand to demonstrate my platonic intent. Not that I wouldn't cop to wanting her if she asked—if she wanted me, too. "I can leave before morning. I just want to give you a chance to recharge your batteries."

Stella starts to whine and flex in my arms, so I pull her in close and dip a kiss over her tummy.

"You'll watch her for me all night, huh? I wish, but I don't have any bottles filled." She takes Stella and lifts her shirt. I try not to look as Stella latches on, but I catch the low, full circle of Lee's breast, her pale skin that's never seen the light of day, and

it stirs me. She tosses a blanket over Stella, and I relax again. "Still hurts like hell when"—she gives a slight gasp—"she starts. Everything's so painful." Lee lands her head back on my chest, and I readjust, so she can use me like a pillow.

This is the new norm, Lee and me. Our friendship reinstated to pre-Mitch levels. Those electric stolen moments have intensified, increased in volume and number. It still catches me off guard, though. I've always believed it was going to be Lee and me until Mitch injected himself into the picture, snatched her from underneath me then cut me off like I had the plague.

"You'll never guess who I got a gift from." Her eyes close with fatigue.

"Who?" It takes everything in me not to press a kiss over the top of her head. It feels natural. The warmth radiating from her body pulls me in until my cheek washes over her hair.

"Viv."

A groan escapes from deep in my chest. It physically pains me to know she's pestering Lee.

"A gift huh?" I'm more than skeptical. "Like what, firearms?"

"No," she says, batting my stomach playfully. "Two pink dresses." She gives a quick glance. "What happened between the two of you? Can I ask?"

"Yes, you can ask." I take a deep breath. "She ate me for breakfast. The end."

"Oh." Lee suppresses a smile at the thought, most likely because she knows Viv is more than capable.

Lee and Viv were never friends. No real reason I can pinpoint other than it would be like pairing a kitten with a bear.

"So what brought you together?" Lee blinks up trying to hide her viral curiosity. "There must have been something in the beginning—you married her. Was it pure animal lust?" She bites down on her lip, but a squeal of laughter manages to bubble through.

Viv was a wrestler in bed—a dominatrix who longed to castrate someone. I got out just in time with my body and soul intact.

"Not lust." I look down at her. Our eyes magnetize, and I can feel the powerful pull between us, inescapable as oxygen in a fire. "Lust is what I have for you," I whisper.

Crap. It's like I can't control my mouth around Lee.

Heat rinses over my face, spreads throughout my body like a bona fide nuclear meltdown is taking place. Here they are—my true intentions laid out like a deck of cards, exposing my hand. It's up to Lee to determine if it's good or bad. I wouldn't blame her if she kicked me out, told me to never come back.

Lee reaches up and cradles the back of my neck with her cool fingers. She pulls me down just shy of her lips and hesitates. My lips part in anticipation. I close my eyes never wanting to open them again without tasting her first. Lee brushes over me with a barely there pass of the lips. I'm not one to ignore an invitation, so I press in—sealing my mouth over hers then delving into the holy of holies and swiping my tongue ever so softly until she meets me with her own. I kiss her back, longer, much stronger than she most likely anticipated. Lee strokes her tongue over mine in smooth clean swipes that hold the flavor of strawberries and wine. She dives in deeper, probing me, telling me she loves me with the warmth of her mouth in an exchange that feels like a slow sweet eternity.

My arm glides around her waist, and I bump into Stella. I forgot she was nursing, and this arouses me on an unnatural level. I keep my lips conjoined with Lee's. There's no way I'm stopping. I've waited my entire life for this moment. All those years of worshiping at the altar of Lee Middleton and finally a victory kiss—a sober, heartfelt testament of my affection for her.

Stella kicks, and I catch her tiny cold foot, warming it in my hand. This is what it would feel like to have a family. A wife.

A baby. Not just any family. Not with Viv playing the spousal role—not with her satanic spawn.

No. This is Lee.

This is heaven.

The Wedding

Lee

Eighteen months later

Kat and I hover over a picture of our parents—my mother with lemon-yellow hair, my father's shock of white at forty. They wear clean, dutiful smiles. My father gazes at the camera with a daring twinkle, sharp angled cheekbones that neither Kat nor I were blessed with. My mother is stunning, almost arrogant in her beauty. She adorns herself with layers of gold glittering necklaces. Long, pink seashells dangle from her ears. My uncle managed to keep her collection intact, mostly costume jewelry. It was all tarnished and broken by the time I was twelve.

"Funny how that happens," Kat muses, pulling out a bucket of crayons for Stella from her kitchen drawer and enough coloring books to keep her busy until she hits her freshman year in college. "Every time some big event is on the horizon that picture hooks me."

In two weeks I'll be married to Max. That's the big event—the next big earthquake in our existence.

"I know," I say, running my finger over the photo, the paper is tattered and soft as velvet. "I wish they could be here. I wish a lot of people could be here." I flatten the tablecloth with the palm of my hand, trace the woven border with my eye. "But

then I guess if Mitch showed up, there wouldn't be a wedding." I blink back tears.

"If Mitch showed up there would be a shootout." Kat gives a gentle laugh while entombing our parents in the family album.

"Any news on the baby front?" I ask. Kat and Steve are in full throttle baby making mode after a long hiatus.

"I started." She shrugs it off, pretending to pick at the chipped polish on her fingers. "It's only been three months, and God knows I'm not in a hurry. If it doesn't happen soon, I might take a year off. Steve and I are thinking of starting up the business again."

I make a face at the thought of them reigniting their printing business. It was lucrative the last time they ran it, but Steve was offered a position at Global Pacific as a software consultant, and the real job won out.

"What's the face?" Kat makes crazy eyes at me because she's insane like that, plus she knows me too well. It's impossible to keep my opinion to myself.

"Nothing." I twist the napkin until it's thick as rope. "It's just that the last time you did this you said it sucked dry your savings and nearly cost you the house. I'm just not sure why you'd think to go in that direction again, but I'm not saying a word."

"You, Lee Townsend, are judging me?" She raises her coffee in a mock salute.

A wry smile pinches over my lips. I knew she'd go there eventually just not so razor thin close to the wedding.

"That's right." I hold up my hands a moment. "Guilty as charged," I whisper, glancing at Stella over at the other end of the table. "I'm marrying, Max Shepherd. A direction *I* never thought I'd go in, but, then again, Mitch isn't here to protest the idea." I slump in my seat. "Truth is, I've always had a special place in my heart for Max. And if it weren't for Mitch, it would have been Max."

"You ever share this with him?" Kat leans in with her eyes as dark as a summer storm, her smile dipped in grief all for me.

I shake my head. "You know, it's funny. Mitch and I never discussed Max. It was as if he was gone from the planet, as if their friendship never existed. And with Max, he's sort of the opposite. He's fine with me mentioning Mitch, and he usually matches me story for story. I don't think Max felt the same level of hatred that Mitch did."

"That's because Mitch is dead." Her expression flattens.

"Thank you for your blunt analysis."

"No, it's true. It's easier to like dead people. It's a well-known fact. Besides, Mitch probably had the threat of competition. He probably didn't want Max hanging around trying to *steal* you. And, well, Max doesn't have to worry about that."

A dry laugh huffs from me. "Could be. But I don't think Mitch was ever threatened. He just couldn't get past what his father did. And with his dad six feet under he needed someone to blame."

Kat taps her hands over the table. "Water under the bridge."

"You're right. And I think you and Steve are going to do great with the printing business." I try to muster all the enthusiasm I can for Kat and Steve's financial disaster in the making. "Call me if you have any problems. I'm getting pretty good at putting out fires. I've learned more about the administration end of business than I thought possible thanks to Max. He's an excellent teacher. It's what made me fall in love with him—his strong attention to detail, especially when it comes to Stella and me."

"We won't have a problem." She knocks on the table. "So what's with this exclusionary bachelorette party? Colton taking you to Vegas? Getting you smashed and bagging you himself?"

"Please. It's an *unofficial* bachelorette party. Besides, it's kind of nice he's the one and only guest. We're watching movies."

"I know the kind of movies he likes to watch." She rolls her eyes. Kat went through a Colt phase herself, only he wasn't biting so it was mostly one-sided.

"The only reason I agreed to it is because Max is out of town. And, I think Colt needs help with the psychological transition. Me seeing Max was one thing, but becoming his wife is like twisting a blade in Colt's back."

Most likely his brother's too but neither of us say it.

ഝരു

On Friday night, a full week and a day before the wedding, I gird my loins for an evening of shenanigans and madness with my once upon a brother-in-law. I'm sure there's hard liquor and porn in the lineup—in other words, a normal night at Colt's. I'm hoping tonight will be less blow up dolls and penis straws and more watching a chick flick with what amounts to my ex-boyfriend.

Colton lives in Janice's guesthouse behind the castle-like Townsend estate. His den of debauchery sits a good half-mile away so he doesn't feel like his "mommy" is watching over him.

"Look at you!" I say, stepping inside with an armload of take-out. Colt's house is spotless, the magazines all fanned out over the coffee table as if this were a dentist's office, and the windows have nary a fingerprint on them. "This place is immaculate." God, it's neat as a pin, which only exemplifies the fact I live like a pig. Or maybe I've just forgotten what a house without a child in it looks like. No Barbie dream house, no layer of Legos covering the floor.

"I can't take the credit." Colt swoops in with a kiss. I turn slightly and he outsmarts me, landing his lips square over mine.

"Wow," he winks, taking the bags from me. "We're getting right to the action."

"That was an accident—on my part." I shoot him a wry look. "What's with the hygienic environment? One of your floozies finally call the health department? Is the FDA cracking down on those obscene desserts you've been rumored to serve?"

We make our way to the kitchen. The counters are strategically lined with beer bottles from around the world. A picture of a naked cantina girl stares back at me from over the sink.

"Very funny," he says, plucking out the Chinese food from the bag like pulling a rabbit out of a hat. "Truth is, I hate the upkeep around here so I've finally resorted to a cleaning lady. I assure you she's a thing of beauty and most pleasurable to watch. If I throw in an extra fifty she vacuums topless. And now, *that's* service with a smile." He pauses and looks up at me with those twin emerald green eyes, same ones that Mitch took with him. Colt smolders into me a moment and my stomach pinches tight. "But I think you know I couldn't care less about the smile."

A moment of silence bumps by as he bears into me with an intensity I've never seen before. He's holding my attention, making my insides quiver, but it's all for his brother and he knows it. I reach out and touch his cheek, his five o'clock shadow, rough as sandpaper. He's got his hair slicked back just the way Mitch wore it. He's lost his drunken playboy appeal and layered beneath that was Mitch all along.

He waves a hand over my face.

"You okay?" He plucks out a couple of champagne bottles and holds one up in each hand, a lewd grin brimming on his lips.

"No thanks. I rarely take in the wine I sell, let alone down champagne for no good reason."

His cheek pulls up one side, no smile. "You're right. Marrying Max is no good reason," he says, struggling to pop the cork.

I ignore his potshot and dish myself some food. "It's nice to know you're okay with this. I guess it's an improvement from last week when you threatened *litigation*."

"Hey, I haven't taken that off the table." He bumps me playfully with his shoulder as he loads his plate.

"It figures. You do realize you rival Stella's best efforts at being a two-year old—well, almost two." Although, thankfully Stella approves of Max. Daddy was her first word, and he more than appreciated it.

Colt doesn't say anything, he just goes into Mitch-mode again with his ultra serious demeanor, those hooded lids that I swear are trying to lure me into the bedroom.

"Look, I know this isn't easy for you," I whisper. "But if it makes you feel better, Max and I haven't even slept together yet. I want to do everything by the book because I know how much Mitch would hate this."

Colt comes to life with a little chuckle. "You cut him off, huh? You know what Mitch would appreciate even more? If you continued to give him the shaft *after* the nuptials. You could have one of those celibate marriages that are all the rage."

I avert my eyes at his absurdity. "Celibate marriages are not 'all the rage.' More like an *outrage*, maybe."

"Yeah, well"— he jabs his fork in food and spins it in a circle like a little boy—"why don't you try it out and report back to me."

My heart drops to my feet. It's like Mitch is in there hiding, listening in, speaking through his older twin. I swear if Colt donned a suit, wore that tragic smile of Mitch's I couldn't tell them apart.

I push my plate back. No point in even trying to eat. All this talk about Mitch, these circular thoughts, I know where they lead. It takes hours to recover from having my heart shattered all over again. Death does a lot of things, but it doesn't take away the patina of misery once you lose somebody. Time doesn't heal all wounds. I'll grieve Mitch until the day I die, and I'm grateful Max understands that.

"I saw Viv today." He pulls my plate back and does his best impression of his brother again.

"Lucky you," I smear it with sarcasm. Who knew it would be Viv saving me from this catastrophe of a conversation. "I've seen her around town a few times—still very single—always inquisitive when it comes to my future husband." There. I'll keep the focus on Max and ditch out the door after dinner. Too much more of Mitch in this room and I might jump out the window just to escape him.

"She gives it three months." He blinks a smile and morphs into Mitch with the long commas inverted on either side of his shit-eating grin. My stomach gives a tight squeeze, and I try to ignore it.

"Really?" I belt out a laugh. "Only half the time she was married to Max? She thinks she's that good, huh?"

"Yeah, well, I told her not to worry." He wraps an arm around my waist. "I let her know I had plans to steal you away"—Colt drops a kiss to the back of my neck—"that the wedding wouldn't happen."

My stomach cinches as he sears me with his touch, and for a second I fool myself into thinking it *is* Mitch. He's crawled into my head for the evening and now there was no escaping him.

"Right," I huff. "Like I'm going to let you seduce me into oblivion." I'm starting to wonder if Kat was onto something. "You're delusional."

We move over to the couch where there's a playoff game on TV, and I let Colt enjoy the last several minutes while I zone

out and stare at the ceiling—so blank and wide, it invites me to drift wherever I want.

The wedding swirls through my mind, but something else is clawing at me, and I can't pinpoint what. It keeps eluding me like a dream I long to remember. I can feel change coming like a wave, ready to crest on the horizon. Something earth shattering this way comes. It unnerves me, makes me shake on the inside. Sure, I've been with Max for a while now, but this was a monumental event. Marriage—becoming Mrs. Max Shepherd.

It's losing that final part of Mitch that hurts the most—his name. Stella has it, and after Max adopts her, she'll keep it as a second middle name. I have it as a business. *Townsend.* I try mouthing it, but it only makes things worse.

Images of Mitch and me on our wedding day come back in snatches—how young we both were, how beautiful. He was ready to leave the reception to start our honeymoon right after Colt gave the toast. So happy, so much joy.

I look over at him next to me on the couch. *Why did you have to die?* I gaze out at Colt as if the answer were about to spew from his lips.

"What's on your mind?" Colt gets up and puts in a DVD.

"Your brother."

"Which one?" He blinks a sarcastic smile. Janice insists Max calls her Mom. Janice is everyone's mom, always has been—hell—*Kat* calls her Mom.

I pull a face. "Your *favorite* brother."

"My favorite?" He stabs a finger in his chest. Colt sports an early spring tan. He's lost weight and his features are more cuttingly handsome than usual, which would explain the line of women trailing him all over town. "You mean the one that used to be *your* favorite."

"That's not fair."

"Life's not fair, Lee. So what's going on? He haunting you?"

"I wish. It bothers me, though, you know, about what he'd think."

"He's rolling over." Colt's demeanor changes—darkens unexpectedly.

"Spinning. Mitch is spinning." *In his grave,* but neither of us will say it. "So, get me some champagne. I think I need that drink now."

The movie drones on. It's so dark in the room, I feel immobilized as the television spasms over us with an assault of light. Colton keeps replenishing my glass, and I pretend not to notice. I think the game plan is to get me good and drunk then disrobe me once I pass out on the couch. I told Kat I'd be out late. Late night, early morning, what's the difference? It's clear I'm spending the night. Besides, I don't plan on adding a DUI to my list of horrific new life events. Not that marrying Max is horrific. *God* no. I love Max. I wish he were here instead of Colton.

I close my eyes, and my head rolls with its own velocity. The world swills side to side, threatening to take me down with its exaggerated gravity.

"Maybe that champagne wasn't such a good idea." I struggle to stand and make my way to the window. Townsend sits in the distance with the moon illuminating the brilliant green vines as far as the eye can see. The cold night envelops the fields, cloaks it in an electric glow like a pale blue canopy. It's an amazing world through a midnight lens—a portal to anywhere, anytime. It lies to you and tells you that all things are possible—that what you desire most is right at your fingertips if only you believe.

Colton crops up behind me and fills my flute to the brim. He fiddles with the remote and lands the TV on some sappy music channel. I squeeze my eyes shut and drain the glass—tell him I want another. I'm not one to hold my liquor. It slows me down. I like the way it heats through me, sets fire to my veins like racing lava. It makes disorientation feel like a whole new

dimension, challenges me not to care or rationalize what I'm about to do next.

I down glass after glass like a repeat performance.

Mitch pulls me in, gurgling his affection into my neck and my hair as I wrap my arms around his waist.

"I miss this," I say just below a whisper.

"You're gonna be on the floor soon," he says, warming the top of my head with his oven-heated breath.

"Come on." I pick up his hand and start to sway. I meant to say *let's dance*, but my tongue can't seem to navigate the words. "God—I miss everything about you."

"I'm right here." His smile brightens the entire room.

"Why were you gone so long?" I pull back to take him in, and the ceiling spins.

Mitch doesn't say anything. He just gives me those bedroom eyes with his lids hooded low because he knows I'm susceptible to all of his devices. He glides his hands inside my sweater, and I let out a breath I didn't even know I was holding. I miss his touch, the special way he looks at me just before he dives in for a kiss. We dance away from the television, and his face gets lost in the shadows. It transforms into a thing of beauty and I gasp.

"You're really here," I marvel. It comes out dull, unrequited.

I pull him in tenderly by the cheeks and land my lips over his and linger. My heart soars, my insides detonate with my pent up lust for him.

An urgency takes over as I bite into his lips. I swipe my tongue over his, soft and fluid, before indulging in a kiss that supersedes time, and space, barriers as wide as the sea—even death has proven no match for our love.

A moan gets caught in my throat as I pull off his T-shirt. My hands spread over his chest in a smooth circle. I pull him to the floor, running my fingers along the lip of his jeans. Mitch pulls my shirt off and touches his heated flesh to mine and my

insides quiver as he extinguishes this primal ache within me. I've missed him with an exploding passion. It feels so good to feel his skin—touch his body one last time.

We peel off our clothes, run our hands wild, like stoking a fire. His lips track a line of molten kisses up and down my body, nothing but a trail of lightning.

His bare flesh rakes over mine. My legs wrap around his back like a vine. Mitch lands his hands over my breast as thrusts himself into me with a forceful plunge. I throw my arms up over my head and let Mitch move inside of me.

❧❧

A seam of light penetrates my lids, and I struggle to pry them open. They're heavy as lead, gritty with sand, and for a moment I wonder if I fell asleep at the beach again. Of course, Stella is always nice enough not to drown when I do that. Not that I make a practice of it.

"Stella?" I try to lift up my head, but it holds the heft of a bowling ball. I give several hard blinks as the scenery around me blooms into some alien environment.

The scent of bacon lies thick in the air as Colt's living room reconfigures itself in snatches.

"Wakey, wakey, eggs and bacon," Colton sings, setting a dish on the coffee table before scooting it toward me with his knee.

"Crap." I get up on my elbow only to see my boobs hanging low with a surprise greeting of their own. "Shit!" I pull the blanket up to my chin before peeking below and confirming my theory. "I'm naked," I groan.

"Relax. It wasn't a catching condition." He shoots me a sharp look as he takes a seat on the table.

"Oh my, God." I dreamed of Mitch—of his masterful kisses, his tongue lashing over me like a brand. "Did we?" I glance down at the thin blanket conforming to my curves.

Colt bears into me a moment too long before relaxing back into his jovial self.

"You did a table dance. You've got a pretty good routine going. Max is a lucky guy." He blinks a smile. "If I were you, I'd work on the stripping part. You damn near broke your neck when you tripped out of your jeans."

I sit up and pull my knees up and my vagina burns like a volcano erupted in it.

I look back over at Colt and hold his gaze because we both know damn well he's lying.

"You're right, Colt. Max is a lucky guy." I press my lips together to stave off the tears. "Maybe we could keep the stripper thing to ourselves." I cut him a look that threatens to hack off his balls with a fork if he doesn't comply. "You know, until I can perfect my routine."

"Maybe we should." He meets me with his steely gaze. Gone is the playful Colt, I know and love, and in his place, the one who judges me through his brother's eyes. And now we have a secret—one I would do anything to erase if I could.

"I'm sorry I ever came," I whisper.

"I'm not."

"You should be."

Mitch
Reeducation Through Labor Center

"Mei," it slashes from me like a barb. My throat is on fire—my head's been burning up with a fever for three days straight.

I clasp my hand over hers as she walks on by, and she takes the rose, casual, as if nothing happened.

Twelve days I counted in isolation for distributing origami. Paper roses. Of all the time spent logging hours in the house of God, all I have to show for it is three verses from the good book, playing fast and loose with my memory—not including works cited. *Go ye therefore into all the nations baptizing them in the name of the Father, Son, and Holy Spirit,* Mathew something. *For God so loved the world He gave his only begotten Son, and whoever believes in Him shall live.* Mathew again? No clue. And the final installment of the proselytization trilogy is *Jesus wept,* nothing to quantify it with, no context, no book, just a weeping savior at best. It works, though. I may be low on ammunition, but it packs a powerful punch in a hellhole like this.

The detention center is a voice free zone. No talking, no whispering to a single soul, and that alone is a part of the torment. Voices are an intrusion, a sign of anarchy at its finest. These cloistered walls are littered with the downtrodden of the male species. The few women that mill around are authority figures, hence, Mei. It's the feminine league that doles out food on the line, offers asymmetrical haircuts at discount prices, and supervises as we trim our toenails, lest we slit our throats in the process. Not a bad way out if you consider the alternatives.

I hear there's an all women's camp across the way, but no dances. It doesn't matter, I've got all the dance partner I need

in Lee, and she's not even on this continent—same planet, though. There should be some comfort in that but there isn't. We share the same sky, same moon. If I think about it too much, I start to lose it, especially at night. I used to hold it in, fight it. But it feels good to shed rivers for Lee. I'm sure she's done the same. I hate the idea in theory, but it brings a little comfort thinking she might still give a damn about her idiot husband who got caught up in a Bible-thumping roundup while sleeping on the job—accused of being a spy, no less. Anyway, that's the only the thing Lee and I have left for each other—tears—enough to fill an ocean. We could raise glass after glass of our precipitous sorrow—nothing but a haze of deteriorating memories.

I can feel the promise of a smile evaporating on my lips. No real reason to smile in this shithole ever.

I wait until lights out then reach for the pen from under my mattress, the paper I've precut to form the God-inspired floral arrangements. If I'm lucky the moon will show and guide my already treacherous penmanship. Some nights I just cut paper—score it with my fingernail while pretending to slit the throats of the assholes that have me hostage. Then I run my tongue over the dry parchment until it loosens moist and wet, and pretend it's Lee. All of my sexual fervor for my beautiful wife reduced to stroking tree pulp with my tongue until it perforates.

I take a breath and consider the gravity of the fucking fall.

Lee and I had forever in the palm of our hands until I managed to get myself locked in a dungeon, proliferating the curse that's been plaguing my family since before the time of my father.

I shake my head at the thought. Every single thing I touch turns to shit. Maybe that's why I'm here. Some higher power wants to protect Lee from the great Townsend travesty—too late for that.

Every now and again I start to hallucinate and find my father sitting next to me. He looks bored as hell, and I can't say I blame him. I want to yell at him—beat the shit out of him, but I'm in no mood to nurture my budding insanity.

The parchment crumples in my hand as if vying for my attention, and I get back to the task at hand—the fine art of making love to paper. Learned all my best tricks from a guy who grew up on a junk boat named Gao. The police caught up with him after he stole a bag of lentils, trying to feed his dying grandfather. He knows enough English to call me *Crazy Mitch*—crazy, because those paper roses are just cause for ruin in this desolate hell. But I saw the hope it ignited in others, the way those words lit the halls like a football stadium at midnight. I always did get off on a forbidden high. Who knew verses from the tree of good and evil could spring an entire fountain of hope in a desert like this.

There's no doubt in me I'll be here as long as the eye in the sky sees fit, but rumor has it he cares about what I want, too. And all I want is to be with Lee and our perfect baby. I can still see Lee clearly in my mind, beautiful always—her scent surrounds me like a ghost. She glows in the midnight hour, comes to life, gyrates around the room good and pissed because I won't come home.

I want to come home Lee, but God says no.

No hope for you, Mitch Townsend.

Here come the waterworks.

Max

Dear Lee,

I'm up before the sun because I cannot wait to make the most beautiful woman on earth my precious wife. I'll be honest. I have dreamed of this day far too long. This moment weighs more than gravity. It encapsulates a lifetime of my love for you, and embraces the life ahead we'll be living together. I'm in awe of everything you are, and so very humbled that you would choose to spend your life with me. Can't wait to see you.

All of my love,
Max

I fold it up and seal the envelope. I'm having two-dozen lavender roses delivered to the beauty salon where Lee is having her hair done. Stella is with her, so I pick out a mini bouquet and sign it *Love Daddy*. It warms me to the bone to hear her say it. Lee taught her that—had her calling me Daddy as soon as she could speak. The adoption won't be final until Christmas, but for all practical purposes I've been Stella's dad since the day she was born.

Lee made sure Stella knows about Mitch. She keeps a picture of him on Stella's nightstand, and Stella calls him, *Picture Daddy*.

My heart thumps unnaturally.

Mitch—probably not a good omen to think about him right about now.

ഇറൽ

"Stop moving before I stab you in the heart." My mother growls while doing her best to sever a major artery with my boutonnière.

She specializes in heart-stoppers, so I don't move, just let her work and be done with it.

The groom's room at the Mono Bay Assembly of God church holds the stench of old socks and stale pizza. I'm guessing it doubles as a doghouse for those not fairing so well in holy matrimony.

"There." She slaps my arm. Her hair sits shorn a little too low over her skull, but I don't say a word. "I'm proud of you, Max. Your father would be proud, too." She presses her lips together, solidifying her resolve. "You marrying Lee is the best thing for this family right now."

I glance over at my brother to affirm my mother's lunacy.

"Unlike Jackie," Hudson grunts while blowing smoke out the window. I've told him twice to knock that shit off. There's no smoking in the holding tank, but Hudson never listens. Jackie's been gone with Josh over a year now. Not that Hudson's been after them. If it were my wife and kid, I'd be right there with them.

"I do what I can," I say, adjusting myself in the mirror. It feels odd dressed in a tux. I'd much rather have worn a suit—a suit I can handle, but this feels foreign, unnatural. In fact, I offered to wear a suit, but Lee thought formal was best. Truth is, I would have worn scuba gear if she wanted me to.

Mom steps in and smooths out a wrinkle on my dress shirt. "Soon as you can, you should consider merging Townsend and Shepherd." The whites of her eyes increase at the thought of a boardroom coup with the crosstown rival.

"Don't do that—makes you look nuts." I fiddle with my tie accidentally stretching one side farther than the other. "And, FYI, I'm not marrying Lee in an attempt to pull some hostile takeover."

"No prenup," she sings. "Nothing's stopping you." Third time today she's reminded me there's no legal infrastructure in the event we decide to dissolve the union that has yet to take place.

I avert my eyes. "Yeah, there's another con I pulled."

A knock erupts at the door, and Colton steps in flashing his cheesy Las Vegas smile. He looks sharp, too much like Mitch for comfort, but I decide to let his genetic deformity slide just this once.

"You made it," I say as he slaps my back and ends with a fist bump. "Did you see Lee?" I'm hoping for a yes. I'm dying without communication. She said no contact until the big moment. She's going old school on me, and I don't like it. Deep inside I'm afraid she'll be a no-show, and it crushes me to think about it.

"Yup. Says she hates you. Changed her mind." He glances at himself in the mirror and twitches his brows.

"You wish." I pluck my tie apart and start from scratch.

Deep down inside I'm afraid he's right.

<div align="center">ಜ೦೧</div>

The sanctuary is decked out in roses. Every square inch of the altar is covered with enough flora and fauna to outfit the Garden of Eden.

My legs won't stop shaking, so I alternate pumping my feet. All of those eyes glancing up at me from the pews make me feel like I'm under a microscope. The last thing I need is to have a panic attack in front of the who-cares-who's-who of Mono.

Truthfully, I thought Lee might want something small since it's her second go-around, but she went all out. In a way I'm glad. It shows she's ready to move on, happy about it, too.

The church is brimming with bodies, standing room only in the back. The last time I remember it being this full was—

Crap. He's getting in my head again. Sorry Mitch. Not today—and for damn sure not tonight. Lee thought waiting until our wedding night would be respectful to Mitch—thus the short engagement. God knows the only respectful thing I could do to please Mitch is lodge a bullet in my brain. Sorry Mitch, you get the casket—I get the bride. That's how fate worked this one out. And tonight Lee is all mine, in name and in body—and do I ever have plans for that body.

The music shifts gears to something slow and melodramatic. Hudson walks Katrice down the aisle—just the two of them. I guess in that respect Lee decided to keep it simple. The wedding coordinator tries coaxing Stella to scoot on out. She's all Lee with her blonde hair, those large doe eyes, and a smile that spreads ear to ear. Stella takes small, stiff steps, the curls bouncing on the top of her head in rhythm. A round of *oohs* and giggles circle the room as Stella sprays the runner with lavender petals, Lee's favorite. Halfway down she runs out of flowers and pitches the basket into air, nailing my mother in the head.

I give a little laugh.

She's my girl through and through.

Her patent leather shoes pick up speed until she crashes into my arms.

"Daddy!"

"Good job, baby." I give her a quick spin, and plant a kiss on her cheek. "God, I love you." My heart sings holding her like this.

It's all happening. This is real.

The crowd turns. Lee appears in the doorway as a shadow, her arm linked with Colt's.

Shit.

I bite my lip to keep from saying it out loud.

From this vantage point he looks every bit like Mitch. But it's not. It's just some wedding day mind fuck because deep inside I know its Colt.

Lee steps into the light, and illuminates the room all by herself. She steals the beauty from the flowers in her hands, the roses at her feet. Her hair is swept back, and she beams a big smile directed right at me. She looks like a queen—a goddess—some supreme being created just for sheer beauty.

Tears well up unexpected, and I try to blink them away.

Lee strides down with her gaze fixed on mine, her intoxicating smile with its sultry implications.

"You're so damn beautiful," I whisper, as she shoulders up beside me.

Her mouth falls open. She looks down at her shoes then back at the open door as if she woke up and found herself standing at the altar with me of all people playing the part of the groom. Her eye twitches, and she jerks like she might make a run for it. Her gaze lingers at the gaping space as if she's waiting for someone, as if she might have left someone behind.

The last thing I want is Mitch getting too far in her head, crawling into her mind front and center and getting comfortable for the show.

It's time to break with tradition and pull her out of the pit of sorrow she's fallen into. I don't want her to forget about Mitch—I just need her to love me. Mitch had his moment, and this is mine.

I circle my arms around her waist and crash my lips against hers—loving her with my hungry affection until she moans like a dove in front of the entire congregation.

The preacher bleats a half-hearted reprimand, and the room ignites with laughter. I don't know what he said or why the room has suddenly erupted in cheers. I'm too lost in Lee and the deep well of her mouth. I take her face up in my hands and continue to shower her with slow, lingering kisses until one by one the memory of everyone who has ever lived on the planet disappears.

THE SOLITUDE OF PASSION

The Crystal Oaks Resort gleams under a baby-faced moon.

Lee wanted the reception partially indoors with a dance floor that bled out under the stars. A sea of tuxedos and women in sparkling gowns swirl over the wooden expanse, perfuming the night with laughter.

The wall of humanity is impossible to navigate, so I hold Lee by the waist all night as we make the rounds, thanking people for coming out. It's like walking in a dream holding Lee—*married* to Lee. Like my time before Lee never existed, like it happened to someone else.

We smack into Viv and some poor idiot with enough shellac in his hair to reflect the overhead lights like high beams. It was Lee's idea to invite her, and I hope Viv doesn't make her live to regret it.

"You did it." Vivienne offers one of her signature scowls. Her dark hair is draped over one eye, and it looks as if she stained her lips with the blood of her latest victim.

"It's so nice you came." Lee's teeth glitter. She hasn't stopped smiling since I gave her that last official kiss and made her my wife. She outshines the opulence the venue has to offer. The moon and the stars don't have anything on her. I can't take my eyes off my beautiful wife. Lee Shepherd. I've dared to think it a few times when she wasn't mine, and now its here, and it still feels foreign as if on some level it could never be true.

"I plan on coming to all of Max's weddings." Viv bears her fangs for the hell of it.

The music, the laughter, it all grinds to a halt as a surge of rage sirens through me. Leave it to Viv to turn a sacred moment into a heap of sarcastic bullshit.

Lee throws back her head and laughs before sharpening her eyes on my, first and only, ex-wife. "Then I suggest you take

a seat—eat the cake, enjoy the music. Max won't be having another wedding—not to you, not to anybody. When two people find each other and know it's right, it lasts forever."

"Oh, come on, Lee." Viv bleeds a necrotic smile. "You and I both know forever is a lie. People leave, they *disappear*—and everything changes."

I knew Viv was as bitter a bitch as they came, but I never thought she'd crack us over the skull with Mitch's bones on our wedding day.

Lee's face bleaches out, pale as chalk. "Max and I aren't going anywhere," she whispers. "Forever starts tonight. And the only person who should disappear around here, is *you*."

Viv stiffens. Her features darken, and for a minute I'm sure I'll have to play the part of a bouncer. But something in her relents and she snatches her date by the wrist before stalking off.

"You can thank me later," Lee says, holding one arm open to Stella who's running in this direction.

"I plan to."

"Mommy!" She squirms from Lee then jumps into my arms. "Daddy!"

"Whoa." I toss her in my arms and give a gentle ride. "Look who's here? My two favorite girls." I pull Lee in and form a small circle of love, just the three of us.

We sway to the music in our own private bubble. Lee laughs, plucking the tiara from her hair and placing it gently over Stella's curls. She peels a quick kiss from my lips and narrows in on me with fire in her eyes. Lee is burning, and its all for me.

This is everything I've ever wanted. Lee and Stella—a real honest-to-God family.

Nothing can ever stand in our way.

We ditch the reception early and leave Stella in Janice's trusted hands. My mother offered, but we were quick to decline. I'm sure she'd have Stella smoking stogies and toking off the bourbon after spending a week with her.

"Look at this place!" Lee takes in the honeymoon suite that overlooks the roaring Pacific. Outside the expansive windows, the world glows an eerie hint of purple as the stars hide beneath a veil of fog.

Candles illuminate the room. But in truth, Lee is all the light I need.

I plant a kiss over her neck, in the hollow of her shoulder, down lower still until she moans into me.

"I'm impressed," she says, taking in the sight.

An explosion of rose petals in orange, lavender, and red cover the floors, the bed, the dresser. I paid an interior designer a small fortune to make it the most enchanting, fairytale of a room you'd ever want to be in.

"I don't know how you pulled this off, but you're a brilliant man, Max Shepherd."

"The room or marrying you?" I reel her in again and dot her nose with a kiss.

Lee gives a seductive smile before pulling away and strutting to the other side of the bed.

"Where do you think you're going?" The curve of a lewd smile plays on my lips. I take a step forward, and she darts around me like some erotic game of cat and mouse.

Lee lets out a bewitching laugh before crawling onto the mattress. Her perfectly manicured fingers lift her dress above her knees, exposing a pair of hotter than hell lace panties, and I let out a groan. Petals flutter in the air like confetti as she makes her way toward me. I take her in like this, Lee in a wellspring of roses—the beauty of nature rising to greet her. It's all so perfect. She reaches over and pulls me in by the tie—raking open my shirt like it was on fire.

"Am I going to have to do this all by myself?" She asks with her lids half-closed, her lips parted and ready like I've envisioned countless times before.

I sink my knees on either side of her. "Can you?" I tease. "Might be fun to watch." My heart tries to bullet out of my chest at the thought of Lee lost in ecstasy while I hangout on the sidelines. "Not tonight, though. Tonight, I definitely plan on pulling my weight."

"Prove it." Her lips curl in a dangerous smile.

"I'm not one to back down from a challenge."

I unzip the back of her dress and pull it over her head. Lee reaches back and unhitches a barely-there lace bra with her pink nipples showing through. She hitches her thumbs into her shoestring underwear, and they drop to her knees with a flick of the wrist.

Fuck. My heart slams against my chest like a virgin on prom night. Dying of a heart attack suddenly feels like a very real option.

"Hot damn," I whisper, hardly able to maintain my breathing.

I touch my finger to her lips and she inserts it in her mouth, pulls it out in one slow drag with her tongue riding hard over the back of it.

"Nice." I pump a smile with my hard-on ready to burst the seam of my pants. I trace a line down her neck and her head falls back.

"You like that?" I inch toward her, tracking my finger slowly down her body until I hit the soft curls that dip down between her thighs and stop.

"Come on, Max," she pulls the words out in less than a whisper. "Get with the program." She gives a half-smile while I tear off my shirt, glide out of my shoes, my pants, my boxers.

Lee presses her body against mine, and everything in me comes to life for the first time in my entire existence.

Her lips pepper me with a hot string of kisses before finding my mouth and slipping her tongue so far down my throat I think she might actually fall in. Swallowing Lee, now that's something I could sink my teeth into.

I groan into her, maneuvering my body over hers. My hand latches onto her breast, and I move my mouth down over her nipple and give a gentle bite.

I let out a groan for miles.

Lee arches into my body, and lets me know she's there with me one hundred percent. I lunge over her in a frenzy of kisses—my urge to attack her on a primal level outweighs any need I might have to protect her. Being with Lee, is a powder keg, a starvation I'd like to satisfy in less than three rabid bites. I plan on devouring her well into the daylight hours and then long after that. Those were my own private vows, the ones I plan on implementing immediately.

She takes up my hands and rides them over her body, runs my open palms over her soft breasts, pulls me down to make a proper introduction to her hips, her thighs. I round out her curves like a dream. I may have been drunk when I slept with Lee Middleton once upon a high school party, but I committed her body to memory and replayed the footage far longer than I ever should have.

I slip my hand between her thighs and groan as I feel her warmth, the wet slick of her budding affection.

Tonight we make new memories—ones that I won't have to bury in my subconscious because I'm afraid they won't happen again. It's happening—Lee and me, floating in the perfect sea of our love.

Lee wraps her legs around me, her bare flesh sears over mine. She takes me into her hands, traces me out with her fingers and rubs a little circle over the top of my dick with her thumb. She looks up at me and bites down a smile.

"Look at you." Her eyes widen with surprise as she strokes the length of my dick. "You've got some damn impressive equipment, Shepherd."

My chest trembles with a quiet laugh. Mitch blinks through my mind, and I evict him and his unimpressive equipment from my subconscious.

"You're all mine, Max Shepherd." She glides her hands over my cock again, and a guttural moan escapes from deep inside me. "Forever, you hear me?"

"Forever," I whisper into her open mouth. Lee explodes a kiss over me like a nuclear detonation, something just this side of violent, something charged with an intimacy we've never shared before. Lee glides her hands down over my back, guiding me inside her.

"I love you," I moan the words, hot in her ear, as Lee becomes my wife in every way I have ever dreamed. An entire slew of memories slice by of Lee and me at every stage and age—swimming at the beach as kids, those stolen glances in junior high, that final explosion of lust in high school that we finally have the chance to recreate. A part of me knew right from the beginning she'd be mine. Fate restored our journey, put us back on the right path, and here we are, with me burrowed deep inside of her—Lee wrapped around me like a glove. I never want to leave—never want to let go.

"Max"—she moans—"I love you so much." It wrenches from her in a burst of passion.

If there was one moment in my life I could replay over and over, it would be this one, but I won't have to.

I'll be living it.

6

Borrowed Time

Lee
Three Years Later

"So are you going natural?" I ask Kat as we watch the waves crash over the shore from the back patio.

Four months ago they implanted five embryos, and three of them took. We sit outside on the deck, facing the listless horizon as the fog ebbs over the sand, crawling along the dunes like a plague of gossamer spiders. The salt ripens my senses, leaches onto my skin in a humid, sticky layer. It's so hazy this morning you can't see the water. You need to have faith it's there—that it won't whisper the words *I'll be right back* then disappear forever.

"Are you kidding?" Her eyes bulge at the thought. "Hell, yes, I'm going natural. I have a way higher pain threshold than you."

"As evidenced by?" I'm completely amused. Kat for sure has no idea that the threshold which she speaks of actually consists of *pain*. She believes eating three cheeseburgers in a row qualifies her for a morphine drip.

"For starters, I'm married to Steve." Evidently there has been some strife in the Robinson household. Three IVF treatments have the ability to land a nail in the casket of any

legal union. Rumor has it it's a real bitch on their bank account, too.

"Anyway," I whisper, "all I have to say is thank God for Max. If I were left to my own devices, I would never have gotten that epidural with Eli. Max was like a pit bull with the nurse until she called the anesthesiologist." Max has proved to be my hero in every way. The night we had our precious baby boy was amazing. The only difference between that birth and Stella's was that Max was actually in the delivery room while the miracle happened.

"That's because he loves you." She looks disgusted by the thought. "You guys are sick, you know that? I've seen seventh graders with more ability to curb their hormones." She blinks a sarcastic smile as she pulls apart the donut in front of her—jelly filled—my favorite.

"He does love me. By the way, we're trying again. Are you going to abuse that thing or eat it?" I reach over and pinch off the side before popping it in my mouth.

"You're trying?" Her face smooths out with surprise. "How exiting! How long did it take with Eli?"

I glance over at my dark-haired boy. He wears his father's features like a mask. He's gorgeous to the point of agony.

Katrice has been hinting nonstop how nice it would be to have a cousin close in age. The veins in her neck protrude like blue cords beneath her parchment-like skin. Something tells me she's going to get more translucent as the pregnancy goes on. She'll be my sister, the ghost.

"Honeymoon baby. Same with Stella." I wince when I say it. Different honeymoon. Different husbands. I hadn't thought of Mitch for almost two weeks. I hate when he comes at me like that, out of the blue like a poltergeist on the attack. Of course, I see him in Stella's room on her nightstand, but I'm almost immune to that picture now. Almost. It's self-preservation. I can only take so much heartbreak. He's so damn handsome in that picture. He burns into my mind so easily I try not to look

at him anymore. I keep telling myself it's not Mitch. That it's just some placeholder that came with the frame. But I can't ignore him for too long. And now he'll percolate in my brain for hours.

"Lee!" Kat wraps her arms around me before pulling away. "We'll be close."

"Maybe," I shrug. "We'll see how fast it takes Max and his swimmers to pull it off. Besides, I'm only having one to your three." I'm not sure triplets are functionally practical, although nature doesn't really ask you these things, it merely acts, and you *react*—like with Mitch dying.

"So about a month with Eli?" Kat picks at a loose thread on her maternity jeans. Her eyes stray as a trio of surfers strut by, one has a longboard hitched over his head with red and blue stripes that run the length of it.

I feel horrible telling her how easy my babies came when she had to move heaven and earth and inflict a double mortgage on herself to do it.

Eli slams his fists into the screen before coming outside and plopping down between us with his dark hair, his bright blue eyes. He squeezes a yellow truck in his hand. He's all boy just like his daddy. For a while I was paranoid that maybe he was Colt's, but Eli quickly morphed into a mini version of Max and I let that insane idea go.

I glance back at Stella, still at the kitchen table, drawing in a sketchbook that Sheila brought over a few days ago.

"You know—I take that back," I say. "It might have been when we got home." Max and I went to Turks and Caicos for our honeymoon, never did see the sun or sand with the exception of when the plane was landing. An erotic heat wave washes over me with the memory. "We went out into the fields—Max was going to show me how the new bird nets worked. I was afraid they'd choke out the vines. Anyway it started to rain, and Max thought it was a good idea to mud wrestle." I close my eyes, lost in the memory—Max and me

rolling around the crimson soil—his tongue tracking over my chest in long fiery strokes. "I'm positive it was that day." I push my finger to my lips. "God. It just hit me. I made a baby with Max Shepherd in Townsend field. I was defiling sacred ground and didn't even realize it." I give a guilty smile down at Eli.

"Oh, come on," Kat starts, "you should be used to pissing on Mitch's proverbial grave by now. You're still living in the same house with a man he wouldn't cross the street for."

"Stop." I avert my eyes. Kat knows she can get away with verbally murdering Mitch over and over in a weak attempt at humor. It's my fault because I let her. I like hearing his name—talking about him as though he were real. He doesn't feel real anymore. Maybe that's the biggest heartbreak of all. "You're not funny. Besides, it's my house and they're my fields, have been for years. Mine *and* Max's." Once we married, I made sure everything turned into a joint venture. "I guess it was just a good year for babies. Maybe we should start a new line of bottles—the fertility series."

"You're terrible. And late with production." She taps her belly.

"Please," I balk. "You'll have three underfoot driving you crazy, wishing you had none, and then, poof, you'll get pregnant again on your own. Happens all the time. You'll have six or seven before you know it."

She gurgles a laugh while shoveling a chip full of salsa into her mouth. Her honey butter hair curves under her chin. She's chopped off the locks of her youth but I've held onto mine. It's almost down my back. I can't seem to part with it. I like looking in the mirror and recognizing this version of myself as the one that Mitch knew. In a small way it helps keep him around. I've already changed my husband, my name, rearranged my family, a part of me needs to recognize the girl in the mirror.

"Guess who else is having a baby?" I almost forgot all about the latest Shepherd family scandal.

"Who?"

"Our favorite centerfold." Hudson's new girlfriend, an ex-stripper named Candi with an 'i' is the glorified dancer in question. She spells her name out as a part of her introduction. "You think she's ditzy *now*? I think all of Mono should fear for its safety once her hormones kick in. A pregnant brain is a very real thing."

"All knocked up with Shepherd dough to blow, huh? How long have they been together?"

"Three months. That's like a fiftieth anniversary in Hudson relationship years."

"Any word on that other kid of his?" Kat snarls as if Jackie kidnapping Joshua was somehow Hudson's fault. Probably was.

"Hasn't seen him in over two years. She's moved to North Carolina permanently. Enrolled him in school and everything."

"Oh my gosh. That's terrible."

"One would think. But Hudson doesn't seem to mind. It's killing his mom, though. Max is pretty upset, too. He wants to plan a trip out after Christmas."

"He's a good uncle."

"Max is good at everything—for sure he's a better dad than Hudson any day. Weird thing is, I don't think Jackie and Hudson ever filed for divorce." Eli rides his truck up my leg, tickling me in the process. "Hey you!" I pick him up and bounce him on my knee, watch as his baby fine hair wafts in the breeze and fans out like a plume of ebony feathers.

"So"—Kat cinches her cheek up one side—"how's Stella doing in preschool?"

"Loves it. Max and I cried her first day, and she didn't even wave goodbye."

"You're a brave girl, Stella." Kat shields her eyes from the sun struggling to break through the haze.

"I hear you," she shouts from inside.

"She hears everything," I whisper. "I have to spell out all my naughty thoughts now."

"Like?"

"Like none of your f-u-c-k-i-n-g business." I laugh.

"Bet Max enjoys those."

"More than you'll ever know." A private smile curves my lips. "Max has a dirty streak a mile wide, and I love every naughty inch of it."

"I've always suspected Max Shepherd was a freak." She bites down over a chip and raises her brows.

I lean back and watch the waves roll in, one by one, chaffing against the sand in a constant surge of anger. A lone surfer paddles out, and from the back, he reminds me of Mitch—same golden hair, same broad shoulders, defined biceps. There he is again. Drifting away from me as if that were his destiny all along. From here I can fool myself into believing it really is him.

Phantom Mitch hops up on the board. He catches a small wave only to abort the mission and pencil dives into the water.

"You're thinking about him, aren't you?" Kat always knows.

"I can't help it." Mitch is like a hurricane that ripped through my life. So glorious and wonderful at first, then he blew it apart—left me with the devastation. Hurricane Mitch—not sure that's the legacy he would have wanted.

Kat leans in. She twirls my hair at the base with an apprehensive smile. "You never really made peace with him, did you," she whispers.

Eli squirms and bucks until I put him back down by my feet. Same sweet dimples, same intense eyes as Max.

I have a beautiful girl, a beautiful boy, a husband who would set himself on fire for me—then why in the hell do I feel so unsettled?

"Maybe I haven't made peace with him." I stare out at the lone surfer as he traverses a wave—rides it until it funnels out.

He stands on his board a second before sinking back into the water then disappears from the planet just like Mitch.

It's true. I strapped Mitch's carcass to my back and have been dragging him around silently for years. He's the ghost in the bedroom during those intimate moments between Max and me. I still see the hurt in his eyes every time I look at Colt. I've let him down. I can feel it.

"Let go, Lee. Forgive him. He didn't die to piss you off," she whispers it sweetly like only a sister can.

The surfer garners my attention again. I forgive you, Mitch. Your wave petered out. It trickled to nothing. God called you home. I can't drag this lingering pain around anymore. It wasn't your fault. It wasn't Colt's. It just happened.

Stella runs out, fanning the picture she's been working on. Her golden curls spring up as she jumps into my lap. I kiss her face as she wiggles in my arms. Mitch hides there in her eyes, but I pretend not to see him.

"Hon, this is beautiful!" I marvel at the four smiling stick figures, the sun in full bloom overhead.

"It's me, you, Daddy and Eli," she sings.

Colorful poppies surround us against a field of green.

"I love it," I say, kissing her hair. "We're a perfect family."

She didn't draw Mitch. She never does.

He's out of the equation forever.

And yet, deep down inside, I still feel unsettled.

Mitch

Darkness covers me like a shroud. I've spent the last fourteen days straight in the belly of the wicked whale. No light, less food, even less desire to keep breathing—all hope is gone—nothing but Mitch in a foxhole.

I shift the weight from one knee to the other as I try to explain a few things to God. For instance, I'm almost okay with Him leaving me here. I know He has a higher purpose—I *hope* He has a higher purpose. And if He doesn't have a higher purpose, I suggest He think one up real quick.

It hurts a little too much knowing I'm sinking my life in this dungeon, losing all that time with Lee and our baby, missing my mom and brother for nothing. I don't really need to know there's a higher purpose, I just need there to be one. And—if he's got a thread of mercy left in Him today, I hope He gets me on the next plane out.

I lie back down and close my eyes. It's Lee time. We walk our yellow lab. Have coffee before the kids get up. I usually don't make love to Lee so close to sunrise, but this morning she's entertaining me by taking off her clothes. I give a little smile. Damn it all to hell, Lee. What are you doing to me?

Everything about Lee is the same in my mind's eye. She doesn't age, her hair never changes, those beautiful eyes still smile at me without trying.

The surprise of electricity goes off overhead—looks like it's back to the grind for me.

Lights, camera, action.

The walls of the sweatshop drip with oil. The floors are dusted with sand from a spill on the manufacturing line last week. A string of bulbs dangle from bare wires, dotting the facility with the not-so-thinly veiled threat of turning the place into an incinerator. I'm sure this rat hole has more than its fair share of electrical and architectural felonies taking place. At home I couldn't install a window without five different building inspectors breathing down my neck, and here they've jerry-rigged an entire infrastructure.

Gao finds a seat next to me on the production line today—the lentil assassin. Although, technically he didn't assassinate anyone, he was trying to save them—*feed* them. This place is rife with irony.

Rows and rows of worktables line the dank, humid room which smells of rancid urine. Two boys, ages twelve and fifteen, occupy the table in front of us, and I flick a couple of paper roses across the floor toward them. I've been to isolation over a hundred times since they pushed me in and threw away the key. It works out to be about every other week. It's dark, but it offers more quality time with God and Lee. Nothing like some time with the fam so I'm not too spooked by the consequences.

The young boys stoop down and slip the folded roses into their shoes before looking up with their dead expressions. I've spent months with them and never once seen them crack a smile. It's weird seeing kids here. Although, they're not kids anymore. This place sucks the soul right out of you, crucifies you for sins you've never really committed.

"Mitch," Gao whispers while trying to master the art of ventriloquism. He stares down with great intensity at the pool of beads before him as if he were mapping out the cure for cancer. This week's mind numbing task consists of landing multicolored bits of plastic into what looks like a tackle box.

My fingers beg to fall off as I fumble to keep up with my unreasonable quota of fourteen chests per hour. Not sure how many hours, but I don't stop until it's good and dark outside

that window. I'm not certain what exactly lies beyond the boundaries of these walls. When I first arrived someone got up and tried to sneak a peek, but they shot him with a dart. He fell to the floor like a stone, haven't seen him since. Mostly I sit on my ass and shut the hell up. I prefer to break the rules on my own terms.

"I got paper book," Gao hisses it out like a sneeze. "Small paper book of your God."

I pump out a smile at him. I'm not that enthused. Half the people I give my work to can't read English.

"Master work," he assures.

We sit, still as stone, as a patrol guard makes his way down the aisle.

"Thank you," I whisper.

Water comes to the desert. I haven't laid eyes on anything that remotely resembles the English alphabet other than what streams from my own hand.

Slow methodical footsteps retract and stop just shy of my shoulder. I don't turn around just keep at my work as though sorting the blue beads were the defining axiom of my existence. At this point it probably is.

A sharp blow strikes the back of my head. Blinding white-pain sears through my skull. The room sways, and for a brief moment I think I might pass out. Turns out I'm not that lucky today.

Two men in uniform charge in my direction and escort me out by way of the ever so popular push-shove method. It doesn't take long for me to see blood dripping over my shoulder. Looks like I get to clock out early.

ಬಿಂಬ

"Bandage for you today."

Mei is on duty, so I'm feeling pretty comfortable. We sit in her small eight by ten depository that doubles as surgical quarters with mouse feces and dried blood scattered freely across the laminate flooring. She wipes the blood away from my temple and gives me another brown work shirt fresh from the laundry. I take it in and smash it against my nose. It reeks of bleach, and that alone feels pretty damn extravagant. Everything else around here, including my fellow inmates, smells like ass crack and that's a scent I can never get used to.

"You stupid." She slaps the back of my neck for good measure. "Keep you mouth shut. They going lock you up in dark room for good one day. We forget about people in there sometime. Bad smell come. We wait until it finish before we open door again."

"Nice." My mind splinters for a minute. That's exactly what happened. The whole world forgot about Mitch Townsend. They shut the door and are trying to ignore the stench. I never could figure out why they didn't move mountains trying to find me. I'd like to believe they're still looking, but reality begs to differ.

The phone rings, and Mei picks up without the courtesy of anything that resembles a hello. Her moon-shaped face doesn't flinch as she rattles off a series of singsong phrases. It sounds jagged, like a saw trying to hack through the trunk of an oak—wind chimes—some ancient vocal exercise. I take a seat by the door and close my eyes as I wait for the cattle prod to tell me what to do next.

The faint sound of laughter lights up the hall, and my eyes spring wide. *Laughing.* That's something just this side of illegal in this shithole. A strong male voice speaks in perfect English. I lean my head out the door with curiosity as he rattles on about travel arrangements. People actually leave this place? Doubtful.

A sharp dressed man in a navy suit, blood red tie notched just below his neck, speeds in this direction. I haven't seen anybody dressed like that since I was back in the states.

"Hey," I shout after him as he passes me by. "Excuse me?"

He turns, still moving in the opposite direction, glances at me, and reverts over. "Yes?" His eyes run over me in my sorry state of disrepair.

"Are you a lawyer or something?" God, let him be a lawyer.

"Kyle Wong," he barks it out. "What's your story?"

My body seizes with hope, and my vocal cords weld together. My chest reverberates like a time bomb. Kyle Wong lit the fuse, and now I'm probably going to blow to pieces with the prospect of seeing Lee again. I glance over at Mei. If this is a trap, I'm falling in hook, line, and sinker.

"Mitch Townsend," I say, extending my hand, but he doesn't take it. "I came here to do some work a while back," it speeds out of me. "Can you help me get in touch with my wife—my brother? They'll hire an attorney. *You*, if you want."

"An attorney from the states has no jurisdiction here. Nobody does." He takes a few steps back. "Mitch Townsend, you say?"

I nod eagerly.

"Nice to meet you." He lifts his hand before speeding down the hall.

He takes all of my hope with him.

Max

I give a series of hard blows against Hudson's door. I have to take a piss, and it's a hundred and twelve fucking degrees out here, literally.

Indian summer. Two weeks into fall and you'd never know it. Hotter than hell. It says so on the gnome thermometer flashing his bare ass at me. Apparently Candi has a thing for miniature elflike creatures as evidenced by the fact she has them splayed all over the property. I don't know which is worse, her collection of miniature mutants mooning the houseguests or the steering wheel graveyard of my brother's that continues to thrive. Not to mention the fact Hudson has managed to add a tire monument to his long list of automotive offenses—a stack of necrotic oversized donuts that rival the pyramids in girth and stature.

The door cracks open, and I push my way through.

"What the hell took so long?" I ask, ditching into the bathroom. It occurs to me as I'm relieving myself that the mane of blonde hair blown up like a beehive didn't belong to my bonehead brother.

"Sorry, about that," I apologize to Candi as soon as I get out.

Her arms are folded against her waist semi-pissed at my not-so-neighborly entrance. She's wearing four-inch heels, one long tank top stretched over the Himalayas with no sign of any kind of bottom, and it registers she's dressed to greet the Shepherd she's a little more intimately fond of. I avert my gaze like pulling out of a fire, but she leans in on my shoulder and purrs a strangled hello.

"Whoa." I hold my hands up and stride over to the kitchen.

Lately it feels like whenever I'm around she's hitting on me. Then again, she probably hits on everyone—no reason to think I'm special. Like I'd pay her any attention. I've got Lee. No time for three dollar whores. No offense to Candi. It just so happens that a "three dollar whore" is the garden-variety girlfriend for my brother.

Hudson struts in through the back door and nods over to me. "What's going on, little bro?"

"You tell me." He called while I was lying prone in Townsend field. There's a leak in the irrigation line that's turned the earth into soup and has already cost Lee and me a quarter acre.

"You fix the line? Hey, you want a beer?" Hudson's face softens.

Asking about the line? Plying me with liquor? I smell a financial burden brewing. Hudson's kindness always comes with a price tag.

"No thanks. Line's all right for now. Think I torqued my shoulder though." I rotate it clockwise a couple times before following him into the dining room and grabbing a seat at the table. Candi clicks her heels in the opposite direction, taking her hormonal self upstairs, and suddenly it becomes too quiet.

"Spill," I say. "I need to get home." It's baby-making night. Lee's ovulating—she called me twice to remind me, which is sort of ironic since I end almost every day making love to Lee anyway. It's a pleasure, a *treasure*, anything but a chore.

He scratches at his scruffy hair, long and matted as a lion's mane. "I need some cash, dude."

"What's new?" I pull his beer over and take a swig before sliding it back. "There's no way in hell I'm lending you anything that even remotely resembles currency."

His features darken as if there were more to the story, but he's not laying down all his cards just yet. "I'll pay you back." His eyes bulge unnaturally revealing an entire network of crimson railroad tracks. I'd like to believe those were hard won,

from tears, but thanks to the jars of weed he has stored out back, I know better. "*Twice* what I owe you."

"No, you won't. What happened?" I don't need to ask. I already know. He lost another bet, but I want him to verbalize what a loser he is. I want him to squirm like the sack of shit he's panning out to be.

"It was rigged." He shakes his head. "I swear. I'm not messing with those bastards anymore." He swipes his fingers over his eyes. Good God, he's actually harnessed the ability to manufacture tears. Who knew I'd be treated to a performance piece? "You gotta do this for me. Just one more time, I mean it."

"What's the damage?"

"Seventy-five."

"Shit!" I slam my palms over the table, and the walls rattle like thunder. "It took a whole lot of convincing to get Lee to dip into our personal savings to bail your ass out of hock just three weeks ago—*fifty grand* I just gave you. Are you some kind of fucking moron?"

He slinks back with an infuriating look. "They threatened the fields."

My mind goes blank. It's like his words chaffed my brain and took all my rational thoughts with them. I bunch his shirt up by the neck and shake the holy shit out of him. "You stupid little prick."

Candi races in screaming. She tries to break up the love fest by digging her press-on nails into my neck. I give a hard shove and knock Hudson backward onto the floor.

"Last fucking time!" I bark.

Hudson pulls his lips in a line and doesn't respond to my rage. He knows he won.

I don't say anything else, just walk out the door.

I sit outside the beach house a moment before getting out of the truck. The lights glow silent inside, bleeding a resolute peace out into the street. Hudson had my blood boiling all day. I need to cool off, pull it together before I snap for good. Putting the fields in jeopardy far exceeds a boneheaded move. I'll have to move him to Greenland to get rid of him, ship him off to the North Pole—*China* before he jeopardizes Lee and the kids.

I close my eyes a moment. He's going to get us all killed if he's not careful, and God knows Hudson is a lot of things, but *careful* isn't one of them.

The searing night air covers me like a blanket straight from the dryer, hot and smothering as I head toward the door. Lee races downstairs soon as I walk in, jumps up and kisses me wet on the mouth.

"That fixes everything," I say it warm, rolling my cheek in her hair.

"Shh." She presses her fingers to her lips and bites down a smile.

"Both of them?" I mouth.

Lee nods as I take in her beautiful face. "They swam in the pool at Kat's until they were ready to pass out. Eli hasn't made a sound." She's wearing the white silk robe I gave her for Christmas, the one that hardly covers her bare bottom. She's all hot and bothered, probably wet for me, too. I run my hand up over her thigh and circle around the front to confirm my theory. My fingers smooth over her soft skin before dipping down to her moist slick, and a dark laugh gurgles from my chest.

She doesn't ask if I'm hungry or how that cracked line panned out in the field. Lee is all business as she leads me upstairs, and I can get damn well used to this.

Who needs a warm meal when you can have a smoking hot Lee waiting for you at home?

THE SOLITUDE OF PASSION

I slip a dirty smile in her direction. Hell, I *am* used to this. Lee is the wife that other guys dream of and probably quite literally.

The bedroom flickers with candlelight. The shower is already running, so I strip my clothes off in front of Lee's watchful supervision, nice and slow.

"Don't take your eyes off me," I whisper, no smile.

"Oh, I won't." She meets my ultra serious demeanor, a smile playing on the edge of her lips. "I don't want to miss a second of the show."

Lee wants a girl this time. She read some book that promised her a daughter in exchange for scalding her husband's balls in the shower just before lift off.

"Aren't you coming in?" I peel off her robe and run my hands over her smooth shoulders. Lee bounces up on the balls of her feet. I evade the kiss she was eager to give me and run my tongue over her bare tits instead.

"Oh"—she gives a dark laugh—"is that how you're going to play it?"

"Yes." I pull back and take her in. Lee is a goddess that should be venerated. I should drop to my knees each time she's in the room, and I've fought the urge on more than one occasion. "That's how I'm going to play it. Now come in with me." I pull her close to the shower. My fingers dig into her waist just enough to make her giggle.

"And boil myself?" She hikes her brow deep into her forehead. I love it when she does that. It makes her look criminally insane, and God knows I love her brand of crazy beneath the sheets. "No thanks." She wrinkles her nose. "I hear the burn unit isn't all it's cracked up to be." Her lips give a dangerous curve as she scratches at my chest. Her hand slides down, her fingers drip like honey as she strokes my dick until it feels like it's going to burst right out of my skin. Lee spins me around before things get too out of control and shoves me into the oven.

"See what I do for you?" I let out a growl as the knife-sharp blades sizzle over my skin. "I'm enduring third degree burns for you, Lee." I lather up like its some military exercise and shake my balls at her while she supervises. She belts out a laugh while holding a towel at the ready. I jump out as fast as I went in, numb from the hellfire—the *lava* blast that melted my skin. Lee rubs me down, anxious and quick as if my sperm had some timer attached to them. She gets on her knees to dry off my legs and looks up at me like she's about to beg for something.

Her features soften as she gazes up at me. "I love you so much, Max." She shakes her head as if she's sorry about something. "Thank you for doing this for me."

"Hey." I pull her up and lead her backward into the bedroom. "Who says I'm doing this for you? This is all about me, girl," I tease. Hudson and that insane scene from earlier pop into my mind. I'll tell her about Hudson after I make her breakfast in the morning. It's the last time, I swear. He can sell himself on the streets after that for all I care. It's the fields—my family that I'm doing this for.

She belts out a laugh "Silly me. I thought this was about *us.*"

"It's always about us." I dot a kiss over her lips before pressing in a little deeper, my tongue strokes over hers with a fevered rush. "Because there's no one better than us."

"Nope." She bites down over her lip and holds her gaze to mine. "Now I'm going to fuck you Max Shepherd, and you're going to have to take it like a man."

I depress a smile in my cheek but don't say a word just let Lee pull me over to the bed by the fingers.

Lee pushes me onto the mattress and flips on some raucous rap music just low enough to set the mood, and it takes a minute for the ex-rated lyrics to set in.

"Damn, you're a nasty girl, Lee." I roll into the center of the bed and pat my stomach for her to take a seat. "Most

women would prefer something sleepier—*weepier*," I muse. She jumps on my chest, landing her knees on either side of my face. I catch her hand and gently graze on her finger with my teeth.

"I'm not most women, Max," she sways with her eyes closed. "I can feel it. This is the night we're going to make our baby."

Stella and Eli blink through my mind uninvited. I try pushing them out, but they keep resurfacing. The last thing I need is a lingering image of the kids before manhandling my beautiful wife.

A seam of moonlight falls over her, and she lights up the room like some ethereal queen. Her body bleaches out pale as stone, her curves glow with the kiss of moonlight enunciating her beauty.

Lee shakes out her hair, rains it over my face in soft waves before straddling herself hot and wet onto my lap. She rocks side to side with a grin on her face before attacking me with the grace of a wrestler. Lee has the championship hanging in the bounds, and she's in it to win it. I fight it just enough to hear her grunt and push before turning her over, pinning her arms up over her head and melting kisses over her eyes, her nose, her lips.

"What do you want Lee?" I moan into her ear while her breathing grows erratic. Her skin is hot to the touch. I let out a little laugh as she grinds her hips into mine. "Use your words." I kiss her temple. It's the same phrase we say to Eli ten times a day.

"You're funny Shepherd." She runs her tongue up the side of my neck and a groan gets buried in my chest.

"Damn, Lee." I tuck my face in her neck and take in the clean scent of her hair. "Tell me what you want?" I like teasing her like this. I'm not above making Lee beg on occasion.

She reaches up with her mouth and gives my ear a solid bite.

"Whoa." I pull back, my chest trembling with a laugh. "You want a piece of me?"

"Just one." Her lips curl up on the side.

"Which one?"

"The one that paralyzes your vocal cords." Her knee glides up and gently clips my balls. "Fuck me, Shepherd or I'm going to have to call in the reserves."

"I'd tell you to watch the language but you know I like it." My chest rumbles as I crash my lips to her. "In that case—" I push her knees back and thrust in without warning.

A strangled sound gets caught in her throat and her eyes roll back. Lee lets out a little laugh.

"Look at me." I push in deeper as I get up on my elbows. "I thought you said you didn't want to miss a minute?"

Her lids flutter open as I pull out slowly then thrust back in with a marked aggression, repeating the effort until she chokes for air.

"You win." She pushes me in by the small of my back and lets out a gut-wrenching moan.

"God, I love you, Lee." My body begins to lose it. I rail over her until I'm blind with pleasure. Hours feel like they stroke by but it's just been minutes. A moment in Lee feels like the sweetest eternity. She lets out a strangled cry and pulls me in by the hair. Her hot mouth glides over mine as she writhes beneath me. "Shit," I whisper. "I'm coming." A hard groan kicks from my gut as I tremble inside of sweet, beautiful Lee.

She gives a heated laugh in my ear. Her skin slicked with perspiration that matches my own.

"Do you think we made our baby?" She blows it out in a rush.

I lean up and take her in as the moon drips over her with its night magic in purples and blues.

"Nope." I press a kiss over her moist forehead. "I think we'd better try again."

I stay up half the night locked in passion, wrestling Lee, and the other half of the night dreaming of a sweet baby girl.

7

Freedom

Lee

The sky holds the color of butter while the heat flogs down over Mono like a punishment. It's these last days of summer, bleeding into fall, that always manage to feel achingly dreadful. The colorless sky, the sauna-like heat, it all feels off, unnatural, and yet we need to accept what the world gives us, just bend over and grab our ankles—go for the ride. That's how life works. I guess in the end there's nothing we control unless you count the smile on your face, and even then it's iffy.

The evening of Sheila's birthday party falls on a Saturday. Max's mother isn't exactly known for her plethora of friends, but the few she does have gather at the Shepherd estate in honor of yet another birthday candle.

Last week, quite by accident, I bought her a vase that closely resembles a delicate part of the female anatomy—a labia to be exact. I didn't even notice until Max pointed it out as I was wrapping it this morning, which led to interesting banter and an early morning arousal factor that landed us both in the bathroom—me with my legs spread wide while Max pretended to do a little juxtaposition.

We enter the Shepherd estate through the side yard, and the kids run off to play. Sheila makes sure the grounds are

immaculately landscaped with rows of Italian cypress and miles of rolling green lawns. I spot her over by the porch speaking with an older woman, and we exchange a wave. I don't even know how old Shelia is. She keeps her ages and stages close to the vest. She has her new boy-toy here who looks embarrassingly like Max, and this sends the not-so-high society of Mono a titter. The sun has almost set, but the heat continues to imprison us like we've been abandoned in a sweltering car and can't get out.

Candi and her overblown everything crashes into me on her way inside the house, leaving her boobs to ricochet from the effect. She's probably experiencing a silicon meltdown and needs to step into the freezer just to maintain her composure, literally.

I want to say *are those real,* but instead I opt for, "How do you feel?"

Candi gives a dull smile before fanning herself with a paper plate. She's wearing a tropical inspired two-piece and not much else. The world's tiniest baby belly hangs from her middle proud like a trophy.

I'm not too thrilled that Stella and Eli are exposed to her questionable version of undress. I'm about a second away from throwing a blanket over her as a part of my parental responsibility.

"I'm sick. I'm *so* sick." She reaches over to the dessert table and shoves a couple of brownies in her mouth. In typical Candi fashion, her actions don't follow her words.

"It'll pass," I assure. "Most things do." Not all things, but I leave that part out.

Max waves to me from under the patio, and I speed over before I entangle myself in Candi's cleavage.

"Can it get any hotter?" I ask, falling into his lap. Max and his cutting good looks—I don't think I could ever tire of laying eyes on this man.

"I think it actually gets hotter in relation to how close I am to you." He dots my lips with a kiss. "You're too hot for all of Mono to handle. I hate that other men get to look at you." He gives a wry smile before passing me a bottle of water.

"Thank you," I say, taking a sip. "And, for the record, you're the only man I ever want to see me—clothed or naked."

He tweaks my ribs, and I bounce with a laugh.

We watch Stella and Eli play in the kiddie pool while Sheila supervises from the sidelines. The pool belonged to Josh, but he hasn't been around in years. Sheila never mentions him anymore. It's like his name—his person, they never existed. Sometimes it's easier to pretend that the people who disappear from your life were never in it to begin with. God knows I've stopped up a wound or two that way. An image of Mitch and his impossible smile flashes through my mind. I shake him away before he pulls me down to the grave and I end up in a catatonic ball on the floor. Lord knows I've logged far too many hours in that position.

"What do you think?" Max breaks out into a spontaneous massage over my shoulders, and I groan with approval. "Should we knock out the presents?"

"I don't see any other way out of this catastrophe," I moan into him as he continues his barrage of digital affection.

"We haven't had cake." Sheila pops up unexpected. I glance over at the kids and see that Colt has managed to squeeze himself in the plastic-lined tub, and for a minute I wonder if he qualifies as adult supervision. "I'm a big believer in tradition," she continues. "Cake first. And please, Lee, stop referring to every Shepherd event as a catastrophe." Her eyes bulge from her skull. It unnerves me when she does that. If I didn't know better I'd think it were a tragically unnatural condition, but for Sheila it's just par for the course. It makes me question whether or not my children are in danger of bullfrog genes. Of course Eli was spared, and Max is stealth—godlike. If

I had a daughter that looked exactly like Max with that thick ebony hair, I'd call her Black Beauty.

A soft ache stirs in me as I twist into him. He's so gorgeous, and he's all mine. It almost doesn't feel fair.

"The gift is for my wife," he says before pulling me in. "I got the antique press," he whispers it hot and sultry right into my ear.

"Oh my, God!" I throw my arms around his neck. "You did?" I've been wanting—*drooling* over a six-hundred-year-old wine press that was ready to go to auction.

"All for you." He presses in a heated kiss.

"Thank you," I whisper. "We'll put it in the museum." A year ago Max and I filled the lobby of Shepherd Inn with antique pieces we've been collecting in an effort to offer more than just a tour of the winery. This way guests soak in a little bit of history while visiting the facility. Local schools come up all the time. We offer shuttle rides through the fields and presses. Max and I have taken Stella and Eli out on field expeditions more than we can count. Which reminds me, "Stella told her teacher we make grape juice."

"My own daughter insults me like that?" His dimples dig in as he holds back a grin.

"Somebody needs to keep your ego in check," I whisper, slipping my hand up his shirt and gliding it over his chest, nothing but skin over steel. It's no secret Max hates working in the fields, but his body sure appreciates the effort. "I love you, Max Shepherd. You know that?" The words stream from me, soft and dreamlike.

A slow growing bulge blooms in his jeans just under my left thigh, and I lean into it.

"Promises, promises," I muse.

"That's one promise I plan making good on sooner than later—and, you know I love you more." He presses in with a sweet kiss, slipping his tongue straight into my mouth before pulling away like it never happened.

"Playing dirty, are we?" I rake my fingernails over his chest before dipping them into the lip of his jeans. "What in the hell is going on in those pants of yours?" I whisper, biting down a smile. "Have you been looking at Candi again?"

His chest rumbles with a laugh. "Candi's the anti hard-on," he says it low, secretive. "That woman can deflate every dick in a ten mile radius just by opening her mouth." He pulls me down by the neck and crashes another searing kiss over my lips.

"Enough, you two." Shelia sprinkles us with water as if she were baptizing us. "Get a room would you?"

"We'll do better than a room," I say, bouncing off his lap. "We'll get the cake." I pull him up with a look that suggests a detour to his old bedroom is in order.

Colt shouts something to the kids, and Eli shrieks with laughter. It ignites a fire in me, charges the air with the currency of youth, makes me want to have a thousand dark-haired babies with Max.

We head into the house and a layer of refrigerated air congeals over my flesh.

"Oh, that feels good," I moan. "I never want to go out there again."

"You know what I like about you?" Max reels me in, blessing the top of my head with a quick peck.

"What's that?" I give a little laugh because I know where this is going.

"The fact you're always hot and bothered." His cheek slides up one side, and his dimples dig in deep. Max knows how to render me useless with little more than his facial expressions.

"The fact I'm hot and bothered is simply an aftereffect of being near you." I hook my fingers over his jeans and give a gentle tug. "This way," I say, leading him up the stairwell.

"Did you hide the cake upstairs?" His eyes glow sky blue against the dark expanse of the hallway. He's seducing me with that ultra-serious demeanor he knows I can't resist.

"Are you complaining, Shepherd?" I cover his ear with my mouth and let it out by way of my teeth.

He gives a hard moan. "Never." He swoops me up in his arms and carries me over the threshold of his old room, locking the door once we're inside. I bounce to my feet and push him over to the bed.

Max's bedroom encapsulates his teenage years. A bookshelf sits rife with paperbacks, old sports trophies that have long since lost their luster, an empty champagne bottle he swears we drank from the night we were together in high school, old yearbooks stacked four deep on the top shelf.

I run my finger across his desk and hold up a film of dust for his inspection.

"Your mother does not love you," I tease.

He lands a kiss high over my cheek and pulls me onto the mattress in one swift move. "Looks like I'm going to need you to kiss all the pain away." He runs his hands up my dress and unhooks my bra with a twist.

I push him back onto the patchwork quilt decorated with alternating balls and bats. "How many girls did you have on this bed?"

"Just you." He closes his eyes and pulls me down until I'm sitting right over his chest.

"Max!" I give a playful swat. "I've never slept with you in your room before." And it feels criminal.

"Yes you have, plenty of times," he says it groggy with his lids half-closed. "You were just physically absent, so you couldn't enjoy it."

"Very funny and slightly disgusting." I groan into him as I unbutton his jeans. "But I'm here now. If you're good, maybe I'll let a fantasy or two play out."

His eyes gloss over as he flashes his signature brilliant smile. "You're a real live wet dream, Lee."

Max pulls my dress over my head, quick as a heartbeat.

"Nice move, Shepherd."

"Are you kidding? I've been dreaming of the things I could do to you on this bed for years."

"Oh? I'm amused by this."

"That's right." He hooks his finger into my panties and tugs them off, forcing my knees together for a moment. "You had it right the first time." He pulls my legs on either side of him, high on his chest. "You gave me my first hard-on, you know that?" It comes out more informative than playful.

"I'm honored." I trace out a letter S over his chest with my finger. "You gave me the girls equivalent."

He rumbles beneath me with a dull laugh. "I thought we'd have something big back then." His eyes expand just past me as if he were living out a painful memory.

"Yeah," I whisper, afraid we'll drift too far and I'll get lost in the black sea of grief with my legs awkwardly parted over his chest. "I thought we'd have something big, too. And, now, we do. Maybe we always knew this day would come." It feels as though I've defused a bomb. My thighs tremble from the sheer terror of where the blast could have landed us.

"We're here, aren't we?" His dimples go off, and my insides melt at the sight of him.

"You want to know something?" I touch my fingers to his perfect face and trace out his lips like I used to dream of doing way back in junior high when Max wouldn't give me a second look. "I have burned through a thousand nights thinking about you under the sheets."

"Really?" He looks stunned by this.

"True as God."

"Lee." His lips tremble as though this were too much for him, like he wanted it but never knew it could happen.

We almost had something way back when but life gave us a detour, and, now, here we are, right at the starting gate—the bedroom he spent all those nights in, hot and bothered.

"You know what would make the sixteen-year-old boy in me really happy?"

"If I let you beat me at a video game?"

Max moans out a laugh. "And this." He pulls me in by the knees and lands the most intimate part of me over his hot mouth. His fingers dig into my legs, imprisoning me in this position—not that I would ever move. There's no place I'd rather be than right here with Max Shepherd burying kisses between my thighs. "I'm going to love you, Lee." Max pulls me deeper and rides his lips, his tongue over me in waves, his teeth grazing me ever so gently.

A heated breath escapes my throat, and I give a little cry.

Max thought we could have something big, way back when. The truth is, I did, too. I thought for sure he wanted me, but he didn't fight for me and Mitch did. Max made the decision all too easy, and I can't help but wonder what would have happened if he didn't. Mitch and his glorious face blinks through my mind, and I push him away. It's water under the bridge now. I hope my heart can accept that one day, maybe then I can finally move on without the agony of losing him all over again. I'm with Max now. I belong to Max. A part of me has always felt like that even when I was with Mitch. And, ironically, now that I'm with Max, I know for certain a part of me will always belong to Mitch. It's a twisted game my heart plays, and I want none of it.

Max burrows in and lashes his heated tongue over me until I forget all about the world and everyone in it.

It's just Max and me.

No more detours.

After an hour-long lust-filled exchange, that has forever scarred the landscape of Max Shepherd's childhood bedroom, we drift back downstairs. The crowd outside has dwindled considerably. Most of them have probably melted into the lawn, considering they were made of wax and silicone to begin with.

We present Sheila with a cake that's frosted a garish shade of red and strike up our vocal cords in honor of the birthday girl herself.

Stella and Eli belt out "Happy Birthday" so loud you would think Sheila was on the moon or *dead*. I love the way their voices rise up over the crowd—how they sing with a passion that says we're unafraid of anything. I miss having that kind of fearlessness. I wonder at what point it left me—with the death of my parents or with Mitch?

I try to shake Mitch out of my head like dissolving the picture on an Etch A Sketch.

"See that?" I whisper to Max as the crowd disperses. "We officially have the cutest kids on the planet."

"That's because the most beautiful *woman* on the planet is officially their mother." He lands a kiss on the edge of my lips.

My mouth opens to return the compliment and closes just as fast. Stella holds Townsend DNA, and in this strange moment, I can feel Mitch lingering between us like some forgotten apparition.

"Let's put some teamwork into this." I nod over to the frosted monstrosity.

I cut the cake while Max scoops the ice cream.

"This stuff is rock solid." His bicep redefines itself as he digs into the carton. "It's like I'm hacking it from a glacier." He chips a piece and flicks it at my neck, licking it off in one hot track.

"Hey, hey." Hudson drifts over with a plate in hand. "This is a family show, keep it PG." He tosses a crumpled napkin at Max. "Got a second? We need to talk."

Talk. I'll give him something to talk about. I've been avoiding his fiscally unsound mind all night. Robbing me of over a hundred thousand dollars makes me a little more than stabby. I shoot Max a look. Last time my ass.

Candi struts over with her pale expanse of flesh, rippling with the slightest movement. Why do I get the feeling we're about to get tag-teamed by Hudson and his hussy half?

She bats her ferociously long lashes in my direction. Swear to God it looks as if she sacrificed a pair of butterflies for the effect.

"Can I talk to you?" She bites down on her cherry red lip as if she's flirting.

I'm guessing a loan has something to do with it. All that peroxide and Botox doesn't come cheap. I'd add clothing to the list, but that's a non-issue with her at the moment.

I hate to burst her financial bubble, but I'm the wrong Shepherd to hit up for cash.

I follow her out to the side yard where the crickets sharpen their cry and the smell of night jasmine lights up the air with its delicate perfume. The scents, the sounds of evening are bolder out here—virginal—undisrupted by the untamed air.

Candi's skin glows a dull bisque against the velvet backdrop of a navy sky. She looks surreal, luminescent, makes me wonder if she's human or some high-tech blowup doll that I inadvertently financed for Hudson.

"Okay, so," she sighs, shaking her head. "A long time ago..." She jabs her hair behind her ears.

No good story ever starts with those words. A warning flare goes off in my chest. A horrible feeling wraps itself around me, thick as a kerosene-soaked blanket. Something tells me, Candi is about to launch a blowtorch confessional.

As soon as she and Hudson started dating they became fodder for the tabloids—dubbing them "the vineyard giant and the pageant queen." Pictures of her and my moronic brother-in-law splash the supermarket checkout stands at regular intervals with each headline more outlandish than the last. They've managed to pull down the stock of Townsend Shepherd Inc. with every snap of the shutter.

"A long time ago, when I was barely eighteen"—she nods into the caveat—"I met this guy who said he filmed models."

I close my eyes. "Sex tape," I whisper. "It's going to take us down like a stone." I'm going to strangle Hudson for bringing this woman into our lives—although I might have to strangle Sheila first for bringing Hudson into the world. The natural hierarchy of homicides insists I start at the root.

"It's going to take *you* down like a stone?" She bats her lashes at me incredulous, and I'm half tempted to free those butterflies by ripping the wings right off her eyelids. "What about me? I'm going to be a mother." Her long fingernails glitter over her belly like ten miniature flames, and, right about now, I'm wishing they were—that she might magically combust and take all these problems with her. "I'm going to have to face my baby one day. What if he or she sees it?"

"Rest assured, he will. He won't want to, but that's the way the world works, Candi." Maybe it's the heat setting me off, or the blank canvas of night that's swallowed us whole, or the fact in a week I'll be wishing the only blight Hudson had stained our world with was a simple cash draw, but I don't stop there. "Not only will your child see it, but he or she will be mortified that all of their friends can enjoy it for their viewing pleasure as well." I take in a breath. Nothing I say will really matter in the end.

Her face contorts into all sorts of open-mouthed positions. "I don't think—" her voice breaks. "I never think." She drops her face into her palms and starts in on a low, moaning wail.

Crap.

I feel horrible. Reducing an expectant mother to tears was nowhere near the top of the to-do list today. I wrap an arm around her shoulder. Candi can't change her past. God knows none of us can. Me of all people should appreciate that barbed wired truth.

I'm sure Candi has a sweet side to her if I just get to know her a little bit better, and with the DVD I'll be able to do just that.

She continues to tremble into her hands, and guilt lines me, heavy as lead.

"It's me who never thinks," I say, pulling her in. "I'm really sorry."

Candi presses in, and my face gets buried in her hair, the light scent of licorice permeates her like a fog. It reminds me of Stella after a bath. It reminds me that Candi is somebody's daughter. And, for a second, I wonder if Stella could ever land so far off the mark in life.

Candi gives a death grip of a hug, and those expansive foam pillows she calls boobs conform to my body, tight and smothering.

I'll have to make sure there's always a three-foot clearance between Max and her ever-expanding bosom.

"*Lee.*" Max's voice penetrates the shadows.

"We'd better get back," I say, ushering us in the direction of the patio. "I wouldn't worry too much about that tape. Why let something that happened a long time ago ruin something special that's happening now?"

"I guess you're right. Hudson and I have made much better films. I could do things now that I couldn't even imagine back then. That's part of what's got me so upset."

My jaw goes slack.

Figures. Candi's sting of embarrassment has more to do with her inexperience than it does bearing more than her soul to the viewing public.

We trek back and find Max cradling Eli on the porch and my heart melts. I kiss my little boy's feather soft hair. Eli is pliable in Max's strong arms—exhausted past the point of no return. I hoist Stella over my hip and offer Candi another partial hug.

"No matter how painful it's going to be, you'll get through it," I say. "Trust me, I know. I had a dark period myself."

Max glances up. The whites of his eyes cut through the night like glass.

"But Max saved me," I add quickly, whitewashing Mitch from our lives with a simple stroke of the tongue.

It was so damn dark, and Max pulled me out.

We say goodnight and walk toward the car as a stabbing pain blooms in my heart.

Max may have saved me, but it still hurts like hell.

I never said the pain would disappear.

Mitch

It takes an entire day to readjust to the light—start seeing people and things without spots or lines running through them. Just three days this time in solitary. I think they're going soft.

I spot Gao in the dining hall just before lunch. Sometimes they shift the population, and people float into the sea of humanity. It takes a while to relocate them once you've lost touch.

"Paper book," he says. "Wear nice shoes. I give you tomorrow."

Nice shoes—as in contraband receptacle. There are only flip-flops and slippers here. You need the slippers to do the transport. If the authorities come by and you freak, you can easily kick it out and look the other way. I've seen enough of my origami floating around to figure this out. You have to request the shoes. You need to convince them that your feet hurt so damn much they're about to fall off. The shoes aren't impressive—not much more than corrugated cardboard, but they work.

"I'll dress for the occasion."

A strangled vibe takes over the hall. One by one, all eyes turn toward the back as a small band of guards walk shoulder to shoulder up and down the aisle ways.

Strange.

They're looking for something—someone. All suited up in fatigues, each hugging their long, slender weapons as if it were a woman. Something big is about to go down—a beating, a hanging. They don't dress to impress unless there's some form of torment at the other end of the necrotic rainbow.

You could hear a pin drop as the tension chews through the air. It's not until they enter the aisle across from me that I

note a small, dark head bobbing in their midst with sunglasses set neatly on top. He pauses to scrutinize every being at the table, advancing at a decent clip until I recognize him, and my heart stops.

"*Kyle.*" My voice reverberates off the walls like a gong.

His expression brightens as he cuts through the tables, landing just feet away. "Mitch Townsend?"

"Yes."

"You've been dead for the last five years."

<p style="text-align:center">℠ℂℤ</p>

It's hard to focus in on anything once you hear the words *you're free to go.*

I told Gao to keep the paper book. Officiated him as the keeper of the pearly gates, and follow Kyle downstairs to something I never thought I'd see while still in my body—the fucking beautiful exit.

The guard at the gate opens it with such passive disregard I'm almost disappointed. I sort of envisioned going out in a blaze of glory—a twenty-one gun salute while absorbing the bullets right into my back, but there's nothing. They let me out as if I were a visitor, a Westerner who just toured the facility.

I take three steps outside the building before the humidity hits my skin. The foreign orb in the sky blesses me with its glory as I hold out my arms, soaking it all in. A fresh blast of air washes over me like a baptism—like a birthright, and I lose myself in a vat of tears.

Kyle speaks in a low hushed tone, but his voice gets lost in the rush of the city blooming in my ears.

Everything is new. It's as if the world refined itself in the time I was gone and now its sharper, crisper, more stunning than ever before. Just having this kind of space—this kind of freedom to move paralyzes me on some level. To know that

somewhere on this planet is beautiful, beautiful Lee scares me to death.

A parade of people congests the sidewalk and mow us over to the edge. I watch the wall of humanity, the dark carpet of hair bobbing up and down the street, and for a moment I'm lost in the tide with panic railing through me. There are so many damn people on the planet. How could I have left Lee for a moment? And all these years she had to learn to survive, to fend for herself because I was too incompetent to get back to her. I pause a moment and try to let life catch up with me as my newfound attorney pats me on the back.

"Let's get you some clothes. You hungry? Hope you like Chinese."

<div align="center">ꝏᴄꜱ</div>

Kyle Wong fills me in on the world events of the last five years, smaller phones, social media, battery-operated cars. The only thing I remember were women and wine, and, at that, there was only one woman for me.

I soak it all in over a plateful of delicious food that redefines the less than palatable crap I've been forcing into my stomach since I've been here. Kyle bought me a brand new pair of Levis, a pair of Nike Air sneakers, and a T-shirt with the Chinese flag emblazoned across the front as a souvenir. He's got a dry sense of humor I've come to appreciate the last twenty minutes, and to tell the truth he could have dressed me like a duck, and I would still appreciate him.

"So I'm going to do a press release when we get back to L.A." He blots his mouth. "You just tell them you'd like some privacy. I'll handle the rest. I'll field a great book deal as soon as I get back to my office. We're talking six figures to begin with, but easily the numbers can skyrocket."

"I need to call my wife."

His chest pumps with a laugh. "Everyone thinks you're dead. After five years I suspect she's moved on." He glances to the ceiling. "If you're lucky she's just coming off a divorce."

A stilted smile wobbles on my lips. This is life through the myopic eye of an attorney. A dark well of an eye with tendrils that chase dollars, but a beautiful eye that plucked me from the hands of my misery nevertheless.

"Maybe I will get lucky." I smear it with a wry smile. "Anyway, I'd better call my wife. My mom might have a heart attack if she hears my voice."

"She might." He nods appreciatively. "All hell is going to break loose once word gets back that you're alive. Just wait and see."

<p style="text-align:center">℠℠℠</p>

Once Kyle settles me into a hotel room, I try calling Lee, but keep getting a man who claims he's never heard of her. Memorizing phone numbers was one thing I made a point to do religiously. Obviously the false doctrine of rote number memorization wasn't my strong suit. I can't remember Colt's number either, so I dial the house, the one number my mother hasn't changed since I was seven—at least I hope not.

The phone rings, and I try to make myself comfortable on the enormous bed in an effort to calm my nerves. Kyle put me up in a room next to his. I told him I'd meet him for dinner, although I haven't eaten this much in the last two months— hell, maybe the last five years.

"Hello?" A male voice grumbles from the other end.

It's Colton.

My throat locks off, and I have to remind myself to breathe.

"*Hello?*" His voice grows cold in agitation, and for a moment I'm paralyzed by the thought he might hang up. I close

my eyes and thank God it wasn't my mother. Killing people with the sound of my voice isn't the way I'm hoping to reintegrate myself into society.

"Colt?" I press out his name—try it out on my lips for the first time in half a decade.

"Speaking."

"It's me, Mitch."

Silence clots up the line.

"Don't hang up." He probably thinks it's some sick joke. I rattle off what happened, quicker than a shotgun blast—how I came to the reeducation center, how I got to the phone.

I can hear him breathing—staccato intakes of air, jagged heaves that indicate he might be sobbing, inebriated—*both*. A thin veil of tears masks my face, but I manage to sniff back the trauma and continue.

"I need a ride home from the airport. Can you do that for me?"

"Yes. Of course." His voice cracks when he says it. "I'll bring Mom. Hell, I'll bring *Lee*."

Lee.

A release—a whole fountain of tears flows from me. I wasn't going to ask—afraid mostly she might have died, my biggest fear, second only to marrying someone else, although I haven't taken that off the table just yet.

I give Colton the flight number and time of arrival and ask him not to tell me anything else about Lee or the baby. I want to see my child, or hear about her or him for the first time through Lee's beautiful lips. And for sure I don't want to torture myself for the next twenty-four hours regarding the private details of Lee's life—the ones that might make me wish I were back in the armpit of isolation. I need to keep hope alive, learn as I go, not expect too much.

"She look the same?" It's the one luxury I figure I can afford.

"Stunning." He doesn't say anything else, so I don't push it. Stunning is more than good enough. I'd love Lee no matter what she looked like, and personally I wish she wasn't so stunning while I was away, but now that I'm headed home, I'm pretty damn glad.

"See you on the flip side," I say. "Love you, man."

"Love you too, Mitch."

80C8

Hong Kong International airport is polished—cosmopolitan, and a far cry from the barbarism of the detention center I was imprisoned in. The first hellhole was flat out barbaric, strongly capable of evoking the envy of any medieval tormentor worth his salt. The second, prison just the same, but with palatable living conditions if you happen to be a rodent or a roach. I push both out of my mind as I try to keep up with Kyle who walks at a frenetic pace. I don't bother telling him I'm weak, that I haven't walked this distance since I got off the plane five years ago.

Five years. It felt like ten, felt like a lifetime—like it happened to another person entirely.

The flight attendant asks for the passport I don't have. Instead I provide the paperwork Kyle squeezed out of the U.S. consulate's ass like a dime store magician. My stomach turns as she calls for reinforcement by way of a supervisor. Together they sit and scrutinize my flimsy paperwork as visions of Lee warble in and out of my mind. She's so damn close I could feel her. Please God don't take this away. Spending another minute here—one fucking layover, might actually kill me.

They mumble into one another swift and pressured like a pair of nonplused humming birds before nodding me through.

It's happening.

I'm walking on air. Not sure my feet ever touch the ground as I follow Kyle into the long, snakelike terminal. I can see the crack of daylight that splits the distance between the plane and the boarding bridge. Made it.

Baby steps to Lee.

I hold onto Kyle's shoulder all the way to first class.

A stewardess appears with a beverage cart and a basket filled with fruit and candy before I can buckle my seatbelt. So much luxury, so much attention to superfluous detail—everything in excess, and all I want, all I need is Lee—Lee in all her beautiful simplicity—Lee and our baby.

A seam of tears seals over my lids as I try to imagine how it will all unfold.

The plane takes off, filling my ears with a violent rush, metal fighting gravity, pulling me to Lee like a missile. China descends, and I wipe the dust off the soles of my feet and curse it as we thrust into the virginal sky.

I did what I could, littered their world with paper roses, and now I was free to go.

Lee and all her glory.

I wonder how she'll greet me? I'll know by how she kisses me whether or not she's married. Maybe I'll get a peck on the cheek? Worse, maybe she'll stand at arms length while pushing flowers in my direction, shaking my hand as if I had just championed a cause in honor of our country. Definitely not what I want, but I'll take it. I'll take anything she wants to give as long as I'm near her again. Then there's my favorite scenario—Lee diving down on top of me with unbridled passion—security alerted to wrestle us apart.

Tears spiral down my face, quick and furious.

I'm coming home, Lee.

Finally.

I am coming home.

Max

The sun presses down over Townsend field like a penalty. It rains white-hot machetes, feels like it's splicing my skin open with every stinging ray. I pluck off my baseball hat and put a call into Colton.

"You coming?" I snipe at him because I damn well know he's not. His useless ass was supposed to help me dig out the line an hour ago to keep the plumbing cost down by doing half the work. I'm not even sure why I bother. If Colt shows it'll be a bona fide miracle. I'll have to call the fucking Vatican.

"Nah, man, sorry," he rasps into the phone. "I forgot I have to pick up a friend down at LAX. I just asked Lee to come with, you mind?"

"Nope." I give a hard exhale. "I don't mind." Knew I couldn't count on Colt. I hang up and call Lee.

"What's going on?" I ask, trying not to sound as irritated as I am.

"Colt begged me to drive down to L.A. with him. He's probably picking up some mail order bride. I just dropped Stella off at school. Eli's with your mom."

"L.A.'s pretty far. What time do you think you'll get back?" It's a good three-hour drive—each way. "You know he's using you for the fast lane." I give a half-hearted smile. I should be the one stealing my wife away on a day trip. Looks like Colton Townsend outsmarted me for once.

She clicks her tongue. "He says the flight comes in at one. By the time we turn around—let's say six with traffic? Look, I'll be home for dinner. How about you and me sneak out tonight? I'll have your mom pick up Stella. I'll roll around in the fields with you if you want. We can get down and dirty just the way you like it."

A dull laugh escapes me. "Get home in one piece. I'll take you out to dinner. No rolling in the fields. I'll find somewhere much more desirable to roll around with you. I'm all for getting down and dirty."

"Deal. Don't work too hard. We're still on baby time."

"Looking forward to it. Love you."

"Love you, too."

What I'm not looking forward to is the scalding shower that she believes magically produces baby girls. I swear I think she gets a thrill out of pushing me into that incinerator. It makes the hostile efforts of the sun feel like a cool spring shower.

Not that I mind.

I'd step into a thousand ovens for Lee.

8

The Reunion

Lee

"Mom?" I'm a bit surprised to see Janice in Colt's oversized SUV. "You don't need me, Colt." I can stay in town and get important stuff done like bribing Max to come home for lunch—having him in every room in the house before dinner.

"Get in," Janice insists. "It'll be fun. When was the last time we did a road trip? You want the front?" She starts to get out of the car.

"No, no. I'll hop in back." I crawl in, and Colton hits the gas before I can properly shut the door. "Careful, cowboy. Max wants me home in one piece."

Colton catches my eye in the rearview mirror. "Well, if Max said it, I guess I'd better do it."

"Stop." Janice taps his arm. She looks frayed, aged and this unsettles me.

"Like it or not, he's here to stay." I lean in toward Janice. "And, by the way, we're trying again." I sing the words like a dream. Janice wants another baby in the family as much as I do.

They exchange looks, and Colton keeps driving.

"I *said*, I'm trying to give you another grandchild." I place my head near her shoulder. Janice has been after me for months to expand the family.

"Terrific." She doesn't turn around, just keeps her gaze locked on the road.

She probably didn't hear me over the radio, probably thinks I'm talking about a manicure.

"It's finally cooling off," I say, relaxing into my seat.

Neither Colton nor Janice say a word, each lost in their own haze of silence.

It's early. I doubt they've ingested the required amount of caffeine to kick-start the engine. I have a feeling this isn't going to be much of a road trip.

I get comfortable, using my purse as a pillow and drift off to sleep before we ever get out of town.

ⓈⓄⒸⓈ

"Lee." Colton shakes me until I snap out of my dreamlike stupor. "Get up, we're here."

"Really?" I slip my seatbelt off and take in the shock of light pouring in from the window. A steady stream of traffic bustles around us. "I can't believe I slept all the way," I say, giving a few hard blinks with my eyelids as coarse as sandpaper. All of these baby-making sessions have kept me up until two and three in the morning this past week. Making love to Max has finally caught up with me. Who knew the drive to pick up one of Colt's floozies would prove to be medicinal.

Janice wipes her eyes, probably slept all the way down, too. Poor Colt—must have felt like he was transporting corpses.

"You awake?" I rub her back.

"Damn allergies." She pushes a tissue into her eyes.

Looks like she's been crying, though—bawling, if you ask me. Figures. Colt probably confessed to picking up a prostitute

and shattered her dreams of him ever becoming a decent member of society—a good boy. Poor Janice lost the only good boy she'd ever have in Mitch. She has Max, though, and Max has proved to be nothing but a prize.

"Take a swig." Colton shoves a water bottle in my face like I just ran a marathon. "Trust me, you're going to need it."

I don't fight it, just down a good third and hand it back.

"Hydrating me?" A dull smile hedges on my lips. "How much luggage am I going to be hauling?"

He cuts a look across the street. "I'd venture to guess, none."

ΒΟ(Β

Los Angeles International Airport is thick with jostling crowds. People buzz in dizzying circles. Suitcases are dragged at intolerable speeds—stacked and loaded onto cumbersome carts. Every third person is shouting into their phone. It feels as if the entire world is trying to outpace itself while bodies stride off in twelve different directions.

I miss the hustle and bustle of travel. It's been ages since I've been on a plane. It's hard with the kids, but Eli is older now. I should mention it to Max. We could spend Christmas in Hawaii and make our baby in paradise. Then again, every day with Max is paradise. Wherever he is, that's where paradise is.

Colt takes me by the hand as if I were a child that's prone to wander and leads me into the cavernous Bradley terminal. A crowd swells around the arrival gate as passengers trickle out.

He shoots a look over to Janice. "Made it." Colt gives an apprehensive smile that says something else all together.

"Who are we picking up again?" I'm so scatterbrained these days. He might have mentioned it. I look from Colt to Janice, but they're lost with their eyes fixed firmly on the

passengers as they step out of the elongated hall. "What color hair does she have?" I ask, only half-teasing.

Colt frowns into me, his entire demeanor downgrades to something just this side of pissed, but if I didn't know better, I'd swear it was sorrow.

"What's going on?" I latch onto his shoulder and step into him. Something in me lurches as if instinctually I know this isn't good.

"Lee." He presses his lips together until they bleach out like paper. "I need to tell you something."

"What?" A fire line rips through me—panic a mile wide. A palpable buzz ignites in the air—an electric clatter of people speaking all at once. Happy passengers reunited with waiting relatives sink into the crowd. "*What?*"

His Adam's apple rises and falls as he eyes the gate behind me. He doesn't say anything else. An explosion of tears fills his eyes and spill out on the front of his T-shirt. He holds his stare, stone cold like a statue, as if he's been eviscerated on an emotional level, and I can't figure out why.

"Colt?" Everything in me goes numb.

I turn slowly and follow his gaze. The world warps, the voices morph into one another until it sounds outright demonic. A bomb is about to go off, and I have a feeling Colton led me straight to the fuse. Janice gasps. She clutches at her throat as if she were struggling to breathe, her eyes still locked in the distance.

The planet, the universe, it's all off kilter. My insides transform into a ball of nerves because I can't for the life of me figure out what in the hell is happening.

My breathing picks up. My adrenaline surges like a cyclone. I can hear the echo of a heartbeat in my ears as the world clots up around me.

A line of photographers nine deep garners my attention. All eyes are focused on the small dark cave that spits

passengers out in sparse numbers. They light up the room with a photomontage and the ceiling quivers like lightning.

A body stains the doorway with its shadow. Swear to God, if Colt dragged my ass down here to see some celebrity, some aged hippy who makes his living singing about margaritas, I'm going to—

Janice screams—she howls like a jackal in the desert, a primal scream so visceral it rails along my nerves like the serrated edge of a very sharp knife. I snap my head back to the holding area as passengers continue to stream out into the clearance. They move briskly around a man who remains steadfast—he catches my stare and holds it, doesn't move a muscle.

It looks like...same glowing eyes, same hair, but it couldn't be. I don't want to say his name. I don't want to burn this day to the ground, and judging by the way Colt and Janice are acting, its already in cinders, headed for the ash heap.

The man offers a heavy smile, and I blink up at him in amazement. His smile slowly stretches into a grin. He holds that familiar face I've longed to see for an unimaginable eternity.

"Oh my, God," it comes out less than a whisper.

The ground warps and shifts. Time freezes—the frenzy, the noise, the population at large ceases to exist.

"*Mitch?*"

Everything in me loosens. A slap of shock so violent jars my body I lose the ability to feel, to breathe, to understand a damn thing I'm seeing. I part the manic sea of bodies like swimming upstream, never losing eye contact, never daring to blink. This feels like a dream within a dream. The illogic of the moment drowns out the voices, circumvents the laws of nature, and he's still here, stepping toward me—hesitant—alarmingly familiar.

Mitch.

I don't question the illusion, simply race to his likeness.

"*Lee,*" he says my name with those lips—his voice clear and strong.

Our bodies collide, and he remains solid as I wrap my arms around him. He doesn't evaporate like smoke, like so many times in my nightmares. I jump up and hike my legs over his hips, knocking the two of us to the ground like bowling pins. I crash my lips over his and devour his mouth, his tongue, his teeth as I dig my fingers into his shoulders.

God I can feel him, *taste* him. I'm sinking into the lie, and I never want to let go.

Everything in me electrifies as I dissolve into kisses as strong as a power surge. These were deep lingual epithets that gave testament to the glory that is known as love. Dynamic convulsions erupt in my body beyond any pleasure I have ever known. My insides quiver as I dive deeper and deeper into this mysterious new abyss.

We must have been in a spectacular crash. I must be lying in a coma or lying in state because I'm devouring Mitch—soaking in the familiar feel of his frame beneath me. It is all so real I want the world to recognize this master delusion—quantify it with their own optical imagery. I would have thought he was a stranger had he not said my name. But he came back to me. He moved a mountain and found his way back.

We roll over the floor like bear cubs in a lust driven tirade. I pull away a moment and catch his sweet smile before we both break out in tears. My lips fall over his, and there is nothing in this world, above or below it, that can take away the exhilaration of this moment.

"I love you, Lee." His voice strains as he presses his lips to my neck. "God, I missed you."

"Mitch," I whisper. It's more than a dream. It's real.

He rolls over on top of me and rains kisses over my face with his lips before running his tongue deep into my mouth

with a renewed vigor. These magical kisses stretch out for weeks, for months, for five long years.

A soft prod lands on my side, and we both look up at the unfriendly face of airport security.

<div align="center">ଧ୍ୟଓ</div>

I pull Mitch over to Janice and Colton. They fall over him with tears and laughter, a scream still locked in his mother's throat. Colt pulls back and socks him in the arm as if he had simply returned from a grocery run.

A young man with a sharp gold tie takes Mitch by the arm, redirects him over to a handful of film crews as a crowd of microphones are thrust in his presence.

Mitch looks over at me, and his smile widens.

I can't stop staring. I can't stop shaking. This is real, and all of this madness unfolding around us is because he's back. The whole world held its breath for five long years, and today we exhale together.

"I'm pretty tired," Mitch whispers into the microphone at the helm of this media circus. "I think for now I'll defer all questions to my skilled attorney. I've got a wife and family to get back to." He gives a wink to the sharp dressed man by his side and heads back over.

A knot settles in my stomach and rips through the enthusiasm with an unpleasant surprise. His words burn through my heart. *Wife and family.* For a moment I wonder if I qualify for either of those things.

The sharp sting of reality comes back in a rush. I've done the unthinkable and married his longtime rival—handed the keys to the kingdom over to Max Shepherd—Max who I love.

I push all thoughts of Mono out of my brain.

I've got Mitch now and a three-hour car drive. I'm not going there just yet. I'm going to enjoy Mitch. My husband.

<div align="center">166</div>

Mitch wraps his arms around me and presses his lips over mine. It feels so familiar, so achingly real it guts me on a primal level.

"What happened?" I whisper. "Where were you?" An entire tidal wave of questions beg to erupt.

"I went to some makeshift church service and never came back." Mitch presses into me almost apologetically. "I got arrested for being a spy." He tightens his arms around my waist and blesses the top of my head with a kiss before continuing. "They sent me to something just this side of a prison camp—called a reeducation center." His eyes squint a smile all their own. "No judge, no jury—the police decide who goes and how long they stay." He glances over at Colt and Janice. "They locked me up and threw away the key until that guy showed up." He nods over at the attorney still wading through questions. "He helped untangle the knots to get me released."

"What the hell were they educating you on?" Colt looks good and pissed.

Mitch washes his gaze over me and presses out a sad smile. "Heartbreak."

A herd of photographers make their way over, and Colt pushes us toward the exit.

"And we're out of here." Colton leads us out of the terminal and into the streets, where we breathe the same fresh air for the first time in years.

Mitch and I dive into the backseat of Colt's Suburban and lock into one long embrace. We fall over our *I love yous* as our lips collide like a dream. We run our hands over one another as though we were mapping out new terrain.

I don't want to think of the confusion, the fallout of Mitch's great life reprisal. This is my waking fantasy come to life, and I just want to take in every moment he's here safe in my arms.

"Mitch," I breathe his name, memorizing his features as though they were all brand new to me, and on some level they

are. I let my lips familiarize themselves with the landscape of his forehead, his eyes, cheeks, his chin. He's perfect. This is perfect love. A dream I refuse to wake up from.

"I love you, Mitch. Thank you for coming back to me."

Mitch

Lee settles in my arms, and I rest my head over hers as I watch the grey highway needle into the horizon. Cars whiz by in a blur. The trees in the distance dot the ever-increasing blue expanse, and I marvel at how big the sky is. All of this is new again. It was buried there in my memory, and, now, here I am, experiencing it all for the first time in years. But its Lee my body is keyed into—her steady breathing—her amazingly precious face that hasn't aged a day. She looks identical to the last time I saw her, so does Colt and Mom—makes me wonder if any of it was real, if China exists at all.

The baby filters through my mind but I'm too afraid to say anything. Lee hasn't mentioned it. Maybe the trauma of losing me caused her to have a miscarriage? Maybe she forgot she was having our baby all those years ago so I don't bring it up.

Soon as we can, Colt pulls over, and we step into a fast food restaurant to grab a bite. I don't take my arms or eyes off Lee, beautiful, gorgeous, *stunning* Lee. I hold her like I never left, like it hadn't been far too long since I touched her in the flesh. I bury my face in her hair and take in her clean scent. My fingers curve around her back to the beginnings of her soft breasts, and it makes me want to pull her into the bathroom and have my way with her.

Mom goes on forever about how thin I am while itemizing all my favorite foods and putting together a verbal grocery list.

We get our burgers and opt to eat outside beneath a giant red umbrella. The pink hue washes over Lee and makes her glow, tints her hair, and I take her in like this. Colt sets down a tray, and I take a careful sip from my soda. It tastes like heaven. The burger looks enormous, like ten meals in one, but I can't

focus on anything else but my beautiful bride. I'm hungry, but it's nothing some ground round is going to satisfy.

"I almost forgot." Her mouth opens with a renewed surprise. "You have a daughter! *Stella*."

"A girl." A small laugh trembles from my chest. A wave of relief collapses over me and I fight the urge to cry. "Stella? I love that." I pull Lee in and close my eyes—I remember the days I called Lee, *Stella*. "That's a perfect name."

"I have a picture." She fidgets with her purse.

"Gorgeous girl," Mom says. She opens her mouth to say something else then closes it again.

"Here." Lee holds out a svelte black square of a phone like the one Kyle Wong had. I hold it up and examine the picture.

A girl stares back at me, and I'm stunned at how old she looks. She's almost five, I know this, but for some reason I pictured her as a newborn, a toddler at the most. Her hair is blonde like Lee's, long in twin braids. I can see myself in her smile, her lawn green eyes.

"You're right Mom," I whisper, my voice breaking at the sight of this sweet daughter I've yet to meet. "She is gorgeous just like her mother." I swallow hard unable to take my eyes off her. "Can I meet her today?" It's strange to ask permission. I'm still not sure where I fit in or if Stella knows anything about me.

"Of course, you're going to meet her today." Lee says it with forced determination. She takes the phone back, shuts it off before replacing it in her purse. "Mom, we'll go to your place." She bites her lip when she says it. Lee always bites down on her lip when she's nervous. That small action unsettles me, makes me wonder what has Lee rattled other than my spontaneous resurrection.

"So, where do you live?" I give a gentle smile to Lee and my insides bounce as if they were hungry for something only her flesh could offer.

Her eyes round out with surprise and I'm suddenly regretting going there so soon.

"Sorry"—I glance down at my food a moment—"I promised myself I wouldn't pry, but if you're an hour away or more, I wouldn't want to put you out." Truth is, I want to put them all out. Something about the conversation is strained, and it's starting to feel like I have to dig for details. I'm not sure why, but I thought they'd spill the news of their world like an oil slick on the drive over.

"I'm still at the beach house." Her features relax. Her lips curve at the edges. "I'd never leave. That's all I had of you—other than Stella."

My heart soars. Our house. She never left. Maybe she's single? I glance down at her ring finger. It's bejeweled and quite nicely. It's not my ring though. This one is much bigger, and the diamonds are in the wrong configuration. My stomach lurches and suddenly just being near food makes me want to vomit.

"How's the vineyard?" I shift in my seat, directing the question to my mother.

"It's in great hands." Her voice is calm, even-keeled. She looks serene when she says it, so I believe her.

I glance over at Colt. "Are they your hands?"

"Nope," he shoots back. There's an undertone of irritation when he says it so I take it Colt doesn't approve of the hands it's settled in.

"Then it must be great," I tease. "Tell me about your life, Colt." I slide in tight next to Lee, wrap both my arms around her like she might float into the air if I don't.

"Same old, same old. Still skin diving, enjoying life."

"You took up diving?" I'm surprised by this. I tried to get Colt to surf for years. Colt swore he was allergic to water.

"Diving for women," Lee corrects. "He's become the predator we always knew he could be." Lee gives me a squeeze while brushing a series of soft kisses along my neck.

"Excellent. And you?" I direct it to my mother. Her dark hair looks freshly died, her bright lipstick neatly applied. She

looks beautiful in her own right. "How's the world treating you?"

"Better now than ever before." It comes from deep within her, soulful. I could see the years of hurt etched in her eyes, and I'm damn glad I lived long enough to help take it away.

"We need to marry her off"—Colt eases into a grin—"find her some old playboy that can keep up with her." He nudges her gently, and she makes a face. I can't imagine Mom with anyone but my dad. Too bad he didn't feel the same.

"How about you, Lee?" The words come stilted from my lips. Something about asking Lee about her personal life scares the hell out of me. "What's going on with you?"

A bird chirps in the background, a car pulls into the drive-thru—all the world fills in the void of this inescapable silence.

Colt plucks his drink from his mouth. "We better hit the road. Traffic's going to be a real bitch."

Lee and I bag our food. Neither of us took a bite.

She's quiet on the ride home. Our bodies are intertwined, but there's a notable decrease in the number of kisses she offers. Something tells me the number is about to plummet the closer we get to Mono.

ॐ

My mother's home erects itself like a relic from some bygone era, still wearing all the pride from my childhood. The palm trees out front stand like watchmen on either side of the entry, the bright red Impatients dot the border garden in the exact same pattern they had when I left.

We head in and I take in the familiar scent of refried oil, the slight hint of garlic permeates the air. Everything is exactly as it was the day I left—the furniture sits unrepentantly the same. I stride around the house of my youth and inhale the familiar scent held hostage in my memory for so long. It's

unbelievable on some level. I half-expect my father to come down the stairs and greet me.

Mom ushers us into the family room. There's a breathtaking view of the vineyard with a tangerine sunset just cresting the hillside. It ignites the landscape with all its salmon-colored glory. The frame of the window makes it look like an oil painting. The bright green rows of precious vines still line the property.

"It's still here," I muse.

"It's still here, Mitch," Lee whispers warm into my ear and circles her arms around my waist. "Come on." She coaxes me over to the couch and kicks off her shoes. Lee pulls me in and settles herself in my lap. Her head falls over my chest without hesitation and we hold each other just like we used to in high school.

"Colton, call for take-out," Mom barks the order while hauling in a tray with a pitcher and glasses. "We need to get some meat on those bones, Mitch." She sets down her load and pours both Lee and me a glass of lemonade.

A widescreen television sits hooked to the wall and demands my attention. The only new addition in five years, and I'm pretty sure Colton's purchasing power was behind it.

"You okay with Chinese?" Colt asks, his eye twitches like there's genuine concern behind the question. "You're not gonna go post traumatic on us, are you?"

I'd be offended, but, the truth is, I've been craving Colt's sarcasm. I'm behind five years' worth, so I guess it's a good start.

"Go ahead." I'm not hungry. Not until Lee ends the mystery of the wedding ring or until I see Stella—my daughter. As much as I hate to admit it my entire body is flush with anxiety. That's one reunion I never imagined.

Lee runs her hands up over my arms and snags on a wandering scar that jags up my skin like lightning.

"What's this?" Her face clouds with concern as she tracks the deformity with her finger.

For a minute I think of telling her I got caught on a wire. I'd be in control of the scar that way, not hogtied and whipped like an animal the way it really went down.

"It's nothing." I meet her gaze, and she holds it strong as steel. I never could lie to Lee. "We don't have to talk it about it right now," it comes out almost inaudible, and I manage to bring the energy down in the room—all eyes on me. "I'm okay." I hold up my hands. "The important thing is I'm sitting in the right place with all the right people." I pull Lee in and melt a kiss over her cheek. She turns and kisses me square on the lips, airport style. She's still hungry, chock full of passion, and I have a feeling it won't be long until—

A brisk knock erupts at the door. Lee and Colt exchange stilted glances before bolting out of their seats.

"Is it Stella?" I'm hopeful as I follow them over to the entry.

Mom opens the door, and her face loses all color.

"Hey, Mom." A tall dark-haired man strides in and kisses my mother on the cheek with a boldness that suggests he belongs here, calling her "Mom" of all things.

He turns to Lee, does the same without hesitating, and my stomach cycles because I have a feeling I'm about to meet the man that supplied my wife with the new rocks on her finger.

Shit. His frame, that shock of black hair, it all looks startlingly familiar. It's not until he turns to the side that I make him out clearly—peg him for the bastard I was afraid he was.

The life drains from my body. The room fades to grey, and my head feels like it's about to float off. I take in a series of shallow breaths and fight the urge to pass out—kill him, either or.

Max Shepherd.

"Let's go," he moans into Lee with his arms wrapped around her waist as if he's done it a thousand times before. "My back is killing me." He tucks a kiss over her temple. "Let's jump in the hot tub. Start our night off right." A greasy smile cinches up the side of cheek as he melts over her, not bothering to look in my direction once.

Max Shepherd. He so brazenly propositions my wife, right here in front of my mother, my brother, and nobody blinks.

"Actually..." Lee pulls his arm off her waist gently. Just when I think she's going to push him away—out the door—she interlaces her fingers with his instead. "Look who's here?" She glances over at me and apologizes for everything with one forlorn look. "It's *Mitch*."

He settles those blazing blue eyes over me, and his face bleaches out as he tries to make sense of what's happening. He staggers a bit while leaning in to shake my hand and pulls me into a tight embrace instead.

"Mitch! What the hell happened?"

Lee strings out the story swift as a bee.

The air clots up with silence again. We just stand there, lost in this macabre reality—a real *what-in-the-hell-now* moment.

"You look great man." Max has that fight or flight agitation happening.

"You, too." I don't put any emotion behind it just drag my eyes over to Lee as I say it. She could have warned me—hell, Colt should have said something—my mother.

Lee looks up at him, her eyes wide with a secret language all their own. "You want to get the kids?"

Kids?

I lean up against the wall for support. For sure I need a seat now.

"Sure." His eyes round out. "Can I talk to you outside?"

Lee gives a quick glance in my direction before following him out.

Colton shakes his head at me. "You didn't want to know, dude. I didn't want to tell you."

"Any other piece of crap I should be made aware of?"

Colt bears into me—his face cold as stone. "Lee gave him Townsend."

Incomprehensible fucking nightmare.

Max

"I didn't know, I swear to God." Lee renews the surprise on her face and her lips quiver.

"I believe you." It stutters out of me stilted as shit. There's no way she'd be able to keep something like this from me. She wouldn't have been able to sleep last night—sleep with *me* the way she did. "I called you six times. Did you shut your phone off?"

"I didn't want to tell you over the phone." Her forehead erupts in a series of worry lines. "Besides, he didn't know about you until just now."

Lee didn't tell him. I walked in, kissed Lee, and asked her to hop in a glorified bathtub with me. I went off like a bomb in his face and didn't even know it.

There's a slight satisfaction in that, although I know I shouldn't feel that way. Guess old rivalries die hard even if it was mostly one-sided.

"He seemed to take it pretty well," I say it for Lee's sake. Poor bastard is probably dying in there right now. Me with Lee is like a lethal dose of arsenic right to the bloodstream. I'm sure he's wringing his hatred for me, distilling it into a perfect brew of revenge.

"You *think*?" Lee shakes her head. "Go ahead and get the kids. I told Mitch he can meet Stella tonight." She looks down at my chest. "We'll talk to a child psychologist to figure out the best way to do this, but for now"—she shakes her head—"I think they should at least meet." She looks off into the distance, fixing her gaze on nothing in particular. I'm thankful she used the phrase *we'll,* hoping that idea of a *we* won't evaporate before I get back from my mother's.

The sting of fresh tears bites as I collapse my arms around her.

A band of sparrows bolts from a tree over by the car. That's what it feels like. One moment you're sitting comfortably in the nest, the next thing you know the owner comes back and blows your world to pieces.

"It's going to be all right." She presses into me and holds on tight.

I don't think it's going to be all right. I don't think it's even going to be mildly okay. I'm fairly certain it's going to be a disaster. A violent struggle for Lee's heart is about to ensue—it's going to be nothing but an all out war.

<p style="text-align:center">ഇരുഗ</p>

Mitch Townsend is alive and well.

I drive to my mother's stunted in a macabre, deafening silence that makes it feel as if a fog has settled in my brain. Lee shut her phone off, and I can't stop ruminating over that fact. I think maybe it wasn't so much her not wanting to scare the hell out of me—more that she didn't want to ruin her moment with Mitch. Not that I blame her, but it doesn't stop a wall of jealousy, wide as a mountain, to erect itself in my heart. Mitch coming back has shattered every delusion I ever had that Lee and I were solid. There's only one thing in the universe that could ever cause her to entertain the thought of leaving me, and until thirty minutes ago, he was dead and buried, an entire continent away.

Mom's car is tucked in the driveway. I bolt out of the truck and give a hard knock over the door. It swings open before I can fully release my frustration out on it.

"Where's the fire?" Mom jumps aside as I rush on in.

"Mitch Townsend is back." I barrel past her, looking for signs of Hudson. I'm not sure why I was hoping he'd be here.

<div style="text-align:center">178</div>

He rarely comes by. Today, though, of all days, I wouldn't mind a little brotherly camaraderie.

"They had his remains shipped over?" Her voice softens. "Is Janice going to start a mausoleum? I hear that's good for closure." Her neck jets out. My mother is not really into Townsend family closure. Not after Janice blackballed her from all of Mono Bay society the rest of her natural days. Not that it was Janice's fault at all. But that's the world according to my mother. It's hard to deny her a grudge once she's claimed it.

"He's alive." I pound my fist over the dining room table, unsettling the crystal arranged down the center in a tremor.

"What do you mean, *alive*? They found him?"

I recount the story Lee rattled out and hardly believe a damn word spewing from my lips.

"I feel bad for the guy." I blow out a breath. "I really do. But *fuck*—what now?"

"You think he's coming after Lee? *Stella*?" Fire rises in my mother's eyes, nothing but desperation and fear.

"Why wouldn't he?" Stella and Eli come running in and tackle me at the knees. "Go get your stuff." I tousle Stella's hair before she takes off and wonder if my days of holding her, calling her my daughter, are numbered.

"You've got all the cards, Max." My mother's eyes struggle to dislodge themselves from her skull. "Don't forget who's married to Lee, who runs Townsend, who *owns* Townsend. You're a father to that little girl." She presses her finger into my chest. "It's all you."

I'm holding all the cards. Then why can't I shake the feeling that the rug of my entire existence has already been pulled from beneath me?

9

Picture Daddy

Lee

The sky over Townsend vineyards is dripping with crimson, nothing but a blood red backdrop, the final curtain draping over an unordinary day. I lean against the door for a moment and lay my hand over the smooth mahogany. What is going to come of this? Mitch is back—*my* Mitch—so what does this mean for Max and me?

I pluck my phone from my pocket and put a call in to Steve—tell him to break the news gently to my sister. The last thing I need is for her to come undone, lose those precious babies from the shock of it all. I could hear Kat pawing at him in the background, demanding to know what I'm saying—wondering what threw him in such an explicative-riddled tirade. The truth is, I really need Kat right now, her wisdom—her sarcasm, but I couldn't live with myself if anything happened to those babies.

I head back inside, and Janice wraps her arms around me in a long, strong hug.

"He's back, honey," she whispers sweetly through tears. "My baby is back."

"Thank God," I say, making my way into the living room. I spot him in the yard from the window so I head out and

inspect the landscape until it gives up the effigy of my beautiful and definitely-not-dead husband.

Night falls around us as a sterile seam of light encircles the moon. It casts its illumination on the treetops, the hills, missing the shadow Mitch has buried himself in entirely.

"Hey." I sit down next to him on the cool wood bench and slide over uneasily. Mitch remains rigid, his eyes focused on some invisible horizon, unmoved by my presence.

"Why didn't you marry, Colt?" he says it without emotion, just words strung together in an effort to mask his anger.

"Colt?" I wrap my arms around him and lean my head on his shoulder. "Monogamy is not high on his list of priorities."

"He would have given you back."

A moment stilts by and neither of us breathe.

And there it is. He's afraid Max won't give me back. Oh God. I don't know what to say to make the pain go away, so I opt for nothing. Instead, I look up and lose myself in those sage eyes I thought I'd never see again. I lean in and press my lips soft against his, pausing to savor the moment. My tongue swipes careful over his as I indulge in the hot of his mouth through a river of searing tears. I don't have any answers for him and that makes kissing Mitch the only logical solution. It's a holy exchange that aches to express something deeper than words, one that assures him of promises I'm not ready to make with my vocal cords.

I'm not sure at what point touching Mitch—pressing my lips to his, will start to feel morally wrong. For now it feels like nothing more than a dream—unreachable kisses that span the barrier of death we've somehow managed to cross. We found the loophole and just went with it.

"I love you so much." I try to reassure him with words, with my mouth, but those are just words with no real solutions to back them.

"Hey," Colt barks through the night. "Max and the kids are here."

<p style="text-align:center">🙰🙵</p>

I lead Mitch by the hand as we head into the house, transferring my grip to his shoulders as we meet up with Max and the kids in the family room.

"Mitch"—my voice trembles while Stella steps forward as if she knows she's the central focus of this entire exchange—"this is Stella and Eli." I watch as he takes them in. First Stella with her large eyes set right on him, then a more scrutinizing look to Eli before breaking into a soft smile.

"Nice to meet you both." He leans over and tousles Eli's hair. "You look just like your dad." Eli magnetizes to my leg and doesn't let go. I can't even imagine how much this hurts Mitch. Here he came back to me, and now I'm making him swim through razor blades by shoving my life with Max in his face—*Max* of all people.

"I know you," Stella says with a sharp tone. Her little body postures a moment taking him in. "You're Picture Daddy."

The world stills. It's the last thing that would have entered my mind, Stella pegging Mitch for who he really is—identifying him as her father in less than fifteen seconds.

I clear my throat. "Stella has your picture on her nightstand." I glance over to Max for help.

Stella takes a bold step forward and picks up his hand. "I kiss you every night." She bats her lashes at him and waits for him to make the next move.

Mitch drops down and wraps his arms around her. He closes his eyes and rains down kisses over her hair like he's missed her with an indescribable ache.

"I prayed for you, Stella." He pulls her in. "Every day I prayed that God would keep you safe."

Stella pulls back and examines him. "Mommy said you kissed her and put me in her tummy."

<p style="text-align:center">182</p>

Mitch gives a gentle laugh. He glances up at me, and my stomach explodes with heat. This is what our family would have looked like. Seeing Mitch with his arms wrapped around Stella is more than a gift.

Stella presses her small hand into his chest. "Daddy kissed Mommy and put Eli in her tummy. My mommy says he's going to kiss her again and give me a baby sister."

Shit.

Janice gives a loud clap. "Guess what, Stella? I have a surprise for you and Eli upstairs." She takes Eli by the hand, and the three of them traipse off.

"That went well." Colt flops on the couch and folds his hands together as if settling in for the show—like he's anticipating some big power finish, worthy of his time away from the strip club.

Both Max and Mitch shoot him a look before taking seats opposite one another. They exchange dangerous stares, rife with deadly implications. This was it, the moment of my discontent. Now it was just a matter of who would draw their weapon first.

"So how long did it take for you to close in on my wife?" Mitch doesn't filter his hatred when it's just us in the room. He doesn't waver from his venom-filled glare.

Max takes in a deep breath. "All right, Lee." He glides his hands over his knees. "We'd better go. Kids are tired, and we need to get to bed." He makes his way over and slings his arm low around my waist.

Mitch appears in front of him quick as an apparition with his chest puffed out. He's not opposed to a felony or two tonight, I can tell.

"*We* need to get to bed?" Mitch mimics the audacity while shoving Max into the wall.

"I meant the kids." Max is quick with the correction.

"Mitch, don't do this." I step between them half-afraid I'm going to get clocked in the process. "He didn't pull anything over on me. This isn't some revenge-based marriage."

"I'm sure there's a butcher knife in the kitchen, Lee." Mitch pulls a bleak smile. "Why don't you slit my throat with it—finish me off."

Janice reappears, panting from her effort as though she's missed something.

"Well"—Max broadens his chest—"it's a miracle you're back. Glad to see you again." It comes off sarcastic like maybe he's not so glad to see him after all—I'm betting he's probably not. Max holds out a hand to Mitch.

Mitch glares down at it, doesn't make a move. I'm pretty sure he's not going to shake it—*break* it maybe.

"Mom, Colt, goodnight." Max nods into them before heading for the door. "Stella, Eli, time to go."

"Stay a little longer." Janice coaxes while pulling him back inside.

Mitch opens his mouth then closes it, staring at his mother in disbelief.

"I'm so sorry." Janice smooths her hand over Max's chest. "He's just tired. This is all new to him."

Mitch chokes on a laugh. "It looks like you've all been drinking the Kool-Aid." Mitch is beside himself. "This is *Max*. This is generational warfare infiltrating you on the frontlines." His eyes expand as he takes me in. "Lee?"

Mitch—I've ground all of his hope down to nothing. There's so much pain and hurt on his face, I can't bear to look at him.

"How about breakfast in the morning?" My lips tremble as I make the offer. "We'll pick you up around eight?"

His mouth falls open as if for the first time tonight he realizes he's not coming home with me, to our home, to our bed.

"Sure." He looks resigned to the fact I'm leaving, being ushered out the door with Max Shepherd's hand in the small of my back.

Stella and Eli run out into the cool of the night as Max guides me with a gentle push, but I retract and make my way back to Mitch.

I collapse my arms around him, pulling him into a tight embrace that I hope will be enough to last all night. Not one part of me wants to go home. I'm afraid I'll break the spell—that I'll wake up in the morning and this will have been an impossible dream. But I know Max needs my reassurance tonight more than ever, and Mitch needs a moment to absorb all of these horrible truths.

"See you in the morning." I press a kiss over his lips. Mitch doesn't move. He's rigid with disbelief, the stunned look of betrayal still fresh on his face.

"In the morning," he whispers.

Max ushers me out the door as if the roof was on fire.

Mitch is back. All of my prayers have been answered. It's nothing short of a miracle, and now I'm so frightened I wonder what I've done—how to get us out of this mess. We've become a tangled necklace that needs to be ripped apart with no hope of ever being whole and beautiful again. Everything is about to change. I know this. I can feel it, see it. But nothing is willing to give, and I could never leave Max.

Max saved me. He doesn't deserve this. He never signed up to be second best to Mitch. I would never let him think that. I could never leave Max, but in a strange way I don't feel married to him at all anymore. Now it's just cheating on Mitch in the worst way possible.

Mitch

Molten hot water beads off my skin as I indulge in the world's longest shower. I'm not sure how successful I was in washing the grime of reality off my flesh, but I concede and put on the clothes Colt scraped up for me. Wish I could wash Max Shepherd away—ship him off to the nearest desert island, hell, reeducation center.

Downstairs I find Colt and Mom huddled over the kitchen table with anxiety-riddled faces. Figures. As glad as Mom is to have me back, she's worried for me and most likely for Max. It just proves her heart is too damn big.

"Where are the keys to your truck?" I ask, giving a gentle shove into Colt's shoulder. There's no way in hell I'm going to sleep tonight, so why bother trying.

He plucks them from his pocket and dangles them before me.

"I don't know, man." He snatches them back into his palm with a clear look of apprehension. "The idea of you navigating your way around Mono at this late hour, sans any vehicular history for the better part of a decade, kind of has me worried."

"Thanks." I snatch them up and bolt for the door without acknowledging his vote of confidence.

"Where are you going?" Mom shouts after me.

"Just getting a burger."

Colt sprints down the driveway and hops into the passenger seat uninvited. I don't really mind. I've got one serious fucking bone to pick with him anyway.

We speed out the driveway and slide onto the main road with a bit more drama than I bargained for.

"Relax." Colt struggles with his seatbelt. "Try not to get yourself killed just yet."

I don't say anything, just keep driving until I get to my favorite fast food restaurant and order twelve cheeseburgers by way of the drive-thru.

"I need some cash." I flick my fingers at Colt. "You want anything?"

"That's enough to efficiently clog both our arteries." He gives a wry smile as he forks over the dough.

"They're all for me. I've been slacking off in the artery-hardening department. What do you want?"

"Two burgers. And, by the way, death by cholesterol isn't the best suicide solution either."

I throw in some drinks and fries—and exchange the bills for two piping hot bags.

"I miss all this," I say, driving back out into a blanket of darkness.

I make a left instead of a right and head down toward the shore.

The moon blanches the landscape with its pale illumination, and suddenly it all feels like a dream—hell some of those fantasies in isolation felt more real than this.

"So where we going?" Colt seems disinterested, his question lodged behind his burger.

"Home." The one I shared with Lee. The one I *built* for Lee.

"Dude."

"Relax. I just want to see it. Make sure it's still standing. I wouldn't want anything but the best for Max fucking Shepherd."

"I've got news for you." Colton crams his burger into his mouth before washing it down with a few quick swigs. "Stella and Eli didn't ask to be put in the middle of this. Just chill out— don't do anything stupid."

"This?" I straighten. "What's this? Two days ago I was a prisoner at the hands of homicidal maniacs, and now I'm responsible for *this.*" The ocean gleams from between the houses as we drive down the familiar streets. I take in the white caps crushing the sand, watch them wash out in a peaceful surrender. That's what the world wants me to do, surrender to the circumstances. I kill the lights as the house comes up on us. "God—there it is," I whisper, pulling alongside the curb about a half a block down.

It's still there. Standing in perfect form like a two-story soldier built to protect.

A spring of tears well up in my eyes, and I blink them away. It's all real now—Lee and her new family, moving on without me.

"Dude, I know it's killing you." Colton readjusts himself in the seat before putting his bare feet up on the dash. "Max is pretty decent once you get to know him. He's sort of like a brother."

"You think she'll kick him out?" I want to cut to the chase. Certainly Colt has insider information on his decent new "brother."

It's quiet a few seconds too long.

"Shit." I sink in my seat in defeat. This isn't going well. Not in any one of my fucking fantasies did I come home to this hellish alternate universe. I wouldn't even qualify this disaster as a nightmare. We've drifted far beyond the horizon of some common nocturnal wandering.

"I don't think she should be put in that position." Colt jumps to her defense. "She's confused right now. Give her some time to figure things out—but don't hold it against her if she doesn't come barreling out with a suitcase in the next ten seconds."

"It's not Lee who should leave. I'd die before Shepherd squats in my house by himself." The lights are on upstairs in the back. Master bedroom. An image of his hungry mouth

roving up and down her creamy skin comes to mind uninvited. "He's defiled it. We'll have to burn it and start from scratch." The lights go on downstairs, and I sink a little lower as though they could see us. "You always liked, Lee." I leave it there to see if he bites—to see if he can explain how in the hell he let this tragedy unfold without so much as a whimper.

"Lee's a tough nut." Colt shifts before plucking another burger from the bag.

"I will hang you by the balls if you don't detail to me what in the hell happened."

"Fine, but you asked for it." Colt leans up against the door and gives a long blink. "Lee needed help with the business. She was a fucking wreck, and Max was more than eager to comply. He started hanging around every day. And, after Stella was born, they were sort of, together."

"After *Stella* was born?" Ironic how my anger helps me see with perfect clarity. I let the idea simmer until my eyeballs demand to shoot out from sheer pressure. "That's not even four months after I disappeared. Nice to see Max doesn't waste any time."

"She had needs."

I throw the bag of burgers at his chest.

"*At the vineyard*—she had needs at the vineyard. Besides—" he hesitates.

"Besides what?" I demand. Colt's face is starting to look like a bullseye right about now, and my fist is looking to relieve some tension.

"Never mind." He shoves another burger down his throat to keep from rattling out the atrocity. Although, I don't see how it could get any worse.

"Besides what?" I pull the keys from the ignition, and rattle them. "We'll be here until morning unless you finish that thought."

"I'm seeing someone now," he nods, satisfied with his transition. "Some chick from French Polynesia, can't

understand a damn thing she says, but we speak the same language after a couple margaritas. You want me to set you up with one of her friends?"

I jam my fist into his arm, put some meaning behind it as a taste of what's to come. I'm not opposed to the idea of beating the shit out Colt in lieu of Max tonight. "Say whatever the hell you were going to say."

Colt shakes his head and looks up at the house as a shadow moves across the window. "I don't think you're—"

I snatch him by arm and twist it behind his shoulder. "You don't think, Colt. That's why I'm in this mess. That's why Stella and Lee have to put up with the fallout of all this bullshit because you can't fucking think straight."

Colt pushes me off and lets out a heated breath. He knows its true. He can't even deny it. Stupid broken leg. If he would have paid attention to the one simple task I gave him that day, we wouldn't be having this conversation right now. I'd be upstairs kissing Lee, *putting babies in her tummy.*

I lunge over and wrench his arm just waiting for the next stupid thing to fly from his lips.

"I slept with Lee."

I let go with a shove. "What?" His words sting like a fresh slap.

"Jeez. I think you hyper-extended my shoulder." He takes a swig of his drink as though nothing happened. "Actually, she slept with *me*—a week before the wedding. She thought I was you. *Willed* me to be you. She was tanked out of her freaking mind." He shakes his head at the memory.

I glance out the window a moment. An image of Lee wrapped around Colt sears through my mind. I can feel her desperation as she "willed" him to be me.

"A week before the wedding, huh?" I state it more as a fact than a question. Lee was feeling guilty—wanting me so bad she was willing to lose everything with Max for just one more

night. Colt was just a stand-in for the real thing. "You walk her down the aisle?"

Colt mutes up and gives a quick nod.

I don't say anything just start the ignition and drive past my old house like I've done a thousand times before. I don't notice any stop signs or pay attention to the signals as I race back to my mother's driveway. I jump out of the truck and come around the passenger's side before plucking him from his seat.

"What the hell?" He tries to stave me off with a burger.

There's not a burger in the world that's going to stop me from what I'm about to do next. I bash his face in with my weak, undernourished fist until it feels like I'm going to pass out from the effort. I'm not sure if I truly blindsided Colt, or if he's letting me beat the shit out of him for all the misery he's caused—nevertheless, it's good practice for the flesh ripping I plan on gifting Max in the very near future.

It's only fair.

Max

The fresh sting of California sunshine falls across my eyelids through a crack in the blinds. I glance over at Lee sleeping peacefully beside me and carefully untangle our limbs. She's so beautiful, so damn heartbreakingly gorgeous I'd wake her with a kiss, but the truth is my head is still spinning from a long night of zero sleep. Instead, I jog downstairs and peer out the window to see if Mitch is staking out the house. I would if the roles were reversed.

No sign of Mitch—yet.

I make my way over to the family room, still wiping the sleep from my eyes. I'm not sure I slept last night, just tossed and turned and thought about how Mitch is going to inject himself in our lives. I held onto Lee for dear life as if she were about to be blown away by a cyclone. Honest to God, this nightmare scenario never once played out in my mind.

Outside the blue Pacific is veiled in a thin layer of fog. I open the slider and feel the cool rush of morning air waft in, filling my lungs with the sweet brine from the ocean. The trio of Coke bottles that sit on the mantle, campaign for my attention. The one in the middle is filled with a mixture of Townsend, Shepherd soil, the one on the right with Townsend, the left with Shepherd—a gift from Lee on our first anniversary. It was a symbol of who we were, how we breeched long past rivalries and combined the two to create an unstoppable enterprise. Now Mitch is back, and he's going to extricate every last Townsend element from my grasp and reclaim it as his own. I'd be delusional to think otherwise—hell, I would do the same. Lee first.

Like some robot on autopilot, I put on a pot of coffee and lean up against the counter while it percolates. It's hard to

believe life has turned into a heaping pile of shit in less than twenty-four hours, although I suppose the opposite is true for Mitch. I vote Lee should stay with me while Mitch does another tour of duty.

A dull laugh rattles from my chest. I wouldn't want Mitch going back. Hell, I'm glad he's not pushing up daisies, but I can't see us rekindling any kind of non-existent friendship, not with Lee in the balance—not with her in my bed.

I glance out the window as the marine layer settles over the horizon, thick as frosting. Lee has got to stay with me. I'm not above begging—not when it comes to my wife. I can't imagine not keeping my family—my business intact. I thought Lee and I would last forever.

The coffeemaker burps, rousing me from my dreamlike stupor. I pour myself a cup, and wander out onto the patio.

Beach front. Mitch put a triple lien on Townsend just to pick up the property, not including the cost of materials to build it. Of course it was worth it in the end, but questionable financial moves like this one is what ran his company into the ground. By the time Lee led me to it, I had to resuscitate it with some serious mouth to mouth—Shepherd finances to Townsend until it finally eeked out a profit.

A wave crests through the mist, and pulls up on shore, bubbling into sea foam before peeling away.

My father never made a mistake in business. He made plenty in his marriage, thus turning my mother into a wandering ball of lust, but not in the boardroom. He knew the difference between a calculated risk and a bullshit deal that would land you upside down, raining the change loose from your pockets. And now, every time I'm presented with a fork in the road I ask myself what would Dad do?

So here I am—unexpectedly staring at one big fucking fork in the road. Now what? Can't exactly use the same philosophy when it comes to Lee and me and this tangled net

we're snared in. This is just another case of Townsend bad luck. There's no other explanation.

Ironic how my mother loves to lament the fact Lee and I are so normal. How we cleanse the debris of white trash shenanigans she and Hudson seem to continually suck us into. Hudson with his lovely new porn star girlfriend. The sex tape comes out soon. A perfect holiday gift for the pervert on your list. I guess that qualifies Colton for a copy, probably two.

"Morning." A cheery voice comes from behind. Lee offers a spontaneous massage to my shoulders, and I repay her with a groan of satisfaction. I pull her onto my lap with a kiss. Lee didn't push me in the shower last night. To tell the truth, I was too jarred to think straight, and her elation didn't exactly help the situation.

Her jeans catch my eye.

"You're dressed," I say a bit surprised considering the hour. I guess I shouldn't be too caught off guard at her hyper-willingness to get the day started—not with the big impending reunion scheduled for later this morning.

I take a closer look at her hair, her makeup. She looks immaculately put together, more like a night on the town than a quick jaunt out for some eggs. The more I inspect her, the more my stomach sinks like a brick.

"Get ready," she whispers, pulling at my shirt. "We can drop the kids off on the way."

Her eyes sparkle like an unblemished summer sky. Her lips twist as she purrs. Lee is floating on air, and this unnerves me. She's so damn chipper it's grating on me.

"I'm not going." I let out a breath I've been holding since last night. I'm pretty sure the entire event would end up in a verbal or physical altercation, both if I were lucky. And judging by the way Mitch has evaporated, it wouldn't be a fair fight. It's like he stepped out of a concentration camp. It probably wasn't much better.

"Oh, *no.*" Lee's smile melts from her face as if she were genuinely disappointed. "Please? It won't be the same without you. Besides, that way I won't have to recount every detail to you when I get back. Don't you want to know what happened?"

"Yes. I want to know everything." Not really. I know enough. All the important details anyway. She hones in on the sarcasm in my voice and frowns. "You go." I slip my hand up her shirt and rub her back. "I'll take the kids to school. Actually I might keep Eli home. I saw him pull at his ear last night. He might be coming down with a cold." Eli's more than a little prone to ear infections. Both Lee and I know the fallout—a multitude of sleepless nights, and force feeding him medicine that he likes to spit back in our faces.

"Max." She closes her eyes a moment as disappointment permeates her. "Are you sure? I could have your mom or Janice watch him."

"I'm positive." I want to tell her that I'm not ready, but its pointless considering I'll never be ready to deal with Mitch.

"Okay. Well, thank you." She gives a little bounce, and for a minute I'm not sure if she's thanking me for staying with Eli or for not interfering with her outing. "You deserve an award for being the best father of the year. I'll have to bake you a cake." She dots my lips with a kiss.

Great. Now I'm practically a hero for not going.

"You're all the reward I need, Lee."

Her demeanor changes as she takes me in, desperate and broken from just one brief encounter with her not-so-long-lost husband. It's the repercussions that have me fearful—that have me wondering how fast she'll shove a suitcase in my face and tell me to get the hell out.

It's not so much Mitch keeping me from going, or hearing him recite the atrocities that most likely occurred, it's the pain that ignites in me when I think of Lee looking at him in that way. It's the thought of feeling like a third wheel on some date my wife is on with her dead ex-husband. It's a nightmare within

a nightmare, and there doesn't seem to be a way out. I wish there were some great analogy that could relay how I feel—some girl who would drive Lee to the edge of a mental cliff, but there isn't. I don't have some great love who has suddenly resurrected herself to compare the situation. Lee is the only one for me. Always has been. Always will.

Lee and I were a whole encyclopedia of wonder and excitement together, and now I feel like nothing more than some old, useless receipt.

She leans in and plants a string of kisses over my cheek. "Take Eli to your mom's. I'm begging you to come. You can see for yourself that I'm still your wife."

There it is. She hit the nerve. Didn't bother with Novocaine, just drilled right in and I'm so glad she did. Those were the words I've been craving all night and into the morning.

"I know." I pull in close, bump our foreheads together and stay there. A flood of hot tears swell beneath my lids, they filter down and penetrate my shirt uninvited.

Lee knew what I needed to hear. She knew the exact words I needed to comfort me, and she gave them like a blessing.

"So, are you coming?" Lee doesn't wait for a response, simply covers her mouth over mine and bathes me with a deep, sensual kiss.

"I'll be with Eli," I whisper. "I just need more time to wrap my head around this."

A million years to be exact.

The Art of Love

Lee

The sun crests over the Townsend estate as I pull into the driveway. Mitch comes bounding down the stairs and hops into the passenger seat wearing a heart-stopping smile, and I take in a breath. A quiver runs through me at the sight of him, and now it seems like the worst idea in the world not to have brought Max along. I know if I pleaded just a little longer, he would have caved. Max would figure out a way to fly to the moon if I asked him to.

Mitch settles his eyes on me, sad and forlorn. "Nice car," he says, securing the seatbelt. He doesn't lean over and kiss me, just a platonic greeting as though he had somehow acquiesced to the fact I was married to his enemy. I don't buy it, but I meet him on his terms.

"Thanks. I needed something bigger after Stella." I stop short of adding, *Max helped me get it.*

"Yeah, I figured." He nods uncomfortably. "I'm glad." He tracks those jade green eyes I've dreamed of a thousand times, slowly over my features.

It's awkward. I could never have imagined an awkward moment with Mitch, and now here we are experiencing it.

He glances in the back seat before reverting his sad gaze. "So where's the family?"

My stomach clenches when he says it. There wasn't the slightest hint of malice in his tone, but it felt sharp as acid in a rancid wound.

"Eli," I whisper, shaking my head, "he's not feeling good. Max stayed with him. Stella is in school—preschool." I bite down on my lip to keep from bawling. Just the thought of all he's missed is the knife in all this. "She's so smart. She asks a million nonstop questions, and her vocabulary is out of this world for a girl her age. She's just learning to read. She's picking it up so quickly. Max and I think she's a genius."

Mitch winces when I say his name.

I try to focus in on the road as we navigate onto the highway. The evergreens skirt the inland route, but there's nothing except clear blue ocean to the left.

"I don't doubt she's a genius. She gets that from you by the way." He reaches over and squeezes my knee. An entire current of affection races up my leg, and it takes everything in me to keep from stopping the car and pulling his body over mine. I'm so thirsty to hold Mitch, I might pass out soon if I don't drink him down. "How about Eli? I want to know about him, too."

I blink a smile over at him and let out a sigh of relief. I was so worried it was Stella he wanted and would look through Eli as though he didn't exist—turn him into an extension of his hatred for Max.

"Eli..." What can I say other than the fact he's Max in a two-and-a-half-foot package? "He's quiet—pensive." I shrug. "He likes trucks, and boats, and dirt all on an unnatural level of course. He gives the world's best hugs. You'll have to see for yourself."

"I can't wait to see for myself." He warms his hand over mine, and my stomach swims with elation, not only for his

THE SOLITUDE OF PASSION

touch but for his willingness to accept an important part of my life.

Mitch is an all around better person than me. Had he gone off and married someone else—had a child with her—I don't think I'd be as accommodating. I hated a girl in college once after I dreamed she was interested in Mitch. *Hated* her because of a stupid dream. And, here, Mitch is living anyone's worst nightmare.

We drive for a short while in a cloud of silence, content with the echo of our breathing. Everything about this new reality holds all the strange nuances of a dream, like something that unfolded out of my imagination because I willed it to happen.

I pull into The Waffle Shoppe parking lot, but it's full, and after three long revolutions I give up and park at the Mono Bay Hotel right next door. Bodies are teeming out of the restaurant, mostly men in three-piece suits, which is an anomaly for the place. We hop out, and I take up Mitch's hand, rub his arm in an effort to let him know it's okay for him to touch me—that I won't break or recoil. In fact, I want it—demand it.

Mitch smiles and holds my gaze. "You look beautiful, Lee."

I bite down over my lip and don't say a word.

It's cool as we step inside the establishment. Bodies are lined along the entry, and it's becoming clear it's going to take more than a little while to get seated.

"Two please," I say to the hostess. She bows into me with a smile. Her powder blue bonnet covers her grey curls. They look like frail wires poking beneath her enormous hat.

"There's a one-hour wait." She frowns as she says it. "Big dental convention this week." She nods toward the wall of suits to our left.

I'm hoping most of them will make a trip over to either Townsend or Shepherd, which will be great for business. Every time there's a convention in town, we get a run of people.

I pull out my cell to warn Max to prepare for an onslaught, but drop it back in my purse like it were a snake on fire. The last thing I want is Mitch listening to me talk to Max about Townsend.

"Let's hit someplace else." Mitch wraps an arm around my waist as if to coax me to the door and something about it feels intimate, right.

"You can try the hotel," the hostess offers. "They've got a great buffet, and you might get in quicker."

Mitch and I don't put up a fight. As much as I want to spend time with Mitch—the thought of huddling in the blazing sun for an hour as we wait for a seat might kill the magic of his first day back.

"This is a miracle," I say as we walk back through the parking lot.

"This is better than a miracle, Lee." Mitch brings my hand up to his lips and presses in a kiss. "I died every day without you, and now I can breathe again."

"Mitch." I wrap my arm around his waist and sniff hard to keep from weeping. "You're heaven to me."

We pause just shy of the entry, and I take him in, gaunt, a thinner, frailer version of himself, but he's still there—so perfectly beautiful.

He ticks his head and leads us inside.

The hotel lobby is comprised of polished black granite, a gleaming brass sign points to an expansive dining room chock full of what I can only assume are dentists. The decibel level alone rivals a jet engine as a steady roar of unintelligible voices circulates around the room like a static draft.

"We could drive to Creek Side," I suggest. "There are tons of places there." I'd sit in the car and hit a drive-thru if he wanted. All I really need to satiate me is Mitch.

"Can I help you?" The concierge calls from behind the thick granite counter. "Do you have reservations?"

I look to Mitch as a thought twitches through me.

THE SOLITUDE OF PASSION

"How many in your party?" He doesn't bother to look up from the keyboard. He's already scanning for an opening.

Mitch takes a breath, locks eyes with me, and lets out the slight impression of a smile. "We could order room service," he suggests.

"And we'll be able to hear each other better," the words speed out of me.

It takes less than five minutes for the concierge to hand us a square plastic key, less than two minutes for Mitch and I to ride the elevator up and find our room.

We don't hesitate stepping inside.

<p style="text-align:center">“”</p>

The door closes behind us, encapsulating us in this private membrane, and all I can see is Mitch and his blessed-by-God face.

"So"—I take a step deeper into the room as if enticing Mitch into the mouth of a lion—"what do you want to order?" The words come from me far more sultry than anticipated. It's so quiet here I can feel my primal yearnings begging for his attention.

"I'm not hungry." He takes a step into me and picks up my hand, the curve of a barely-there smile playing on his lips.

"Neither am I."

A rush of adrenaline surges through me and fills my ears like a heartbeat. Something in me reverts to autopilot, and I remove his shirt in one quick motion.

I take in a breath at the sight.

"Oh my, God," it sails from my lips, quiet as a whisper.

Long jagged welts run over him like shredded rope embedded just beneath his flesh. I run my fingers lightly over one of the lines, tracking it from his stomach to his heart.

"What the hell did they do to you?" I can barely push the words out through the heartbreak.

Mitch doesn't answer. He simply walks over to the windows and pulls the drapes closed, darkening the room to pitch.

He swoops back in, out of breath, wrapping his arms around my waist—and this time it feels anything but platonic.

"I missed you, Lee," he says, taking my hands and guiding them over his back until I'm holding on for dear life.

Mitch brushes his lips against mine before pulling back, gauging me for my reaction. He offers a sad smile before dipping in again and covering my mouth with his. Mitch detonates with achingly slow, unwavering kisses. The universe starts up again. It's as though it had stalled, and, now, with Mitch here, it was firing on all pistons—nothing but a cataclysmic echo of exploding stars, an entire meteor shower of sorrow and pleasure intertwined—a comet of lust with a tail as wide as the sea.

It feels like we've stepped into a time machine—easily this could be five years ago in the bedroom he built for the two of us.

He fumbles with the buttons on my blouse, and I don't fight him. Mitch drops to his knees and looks up as if to venerate me. His fingers fall into the lip of my jeans, and he peels them off, watching with careful attention as if he didn't want to miss a beat. He presses in a kiss over my bare stomach and I take in a breath. The long, hot tracks of his tongue incinerate me from the inside. It's nothing but forfeit as Mitch pushes me back on the bed. It feels strangely familiar—like a memory playing out in real time.

Mitch lands on top of me, straddling me with his knees. The room glows like a candle with just enough light for me to see his beautiful face.

My fingers float to the scars on his chest. I can't ignore the welts rising up all over his body. I'm so frightened for him,

but I'm thankful he's here. I'm glad God figured out a way to pull him out of my heart and land him miraculously in the western hemisphere. I'm so glad this fantasy has taken shape in flesh and bones, even if it is just one long dream. I glance down at him lost in his lust with his lips fused just below my belly. We both know this isn't real. We both know he's long since dead and things like this just don't happen. It's hard to know what's up and what's down, what's real and what isn't when you're still trying to pick the pieces of your heart off the ground.

Mitch rises up my chest, my neck, with a trail of feather-soft kisses. I push all thoughts of this gargantuan puzzle out of my mind as he bears down at me with a look of relenting lust.

"Lee," my name streams from his lips like a poem. Mitch meets me with his mouth, diving over me with a kiss that tastes like eternity branding itself from his soul to mine. "I'm going to love you," he whispers, gliding down my body and burying a string of kisses over my stomach, trailing lower until he presses my knees apart.

A groan escapes my throat as he lands the hot of his mouth over the most intimate part of me, and a flare of heat spears through me. He moves his mouth in a steady intoxicating rhythm while kneading my thighs.

Mitch peels off his jeans and rises above me like a phoenix. He crashes his lips over mine and kisses me through a lust-driven smile. I open up for him like a flower—Mitch is the sun I've craved for so long. He pushes into me with a pronounced thrust, and a small cry escapes me that's been building for the last five years. Mitch pushes in, deeper still and fills me with all of his carnal affection—a hard-won groan wrenches from his gut.

"God, I love you," he pants hot into my ear.

"I love you, too, Mitch."

There's not another person in the universe who exists right now.

It's just Mitch and me, lost in our love as his body moves in rhythm to mine.

But Max hovers over us like a ghost.

And, now, nothing will ever be the same.

Mitch

Breakfast turned into lunch, and that turned into dinner, and the only thing we feasted on was each other. All of those lonely nights, every carnal fantasy played out in one luscious exchange—making love to Lee—*fucking* Lee. The explosion of lust went on for hour after blissful hour.

Lee didn't say more than two words as she drove me home. She blinked back tears at every turn, hoping I wouldn't notice. I know she was thinking about Max, how much she hurt him with me of all people.

I wait until her taillights take off from my mother's driveway before bolting upstairs. I can't shake the feeling we just sneaked one in under the radar of parental supervision and it's not right. What Lee and I shared should never feel dirty, illegal, *sinful*. It was pure and innocent, love at its best.

It doesn't take long for me to gather the meager belongings my mother laid out on the bed and toss them into an old backpack I manage to excavate from the closet. Mom is already in bed asleep, so I leave a note on the kitchen table, *I'm going home. Borrowed the truck.*

I catch up to Lee before she crests the hill. I don't think she realizes it's me or that she's being followed. She rides all the way up the driveway then hesitates before killing the engine. I get out of the car and meet up with her on the porch.

"Did I forget something?" She looks bewildered, far more animated than she did the last half hour.

"Just me." I give a lopsided grin and hold up my backpack.

"*Mitch.*" Her mouth falls open, breathless. Her cheeks light up like a Christmas tree as if she's unsure what to do with me, embarrassed by the entire exchange.

"You can't stop me," I say it low, filled with seduction. "Well, you could. But I don't think you will." I give the loose impression of a smile.

Lee fueled me—gave me the ammunition I need to dethrone Max off the king size bed upstairs. If it were anybody else—anyone in the entire world—I would have held back, thought twice about what happened today. But being with Lee, touching her that way, burrowing inside her and never wanting to leave, invigorated me. There's no way in hell I'm rolling over for Max Shepherd, letting him run away with everything I worked for just because life decided to swallow me up in its asshole.

She spins the key in the lock and struggles to open the door before it swings wide, revealing a pissed-off Max on the other side.

She gives a nervous laugh and tries to conceal my backpack with her knee.

We're met with a stone cold expression, nothing but raging hatred directed at yours truly.

"I'm so sorry." Lee attempts to speed past him, but he catches her by the waist.

"Kids are asleep," he says, reeling her into his chest. "It's ten-thirty." He's examining her, waiting for an answer. "And what the hell is he doing here?"

I breeze past the two of them. "I'm home," I say it mostly to myself. This is all so surreal. I'm not sure how to measure the depth of emotion just being in this place invokes in me. "Like the floor." I'll rip it out if he had anything to do with it. I head to the kitchen. Everything is the same—same appliances, same L-shaped couch in the family room. I glance out the window. It's too dark to see the water, but the slider door is open with the ocean breeze penetrating the air and every breath is so wonderfully sweet. It's so good to be back, right here, in the house I built with my own two hands.

A hard shove comes from behind as Max spins me, turns the collar up on my shirt, and pulls me in.

"You want me to kill you? I will," he pants. "I swear to God I won't mind."

I glance behind him for signs of Lee. A prattle of footsteps ignite from above, so I gather we're alone at the moment.

"Relax." I push him off and back up. "Lose the temper. Get comfortable. I'm here, and there's not a damn thing you can do about it."

Max pauses. Drops his arms back to his side while examining me like a predator.

"Don't do this," he whispers. I like how he's dipped his manipulation into the pathetic zone in hopes I'll fall for the spare-the-children card. "Don't bring this drama into my house with my kids. If you care at all about Stella or Lee, you'll leave right now."

"This is my house," I correct. "*My* kids." I'll claim his son just as quick as he claimed my daughter. "My house. My family." I drill a finger into his chest. "I built them both. Since you're such a fucking bleeding heart when it comes to a family in crisis, why don't you avert one by shacking up at the Mono Bay Hotel. Rumor has it, a room just opened up an hour ago."

His jaw goes slack. I can see a fit of rage surging through him, then it leaves quick as it came. He's calling my bluff. Max Shepherd won't believe it for a moment.

He roots his feet to the floor. A minute of silence tracks by with nothing but cross-armed aggression spewing from him.

"This isn't like you, Mitch." You can see the fire in his eyes. You could light an entire solar system with the inferno brewing inside him. "I thought you were *nice*." He spits it out like it was the world's vilest expletive.

"Nice wears off after five years." I butt my shoulder into his as I pass him.

He doesn't bother with a response, just stalks through the living room and up the stairs to the bedroom he shares with my wife.

It's quiet down here—downright eerie. If I wanted, I could convince myself that not a moment went by, that I never boarded that plane, that Colton went instead, and he was really dead.

Poor bastard.

I pull a soda out of the fridge and take a seat in my favorite spot on the couch.

Sorry Colt. I almost miss you.

<p style="text-align:center">❧❦</p>

The blue numbers on the microwave read two o' five when Stella catches me in the kitchen getting a glass of milk. It's pitch black in the house save for the light emanating from the open door of the fridge.

"Picture Daddy!" She throws her arms around my waist and rocks me into a hug.

"Stella," I whisper her name like a dream before catching her little hands in mine.

"I'm thirsty." She pulls back and looks up at me with those lawn green eyes.

My heart nearly combusts in my chest at the sight of her. I'm thrilled she didn't freak out and scream her head off. I'll pour her twelve glasses of milk if she wants.

"Why are you up so late?" I ask, digging a smile into my cheek. She has Lee's tiny nose, eyes the exact shade as mine, and my heart soars just taking her in.

"Couldn't sleep. I thought I heard a burglar."

"Burglar, huh?" I get down on one knee as if I were about to propose. "You're not afraid of the dark, are you?"

She shakes her head.

"Good. You need to be strong and brave. No matter what you might be afraid of, God is bigger. Just remember that." She blinks up at me over the rim of her glass and hands it back when she's through.

"Tuck me," she says, digging her fists in her eyes.

I hesitate for a second as I envision Max storming out of his bedroom in a blind rage and beating the shit out of me. Not that I believe for a minute he'd be stupid enough to scar Stella like that. And, if he did, I'd throw him over the railing—eliminate a lot of problems in the process.

Her miniature gown glows like a paper lantern as I follow her all the way up to her room. She looks like a ghost, and for a moment I wonder if I'm back in detention having one hell of a realistic hallucination—that I'll wake up in a bed of paper roses, squeezing the life out of a pen like I have so many times before.

Stella turns on the light in her room, and I snap it back off again. There's a nightlight on, giving off a gentle glow. She hops into bed, and I tuck the covers around her before dropping a kiss on her forehead.

"I love you, Stella."

"I love you, too, Picture Daddy."

I bless her cheek with a tear-filled kiss, and my eyes snag on a picture set on the nightstand. It's of me on the beach, posing with my surfboard. My insides twist at the sight. That's what I was reduced to, paper and ink.

I head out into the hall and walk over to the master bedroom, stealth as a ninja. When I left all those sunrises ago, I never dreamed it wouldn't be until this night I would be back. I place the pads of my fingers soft against the wood—feel the magnetism of Lee wanting to pull me in. But she can't. There's an intruder in the bed, and his name is Max Shepherd.

It takes everything in me to peel my hand from the door. There is definitely an energy here. I fight the pulsating desire to burst in and toss Max down the stairs, headfirst. Instead, I float back down to the family room, fall asleep on the couch—get lost

in a vat of strange dreams that make me believe I've made my way back to Lee again. But deep down inside I know I couldn't have.

Could I?

Max

I head downstairs early, trying to push the acid-tongued argument I had with Lee last night out of my mind. It happened. Lee confessed to my worst nightmare, and now, forever, I'll have a visual of their bodies locked together in heat. She didn't tell me how far they went, but I didn't need a roadmap. And here, after I saw him, a part of me was glad that Mitch was back—*happy*—and now I see it for the horror it is. He's out to stomp my marriage out like a kitchen fire. I've got two choices, fight or quit, and I can't quit Lee.

It feels like shit knowing she succumbed to him—worse than shit.

Lee swore she was insane, that she wasn't thinking clearly, she couldn't even pin the year let alone understand what was happening, and tragically I believe her. I want to anyway.

Eli giggles from the family room so I head over. His laughter filters through the air mingled with Stella's more discerning laugh. I find the two of them on the couch, cozy as peas in a pod, with Mitch in the middle reading them a book.

"Morning!" Stella sings before dipping her nose back down to where Mitch has his finger. "Picture Daddy is reading to us."

Just fucking, "Great." For Stella and Eli's sake I'll fake sanity. "Anyone want breakfast?"

"Sure." Mitch is quick to answer.

"Stell? Eli?" I *bet* he'd like breakfast. I bet he'd like a lot of things, but I'll be damned if he gets them.

"Picture Daddy made us cereal." Stella doesn't bother looking up this time. "What would you like?" I hear her ask while looking up at Mitch.

He gives a sly smile in my direction before leaning into her ear and whispering something indistinguishable.

"Pancakes!" she shouts. "Picture Daddy wants pancakes!"

"Coming right up," I say with mock enthusiasm. I open and close the pantry without bothering to inventory for Mitch's needs. "Would you look at that? We're all out. Sorry." The last thing I'm doing today is playing short order cook for Mitch.

Stella pulls him down by the neck to discuss his next selection, no doubt. His lips twist in the same way hers do when she's deep in thought, and for the first time the family resemblance knifes me in the gut. I've never minded Stella looking like Mitch while I thought he was tucked safely in the great beyond, but something about seeing her face reflect his, weighs me down like lead.

I get to the business of making a pot of coffee instead of depressing the hell out of myself while inspecting my daughter for signs of her not-so-dead father. I should be happy—*thrilled* for Stella, and yet every cell in my body wishes he never resurfaced.

Stella and Eli head upstairs in a screaming fit of giggles to get ready for school. Looks like the book club has adjourned.

Mitch meanders into the kitchen and steals the light from the window as he blocks it with his frame. "Where's Lee?"

I shake my head in awe that he has the balls to ask. Who knew Townsend had a pair?

"Sleeping in." The coffeemaker gurgles to life. "You must have really wore her out yesterday." I slit the air with the words. I want him to know I'm in on their little fuck-fest. I had it out with Lee for two hours straight before finally turning off the lights. She swore it would never happen again and blamed me for not going with her. *Me.* You'd think the wedding ring would have offered some sort of philandering barricade.

Mitch holds back a smile. Makes me want to tear his head off for even thinking of touching Lee, let alone going through with it.

"Sorry about that," he says unmoved.

Well, gee whiz, he sure sounds sincere. Maybe now is a good time to clarify the topic. "For fucking my wife? That's big of you."

Lee's perfume comes into the room before she does. She's wet from the shower with her hair slicked back. She took one last night, and, now, she's taken one again. I hope that means she'd like nothing more than to scrub Mitch Townsend off her flesh forever, but somehow I doubt that.

She presses her lips together and looks up at me filled with sorrow.

"I'm so sorry, Max," the words bleed out of her. She's apologizing for sleeping with Mitch right here in front of him, and somehow that solidifies her feelings for me.

I wrap my arms around her and squeeze my eyes shut tight in hopes that when I open them he'll be gone, nothing more than some shared hallucination.

Lee pulls back and takes a breath. "I'd better help Eli." She motions toward the stairs. She blinks a quick smile over to Mitch before leaving the room.

I pour myself a cup of coffee and raise it in his direction. "You know what today is?" I ask.

He doesn't say anything just offers a stone-cold stare.

"It's take your wife's dead husband to work day," I say.

Maybe I'll hide his body in that drainage ditch. That ought to fix the leak.

<p style="text-align:center">⁊ك</p>

In an effort to keep an eye on Mitch and his prone-to-wander shriveled testicles, I decide to take him to the helm of Townsend Shepherd Inc. and watch as his jaw hits the floor once he sees it for the well-oiled machine it is.

"It's all mine, Mitch," I say, sitting on the desk while he drinks down the numbers. "Just like that woman you were with yesterday." I wouldn't have rubbed it in his face if he didn't openly defy my marriage vows without blinking.

He purses his lips, unimpressed, while looking over production records from the last six months.

"You didn't bring me here to show off your fiscal handiwork, did you?" He missiles a stack of papers clear across the desk.

"Nope. I brought you here to keep some metric distance between you and my wife. She's confused, and I see you have no problem taking advantage of the situation."

"That's what you did, Max. I'm just taking a cue from the best." Mitch leans forward, spearing me with all of his hatred. "Looks like my lack of imprisonment has placed you at a sudden spousal disadvantage."

"Believe me, there's no spousal disadvantage, here. I'm the one who's married to Lee."

"So you like to remind me." He busies himself with the numbers again.

"Lee and I did what you couldn't. We bolstered Townsend to rival Shepherd. I'm not letting you turn it all to shit again. You can work out in the fields if you want, but that's as close to the company you'll ever get."

His features smooth out. "I'll run Townsend again." He doesn't bat a lash. "You can save the drama for the legal team you'll need to try to hold onto it." He stands and digs a smile into the side of his cheek. "I'll have Lee again and raise both Stella and Eli. In fact, let the record show, I'll take Shepherd off your hands, too."

"And on what fictional planet does this take place?"

"I just dreamed it up." He looks past me, a moment. "Lately all my dreams have a way of coming true." He heads out into the heat of the day.

Mitch, who always keeps his word—the dreamer—the *prophet*.

Sorry, not this time.

Murderous Affection

Lee

The dull roads of Mono stretch out like elastic as Kat and I head over to Dr. Banks, a top child psychologist recommended through my pediatrician. This is what life feels like with Mitch now, pulled out, over stretched, a waist band that's been spent, and you can never get it back to the way it was again. How we'll ever repair what we had seems impossible, improbable, and then there's Max. It's as if our world was locked safe in a water globe, and now we lay smashed on the ground, broken, exposed without the buffer of our fantasy to shield us from this new, strange universe we've entered.

Up in the tall silver building, shrubbery lines the suite, frosted mirrors are laid out in long strips along the wall. All smoke and mirrors, literally. It looks confusing, disheartening. Definitely not child friendly, and it makes me reconsider the decision to come here in the first place.

Dr. Banks is short and balding, with a soft, round face. He smiles peacefully while I recount the details of Mitch and his return, what the implications might be for Max and our family.

"Tell me how Stella reacted." He presses out a peaceable smile that could have just as easily inquired about a gift I gave her for Christmas.

"Fine." I glance to Kat for a moment. "She called him, 'Picture Daddy.' I kept a photo of Mitch by her nightstand, and she recognized him."

He takes in the remainder of his coffee and inspects the ceiling for answers.

"Stella seems to be taking this reasonably well at the moment." He slouches forward and points his chin at me. "I don't mind seeing her, although I will tell you kids are more resilient than adults give them credit for. You mind if I give you a suggestion?"

"That's what I'm here for."

"I think maybe it's you who needs to see a psychologist." He settles a gap of silence between us as I try to absorb his words. "There should be an outside source assisting you to wade through the minefield of emotions you're feeling right now. It's my recommendation that the three of you attend together—both your husbands and you." And there it is. I can add polygamy to the long list of grievances I've walked into backward. "Unfortunately, one way or the other, you'll have to figure this out. I take it this isn't an ideal situation for any of you, but I'm sure a seasoned marriage counselor can equip you with the coping mechanisms you'll need to get through it. Together the three of you will have to figure this out. However, I will warn you, this is a unique situation, there is no textbook cure-all."

"She slept with her ex." Kat doesn't hesitate getting down to the carnal brass tacks.

Shit. I kick her in the shin before I remember she has a belly full of babies. Kat has never been perfect—for sure her vagina has never been a shrine to all that is holy and sacred. Not that I'm excusing my behavior, but still.

She knocks me in the ankle. "I meant, her ex-dead husband. Ex doesn't sound right because there wasn't really a divorce."

ADDISON MOORE

"Thank you for clarifying," I say. If I knew she would turn on me, I would have never brought her along for the ride. I shake my head into Dr. Banks. "I didn't cheat." It speeds out of me so quick even I think it sounds like a lie—like some dirty, illicit cover up that I'd like to forget about. God knows the last thing I'll do is forget about that day.

His dark brows furrow as he examines me. Who am I kidding? He can see my lust for Mitch pulsating out of my ears like steam. He pulls a card from his desk and slips it over to me.

"That's precisely what I'm talking about." He clears his throat. "It doesn't feel like cheating, but that is, in fact, the nature of what occurred."

My heart drops like a stone. Max doesn't deserve this. If the shoe were on the other foot, if he slept with Viv, I would die a thousand deaths from a broken heart. Deep down inside I know Max would never do that to me, and so easily I did it to him. I'm a monster. It should have been me that burned in the car that day, but it wasn't, and it wasn't Mitch either.

"I love Max," it comes from me hoarse. "I love who we were—are."

Dr. Banks presses his hand down over the table and smooths the wood as if he were revealing the solution. "There are obviously very natural feelings that led you to intimacy, Lee. I don't want you to be too hard on yourself." He glances at Kat as if that went for her, too. "But know this, you're staring down the barrel of a very loaded gun. You must proceed with caution." He slides several business cards in my direction as if just the one weren't enough to express his concern for me. They all read the same thing, *Dr. Van Guard, Mono Bay Psychological Associates.*

"Thank you." I gather them up like a deck of playing cards—run my finger over the razor-sharp edge and wonder how I ever got dealt such a strange hand.

I wonder if I'll be able to get Mitch and Max to come with me.

I wonder if I'll want to go.

<p style="text-align:center">❦❧</p>

The sun beats down on the house through an illuminated haze as Kat and I pull into the driveway after our meeting with the doctor.

The garage is open, and I see Mitch's blond hair light up the shadows like a flame. My heart soars for a moment. For one brief second it all feels real as if the past five years never happened, and the only reality we live in is the one we bought into on our wedding day.

"Katrice?" Mitch flashes his brilliant smile as he makes his way over. My stomach bottoms out at the sight of him. Mitch still has the ability to make me feel like a teenager at prom.

Kat attacks him full throttle, wrapping her arms around his waist. She gives into long, convulsive sobs and heaves into him as if this were our post death reunion. I fight the urge to join them, to pull into a tight circle, and crush Mitch with the weight of our relief.

"Congratulations," he says, pulling back. He wipes his cheek with the back of his hand, his eyes still glittering like broken glass. "Lee tells me I'm going to be an uncle."

Kat looks uneasy, her lips disfiguring, uncertain which way to turn. "You are." She gives one of her infectious belly laughs and adds some much needed levity to the situation.

"Kat was just dropping me off," I say, hugging her goodbye. I can feel the stress exuding from her like a furnace. I don't want her babies to feel one vibration out of tune, so I usher her to the car and wave as she drives down the street.

"Look what I found?" Mitch erects his old surfboard between us like a testament to the past.

I run my fingers along the pocked wax. It still gives off the soft scent of its perfume, sweet bubblegum mixed with plumeria, as if a half a decade never blinked by. There's a dent on the nose from the time he crashed into a reef.

I step into him and cup the side of his face. It takes all of my effort to resist the urge to cover his mouth with mine.

"Did you think I'd get rid of anything you owned?" The entire garage is chock full of his stuff. Mitch lingered like a ghost for so long, and now he's here reclaiming his things, his family. And, oddly, it's me who feels like the ghost now.

"*You're* gone, Lee." It comes out sad, so low I could barely make out the words.

"Not true." I shake my head as though I were telling the truth. But we both know I'm not. He's right. I gave away the one thing that meant the most to him: myself.

"I'm glad you didn't ditch the surfboard." He straightens as if the entire exchange never happened. Mitch heads over to the hose and melts five years worth of dust off in one long muddy track. "You think Max has a pair of shorts I can borrow? I'd love to go out."

"Sure."

<p style="text-align:center">₭₮</p>

Mitch follows me upstairs and stops shy of the bedroom. He looks in from the threshold, but keeps his eyes glued on me. It's like the furniture—the room didn't exist.

There he is, my husband at the door. So many times I thought I saw him lingering in the house, thought I heard him rummaging around downstairs, calling me in the night, and now he is here, hesitating as if he didn't belong.

"You can come in," I say, coaxing him over like a stray cat. It must feel strange, hugely emasculating, to wait for

permission to do something he's done thousands of times before.

"That's all right." He straightens his spine against the frame instead.

I watch as his gaze falls slowly to the carpet, the dresser. It's as if he can't take it in all at once. Just the thought of Max filling in this sacred space kills him on a primal level. I know it would me.

I riffle through two drawers before holding up a pair of grey board-shorts for his approval.

"Perfect." He holds out a hand for me to toss them over.

"Come and get them." The words come out staggered as though I'm inadvertently taunting him. "I'm not trying to be mean, Mitch." I take a breath. "But I need you to come in. This is the heart of the house, the bedroom you built for us. This is where I cried an entire ocean for you, and I don't want you to fear it or hate it." I can see the power it has over him, how far down it beats him, and I want him to hurdle that wall.

Mitch moves his foot into the room as if he were stepping into a fire. He looks up and gives a bashful smile as he makes his way over. His arms collapse around me like a life raft, and I pull him in close.

"You made it," I whisper into his chest. "You're really here, and now I can never let go."

"I'm not going to let you out of my sight, Lee." He warms my hair with his words. "We'll never be apart again. I swear it."

A stillness takes over the room as Mitch holds me in his warm embrace. He runs his lips over the top of my head, my forehead, my temple before glancing over my shoulder.

"That's our bed," he whispers.

I look back at the malfeasance staring us both in the face. The bed is still unmade. The sheets hold the divot of where Max held me last night.

"I'm sorry." I give it in a broken whisper. I've inadvertently laid out my betrayal for him. I lured him into the

bedroom and force-fed him the most intimate part of my world as Mrs. Max Shepherd. This bed—this unholy witness testifies against me in the worst possible way. Mitch rests his head on my shoulder. He sears his breath into my neck, his wanting emanates thick as vapors. I close my eyes and take in the moment. Mitch holding me in our bedroom as my flesh cries out for his. I need Mitch to cover me like a blanket, to wipe the pain away with his body moving over mine. I'd give anything to savor that feeling just one more time. Mitch has become my carnal addiction, and it severs the final cord of who I thought I was, what kind of person I thought lived inside me.

His deep, calm breaths rake over my skin, and I close my eyes, soaking it all in. An entire waterfall of tears purge from me. I'm ashamed at how far I let the man Mitch hated most penetrate our lives, but it was *Max*. Max who I loved deeply while Mitch was away, and still do.

I glance up to find his eyes lost in a series of crimson tracts.

"I didn't do it to hurt you," I whisper.

"I never said you did."

"You think he did it to hurt you," it comes out accusatory.

Mitch doesn't respond, just wraps his arms tighter around my waist and presses a kiss above my ear.

"I need you back, Lee." He touches his forehead to mine and closes his eyes.

It's so still, so quiet. I can feel the words he wants so desperately to hear trembling just shy of my lips, but before I can own them the sound of heavy footsteps race up the stairs. Max appears at the door, and I jump back from Mitch like a teenager caught in the backseat with her boyfriend.

My mouth falls open as I hold up the shorts. "He wants to borrow these."

Max takes us both in—his eyes wild with disbelief.

"Go ahead." He glowers over at Mitch.

"Thanks." Mitch takes the shorts and heads downstairs. Max spears me with a look before doing the same.

It's slicing me in two, this schizophrenic love. It's reducing Max to dust while I blow Mitch in his eyes like smoke.

<p style="text-align:center">ঙ৩</p>

Stella, Eli, and I sit on the sand as Mitch surfs in the distance. He paddles out and straddles his board waiting for the perfect wave, but, for the most part, it's flat today. The sun lost the battle with the clouds, and a fog bank as tall as a mountain moves in over the horizon.

Max stands a few feet away, hidden behind the veil of smoke from the barbeque. He volunteered to make dinner, and I didn't stop him. He pulls the burgers off the grill then carefully throws on the buns to toast them.

It's all oddly comfortable. Sort of the way I envisioned my life here on the shore with Mitch. Of course that version never included Max, and I guess that would paint Eli out of the picture, but I can't imagine a world without my precious son or husband.

I pull my sweet, dark-haired boy over and let him sit on my lap while he shovels sand onto my thighs.

Max lands on the blanket next to me—his cologne as warm and sweet as he is. "Dinner's ready." He presses out a dimpled smile, but the sorrow penetrates right through. Max wears his heartbreak on his sleeve, and it destroys me.

"Thank you." I push the words out in lieu of tears.

In the distance, I catch Mitch disappearing into the horizon until he's just a speck. It's as if he's sailing back to China because I couldn't get rid of Max, and my heart shatters thinking this might be true.

"What the hell are we going to do, Lee?" Max whispers it out like a secret, while Eli plays with his sister. The warble in his voice lets me know this is his worst nightmare.

"Mommy!" Stella calls and we glance over. "We're going to dig to China!"

"That's nice," I say.

Max's chest rumbles with a dry laugh. I already know he'd like to toss Mitch in that hole. He'll probably buy them each an extra gift at Christmas if they can figure out how to send Mitch back permanently.

"Come here," I say, pulling him in by the back of the neck. Max lights up like lantern. It's as though Mitch were a smothering scarf, and now with my affections, he could breathe again.

"Lee." He comes in with his eyes as deep as the ocean and blesses me with a kiss. I let Max wash over me, and my entire person sings. There is nothing secondary about our love, nothing in me whatsoever that wants to hoist Max to the curb like an old newspaper. Max crashes his lips to mine, and we drink our kisses down like an ancient wine reserved for this very moment—precious, and few, and God forbid fleeting.

"Thank you for loving me," I say as I blink back tears.

"You can thank me later."

<p style="text-align:center;">ଽଠାଔ</p>

It's not until after we get the kids to bed and Max is in the shower that I'm left thinking maybe having Mitch take up permanent residence downstairs isn't the most pragmatic solution.

I pace the floors like a prisoner on death row awaiting a reprieve. Max and his lustful desires, those sidelong glances, the seductive half-smile over dinner—it's all about to culminate, I can feel it.

It made me nauseous to have Mitch at the table witnessing the display. Mitch and those sad forsaken eyes, the hollow of his person resonating his grief as wide and long as an afternoon shadow.

The pipes sound through the room like a death rattle. Max and Mitch under one roof unnerves me. I stop shy of the window and press my hand to the cool of the glass. My reflection stares back at me—a lost girl in a white gown. My face trembles and distorts itself as I make my way over to the bed. I just need to recalibrate, refocus myself, and then I'll figure out what to do.

Max emerges with a towel wrapped around his waist, his hair slicked back, wearing nothing but a wicked grin as he makes his way over to bed.

"Hey beautiful," he whispers, dotting my ear with his lips.

It occurs to me, as Max sizzles his lust-filled kisses down my neck, that I forgot to tell them about Dr. Van Guard at dinner. Of course, with the kids at the table begging for more of Mitch's horror stories, it wouldn't have been the greatest idea. You would think he had been on some amazing adventure the way both Stella and Eli squealed with delight as he recanted his interment. It was nothing but horror, and, now, I want to scrub my brain clean with an ice pick at the imagery he drew up.

Max glides his lips over mine, and all thoughts of dinner and the kids—Mitch—evaporate like smoke. He pulls my dress off in one easy stroke, and I let him. A small ache in my chest writhes at the thought of never making love to Max again. I'm not ready to stop. I'm not ready to surrender all of my heart to Mitch if it means cutting Max out with a hatchet.

Never in our entire marriage have I asked Max to stop, to put it off for another night, and yet Mitch lingers beneath my lids like a poltergeist. I try to push Mitch away, submerge him into the deepest part of my heart where I buried him these past few years, but no matter how hard I try, he pops up like a cork.

I push my hands into Max's chest before things get too far.

"I'm not sure," I whisper.

A seam of moonlight falls over him, and he needles me with an intense gaze. He knows what I'm thinking. He knows I've propped myself up on the fence, and I can't seem to find my way down. He's going to think Mitch won if I tell him I need to clear my head before sleeping with anybody else. I'm not in the habit of depriving Max of his testosterone release, and with his defenses up this probably isn't the best time to start.

"You think we should do this?" I ask, weak, hardly audible over Max's heavy breathing. I doubt Max heard me with all that blood pulsating through his veins. He pulls me to the bed with the impression of a smile.

"You're my wife, Lee," he whispers it hot in my ear. "This is all we should ever do." He pulls his hands down over my shoulder, drips down to my thighs, slow as a week in jail. He lands over me gently and distracts me with mind-numbing kisses, his tongue comforting mine in a poetic lingual exchange.

There's nothing subtle about making love to Max. You can hear his desire—*feel* his cravings. His heart-stopping good looks, his outright nobility has always been like the most potent aphrodisiac. Women fall to their knees around Max Shepherd, always have, always will.

Max pulls his hot mouth down my chest and lands a soft bite over my nipple. His hand dives between my thighs as his fingers work their soft, easy magic. He rolls on top of me, kissing a trail all the way up my ear as he guides himself inside me with one smooth plunge. It's easy for me to get wound up in this sub-primal carnality—an aggressive barrage of wild copulation as he buries himself in my body. He pushes into me over and over and the headboard picks up his cadence. It knocks into the wall with a violent clap in rhythm with his thrusts.

My eyes spring wide open, and I take in a breath. Shit.

Max wants the entire house, the walls that Mitch constructed, to applaud his efforts.

"Are you kidding?" I hiss, digging my fingers into his back. The headboard continues to explode against the wall as I try to catch my bearings. The noise shoots through the house like a series of gunshots, and Max doesn't put any effort into softening the blows.

Up until tonight, we had a pillow stuffed behind the headboard because the clatter has the tendency to wake Eli. Never mind the fact Stella once asked why we knocked on our wall all night long. I had to make up some story about Santa's Elf trying to get inside to see if she was on the naughty list. But tonight, at this moment, the pillow has been forcibly removed, and something tells me this Morse code is being played out especially for Mitch.

"*Max*," I shout his name then cringe at the thought of Mitch mistaking it for a fit of passion. "What are you doing?"

"I'm loving you, Lee," he pants into my ear, never breaking his stride.

Shit. A boiling anger rips through me. My arms and legs are pinned under his like he's done a thousand times before but this feels different. He's making a point and using my body to do it.

He plunges his tongue into my mouth to somehow convince me to go along with the fornicating display of affection, but I can't. I go limp and wait for him to finish, all the while thinking of Mitch and the horror of having to listen as Max Shepherd has his way with me in his bed.

Every charged knock sends a spiral of grief through me, although I'm not sure I could ever be mad at Max. A part of me wants to hate him for his childlike tantrum, but I've defiled our marriage with Mitch, and all Max ever wanted was my devotion.

"You're using me," I whisper in short staccato breaks.

Max collapses over me throbbing and shaking, and I roll him off with no real effort.

He pulls me in and takes in a sharp breath. His chest rumbles, and at first I think he's laughing. He gives a hard sniff into my neck before pressing in a gentle kiss.

"I'm so sorry, Lee." His voice breaks as he says it. The shallow reserve of light slices in through the blinds and highlights the wet slick on his cheek as his bright lips quiver in this dim light.

I wrap my arms around his scorching body and release a river of tears into his chest.

It was Mitch who was tortured, and yet here Max and I were sobbing into one another like a pair of infants. The three of us had emerged from Mitch's captivity damaged beyond recognition, and now nothing will ever be the same.

Mitch

The coffee tastes like it was filtered through cigarette butts. I head outside onto the back patio where I thought Lee and I would log hours, years, sitting side by side staring at the waves. The salted sea air greets me, thick and sticky just the way I remember.

I settle my cup on the table and watch as the surfers try to contend with tiny breaks. The surf is always better down the beach a good mile away at Needles.

My board lies on the side of the house, staring at me, wondering how in the hell life decided to discard us both so efficiently. I'd hit the water to at least sit and think, but after last night's battle of the rattle, sleep was about as easy to find as Bigfoot. Besides, if I did go out, the only way I might truly find some inner peace is to drown.

The steady thump that trembled through the house buzzes in my mind like a horror movie. I can still hear the slam of drywall cracking overhead, the vibrations shot through the wood beams like a tuning fork. I tried not to think about it, but the visual came at me like a flashflood, and I couldn't get out in time to escape.

Shit. I slap my hand down over the table and my mug startles to attention.

Did Lee want that? Did she really want him fucking her in our bed while the walls belted out a tune for me? Hell, what about Stella and Eli? I don't doubt for a minute it didn't wake those kids. For a moment I thought about grabbing a butcher knife and dismembering Max for the hell of it. Although, I doubt a jury of my peers would believe Max was attacking her, but it might have been worth a shot.

I toss my bagel across the sand at a flock of pigeons nearby, nailing one in the head.

What the hell is Lee thinking? If the roles were reversed and I had married some other woman—correction, some other woman who I *knew* was using me as a means of posthumous revenge—I would've happily filed for divorce by now. How is the math so different with Max in the equation? I would have thought she'd kick him in the face trying to get him out the door, toss his crap out the window in a river of wardrobe vomit. What in the world is keeping him safely tucked in my bed at night?

I flex my hands behind my neck and sink into my chair.

I bet his witch of a mother cast a spell over Lee, and with my luck the damn thing is working.

"Morning." Lee clanks her coffee down next to mine. Her hair is tousled in vanilla waves, and she's sporting dark half moons beneath her eyes. I'm not sure why, but they offer me reassurance. Maybe she lost some sleep in the aftermath or maybe they just figured out how to turn the bed on mute and Max continued with his aggressive assault.

I inspect her further, her face swollen and red in patches. Hell, maybe she was crying. Not that I want Lee up all night weeping rivers, but a night or two of abstinence would sure as hell be nice. Or maybe this is the part where she tells me she hates me and wishes I would leave. A part of me half-expects Max to clock me before throwing me into the shallow grave Stella confessed to digging for me.

"You look beautiful." My voice breaks like the pussy I'm panning out to be as I brace myself for the news.

She falls into the seat next to me before running her finger over the rim of her mug. Her eyes have a difficult time connecting with mine, and my stomach explodes in a vat of bile over what it might mean.

"I'm exhausted," it comes from her hoarse, threadbare from a wild night in another man's arms. Actually, I would have preferred just about any other man. At one point last night I thought I heard her shout his name. I told myself it was just the

wind—that Lee would never lose herself in ecstasy to anyone but me, but Eli refutes that theory, and apparently so did the headboard.

"I was up kind of late, myself." I stretch my arms over my head a moment and take in the brine. "Maybe we can catch a nap." I don't mean for it to come out as sarcastic as it does. Truth is, I miss the mornings we spent in bed after a long night of our own passionate exchanges. We would make breakfast and just hang out.

She takes up my hand and covers it with both of hers. Her eyes light up like two red poppies as her lips quiver. "I'm so sorry about last night." Tears brim to the surface. "Max..." She shakes her head in disgust. "I got this card." She forces an anemic smile as she changes the subject. "It's a referral to a psychologist. I heard great things about him. He's practically a saint." She smiles as though this qualifies him to perform a miracle and judging by our all around crap situation he just might have to. "I want you to come. I think I need some help figuring things out. Max will be there."

A psychologist?

My heart thumps in my chest.

Lee is ready to involve the professionals. She's calling out all the wrong authorities when all we really need is one bloodsucking attorney. If we play our cards right, we could walk away with Shepherd and boot Max off to that Cadillac graveyard along with his useless brother. Not that Lee would ever agree, not that I'd have the balls to do it myself now that Stella is equally taken with him.

"Absolutely. Whatever you need." I want to say, *what makes this decision so damn difficult for you, Lee?* "I love you. Do you still love me?" The words shake from my lips without my permission.

"Yes! *God*, yes." She dives over me with a hug and squeezes my chest so tight I'm caught off guard by how strong she is. The sweet scent of her perfume is identical to the one

she wore five years ago. "We're going to straighten this whole thing out. I promise, I will always love you, Mitch."

My stomach clinches. That sounded an awful lot like a kiss off. Like a kinder way of saying, it was nice knowing you.

"I'll always love you, too." My eyes blur with fresh tears, but I don't let them fall.

"I can't sleep with you anymore," she whispers through tears. Lee pulls back and stares down at her hands.

"Says who?" A fresh sting ignites over my skin as if her words unleashed an electrical jolt right into my heart. "Your husband?"

Her eyes rise to meet mine with her head still bowed. She looks afraid, like I might hit her. God, what if that's Shepherd's moronic way of keeping her *in line*.

"Does he hit you?" It comes out a little more aggressive than I mean it to.

"No." She shakes her head in disbelief. "Max would never touch me like that." She spears me with a look as she jumps to his defense.

"So he said you can't sleep with me?" I'm almost amused by Shepherd's insecurity.

Lee blinks into the wind without affirming those words for a second time.

"He's my husband," she says it low, the roar of the waves swallow up the indiscretion.

"I'm your husband," it comes out defensive. "And I say you can't sleep with Max." I've never asserted some asshole sense of authority with Lee before, not that she'd take me seriously if I did. I'm not sure it came out authoritative either—sounded more like a pathetic plea on my part.

A weak smile slides up her cheek as she takes me in. I wonder how long ago she stopped thinking of me as her anything.

"I'm not going to sleep with Max," she says it robotic. "That outburst was for your benefit, not mine." She closes her

eyes a moment and swallows hard. "I'd better go inside and get dressed."

I watch as she heads into the house and passes Max in the kitchen without so much as a glance.

Give Max enough rope, and he'll hang himself. Stupid people always do.

He stares me down until I turn my face toward the murky Pacific. I take in a lungful of sea air as a palate cleanse for my sick heart. Maybe this psychologist will be the road to recovery that Lee and I so desperately need. Max and his manipulative superpowers—they won't last long. The scales will eventually drop from her eyes, and she'll run screaming back into my arms. She said she would cut Max off. I hope his dick dries up and falls off.

Things look promising already.

<center>❧</center>

Not long after Lee takes the kids to school, I meet up with Colt downtown, and he helps me get a cell phone. My mother put me on her Amex card, so I feel right about sixteen again. When we finally make our way back to Mom's, I find a big bag of clothes waiting for me in the entry.

"Thanks." I shuffle through a few items before replacing them in the bag. I'll look like a preppy freshman, first day of school, but I'm not fighting Mom for her good efforts.

The house still holds the scent of bacon from breakfast, so I meander over to the kitchen in hopes there's still some left.

"How are things going?" Her heels clack as she strides alongside me.

"They're going." I open the fridge and inspect the wares before pulling out the makings for a killer sandwich. "Lee managed to get us signed up to meet with a head doctor. She thinks a good shrink is a step in the right direction." A groan

<center>233</center>

rattles in my chest. "Hopefully the three of us will be able to work things out."

"Can I come?" Colton plucks a beer out before the door has a chance to close.

"Sure." I give a lopsided grin. "You can take Max's place." Like he was fucking supposed to in the first place, but I omit that part from the conversation for the sake of my mother.

Mom and Colt take a seat at the breakfast nook as I whittle away my work of culinary art.

"You know this is very hard for her." Mom glances at Colt before looking up at me as if she wanted my brother to back up her theory. "The ball is in Lee's court, and her decision, whatever it may be, will be life altering. You need to give her time. Give her space. You should consider moving back in with me."

I knew we'd end up here sooner than later. All roads lead to me leaving Max Shepherd the hell alone. And for some nagging reason I get the feeling it's not Lee she's trying to protect.

"No," it grunts out of me. "It's my house. Lee's my wife. Besides, she still loves me—told me so this morning." I give a depleted smile in her direction. I'm not about to spout off about the racket they worked up—correction Max engineered. I'll have to think of an equally painful means of revenge. Maybe I'll take Lee right there on the kitchen table for dessert. If it weren't for Stella and Eli, it might have been more than a playful theory. Although the thought of getting rejected in front of Max sends a pang of embarrassment through me. With my luck, both she and Max would slap me.

"So what about Max?" Colton pops an apple in his mouth and takes a loud, crisp bite. "You just expect him to move out?"

"Et tu Brutus? Where exactly does your loyalty lie anyway?"

itudeTUDE OF PASSION

"I'm just saying," he mumbles through his food. "They've been married for like three years. They have kids together. She has to move carefully."

"They have *a* kid together. In the event you forgot, Stella is mine."

"Not according to the adoption records." Colt tweaks his brows as if he were actually refuting the idea. "Besides, it's Max." He holds out his hands. "He'll gut Lee and won't think twice."

Mom gives an audible groan. "Oh, he would not either." She swats Colt hard in the chest. "Max loves her as much as you do, Mitch. It's genuine. The problem with Lee is, she accepted your death. She put it all behind her and moved on like she was supposed to."

There it is. I was swept under the rug and forgotten about much to my mother's approval.

"You know, Mitch," she continues, "there are no rules on how to do this. That girl has a great head on her shoulders, and she's doing the exact same thing I would have done—seek professional guidance." She raises her chin slightly like she does just prior to saying something she'll be right about later, so I brace myself. "Max and you are going to have to accept whatever decision Lee makes. And that will have to be the end of it."

I swallow hard at the thought. "What if she doesn't choose me?" I throw it out there, curious as to what the consensus might be.

"She'll probably choose me." Colt nods into his beer.

My mother gives a slow blink. "If you were Lee, what would you do?"

I give a dry laugh. "Hamstring—eviscerate, draw and quarter... Lots of creative things come to mind."

"No, Mitch." She drops her voice to her lower register. "You'd need a moment to gather your wits. You would want to take the right path, make sure of your footing. She has to think

235

with both her heart and her head. She's going to destroy Max if she chooses you."

A huff of laughter gets locked in my chest.

I've always wanted to destroy Max Shepherd. Not in a million years would I have envisioned this scenario. Quite honestly, it might be the most barbaric means of execution— Lee pulling his beating heart out of his chest and crushing it beneath the soles of her feet.

It's almost touching.

Max

Hudson appears in Townsend field while the morning dew is still suckling off the vineyard. I must be hallucinating or seeing a very real apparition in my brother's likeness because Hudson doesn't crawl out of his coffin before sunset unless a stripper is there to lure him.

"Bar just let out?" I bend over and examine a dry vine, crushing a leaf in my hand until it turns to dust.

"I'm here to pitch in." He grinds the words out like he means them. I glance up in time to catch one of his greasy smiles. His jeans are ripped and dirty. His hair looks as if it hasn't seen the inside of a shower in weeks. "Just trying to earn my keep like everyone else." His foot-long beard moves up and down like he's some moronic puppet.

I struggle back to my feet and take a break from scrutinizing the thirsty row of concords. This will be the third crop I'll lose this season if I don't do something drastic about the irrigation problem haunting this place.

"No sooner does Mitch come back, than all of Townsend splinters to shit." I toss the leaves from my hand. I used to think the Townsend curse was something my mother drew up from her deep well of bitterness, but now that Mitch is here again, all of the dots are starting to connect. "What do you want?" I bear into Hud. "I'm too tired to play along with this I'm-here-to-help-you crap. Cut to the chase. You're here to help yourself to my bank account."

"Now, now." He shakes his head. "Let's start off on the right foot. How are you doing this glorious morning?"

"Shut up, Hudson." I pluck a dehydrated vine right out of the ground as if I were doing it a favor. "There's no brotherly

love lingering around at this early hour. We're in the no bullshit time zone, so go ahead and shoot straight."

"No bullshit time zone?" He lets out a raucous cackle. "Let's start this day out with a touch of gratitude. I bet you've got a list a mile long of things you're grateful for."

"I woke up on the right side of the dirt, so there's something." I head over to an adjacent row and start examining leaves for signs of moisture fatigue. "Damn plumber wants a hundred and seventy-five grand to replumb. He'll tear through the roots and cost me the vineyard. I'm sure Mitch would be happy to fashion a noose for me to help ease my sorrow."

"There's a good attitude." Hudson's special brand of illegal cologne wafts over me. "So you're lovin' life." He pours on the sarcasm thick as shit. "How's Lee doing? Heard you have a houseguest."

"He's no guest. According to Mitch, I'm the guest." I stop to gauge Hudson's reaction. "Can you believe it? I've been with her for the last five years. We been married three times longer than they ever were—we have a family. I'm the guest?"

His features harden. Something sinister is brewing behind those stoned lenses, and for a moment I think we're actually sharing a brotherly moment. I like the idea of Hudson good and pissed just for me.

"All right." I slap the dirt off my thighs. "What is it? I don't have time to try and read your half-baked mind. I've got a business proposal due in two hours, trying to convince a national retailer to carry Townsend at a big box store. But right about now the only thing I'd like to bottle up and sell to a big box store is Mitch." Hudson, too, but I leave that part out.

"I know people who can make it happen." He cuts a glance across the field. "Just say the word, and Mitch disappears for good."

"No thanks." Fuck. Is that what I want?

I walk toward a row of healthier looking vines. It's never a good sign to see a cluster of life with death entombing it like a

wreath. I shear off a couple leaves from a fresh vine and mash them around my fingers. Moist. Smells ripe, healthy. Plumbing either works or is leaking like a sieve beneath this stretch of land. The only gusher I know of is fifty yards south, and I'm only aware of it because the ground has turned to soup.

"No killing Mitch, you got that?" Sometimes you have to spell things out for morons like, Hud. "You can get wasted and beat the shit out of him on holidays for me if you want, but every one lives to see another day."

"About seventy-five grand can cause a mighty fine accident." He shrugs. "It can move a lot of things—people. Sometimes life's just easier with some folks not around."

I turn into him, shielding the rising sun out of his eyes with my frame. "Seventy-five grand? Is that what it's going to take to get you out of my way today? Lady luck didn't feel like licking your balls this week, huh?"

"Quarter horses."

"Great. I'm going to lose everything I own because of a giant jackass, and I'm not talking about the horse." I push him hard in the chest and knock him back a few steps. "Why do I get the feeling these fucking pipes are the last thing I need to worry about?" I roar. "You and your nitwit friends are going to take down everything I worked for."

"Hold up." He steps a safe distance away from my fist. "I'm talking about doing you a favor, remember?"

"*I'm* dealing with Mitch. Are you here for a withdrawal or not? Does my fucking ass look like an ATM machine to you?" My voice riots over the field like thunder.

"Whoa." His eyes widen as he takes me in. "Never seen you so worked up before, buddy."

"Welcome to the new me. You want the cash or not?"

He cocks his head before giving a slight nod.

If Lee is looking for that one glaring reason to leave me, this just might be it. "And if I don't give it to you?"

"You probably won't see me for a while—eternal ramifications and whatnot." He glances off at the horizon. "You never did care for Townsend field did you?"

There it is, the not-so thinly veiled threat.

"You're a lousy gambler, and a lousier brother, you know that? Your stupid stunt on the tracks could cost me my marriage. And, for your information, nothing can happen to the fields. This is Lee's baby." I turn toward the sun, and let the heat beat into me, nurturing the headache that's promising to blow my brains out through my nose. I let the fire sear through my scalp and brand me, but it can never match the pain I feel on the inside.

"How about I toss in a bonus for you?" He glints into me with the threat of erasing Mitch off the planet.

"Like?"

"Like I give you an extra hug for your birthday." He winks as the sweat builds on his brow.

Seventy-five grand goes a long way. He had to have known I wouldn't lend it to him. I'd be an idiot to do it. I bet he'd be damn grateful if I did. I bet he'd throw in a few personal favors if I wanted.

I vacillate over the idea for another minute, long enough for the sun to fry my last living brain cells.

"Yeah, okay." I wipe my forehead with the back of my arm. "I'll wire it into your account this afternoon. Don't say shit to anyone. If this gets back to Lee, we're finished." But it will. I always tell her.

Honesty isn't always the best policy.

ଧଓଔ

After the bank, I get home ready to shower a film of dirt and Hudson off my flesh before I crash. Three o'clock will be here before I know it, and I want to pick up the kids with Lee.

Voices emanate from the downstairs guest bedroom, and I make my way over. I spot Lee dashing into the bathroom and Mitch propped up on the well-made bed like a prince waiting for his grapes to be peeled. Lee pops back and brushes by me with a quick hello.

"What's going on?" I follow her down to the linen closet.

"Just getting some fresh towels for the bathroom." She pulls a shoulder to her ear and presses her lips together until they turn white. "I'm making up the downstairs bedroom for him." She doesn't say his name, just grabs a stack of towels and makes her way back to the room.

"Lee?" A flash of anger rips through me. I'm already pumped up from having to refill Hudson's tank. I'm pretty damn tired of the way he treats my personal bank account like some magical piggy bank. The last thing I need is Mitch and his never-ending suitcase.

"How's it going?" Mitch smooths out the covers before giving an energetic bounce on the mattress as if testing out the springs.

"Get the hell up, you're not staying," I bark. "*Lee?*"

She jets out of the guest bathroom with her eyebrows pitched into her forehead, clearly annoyed.

"You can't be okay with this," I choke on the words.

"He's ruining the couch"—she bears into me with those glacier clear eyes—"and his back." She looks over at him as he burrows himself deeper into our lives. "Tomorrow at four we have our fist meeting with Dr. Van Guard." She says it like it suggests something—a means to an end. I hate to break it to her, but I have a feeling it's going to be a lot more like running on a treadmill—wear us all out without taking us anywhere.

"I can have him forcibly removed," I say. "A restraining order doesn't sound like a bad idea either." I look right at him when I say it.

Mitch nestles his head into the pillow and mocks me in the process.

"Nobody is getting a restraining order." Lee shoots daggers at me as she plucks a blanket from off the dresser. "What if the shoe were on the other foot? How would you expect me to treat you?" Lee is desperate. She wants to evoke the sympathy card with her role reversal game.

"What if it were *you*." I put it back on her. I don't give a shit that we're arguing in front of Mitch. I glance back at him propped up on one elbow, and his gaze drops to the floor. "What if another woman walked out of the woodwork, and I pined for her under our roof—*slept* with her. Would you be so accommodating with a stack of fresh towels? Would you lend her your bathing suit?"

The color bleeds from her face as she leans against the dresser for support.

We hadn't mentioned it since that night. I'm sure she was hoping I forgot. I wasn't a hundred percent sure she slept with Mitch, but I didn't need a diagram after feeling her regret the minute she stepped back in the house. She mentioned they were "together," and I did the math. Looks like I'm good at math.

"Max," she expels my name in a sigh. "I'm so sorry," she mouths the words, and it makes me wonder if it's Mitch she's cradling in the process.

"I'm sorry, too." I catch his eye, and he glares back at me. For one solid minute I contemplate barreling over and twisting his head off. Maybe I can bury it at Townsend and stop that fucking leak that's killing my business.

Instead, I head upstairs and hit the shower. Dial it up to a decent temperature and wish to God it was Lee pushing me into the fire breathing hell—that she were watching me—waiting for me to get out and make a baby with her—that Mitch stayed dead and buried—that he was nothing but a blip in our memory banks.

I don't know what the hell Hudson is going to do with that money. I think a part of me caved so easily because I want

to believe he's being the protective older brother. That he's going to put a hit on Mitch and not gamble all our profit away like the screw-up he's truly become.

I turn off the water and let the steam swirl around me. So that's it? I've reduced myself to murder by proxy? Pinning all my hopes on my fucking brother, of all people, to pull off the perfect felony? How the hell can I even think of burying Stella's biological father with her present to witness the event firsthand? This isn't what I want. I don't want Mitch Townsend dead by some misinformed target I may have inadvertently put on his back—not now, not ever.

I used to like Mitch. Even when he hated me, I never held it against him.

Now I don't know how I feel about him or the person he's turned me into.

The Counselor

Lee

Dr. Van Guard's office is on the second floor in an unassuming Spanish style building that I've mistaken for apartments the last ten years of its existence. Mitch and Max flank me on either side, both of whom drove here on their own, Max from Shepherd and Mitch from Townsend field where I heard he raised hell today, but that's another issue entirely.

Dr. Van Guard is a happy older gentleman with a circle of grey hair and a warm perennial smile. He nods as I explain our predicament, folding his hands together then pulling them apart, over and over.

I finish with, "And, I feel like I'm married to two different men."

"Unusual dilemma." His eyes widen as he digests everything I've told him. "I think this is something we need to tackle as a team. The three of you need to commit to coming in as a group. I think it's best we break up the session in thirds—first with Lee and one of you, then Lee and the other, then we'll end with the three of you together. Of course, if one of you would like to see me individually we can arrange that as well." Mitch and Max eye each other to see who'll cave first to the

one-on-ones with the good doctor. And, just as I thought, neither of them volunteers.

"Very well," he pinches a smile. "First, I'd like to hear from the gentlemen. Mitch, explain to me how it is you're doing emotionally. What did you hope would happen when you came home, and what resolution are you expecting? Realistically speaking." He reclines deep into his chair and starts in on a never-ending nod.

"I wasn't sure what to expect." Mitch takes in a lungful of air and looks over at me with a mournful expression. "When I called my brother and told him I was coming home, I specifically asked him not to tell me any details about Lee. I didn't want to suffer through the plane ride home knowing she moved on." He turns to me. "I'm so thankful you came to the airport." The words push out of him with an exasperated sorrow.

My heart breaks for Mitch all over. All of those raw emotions he must have felt and he needed to keep to himself, if just for one more day.

"I'm glad I was at the airport, too." I reach over and take up his hand for a moment. It feels safe to do that in here—to comfort Mitch in Max's presence for the very first time. His features look crisper. He's filling in, looking more like himself than ever before. He gives a brief smile and my stomach clenches just like it did in high school when I first fell in love with him.

Mitch clears his throat. "I figured since so much time had passed that she probably remarried." He nods over to Max. "But I guess deep down inside I thought no matter who she was with, I thought for sure she'd leave that behind for me. I would have done the same for her."

His words sink in my chest like a dagger, stinging, uncomfortable—making me wonder if I could die from the wound.

Dr. Van Guard nods. "It seems reasonable. You've loved her all along." He shifts his attention to the other side. "And Max? After you had a chance to process the fact Mitch was alive, what did you expect might happen?"

It's all eyes on Max. He looks to the floor, rotates his wrists one over the other until he gathers the strength to drag his eyes over to me. "I thought maybe ..." He straightens in his seat, expands his chest with a breath until I'm sure he'll explode. "To be honest"—he pats me on the knee—"I thought you were going to ask me to leave." His face ignites a bright shade of crimson. "But you didn't. You did have an indiscretion." He sinks his words in his chest as if they had the power to fashion themselves into a blade and eviscerate him right here in the office. God knows they gutted me. "I'm one hundred percent here for you, Lee—for our family," he says picking up my hands as if we were renewing our wedding vows. Max and his mesmerizing eyes, that infectious smile that trembles ever so slightly just for me—how could I ever hurt him when all he's ever done was love me? "Before Mitch stepped back in our lives, we were right on track." He drops a quick kiss to the back of my hand. "Trying for another baby, running our business shoulder to shoulder. You challenge me. There is nobody else on this planet that I'd rather be with." His eyes glisten with tears. "I'm staying put, Lee. I'm fighting for our family, for *us*." His voice breaks and he swallows hard. "It crushes everything in me to think that maybe you wouldn't do the same."

A knot the size of a baseball clots up my throat, and all I can do is nod.

Obviously coming here was a big mistake. Of course, I want my family with Max, or I would have been out the door the first day Mitch came back. Of course, I want my family with Mitch restored. He's my husband. So is Max. Now I have two. Why is that so damn illegal?

"Lee?" Dr. Van Guard blinks into me. "You look as if you're in a lot of pain. Would you mind sharing your thoughts?"

"Actually, I would mind." I cut my gaze over to a dehydrated Ficus dying in the corner. I know exactly how those brittle leaves feel. I'm trying to hang on as best I can, but the fall seems inevitable.

"That's understandable." He seems unfazed by my curt reply. "I'm going to ask one of you gentlemen to please leave the room for about fifteen minutes and wait in the lobby."

Max rises and shows himself out. No sooner does the door close than Mitch scoots in and wraps his warm arms around my waist.

"Lee," he whispers while brushing a kiss to my cheek as if it took all of his strength to wait to comfort me.

Dr. Van Guard clears his throat. "Mitch, I noticed you were very respectful around Max." He squints out a placid smile. It seems plausible that the good doctor never stops smiling, in fact he could deliver the worst news possible, and that perennial grin would be right there at the ready.

"Sounds like I've got you snowed." He presses a kiss in my neck when he says it.

"When you moved back into the house, were you at all concerned about the strife it might cause?" He narrows in on Mitch with his dark brows, the thick creases on his forehead let us know he means business.

Mitch glances at me before answering. "Not really." There's something harder about Mitch than I remember, but, then again, he's never had to fight for my love before or anything else for that matter, and now he's lost everything. Not that I meant to take anything from him. I would have given him my soul if he wanted it—he already has it. "Max and I have a long history." He blinks a wry smile. "The Shepherds as a whole have an ax to grind with my family. During our junior year of high school his mother lured my dad into an affair. Long story short, it resulted in the death of my father—my family."

Mitch cleverly omits the salacious details of how his father actually met the grim reaper—in her bed, consumed with lust for Sheila Shepherd all the way to eternity. Come to think of it, I've never heard Mitch acknowledge that fact out loud.

"I'm sorry about your loss." Dr. Van Guard's features dim, in honor of Mitch's dead father before the smile springs back to his face. "And before that? Where you on speaking terms with Max?"

"They were best friends." I'm not shy to interject the strange fact. "Their families did everything, went everywhere together. We've known Max since grade school."

Dr. Van Guard looks amused. "So, Mitch, when you gleaned knowledge of the affair, did you end your relationship with Max cold turkey?"

He leans back in his seat, reluctant to answer. "Something like that."

"Not at first," I offer. "It came out in February, right after your Dad died, and you stopped speaking to Max that summer. There was name calling involved, but it never escalated into a fist fight or anything, did it?"

"Nope." He gives my waist a gentle squeeze. "Still saving my left hook for a rainy day." He twitches a smile.

"You see storm clouds on the horizon, Mitch?" Dr. Van Guard peels off his glasses and leans in as if to inspect him for evidence of just that.

Mitch nods. "Category five—gathering momentum as we speak."

I have a feeling all unholy hell is going to break loose one day soon. Max should very well fear for his life when it comes to Mitch and his left hook. Something tells me he's out to avenge a whole lot more than the fact Max Shepherd attached himself to me in holy matrimony. He's out to avenge his father's death as well.

ℬ◯ℭ

Dr. Van Guard excuses Mitch as Max takes his place by my side.

Max takes up my hand as if it were made of glass. He presses a kiss over my fingers with a seam of tears already lining his lashes. I brush my fingers through his dark hair and lose myself in his cobalt eyes for a moment. My insides detonate in a vat of acid at the thought of losing Max forever.

"You okay?" He bears into me with his earnest intent. Max always puts me first, and here I've shoved him into a fire. I wonder at what point he stops caring about me and starts in on hating me for taking so damn long to decide what to do. Deep inside I've never believed I deserved Mitch or Max's love—anybody's for that matter. For a long time I thought my parents left me—ran away because Katrice and I were so bad.

"Max, you mentioned an indiscretion." Dr. Van Guard taps his pen to his desk steady as a metronome. "Tell me what you know."

My stomach sinks like a stone.

Crap. I don't like the way he worded it. It makes it sound as if Mitch and I dished out some titillating details we've been harboring from him.

He gives my hand a gentle squeeze, and I nod over at him. I want Max to purge his emotions—vomit our lives out from these past few weeks to see if we can find a way to salvage something in the process.

"The day after Mitch got back, Lee offered to take him to breakfast." His features harden, the muscle in his jaw pops. "And"—he chokes on the words—"they checked into a hotel instead."

"That's not what happened." My voice gives a soft wobble. "I begged you to come with us." I glance at the doctor. "I wanted Max there, and he wouldn't come."

"I stayed with Eli—he had an earache." Max keeps his brows even with his glare.

"Your mother would have watched him," I say it measured, careful not to rock the boat. Oh, what the hell. "Eli had very little to do with why you didn't get in the car that morning." And there it is. I know for a fact I would have never slept with Mitch with Max there to watch over me. I was insane, lost in a waking dream and I needed him. I needed both of them. "I asked you, several times, to please come with me."

"Is it because you were weak, Lee?" Max gives a slow blink as he waits for the answer. There was not one ounce of judgment this time, just an observation he wants to quantify with the facts. "Because if you would have rephrased the invitation by telling me you were probably going to fall into bed with him if I didn't chaperone, then yes—I would have gladly gone with you." His tone sharpens. The temperature in the room drops about twenty degrees with Max's icy stare. "Or was it the plan all along for me not to go?"

Shit. This is turning into a bloodbath. This isn't helping. It's terminating my matrimonial union—sacrificing it like a lamb at the slaughter.

"I didn't *plan* on anything. I told you what happened. The restaurant was full, so was the dining room in the hotel. We had a concierge practically shove a key down our throats. We just needed someplace to talk in peace, that's all." Why in the hell did I ever volunteer to come here? All this emotional chaos makes me want to crawl into a coffin and sleep alongside my mother.

"It was an affair, Lee," he says it calm, almost quiet but his eyes bloom in a pink shower of pain and let me know how much this kills him. "You broke a sacred trust." He swallows hard. "Lee," my name comes out almost inaudible, "I forgive you." He pulls me in and dots a heated kiss over my lips. "I'm not bringing it up ever again. It's done for me. So this is what I'm wondering"—he shifts in his seat—"if it's over for you like

250

you swore to me that night, why is Mitch still occupying space in our home?"

"Because he thinks it's his home," I say it weak.

"Then maybe we should take our kids and move."

Max is stoic, unrelenting in his love for our family—equally devoted to his hatred toward Mitch.

"One thing at a time." Dr. Van Guard taps his pen. "Max—Mitch shared with us a little about your history together. What I find interesting is that there seems to be a gap of about five or six months between discovering your parents were having an affair to the disconnect in your relationship. What do you think happened?"

"What did he say happened?" Max squints into the question as if he might have an inkling, but he's slow to share.

"He said it fizzled out that summer."

"Fizzled out is right, but I'm not sure why. I wouldn't mind an answer to that one myself." Max leans back and exhales. "We were hanging out long after his dad died. I was a pallbearer at his father's funeral. We did everything together. Then I left that August to go back East, when I came back I was blackballed by Mitch and his friends. They ruled the school, so it made for a pretty lousy senior year."

That was the year he got together with Viv. No wonder—she was practically a pariah herself.

"I'm sorry." I pull him in and rest my head over his chest. His heart beats with an unsteady rhythm, and I want everything else to disappear so I can linger here and feel Max thunder beneath me for an eternity.

"Not your fault." He lands a soft kiss on the top of my head.

Dr. Van Guard flicks his pen in our direction. "What did you think of Lee during high school?"

"I worshiped her." Max gives a sad smile.

I blink into him, stunned. After that night we shared together, he went on vacation. When he came back, he didn't so

much as look twice in my direction. I wonder what would have happened if he did—if he brought his worship front and center.

It might have changed everything.

Mitch

The secretary motions for me to head back inside, so I do.

Lee's got a wad of tissue in her hand. Her eyes are lit up like stoplights, and she looks like she's been dragged behind a freight train.

What the hell did he say to her? It makes me want to snatch the gold pen the doctor has been molesting and jab Max in the eye with it.

"Hey, you okay?" I whisper to Lee as I take a seat. She nods and takes in a quivering breath that suggests otherwise.

"I'm glad I had an opportunity to meet with the three of you." Dr. Van Guard strums his fingers. "Normally I like to see my clients once a week, however, this is an extraordinary situation—I think it's important we progress a little quicker. I'd like to see you back in three or four days. Does Monday sound good to everyone?"

We nod in turn.

If it helps Lee shed Max like dead skin, I'll show up every fucking day and twice on Sunday.

Dr. V nods. "I'd like to give you some homework, but before I do I need to clarify something to you, Max."

Great. Clarify the fact he needs to be disposed of—quickly. I fold my arms and wait for the anvil to crack his skull in half and reveal the maggots crawling around inside.

"Max, I'm not asking you to take a break from your marriage. In fact, quite the opposite, but what I do ask of you is to keep your mind open for the sake of helping Lee come to a clear decision of what she needs to do." He shifts his focus. "Lee, if in your heart you feel like you're married to two men like you mentioned, you're going to need to do some real soul searching. I suggest you spend some serious time meditating

over this and really listen to what your heart says. The homework will be quite simple. Mitch, you take Lee out on a date tomorrow night, if that works with your schedule. And, Max, you take her out the next night. This isn't a couples night, but more of a first date if you will. Lee, I would caution you from treating either of these men with intimate relations until after you've come to a firm decision. It wouldn't be fair to anybody until you've decided what direction you're going to take in life. As for sleeping arrangements, I'll let you figure those out."

A weight lifts off me, heavy as a king-sized bed. One good thing came from this. Both Max and his dick have been handed restraining orders. It's hard trying to hide the shit-eating grin threatening to break out on my face, but I keep it under wraps for Lee's sake.

"Any questions?" The good doctor pans the three of us.

I raise my hand just enough. "So would you suggest that Max move out of the bedroom?" Say yes.

Max leans in and glares. It looks like the penile chastity belt is starting to pinch his balls.

"I highly recommend this." Dr. Van Guard nods in agreement. "Then again, I can't enforce any rules."

"Mitch took the guest room." He shrugs in my direction. "Looks like you should've built a bigger house or never left for China, but then you never make the right decisions, do you Mitch?"

Lee's eyes expand wide as dinner plates. She doesn't seem too impressed with the Mr. at the moment. I'll just keep handing Max some rope, sooner than later we'll have a marriage to bury, and it won't be mine.

ℬℭ

We head off in separate directions with Max telling Lee he'll pick up the kids. I'm sure he'll do the laundry, the dishes, and lick the floors clean with his tongue to get on her good side.

I tell Lee I'll pick up dinner, but I need to swing by my mother's first. It's not until I make the final turn that I see Max's SUV sitting high on the driveway with both Stella and Eli spilling out of the house.

I park and run up with a smile on my face just for the kids.

"Picture Daddy!" Stella barrels into my arms at top speed. Eli says something that sounds just about the same, and I give an amused smile over to Max.

"That's very cute," Mom says, mostly to defuse the time bomb that is Max Shepherd.

"Cute indeed," Max says without an ounce of enthusiasm. He unlocks his truck, and it burps and squeaks to life. The kids hop on in like they've been training hard for the Shepherd circus. God knows once I remove Max from the picture, I'll spare them of that fate.

"So"—Mom looks from me to Max—"how'd it go?"

"It went." Max gives her a hug and plants a kiss on her cheek. "Thanks for watching the kids."

"Max has to move out of the bedroom," I offer. "We're all booked at Townsend Inn. Maybe you've got a few rooms to spare. Why don't you move here for a while, Max?" My lips pinch into a smile, and I don't bother holding it back this time.

"Out of the bedroom?" My mother places her hand to her chest as if the thought made her sick. Another man is shacking up with my wife, and she's *stunned* he's been ordered to haul ass off my fucking bed? Obviously the Shepherd spell is much more potent than I give it credit for. We should have steered clear of the entire lot of them from the beginning. I'm sure after giving it some thought, Mom would be the first to agree.

"I'm not going anywhere," he assures in that calm annoying baritone of his. "In fact, Mitch officially moved into

the guest room—we're all getting along famously." He glares into me once my mother has her back turned. "You up for a game of Scrabble later?" He taunts me with the gesture.

"You bet." I wonder how many points I can get for *asshole*.

The phone rings from inside, and Mom excuses herself as she waves to the kids.

"Chinese okay for dinner?" I ask, mockingly.

"It is if you're going to China to get it." He gives a placid smile. "I'm okay if it's a decade or two late."

"Fuck you," I say it low for his ears only.

His eyes steady in on mine. "No Mitch, that's what life did to you."

"Nice," I say as he gets into the car. I wave to the kids as he backs out of the driveway with a tailspin.

Mom speeds from the house and sticks the phone in my hand.

"Mitch?" A familiar male voice booms from the other line. "Kyle Wong."

"What's going on?" I breathe into the receiver still amped from the exchange with Max.

"What are you doing tomorrow at three-thirty in the morning?"

"Sleeping."

"Wrong. It's time for your fifteen minutes my friend."

Max

"I'm thinking Eli's room." Lee taps her finger against her nose.

"I'm thinking not." I breeze past her into the bedroom and pull out a pair of sweats and a T-shirt from the dresser.

She follows me in and sits down next to me on the bed. The soft scent of spring flowers trails her—a scent that used to make me happy, and, now, it just makes me uncertain. On more than one occasion when she wasn't home, I'd take the cap off her perfume just to inhale her scent. It would feel like she was right there with me—Lee in a bottle. And now I wonder if that's all I'll be left with once this nightmare is said and done—a bottle, a scent, nothing but perfumed air.

The kids are downstairs, busy with the all important childhood task of watching the tube. Thankfully, for my sanity, Mitch is still a no show. I'd rather starve than have him play delivery boy.

"Max"—Lee pulls my hand to her mouth and holds it there—"you're not really going to stay in here, are you?"

"Yes," I say bewildered. "I'm really going to stay in here." I pull off my jeans and throw on my sweats. I'm hoping it'll be this easy, and Lee will agree—*demand* I stay in the bedroom. "We like sleeping together, it's what makes us, *us*."

"I know." She falls back on her elbows and closes her eyes a moment. "But Dr. Van Guard says we should have you move for a little while. I can bring up an air mattress. Eli would—"

"Eli would wonder what the hell went wrong. So would Stella." I steady my gaze over her. Lee's top is slipping off her shoulder. Her lips are parted like a promise. If I didn't know better, if we were the old Lee and Max, I would swear she was seducing me. "Right now things seem to be working with me in here." Not really, but I'm not that into details today. "I swear

I'll keep my mitts to myself." I hold up my hands before collapsing over her on the bed. Lee pants into me, her eyes steady over mine with that wide-eyed innocence I love so damn much. I dip down with a kiss and hold my lips over hers waiting and then she does it, Lee pulls me in by the back of the neck and swipes her tongue over mine, delicate at first then demanding, large and in charge.

"You still want me, Lee," I moan with a smile sliding up my cheek. "Your tongue just testified to the fact. Let me stay. I'll behave."

"Like you are now?" She pushes my finger into her mouth and bathes it between her lips causing my sweats to pitch like a tent.

She's not behaving, but I'll be the last person to call her on it. Hell, if she wants to break all the fucking rules I'm one hundred percent on board.

I take her hand and place it over the rock hard protrusion she's causing in my boxers.

"See what you do to me?" A soft laugh rumbles through my chest. "Let me sleep here tonight. I'll voluntarily withdraw my weapon." I place her hand gently by her side. "Although, I can't be blamed for any actions that take place in my sleep." I plant a kiss on top of her forehead and linger. "Besides, I broke my back in the fields yesterday." I roll over onto the mattress and groan under my own bodyweight. "You don't want me going out on disability, do you?"

"Definitely not, considering it dings my labor report." She hovers over me, looking at me with those long, dark lashes. A burst of light glows in through the window as her face illuminates from the fuchsia sunset.

I take her in like this—Lee, the golden goddess. She can rule the universe with her smile alone. Her eyes could spark a thousand revolutions. I'm damn lucky I only have one jackass to fight off. Unfortunately, for me, the jackass in question is Mitch.

"You're so beautiful." I pull her down and press my lips over hers. We indulge in another mouthwatering kiss and somehow manage to forget the world for the next few seconds. I can lose entire decades just listening to the small moans of pleasure that escape her throat when we're together like this.

The front door rattles then slams.

"Honey, I'm *home!*" Mitch shouts up the stairwell with an all too jovial tone.

"Perfect." I twist my lips.

Lee blesses me with another quick kiss. Somehow that small gesture assures me I've still got an in, that I've got more than a foot in the door and perhaps a body to lie next to at night.

"Hey"—she whispers, scratching at my chest—"how'd you think it went today?"

"Better than expected." The fact I didn't have to yank out my intestines and strangle Mitch with them was a major plus. "But I'm not going to lie, it makes me insane that you feel like you're married to two people." I swallow down the tennis ball forming in my throat. "But I get it."

"Max." She gives a peaceable smile that quells me far more than words could ever do. "I'm not going anywhere. I'm here for you, I swear it—and for our marriage. I just need help wrapping my head around the fact Mitch is alive. That's all, I promise."

This time I don't fight it. My eyes brim with tears, and I blink into her several times. "You're not leaving?"

"No." She answers so quick—so sure, I'm stunned by this.

"I love you so much it hurts." I pull her in and kiss her, deep and wide as the unknowable ocean. Lee just spilt an entire sea of assurances.

I have my wife back.

I'm not losing her to Mitch Townsend, not to anyone.

※◎※

I handle dinner with Mitch just fine. I offer to do the dishes and even manage to whistle while I work to prove I'm not worried about any "date" he's taking her on tomorrow night. Lee helps Stella with her homework at the table, and I can't stop stealing glances at her, smiling like an idiot. Of course, I'm not going to rub the conversation I had earlier in Mitch's face even though it takes everything in me not to. Nope. It's definitely good enough watching him writhe in all my glory.

He eyes me like a vulture once I tell the kids to get upstairs and brush their teeth.

I get Stella and Eli to bed in record time, promising them both a lollipop if they stay put for the night.

I head into the bedroom where, contrary to Mitch's greatest wish, I'm still allowed to reside.

Lee comes out of the bathroom, showered with her hair still damp on the ends. She's wearing the purple silk nightie I bought for her birthday, and I take it as a green light of good things to come—namely me. I don't need a hand-written invitation. I replace the pillow behind the headboard in an effort to secure the covert opts that are about to take place beneath the sheets. Sorry Mitch, the peanut gallery is closed tonight.

I turn out the lights and pull her in as she crawls beside me.

"Hey," she bleats.

"Hey." I lash my tongue up the side of her face as a preview of the many things I have in store for her.

"No, I mean, *hey*." She tries to sink my hands off her hips, but I spring right back up again.

I'm aware women are complex creatures. Lee is of their species, so technically I shouldn't be stunned by her somewhat

polarizing reaction, but still. She turns her back to me, so I start in on a slow massage.

"Thank you," she moans.

I pepper soft kisses over her spine. The taste of her shower sweet skin drives me insane. I would do anything to make love to Lee, for her to show me she still wants me, wants us. It takes another five minutes before I move my massaging techniques south of the border. Lee was never one to let a potential orgasm go to waste. My hand slips into the warmth between her thighs. She's so wet it takes every ounce of strength in me not to plunge inside her. I plan on keeping my hard-on away from the party. I want this to be all about her.

Lee turns around and crashes over my lips with a searing kiss. I brush my thumb over her face and feel the hot river of tears covering her face. This is killing her just as much as it's killing me.

She closes her fingers around my erection and guides me in until I give an involuntary groan. I could die happy like this with Lee. I'd keep our love making a dirty little secret from the moron downstairs for the rest of our lives if that's what it took to keep Lee in my life. Hell, I'd house Mitch in the downstairs doghouse for as long as she liked, so long as we could end every day in this same manner.

I push into her slow and determined. I don't think that since our wedding night it's felt this fragile, this amazingly fucking glorious to bury myself inside her. Lee is the only woman I've ever wanted, the only woman I've ever enjoyed. There's no losing her. My entire world would evaporate without her in it.

"Lee," I groan into her ear.

She pushes me in by the small of my back, and I clasp onto her wrists as I thrust into her with wild abandon.

We test out the pillow wedged behind the headboard for the next several hours. Every inch of her flesh is new again. It was as if almost losing one another brought us closer as we knit

together in sorrow. Mitch and his wonderful midlife resurrection backfired—thank God almighty for the biggest miracle of all.

"Shit," I give it in a heated whisper as my body trembles over hers. Lee lets out a heated cry, her breathing erratic in my ear, letting me know she enjoyed the hell out of the moment, too. Her legs clench around my body, and I hold her there like that.

"I'm changing all of the labels in the morning," I tease through a sea of heated kisses.

Lee looks up at me with her pale, glowing eyes.

"What's the label going to say?" she whispers.

"It's going to say *a good year* next to the date." I pull my lips across her cheek in a sweet line. "We're going to survive this, Lee. I know we will."

"A good year," she parrots back.

"The best."

⠀⠀⠀⠀⠀⠀⠀⠀**ᔥᘐᙘ**

"Wake up." Lee rattles my shoulders, and I startle to attention. She lands a series of soft slaps across my cheek as I blink to life.

"What?" I spike up in bed. The alarm reads three-thirty.

"Something's happening downstairs." She draws the sheets to her chin. "I hear voices."

I pull on my sweats and throw on a T-shirt as I hit the stairwell. A heavy stream of light pours in through the shutters—it beacons through the window at the top of the door as if it were trying to direct a ship at sea.

"What the?" I pull the front door open to find an entire Hollywood back-lot set up on the street. Three news vans and an entire slew of people mill around as if they belonged there.

"And there he is," I whisper. Mitch is firmly seated in a director's chair with a camera pointed in his face.

I storm out on the lawn just as a man with an earpiece strapped to his head stops me cold. "We'll be done in about ten minutes."

"What's going on?"

"Interview. East Coast is live."

"What network?"

"WKLA, the Breakfast Show. Then FNX news."

The *Breakfast* Show? FNX? That's national coverage. I head back in and herd Lee toward the family room. I flip on the TV, and son of a fucking bitch...

"Right now we're trying to work things out." Mitch stretches a smile across his face. There he is in full Technicolor gaping back at me as if he's got all of the cards in his favor. It's all starting to feel like a bad dream.

"And what about the company your father built?" The woman interviewing him nods as though anybody cared. "Have you recovered your footing? Are you taking over once again?"

"I can assure you I have an entire legal team helping me navigate my way back to the helm. I ran that company six years after my dad died, and I intend to run it until the day *I* die."

"Run it into the ground," I quip, and Lee jabs me in the ribs.

"So tell us about your daughter. How did she handle the news?" The reporter folds her hands into her lap like it was no big deal because it's not her life she's fucking with.

"Can't Mitch see she's a wolf waiting to devour Stella's privacy?" I'm shocked he would let her go there.

"She's beautiful—intelligent beyond her years." Mitch's teeth glitter unnaturally. "She's perfectly happy. My wife kept my picture at her bedside, and she recognized me right out the gate."

"My *wife*?" I glance over at Lee.

The talking head beams with delight. "My producer tells me you're in negotiations for movie and book rights, any truth to those rumors?"

"My attorney is fielding all requests. I really haven't discussed any of this with my wife as of yet."

"Twice he's called you his wife," I say, pinching my lower lip.

"I don't think he knows what else to call me."

"And her marriage to Maxwell Shepherd—how is that being handled?" She inquires.

"Handled?" My agitation grows by the minute.

"I'd rather not comment"—Mitch shoots a glance toward the house—"but I will say, we're working with a great psychologist."

"Thank you so much for your time, Mitch. We're all so glad you're back home where you belong, safe and with your family. It's been a pleasure." She extends her hand to him before returning her attention to the camera. "Fascinating story. We'll be back in just a moment."

"Nice." I sag into the sofa and close my eyes. "You think he ever once considered what this might do to our already skittish investors? And you can kiss the European market goodbye."

Lee bites her lower lip as if she knows it's probably worse than the rosy outlook I've painted.

"It was just one interview." She gets up and heads into the kitchen.

I turn the television to FNX, and low and behold Mitch magically appears.

"*Lee.*"

A Good Year For Heartbreak

Lee

In the gloom of an overcast afternoon, Mono disappears in a fogbank that swallows us whole and regurgitates us back into the bitter day like vomit.

Kat and I sit across from one another in the nail salon with our fingers fanned out under the bright lights of a drying machine. I watch as Stella giggles her way through a pedicure. It's her favorite thing in the world, but you'd think she was being tortured to death the way she shrieks and screams.

"Max wasn't too thrilled with me coming today," I say. Last night swirls through my mind like a secret perfume. Max is an artist beneath the sheets. I love Max. A part of me thinks I always have.

"He wasn't thrilled with you coming *here?*" Kat points to the floor, perplexed by the concept.

"He thinks I'm doing it for Mitch. I'm afraid there'll never be enough assurances for Max." I bite down on my lip. "He's used to winning, and winning rarely involves sharing."

"Are you doing this for Mitch?" She makes a face as if it hardly makes sense.

"Please, I've had this booked for weeks."

"Are you excited about tonight?" Her affect softens. Kat's face is filling in as she gains her baby weight at record speed. Her lips look perfectly full in a brilliant shade of ruby. "Just the two of you. Lee and Mitch just like old times. So where you going? Got another hotel in the works?"

"Shut up." I kick her from under the table.

A mist of tears blurs my vision, and I'm quick to blink them away. It'll be just Mitch and me tonight. The two of us—*old times*.

"I don't know," I whisper. "I guess we'll play it by ear. I can imagine what Max will be doing in the meantime, probably making himself insane with the wrong idea. And, don't even think of calling him. The last thing he needs is your not-so-funny sense of humor."

"Please. He'll be fine. And you and Mitch better bring a fire extinguisher." She rolls her eyes at the thought of me surrendering to Mitch again. "I bet he has the play-by-play all figured out." She plucks her hand from under the lights and fans herself. "He's been waiting a long time for this. He probably wants to nail it. And by it I mean you." She winks. "You don't think he booked a room do you?"

"You're really not funny, you know that?" I let out a sigh. " And, by the way, here's another bit of information you can distort with your inappropriate sense of humor. I may have eluded to Max he was going to be the last man standing."

She takes in a sharp breath. "*Max*." I'm not sure Kat has a preference one way or the other who I end up with. Like me, it's just too hard to go there.

"I've been thinking"—I shake my head—"and I can't do it. This is too difficult for me." Stella waves as they get ready to paint her toenails, and I smile back. "I'm going to hang onto both of them, let God choose for me."

"Who?" Kat crosses her eyes a moment.

"You know, the big man upstairs—the one who landed me in this mess to begin with. He's in charge, so I figure he can

have this one. It's too fucking hard for me." He deliberately did this to our lives, and he's welcome to get us out of it. But, in all truth, I think this one might prove to be too difficult even for him.

Kat doesn't move. Her heavy gaze hangs over me for several minutes. "Lee, sometimes the big man upstairs wants you to make a decision."

"Really? Where'd you get that? The Book of *Kat*?"

"It's called free will."

"Perfect. Then I'm free to let him dig us out of the hole he put us in."

"Are you going to share that theory with Mitch over dinner?"

"Nope."

"You going to make him believe you're going to end up with him?"

"I *am* going to end up with Mitch."

"And Max?"

"Yes. God yes, it'll be Max and me in the end." I want to end this conversation. I want to bang my hands up over my ears the way Stella does when she can't take Eli's shit anymore.

"There's not enough therapy in the world for this crap, Lee."

"That's why people shouldn't have to make tough choices. That's why God is going to have to make it for me."

"You need a miracle."

"I'll get one."

But deep down, I don't think I will.

<p style="text-align:center">₨℃</p>

In the cool of the evening, when the trees blow subtle into the blossoming navy sky, Mitch and I officially begin our date.

All of the beauty that's locked in Mitch is unleashed at this moment. Those high cut cheekbones, that tanned skin, those piercing green eyes, you could write a poem about how alarmingly handsome he is.

Mitch helps me into the passenger's side of the truck he's been borrowing from Colt. It's warm in the cab, with the hint of coconut from one of Colt's convenience store treasures. Colt is forever trying to mask odors. I don't know why his truck would be any different.

I glance back at the house while Mitch walks around to the driver's side. Max secluded himself with the kids in the back without so much as a goodbye. Can't say I blame him.

"So, where we going?" I ask as he swoops into his seat. Mitch suggested I dress casual, comfortable, and bring a sweater. All of his bank accounts have long since been closed, so I hope spending money isn't high on the priority list tonight. Mitch never needed anything other than himself to impress me.

"As long as I'm with you, we're already there." He gives a sad smile as we back out of the driveway. He glances in the rearview mirror as the house dissolves in a vat of precipitation.

We turn off the main road and head up the coast. The sun has melted into a tangerine puddle just over the sharp, blue line of the horizon. Soft pink streaks bloom across the sky. It's one of those magical sunsets where you have to acknowledge God for the artist he is and hope he'll replicate the majesty in your own life.

I reach over and place my hand over his. He lets go of the wheel and locks fingers with me. It feels so natural with Mitch, everything does.

"I love you," I whisper. It sounds like the saddest thing I've ever said, and I'm not sure why it comes out drowned in sorrow.

"I know."

He pulls into the lot just past the abandoned pier and parks in front of the dunes—nothing but a white sandy desert

as far the eye can see. To our left, jagged rocks, as tall as houses, track up the landscape before it drops back to the ocean. We used to come here, especially while we were dating. We logged countless hours beneath that rundown pier, listening to waves break over the shore like a war is on the horizon—and it is.

"I miss this." A twinge of excitement rockets through me. "This is perfect." I lean in and wrap my arms around him. His sweet cologne settles over me. It seeps into the past and magically retrieves who we were as if time had somehow become an interchangeable commodity, and we were gifted ten years back in the process. Mitch doesn't let go. He locks over me and breathes a warm river into my neck.

By the time we emerge from the truck, the sun is highlighted just above the waterline in a smooth red line. Mitch plucks two wool blankets from the back. The ones we got from Mexico years ago, pink and blue plaid. They must have been at Janice's. I haven't seen these in forever.

"I'll help," I say, taking one and landing it over my shoulders.

He lifts a giant wicker basket from beneath the second blanket and holds it up. "Hope you're hungry."

"Did you cook for me?" Mitch cooked more than I did when he was home.

"Do you miss my cooking?"

"Insanely. The chocolate crepes have haunted me for years."

"Then it's your lucky day."

"*No.*"

"*Yes.*" His teeth flash like a shooting star, and I hop up and down like a schoolgirl.

We meander our way through the sand over to the spot we've sat in so many times before. The sun is a thin lip of a line, that's already sunk into yesterday. "Make a wish," I say, nodding over to it.

"All of my wishes already came true, Lee." Mitch leans in and gives a sweet peck on my cheek. The warmth of his skin rips a fire through my insides, and I'm not sure if I can handle where this might be headed.

Mitch spreads out one blanket for us to sit on and wraps us in the other. It feels soft, warm, like a memory that blinked back to life. He opens the basket and creates an amazing spread with an entire menagerie of culinary delights.

"Will a small army be joining us?" I tease.

"If it'd make you like me more, I could have the beach stormed in less than ten minutes." He gives my ribs a playful tickle.

"*Hey.*" I knock his hands loose with my elbows. "And no thanks to the infantry. I kind of like it like this, just the two of us—Mitch and Lee."

"Me, too." He presses a kiss into my temple. "I like kicking it old school with you." Mitch picks up a crepe and hand feeds it to me. It tastes rich, soft, and sweet and there's something erotic about the exchange. The strange flesh-like texture of the crepe lands my mind straight into the gutter for a second I imagine it's his body I'm wrapping my lips around, but then again, Mitch's body doesn't generate chocolate emissions, but my mind still lingers in the pretense.

I bite down gently on his finger without meaning to before pushing him in and rewarding him for his culinary efforts. Mitch always made the perfect dessert.

"This is why I love you," I say. "You take such good care of me. You never forget the little things."

He doesn't say anything. Mitch rides his deliberate gaze over me as if he were savoring the experience. He wraps his arm tight around my waist, slipping his hand up my sweater and warms my bare back. My skin drinks him in. My neck arches back, and I bury a moan deep in my chest, trying to memorize how it feels. God I miss his touch. It was as if that

day in the hotel room were simply a dream and this were the very first touch of his skin to mine.

Mitch sniffs into my neck as if he might be ready to shed an entire river of tears.

"Are you okay?" I punctuate the question with a kiss just below his ear, and my lips blaze long after the touch.

"Only when I'm with you," he whispers. "Any updates you'd like to share?"

I think about telling him what I told Kat. But the words dam up in my throat. They catch on the memories I've built with Max and have a hard time breaking free.

"Some nights"—Mitch bows his head—"it feels like coming back was just as big a curse as leaving."

"Don't ever say that." My chest heaves from the horror of ever making Mitch feel that way. "It's a miracle beyond belief that you made it home."

"I doubt Max feels the same."

"Max is in pain. If the roles were reversed..." I let my words dissipate in the breeze. I'm so sick of roles and reversals of fortune, the marriage vows that have slipped through my fingers like dust. I struggle to find words that might make this all somehow palatable. "I can't break his heart, Mitch." I bring my hand up over my mouth and take in a sharp breath. "I can't do it. I want my old life back more than anything, but the thought of throwing Max away like an old pair of shoes—breaks me."

Mitch dips his chin as his features harden ever so slightly. "What about me? Do I break you?"

"You blew my world apart." It comes out far more accusatory than I mean for it. "You were the one who sliced me to ribbons." I hold his gaze a moment too long. "Just help me figure out how to do this."

"I will—we'll get through this." The whites of his eyes expand as if the last thing he expected tonight was an argument. "I realize, that when you married Max, you thought I

271

was permanently out of the picture. Still wish you chose Colt, though," he says that last part under his breath, and it sets off a wildfire of fury in me.

"*You* got us into this—not me, not Colt, and for damn sure not Max Shepherd." Okay, so maybe it was Colt but it flew from my lips, and now here I am shouting into the breeze as if that were somehow going to make things easier.

"It's not my fault." He rocks forward. "I never asked to get detained. I never signed up for Shepherd to steal my company, my daughter—my *wife*." Anger lifts his voice to uncomfortable octaves. It sails us into that vexing abyss, the one that leads to more scarring on our already fragile relationship.

It wasn't his fault. He didn't ask for anything that happened. For me to throw down the gauntlet and try to pin him with the blame is unfair on a whole new level.

"I'm sorry," I say, securing myself around his waist. "I'm not mad at you. I *love* you. I wish you never left. I don't know how to rectify this. I need a road map—something to point me in the right direction, that's all." I'm singlehandedly ruining all of the wonderful plans he had for the two of us tonight. Max swirls around us like a whirlwind, and I can't ignore his whispers. Max didn't ask for any of this and neither did Mitch. I'm not sure why I feel so damn responsible other than the fact I have the ability to put them out of their misery and pick one to move on with. If only there were two of me.

"Do you want me back?" He sounds childlike, boyish, and it completely endears me to him.

"*Yes*. Please, God yes. When I saw you at the airport, my heart splintered in a thousand pieces—I betrayed you—I knew it instantly. Can you ever forgive me?"

"*Betrayed* me? This isn't 1862. I was dead, Lee. You moved on. You lost your mind, and Max took advantage of you." He gives a wry smile as if he only half-meant it.

"Stop." I swat him on the arm. "Max is great. You may never get over how you feel about him, but it's the truth. Think

about your relationship before it all blew up. You were closer than brothers. In fact, Max told me stories that you never did. He really loved you, Mitch. And you know what? He didn't get it. He didn't get why out of the blue you took off and never looked back—why he was suddenly black-balled by you and your friends. He's only had nice things to say about you."

Mitch lifts his gaze toward the necrotic horizon. The wind hisses around us as if it were protesting the idea that Mitch and Max could ever get along, that they ever did.

"You should have heard him yesterday," he says under his breath. "Anyway, enough about Max. My date, remember?" He bumps his nose against mine and bites down a smile. "Let's leave that relationship for the witch doctor." He tightens his grip around my waist and pulls me closer.

"Deal." I nuzzle into his neck. "But I do think if you healed your relationship with Max, things would be a lot easier for everybody—especially the kids. You're both a permanent fixture in their lives."

Mitch gently lifts my chin with his finger, and for the first time tonight his eyes glitter in the dim light.

"A part of me is afraid I'm not a permanent fixture in your life, Lee," he whispers, pulling me over until I'm sitting in his lap. "If I get too close to Max, if I befriend him, it might make it easier for you to choose him. I'll die before I lose you again." He buries a kiss in the back of my hair, and my stomach bottoms out.

Mitch is afraid. Max is hurting. My worst nightmare and my wildest dream have merged, and I'll probably lose them both to other women who are fully willing to commit.

We sit there and stare at one another under the watchful supervision of an angel wing moon. A silver mist sprays over us in saline puffs, trying to cool the building fire that's walling in all of our lust.

Mitch. He looks godlike, nothing but statuesque perfection. My stomach cinches with intensity as he bears into

me with those tear-filled eyes. He lands a searing kiss over my lips that says so much more than I've missed you. It spells out I need you in the most intimate way.

I don't fight it. I don't think I ever could.

Mitch

I'm hungry for Lee.

Sitting on the beach with her lips melting over mine is the perfect end to any given day.

There is not one part of me that's interested in Dr. Be-On-Guard or his rules about abstinence when it comes to my wife. For sure I couldn't care less about Max and the shiny band of gold he flaunts like a trophy he bought at a dime store, with just about as much relevance. And I'm not breathing a word about either tonight. The only thing I want Lee to think of, to *feed* on tonight, is me.

Lee twists into my lap, and I pull her legs up over my hips. I miss her mouth, her teeth, the sweet smell of Lee you need to be deep inside of to appreciate. We pull off a kiss that stretches out for miles. Hours bleed by—all of time stands still in honor of our latent brand of affection. She pulls away slightly, but I draw her back, make her stay with me just a little while more. I love Lee. God moved a mountain—an entire civilization—for us to be together again. I'm not swatting my hand at his efforts and walking away for anybody—least of all Shepherd.

"What are you thinking?" Lee pulls back with a reserved smile. Her eyes sparkle even in this dim light.

"I think this is bigger than the good doctor. I think we've already got our miracle, Lee. The metric distance closed between us, and I'm forever grateful that you're in my arms, right this second." I press a kiss in over her lips and trail up to her ear.

"It's odd how a little divine intervention can heal and hurt at the same time." She warms her cheek against mine.

"I think Max should disappear—for at least five years. It's only fair." I scoff at the idea. Max Shepherd has an aversion to bad luck. He was born at the end of a rainbow with gold coins shooting out of his ass.

Lee pulls back, and gives a wry smile. "It's your dad you're mad at. It was never Max."

"Not true." I press it out before the idea can stick. "My dad is dead, and his mother lives." I sigh into her hair and wonder why we even bothered to go there. "So what's going to happen when we get home? I bet you a thousand bucks Max asks for the minutes of our meeting."

"He's forever the business man." Her back vibrates with a dull laugh. She's so thin I can feel each of her vertebrae—count them if I wanted to. "But he would never do that, so you're going to owe me a lot of money."

"He's a moron."

"Be nice." She tickles my ribs.

"I am nice." I run my fingers to the tender spot just under her arms and rail over her until she's on her back screaming with laughter. Her teeth catch in the light and sparkle like jewels. Lee detonates like a brilliant star against the backdrop of the velvet sand.

"Hey, keep it down." I land a soft kiss on her lips. "People are going to think I'm killing you."

Her eyes glisten with tears as the moonlight cuts through them like prisms. "You are killing me," it comes from her soft, and a little too honest.

"Lee," I whisper, interlacing our fingers. "You're everything to me—always have been, always will."

I bow down with a kiss—lay my body over hers and take root in a heated exchange of lingual affection. God, I love kissing Lee.

The ocean roars in a fury—solid and pissed, as angry as Max. But we lock off the world with a pronounced finality. There's no one but Lee and me left on the planet tonight. It's

nothing but a riot of emotions—the appeasing of our flesh. Our mouths fuse over one another in a series of explosive waves.

Peace. It's come to me at last. I found nirvana, paradise, happily ever after right here in the deep well of Lee's scorching mouth.

I feel at peace for the first time since I've come home.

Just breathing God.

Breathing Lee.

‚Ä¢‚Ä¢

We head home and walk up the driveway hand in hand.

I sneak in one last kiss before Lee slips the key in the lock and turns the handle.

The porch light casts a halo of fog around us. It bleaches us out into vellum, leaves us transparent as unearthly visitors.

I place my hand over hers and stop her from opening the door.

"I can't do this too much longer." I don't mean for it to come out like a threat. Like some ultimatum I'm tossing out at the eleventh hour, but my entire body sags with relief after letting the words out.

Lee's face melts with fear. All of the good intentions I showered her with tonight have dissipated with a few simple words.

"I know," she whispers. "I really feel the same. I'm not sure the therapy will help, but I'm hoping it will." She steps into me, her eyes pleading with me on a rudimentary level. "I can't really expect you to know how I feel, but I can't find it in my heart to just throw Max away." She shakes her head struggling for the next words to make this right. "Come here." She stands on her toes and pulls me in by the back of the neck. Lee touches her lips to mine, and I don't bother restraining myself. Fuck Max and his good boy ideals. Lee is my wife, the love of my life,

and I'll be damned if I'm not putting in every effort to fight for her.

Lee sweeps her tongue over my teeth. She roams around my mouth as if she never wants to leave. I never want her to. I never want this feeling, this moment to end.

Never in a million years would I have imagined us kissing like teenagers outside of the door I hung myself, in front of our home. Lee and I have become a dirty secret to be kept from, of all people, Max Shepherd.

We head inside and smack right into the idiot himself. Max glides down the stairs like some lovesick puppy—albeit, aggressive and angry, lost in a jealous rage, *rabid* puppy.

"Where'd you go?" He doesn't bother acknowledging me. Instead, he wraps his arms around Lee and dots her forehead with a kiss. I bet he thinks we hit the nearest motel and laughed at him for two hours straight while fucking our brains out. That was my first plan of action, but I didn't think Lee would be up for it.

I shoot him a look and head toward the back.

"Just the beach," she says, making her way to the kitchen.

Just the beach? I glance over at her mildly alarmed. I thought I had impressed the hell out of her with those kisses. I thought we revisited who we were and held the residue of our love all the way up the porch.

Her lip curves into a smile as she passes me on the way to the fridge.

There she is. Her play down of our date is nothing but smoke and mirrors for Shepherd's sake. She's probably afraid he'll hack us all to pieces in a jealous rage if she fesses up to how she really feels. And quite frankly, I'm getting pretty tired of the way she guards his heart like it's some fragile ball of glass. You'd think it had the power to unravel the universe if it shattered the way she protects it.

"Get some rest." Max wraps his arms around her from behind and drops another kiss on her temple. "I've got a big day planned for us tomorrow."

My insides cinch.

"A day?" She marvels. "What about the kids?"

"Mitch can watch them." He blinks a smile at me. "He's probably dying for a nice long day with Stella and Eli."

"Sure." I reach into the fridge and pluck out a soda. Swear to God if he kisses her one more time I'm going to disembowel him right here in the kitchen. Or maybe I'll dust the floor with his head before I push him out a window. The rails of this crazy train are clattering. I can't check my emotions anymore.

I shoot him a dirty look as he cages her in with his arms, brushes his cheek against hers like I wasn't even in the room.

Lee glances up, alarmed, totally aware of Shepherd's late night scheme.

"You got a problem?" He needles me with that unibrow of his and a laugh huffs from my chest.

"Yeah, I've gotta problem." A visceral rage brews deep inside me. I've been waiting for weeks for Shepherd to start shit so I can clock him a few dozen times, but I was sort of hoping he wouldn't be holding Lee like some hostage when he did it.

"Stop—both of you." Lee closes her eyes and carefully untangles herself from his gorilla-like embrace. "Max"—she shakes her head and gives a hard sniff—"maybe it's not the best idea to hold me like that in front of him."

Did she just say it was okay for him to hold her like that in private?

Lee darts out of the kitchen and bolts upstairs.

"Nice going, shithead," he grunts. "You put her in a good mood." He doesn't bother hanging around, just bolts up after her.

She *was* in a good mood. Lee is no fool. She knows his awkward displays of affection are designed to piss me off. The more he tries to paw her, the more he riles her up. It looks like

the noose just got a little tighter. And I'll be more than willing to kick the chair out from under him as soon as he's ready.

Voices boom from above, followed by swift angry footsteps. I don't ever remember arguing with Lee. Must be one of those adorable quirks Shepherd brought to the marriage table. The fact he raises his voice to her should send up a dozen red flags, make her think long and hard about leaving him. I'm sure it's something he picked up from his folks before cheating became a part of the equation. I don't really remember Max's father too much, *Eli*. He seemed like a nice guy. Always hung out with my dad who also mistakenly seemed like a nice guy. Turns out they were both a joke. My dad the philanderer extraordinaire—he was no prize after all. Mom deserved better than that. Makes me sick to think of all that crap he put my family through.

A thunderous clap explodes from above, and I sprint upstairs.

Hopefully Lee pumped some serious lead into his chest and not the other way around.

I blast through the bedroom door without bothering to knock, and both Lee and Max turn around. They're sitting on the bed, Max with his shirt off.

"Kids okay?" I pant as I take in the scene. Max has his shoes off at the foot of the bed. His jeans lie folded over the chair, and it's only then I notice he's in nothing but his boxers. My stomach tightens at the thought of him hanging around my bedroom like this.

Lee's eyes are bloodshot, her face slicked with moisture. She walks past me over to the linen closet and digs for something in the back like her life depended on it.

"Kids are sleeping," Max gruffs at me while pulling on a pair of sweats.

I head over to Lee and step in close until I can feel the warmth emanating from her body.

"I thought you blew his head off," I whisper. "I was going to help you hide the body." No joke.

Max steps in. "You wish." Shepherd doesn't break his hard glare.

"Seeing that all my wishes have a way of coming true lately, I'd take cover if I were you."

"Get back down in your hole," he cuts a quick glance to Eli's room. "Upstairs is off limits to you."

Lee swipes us with a look before burying her head in the closet again.

Shepherd's got balls of steel, that's for sure. "The only territory around here is the one I built. Upstairs, downstairs, it belongs to me."

"Found it." Lee holds up an air pump before tracking back to the bedroom.

"We're not doing this." Max trails in after her with his head on fire. "That thing sounds like a jet engine. You're going to wake up the kids."

"Mitch shut the baby's door." Lee instructs, so I do. I pace back over to the master bedroom for the rest of the show. Lee's got the nozzle injected into an air mattress, and it magically starts to inflate.

Max's face bleeds out, white as snow on Christmas morning. Passing out seems like a promise on the horizon. I blink a smile over at him. Already I like where this is going.

"Get out." His brows dart in a line over his features as he glares at me. All these years of knowing Max I don't think I've ever seen him so worked up, so locked up in his anger to the point he can't even breathe. All of the misery the Shepherds have caused my mother, my brother, and me, has finally caught up with him. Max is about to be handed his balls by the only person he's ever worshiped—Lee.

"Done." She screws the cap on and slides the mattress over to Max.

"Fine." He tucks his tail between his legs, resigned to his new sleeping arrangement. "Night." He swipes it up off the floor and pushes me into the wall before disappearing into Eli's room.

Lee gets up and comes over, her eyes still alive with grief. She doesn't say a word.

"Thank you." I wrap my arms around her waist and hold her, feel her heart pummeling against my chest like she just ran a miracle mile.

Max is out of the bedroom. This festering wound inside me has finally opened, and now all that's left to do is heal.

Max

It's so fucking hot.

I give several hard blinks, struggling to wake up. The room looks foreign from this vantage point until Eli smacks me in the face with a small yellow truck. Then it all comes back to me, Lee, the air mattress—Mitch and that shit-eating grin.

"Is that how you say good morning?" I pull Eli over and tickle him before tossing the truck clear across the room.

"*Up,*" he shouts as he pulls me off the floor. Note to self: invest in a better quality mattress and possibly a shotgun, duct tape, and a shovel.

"Come here you." I pull him to his car bed and relax over his pillow. It turns out Eli's bed isn't that much more of an improvement.

Lee came back from her date with Mitch last night revved up like PMS on steroids. I'd hate to be the one to bring it up, but I think she's emotionally allergic to him.

As for Mitch, I'd like to pummel him. Beat him until his ears bleed, then throw him into the Pacific.

Stella wanders in wearing her yellow ducky pajamas. "You had a sleepover?" Her hair is disheveled and her lids still hang heavy.

"Yup." I pull the blanket off the floor and fold it in half. "You want to have a sleepover with Eli tonight?"

"Yes!" She squeals, jumping on the glorified bag of air that pulled the pin on the grenade that lives in my back.

"Okay, I'll let you sleep on the air mattress."

Screams of joy rattle out of her as if she's about to go on some exotic adventure.

"I call Stella's bed," I say as Eli joins his sister.

ഇൗരു

The sun sits high as Lee and I drive over to the Mono Bay Airport, small crafts only. Mitch didn't look so enthused this morning when we saddled him with the kids and headed out. He mentioned he'd be spending the day on the beach with them. Stella and Eli better not drown on his watch, or I might be moved to decapitate him.

"An airport? What's this about, Shepherd?" Lee bites down on a smile as she soaks in the planes surrounding us.

"Let's find out." We head out of the car and into a waiting helicopter. Lee laughs as we levitate into the sky. She's right back to being herself again, pre Mitch's resurrection.

I get the feeling the key to a long healthy relationship with Lee is going to include keeping Mitch as far away as possible. China was good while it lasted. Maybe it's time to notify the degenerates Hudson hangs with—pad his payday a little and see if Mitch makes it to Christmas.

I try to let the thought sail out my mind, but it's too late. It's scalded itself into my brain, ingrained itself like a scar. I wouldn't kill Mitch if it came down to it. But I sure as hell don't mind entertaining the fantasy.

"This is insane!" Lee points down at the beach house as we rise through the air, effortless as a kite.

"There's your baby." I redirect her over to Shepherd in the east. It's beautiful in all of its miniature glory, the hills, the neat rows of vines.

"Oh, wow!"

"Townsend on the left," I say. *Fuck.* It looks like a death camp for foliage—nothing but dehydrated crap. Looks like I'm going to lose another good week figuring this mess out. The hit on my wallet is going to put a nice dent in Stella and Eli's college fund. At this rate they won't have one, and any dreams I might have had about retirement have long since evaporated.

Maybe it is time Mitch gets back in the game. Maybe I'll bill him with the one hundred thousand plus plumbing bill, see if that doesn't shave a good ten years off the backend of his life.

"We need to do this again sometime and bring the kids." Lee wraps her arm around my waist and pulls me in close. Her affections migrate naturally without Mitch in the equation. Then a brick wall of a thought hits me. What if her affections stray in the other direction when I'm not around? Who knows what happened with Mitch last night. He's already established the fact he's not above forcing himself on her. Ironic since he accused me of the exact same thing.

We start in on our descent, and Lee looks mystified.

"Already?"

"Already," I assure her with a kiss that takes us all the way back down to earth.

The pilot lands us in a field just north of a large stream that bisects old Johnson's almond farm. Lee wanted this place more than air a few years back. I tried to make an offer, but Johnson was a greedy bastard. The price was too steep, and he wouldn't budge.

We head out and wave to the pilot as he takes off.

She spins, taking it all in. Her hair follows, wafts through the breeze like down feathers. Lee catches the light and shimmers like gold.

"Where are we?" She lands her arms around me again. "And please tell me indoor plumbing exists here."

"Johnson's farm, and I think if we hike up past that ridge, there's a termite-riddled outhouse. Of course, if you hike up *that* way, you'll hit the main office. Rumor has it they have his/hers accommodations. If you flash a twenty, they might even throw in toilet paper."

"*Max.*" She swats me over the arm. "This place is beautiful." She takes in a quick breath. "Look!" A table and two chairs are set up in the clearing next to the stream. A tall vase is

set on top, brimming with wildflowers. It petrifies the landscape with its riot of color.

"Now how did that get there?" I tease, taking her by the hand. We walk up next to the peaceful river. It's so perfectly still it looks like sheet glass.

"Lunch? Here?" Her lips give a delicious curve. "You really know how to impress." She hikes up on the balls of her feet and gives a quick kiss. A church kiss, the friends-only edition that one might get before being shown the big neon exit sign hanging over the relationship door.

"I thought you'd enjoy catching your food." I nod past her. "There's a fire pit. We can gut 'em and cook 'em. Unless, of course, you prefer sushi."

"Fishing?" She goes rigid. Lee abhors the thought of sticking a hook in any living thing. She wants to believe all of her beloved proteins magically appear packaged in Styrofoam at the grocery store. She's sweet that way. No survival instincts whatsoever, but sweet.

Lee closes her eyes. "Dear God, deliver me from fishing."

I bark out a laugh as I pull her in. "Consider your prayers answered. See those?" I direct her to a pair of silver domes on a stand just past the table. "I've already caught the fish." Not really, more like had a sushi chef flown in for the afternoon. Heard he was terrified by the sorry state of the kitchen.

"If anything under there requires gutting, I promise, the air-mattress will be the least of your worries." She lands a swift kiss on my lips before heading over to check out the fare. "Very nice, Shepherd."

"I thought so." I join her at the table, and we lose ourselves in just being Lee and Max. It's easy like this with Lee. The small talk, the soft hum of the stream, it's all a pleasure to take in, not a moment of strangled silence. "So what do you think?" I wand my hand over the amenities.

"You did good." She leans in and feeds me a piece off her plate.

"Mmm. Thank you." I pull an envelope from my back pocket and hand it to her.

"What's this?" She peels the letter out and examines it for a moment. Her eyes widen with a mixture of pleasure and disbelief. "Max?"

"What does it look like?"

"Looks like a deed." Her hair sails behind her like a beautiful flowing mane, and I want to remember her like this. There's something ethereal about Lee, something that transcends beauty and rises above the mortal definition.

"I bought it for you."

She bumps back in her seat. "You *bought* it?" It comes out a broken whisper. Lee tips the table over into the grass before lunging into me. She lands us backward onto the dry, warm soil. "Thank you." She spreads my arms wide as wings and delivers a disorienting stream of kisses. I tumble over her, pinning her down on the grass and feel her heart raking up against mine. Lee lets out a soft, bubbling laugh, first one I've heard in weeks. The thought of old Johnson's farm as her own brings her downright joy, although I'd like to think it was me she was squealing over. I bite into her neck playfully before lashing my tongue up along her jawline. There's not another person for miles—just the stream, Lee, and me. It'd be a waste to let the moment slip by—for one lonely kiss to be the single peg to hang our posterity on, so I pluck at her T-shirt, giving her ample time to protest, but she doesn't. She pulls my face in with both hands and bites down gently onto my lower lip.

Green light.

I slide my hands up her skirt, ride the curve of her legs inside her thighs.

No sign of Mitch or an air mattress.

It's all systems go.

14

The Spark

Lee

It's strange the times God chooses to answer our prayers, the times he chooses to remain silent. The blinding rays of the sun pulsate through my lids, creating a wall of fire between me and the visible world. Making love to Max over the warm grass on Johnson's farm is a fantasy come to life.

Mitch.

He haunts the moment, disables my pleasure as Max presses into me with his forceful thrusts of affection.

Max chews on my ear, runs his hot mouth down my neck while cupping me with his hands. My mind distorts reality and interchanges Max for Mitch every third second making this feel more like a psychotic episode rather than some monumental moment between Max and me. There have been times I've been with Max that Mitch has floated through my mind, and horribly enough sometimes I let him linger. But this was different. Mitch has embedded himself in my subconscious, and a part of me feels every bit the adulterer with my legs wrapped around another man. I've been with Max countless times, far more than I ever have with Mitch. Loving Max like this feels natural as air and water—and equally necessary for my survival.

This guilt, this sexually-induced trauma inspires a lava stream of heated images— Mitch and Max, the three of us twisted in one lusty exchange. My mind morphs the two of them together and turns them into something interchangeable. I'm not sure who or what I want anymore. As much as I ache for Mitch, I crave Max like water for my thirsty soul. I want it all the hard way. Sometimes I think that's all I've ever known.

Max pulls my legs over his shoulders, and watches me from above as he plunges in over and over. I'm laid bare, spread wide in the open air with nothing but the unblemished sky behind him. Max presses in one final time before trembling into me.

"Damn, Lee," he pants through his laughter as he lands next to me. He swipes the tablecloth lying at my feet and pulls it over our bodies. "That was a hell of a thank you." He lands a kiss on my lips and lingers.

"I'm glad you liked it." I pull my clothes back on like a monkey on fire. My cheeks are flustered with both excitement and horror at what just happened. I'm so afraid I might have made love to Max for the very last time, right here in the open like some grand finale of our fornicating affections. My heart feels like its about to burst at the seams, and if this goes on much longer it just may. That might be the best solution in all this madness—me dying from an inability to choose.

"There's something about you, Max Shepherd." I take him in under the spray of afternoon sunshine and seal my lips over his. "All these years there's always been an undeniable spark. I don't think it'll ever go away." True. Max had my hormones riled up long before I knew Mitch.

His eyes light up an electric blue.

"It won't go away," he assures, pulling me down over him.

Deep down inside, I know this to be true.

The next afternoon, under a dull steel sky, Max and I arrive at Dr. Van Guard's office together. Mitch is already here. Max played big man on campus yesterday, ad nauseam, and drove Mitch into the icy Pacific for the rest of the evening.

Everything in me quivers at the sight of them in the office together—such a small space—for damn sure it doesn't feel safe. Just seeing the two of them together convicts me—makes me feel like a criminal for giving in to Max yesterday. I want Mitch to feel secure, and now I've rattled everything. I'm so afraid he'll leave me, find someone else. The thought of Mitch with someone else would cut me deeper than him dying ever could.

Dr. Van Guard stands briefly as we take a seat.

There must be something that can bond the three of us, something that can take the acidity from our everyday lives. The kids perhaps, but, more than likely, we're headed for a lifetime of misery—competition, and heartbreak, not necessarily in that order.

"Lee, how did the dates work out for you?" Dr. Van Guard initiates his placid smile. His silver hair shines against the backdrop of the dark-stained walls like lightning.

"They were great." I fold my hands in my lap and bounce them. There's no way in hell I'm going into detail.

"Go ahead and share a highlight from each."

"Highlight?" I don't want to make Mitch feel bad for not buying me real estate. "With Mitch it was a tidal wave of memories. He took me somewhere symbolic of the past, and it felt like we were transported back in time." Those erotic kisses come tumbling to the forefront, and I take in a deep breath as if I were soaking them in all over again.

Mitch sweeps his hand over my knee, happy at my interpretation of our one-on-one time.

"Excellent." Dr. Van Guard plucks off his glasses. "And with Max?"

Max. Our hormones exploded like a meth lab, and we had sex that made the field rabbits blush, right there in the open.

"We had lunch by a stream." I don't add anything to it.

"Nice." He looks the two of them over. "Now from your perspectives. Mitch?"

Shit.

Mitch clears his throat, leans forward. "It was quite possibly the best date Lee and I have ever had. We shared an intimacy we hadn't in a long time. I look forward to doing it again."

"And, Max?"

I don't like this back and forth crap. I don't like the way the doctor is carelessly wielding kerosene and matches in the fireworks factory of my twisted love life.

Max gives a quick glance over at Mitch. "It was quite possibly the best date Lee and I have ever been on." He mocks him with his tone. "And, we shared an intimacy *we* hadn't in a long time. Well, at least since a few nights ago. I most definitely look forward to doing it again." He pulls his lips into a hard line and keeps his focus locked on Dr. Van Guard, not a single glance in my direction. It makes me wonder if I was just a "get," something to win and hold over Mitch when he got the chance.

It's like a noxious fume goes off, and no one dares acknowledge it. I can feel the pressing weight of Mitch's sadness, it makes me want to cut out my heart and offer it to him on a platter. I've reduced myself to nothing more than a street whore. A part of me wants to say something hurtful to Max, tell him that I slept with Mitch even though I didn't, and sadly enough it makes me wish I did.

"Lee." Dr. Van Guard flops his pen onto the desk. "Which of these men would you like to have a one-on-one with first?"

"Mitch." As much as he hates me at this moment, I need to rectify myself to him.

I don't even bother looking at Max. He's ignorant if he doesn't know how fucking pissed I am right now—how I'm not

really concerned at the moment whether or not I break his heart in two or four or six hundred pieces.

I listen for the click of the door before I fall to my knees in front of Mitch.

A jet stream of apologies funnel out, one after another. They come out hoarse, barely discernable, lost in a river of tears.

Mitch remains motionless. There's no way to judge how much I've disappointed him. It takes another few good seconds before he gets down beside me. He doesn't bother with words, just pulls me in and holds me. I hate this. I can't stand what we've become—what my love for Max has reduced us to. I never set out to hurt anybody, and now I can't seem to stop.

"It's okay," he whispers, pressing his lips to my ear.

"Lee, Mitch." Dr. Van Guard speaks just above a whisper, coaxing us back into our seats. Mitch grabs a box of tissues off the desk and sets it on my lap.

"Mitch, what's going through your mind right now?"

He shakes his head. "I don't want to verbalize it. I don't want to hurt anybody."

Anybody, being me.

"You don't have to worry about hurting me," I whisper. "I've already done that myself." I've inserted the sharp blade of grief into that narrow space between my soul and spirit—the secret place only God once had the power to divide.

"Lee?" Dr. Van Guard's ears peak back. "Anything you'd like to share?"

"Yes." I straighten in Mitch's arms and touch his cheek. "I choose Mitch. If he'll take me, I want to be with Mitch."

Mitch

"Me?" I want to clarify in the event she said Max, and my brain manipulated it to sound better. I was hoping to hear those words a couple nights ago, but after the picture Max just painted, I think I need her to reiterate.

"You." Her glacial blue eyes pulsate in pools of watery tears.

"Me," it comes out with relief this time. I dive a kiss over her, not really interested in the fact we have an audience or that the good doctor keeps tapping his pen like it's his new favorite song. We don't need to say anything else the entire time we're here, except maybe to Max. He can be in charge of the guest book at our wedding. Hate to leave him out in the cold entirely.

Dr. Feel Good clears his throat. "Lee, if you don't mind, I'd like to talk a little of how to go about this."

For once, I welcome his interruption.

She pulls back and adjusts herself, giving me a mournful smile as if she already regretted her decision.

I keep an arm slipped tight around her waist, my eyes glued on hers. I can't believe I have Lee back. Max killed me with his sucker punch, and it was Lee who resuscitated me with her beautiful words.

"I can't tell him." Lee shakes her head at the doctor. "Maybe you can?"

"No." He gives a soft chuckle as though this were impossible. "This needs to be handled a little more delicately, and I'm not sure if in the office, with Mitch present, is the right environment. I commend you for making a decision, and so quickly at that, but I hardly think this is the venue. He might feel as though we're all ganging up on him, and it might

sponsor a whole host of volatile feelings. It could get ugly fairly quickly, and there are children involved."

The color bleeds from her cheeks. Lee was never one to run toward confrontation. It was always an inside joke between the two of us if she ever got angry at anyone she could always give them the "wrath of Lee," which was nothing short of an apology. I can't really envision her sticking the verbal pitchfork in his chest, twisting it with satisfaction like a rotary blade.

"I'll tell him," I volunteer. Be glad to.

"No." They both say in unison.

It was more of a tongue-in-cheek offer on my part, but I can see why Lee and Dr. Van Guard aren't exactly as giddy as I am at the moment.

He leans in. "Before Max is apprised of the situation, I'd like to present what I think is the best case scenario." Dr. Van Guard points over to me. "Mitch, I recommend that you and Max patch up your grievances—preferably right here with me before Lee breaks the news. We could put in a few extra sessions this week and at least give it the old college try. You'll be sharing children for the rest of your lives. You'll be doing yourselves and your families a huge favor by getting off on the right foot. Now, you *can* do this after Max has been informed of Lee's decision, however, I don't think he'll be quite as open or happy to cooperate."

A smile twitches on my lips. I love how we're all privy to this, and Max is stone cold in the dark with an ax ready to fall over his unhappily married neck. The thought of Lee and me holding a secret so big it's guaranteed to shatter his universe makes me float on air.

"Yes, by all means. I'll patch things up with Max. Let's have it out. One week you said?" I'll have Kyle draw up the divorce papers by Sunday.

"Yes. If your schedules permit, just a few visits."

"Bring him in."

I'm going to wrap up this relationship so fast heads are going to spin. But, if I come across too eager to restore some semblance of a friendship, he might get suspicious and set us back ten weeks—ten *years*. I'd better go along with whatever Van Guard's got up his sleeve. I'll go along for the ride, answer all the questions, so long as the road leads back to my wife.

Max comes in and settles next to Lee, plants a kiss on her lips before she can get a chance to field it. I'm sure that's how he does everything with her. An entire slew of pornographic images crop up and tattoo themselves in my brain.

"Max, we're going to keep Mitch with us if you don't mind. I think now's a good time to pull back the curtain a decade or so and explore the friendship you once had together."

"Not a problem." Max shifts in his seat because he knows this shit just got real. He searches Lee's face for clues, but she doesn't offer any.

"Tell me again," he addresses Max. "You were childhood friends all the way up until high school. When did you feel the rift?"

"I went away that summer to visit family back East." He presses out his dimples at me. "When I came home it was like I had the plague. Mitch had a girlfriend, *Lee*, but I still wasn't sure why he stopped talking or hanging out with me."

"Good." Dr. Van Guard taps his pen like sounding a gavel. "Mitch, what happened that summer that made you give Max the cold shoulder?"

Maybe this wasn't the best idea. Hashing out old problems will only point a shiny white spotlight over what really happened, and I'm pretty sure I'm not going there.

Both Lee and Max lean in and stare me down. I have no intention of sharing my side of the story. If I did, it would drag this whole nightmare out longer than needed—indefinitely if Lee finds out what I did and why.

"I was your average teenager—moody." I flick a finger in the air as if it were gospel.

"Sure." Dr. Van Guard rocks back in his chair. "So what was the logic? Moody quantifies a lot of actions, but to end a serial relationship seems like an unlikely excuse."

Serial? Sounds more natural attaching it to killer than relationship, although killing my relationship with Lee is what Max set out to do from the beginning, so it only makes sense.

"I had a girlfriend." I try to shrug off the conversation. "I didn't hang out with too many guy friends after that. Lee had a way of monopolizing all my time." I tweak her on the knee in jest.

"I'd call you on the phone, and you'd hang up as soon as you heard my voice." Max cranes his neck to get a better look at me. "More than once."

Lee shoots me a death ray as if I'd ran over a litter of kittens just to piss Max off. Shit—Shepherd is going to draw out all of my past offenses and swing the pendulum back in his corner before we get off the couch.

"Bad connection." It comes out stale. "Listen, I'm sorry. I was a jerk. Blame it on too much too soon for not giving a rip about the people around me. My head went numb when my dad died. It took me around the block emotionally so, please"—I lock onto his baby blues and hang on for dear life—"forgive me." Nothing but word vomit. Take it and run with it, Max. We can hug it out later. I can sleep in my own damn bed before midnight if you cooperate.

Max locks me down in an unrelenting stare. He doesn't trust me. He smells something rancid, and all arrows point to the bullshit that just flew from my lips. I'm going to blow us back into the dark ages if I don't bring this down to reality right this minute, shoot us off this pink fluffy cloud I've lifted us to.

"There's something else, but I don't want to say it." There. At least some of the truth escaped. Max can call off that inner siren and stop scowling at me. It's going to be a long life, and like it or not, Max Shepherd is going to be a very real part of it.

I may as well dump out the past and see if there's anything salvageable to colonize a relationship with.

Max

I look from Lee to Mitch. Why exactly is he hanging around in my session again? I'm pretty sure we're not going to high five our way out of this one.

"Max?" Dr. Van Guard observes me. He looks intent as though I'm some new species, and he's unsure of my spontaneous behavior. "It's okay to share your thoughts."

Doubtful. "Lee, is this some fantasy of yours for Mitch and I to get along?"

"Fantasy?" She looks insulted. "We're raising children together. We're going to be spending lots of important milestones elbow to elbow."

"Right." Is that why Mitch is hopping on the bandwagon? The *kids*? It's obvious he's taking the high road in an effort to infiltrate Lee. And what the hell is this other thing he doesn't want to talk about? "So Mitch," I say, daring him to make his final move, "you want to go outside and fill me in on this big secret of yours?"

"Nope."

"All right—didn't think so." I let out a hard sigh. "So did you stop talking to me because of what happened with our parents, or is this something additional I've yet to be made aware of?"

He doesn't say anything, just shifts in his seat the way Stella does when she's in trouble. At least now I know where she gets it.

"Guess I got my answer."

"Wait." His eyes connect with Lee and they stay there a moment longer than I'm comfortable with. "Hanging out with you made my mom uneasy. I think maybe she wanted to limit

THE SOLITUDE OF PASSION

the number of run-ins with your parents, and, if we were constantly together, it upped the odds."

"Your mom loves me." I'm not buying his semantic bullshit.

He nods with a spaced out look on his face. "Okay. Listen, I just want to salvage what we can."

"And how do we do that?" He slept with Lee, so already we're off on the wrong foot.

"Let me back in at Townsend," he pleads. "Show me the ropes. If you're willing to teach it, I'm willing to learn." His face softens, and for the first time in a decade, I feel like I'm talking to the old Mitch. Maybe this *is* a step in the right direction. Maybe in some small way he's willing to accept me with Lee, but I doubt it. Something is lingering on the periphery, something is up and I'm the only one in the room with the blindfold securely in place.

"Sure. I'll clue you in on the joys of Swiss cheese irrigation."

"Sounds like things are off to a great start already." Dr. Van Guard lightens the mood in the room. "As long as we keep our expectations realistic, we could have a mature, adult, amicable relationship between the two of you in no time. For homework I'd like you, *Mitch* and *Max*, to mentally prepare yourselves to really have a heart to heart with one another. Did your families reach out for counseling in any way?"

"Mine went," Mitch speeds it out. His hair glints in the light as his chest broadens with pride.

"I declined the offer." I cut a look over to Mitch. Why does it feel like he's kissing up to the doctor now? Should I be doing this?

"Very good. We'll shoot for tomorrow night?" Dr. Van Guard looks hopeful.

"It's Colton's birthday," Lee says, looking over to me.

"Wednesday will work out better," I offer.

Mitch and I walk on either side of Lee all the way to the car.

I don't know why, but suddenly it feels like we've morphed into a threesome. And I don't like it one fucking bit.

ॐℭ

The next morning my cell goes off before I open my eyes, and I accidently swat the picture of Mitch on Stella's bedside before retrieving it.

It's Janice.

"Hello?" I sit up under the bright pink canopy.

"Did I wake you?"

"No. What's going on?" I'm a little proud of the fact she's got two full-blooded sons, and it's me who she calls when she needs something.

"Look, I don't know whether you've seen it or not, but TS is getting a lot of bad press this morning."

"I'll check it out." The last time Townsend Shepherd got any press at all was when the classroom tour went wrong and wine was given in place of grape juice to a bunch of seven-year-olds. Of course, they spit it out which made us more of a laughing stock than we already were.

"I'll see you tonight," she sings. "Love you."

"Love you, too."

I race downstairs and flip open my laptop. Mitch wanders into the kitchen, doesn't bother with good morning. Knew that whole song and dance was for Lee's benefit.

"Shit," I hiss as I take in the headlines of the *Mono Bay Voice*.

"What's up? Your horoscope telling the truth for once?" Mitch comes over and peers over my shoulder. "What the hell is this?"

"Hudson's girlfriend." There's a picture of Candi holding a bottle of Shepherd merlot. Looks like her triple X debut has gone viral overnight. "Nice. The last thing we need is a bunch of spooked investors."

"Look." He points over to the sidebar. *Interview with long lost owner Mitch Townsend.* I click into it. It's a recap of the circus he hosted out on the lawn a few days ago. "Excellent." Headline reads *Divorce is Imminent for Cocktail Titans Lee and Max Shepherd.* Glad they did their research. I'd hate to think they got any facts wrong." I snap the monitor shut just as Lee strolls in.

"What's going on?" Her hair is slicked back from the shower, her face is fresh scrubbed just the way I like it and it takes all my effort not to haul her back upstairs.

"Candi is in the middle of her fifteen minutes," I gravel it out. "She's suffocating the company along with the idiot stuck between her legs. Your ex-husband isn't doing us any favors either."

"This will blow over." Mitch turns the seat around and plants himself next to me. "The American people have a very short attention span."

"European investors have an even shorter one." I push out a heated breath. "Lee, I'm calling a damage control PR meeting. Clear your calendar."

"Hang on." Mitch is the calm to my storm. "Let's ride it out. If you come across panicked, they'll react the same way."

"We should listen to Mitch." Lee is quick to jump to the Townsend side of the fence. "Give it a few days for things to settle. Maybe it's just a hiccup. Companies like ours are cluttered with bad press all the time."

I don't like the way she's agreeing with him. My gut tells me it's not the right move, and my gut is always right.

Stella and Eli filter in and demand breakfast like a swarm of hungry soldiers. Lee and I both mobilize at the same time. She gets the cereal while I pull out the milk and bowls.

"Daddy!" Eli shouts from the table. Before I can answer I glance over to see its Mitch he's handing a crayon to, trying to coax into coloring with him.

Lee and I exchange glances.

So this is how it's going to be? A vice tightens around my stomach. Lee takes the milk from me and mouths the words, *I'm sorry.*

Why wouldn't Eli call Mitch, *Daddy?* Stella does. It's obvious we're going to need more therapy than we'll ever be able to afford. On second thought, there's not enough therapy on this rolling blue rock to quell the aftereffects of the Mitch invasion. Everything was going so smoothly, so perfect with Lee, until he decided to reanimate himself.

I head over and pour myself a cup of coffee. Lee passes out napkins and spoons as Mitch rescues Eli from toppling off the chair.

"Nice save, Daddy!" Stella beams. She doesn't call him Picture Daddy anymore.

The four of them share a laugh. Mitch tousles Eli's hair and pushes in his seat, helps him with his food.

It's the perfect nuclear family. Nice try, Townsend. But I don't go down so easy.

Lee motions me over next to her. She rubs my back as I soak it all in.

Am I the only one who sees something wrong with this picture?

The Matchmaker

Lee

Janice has the house decorated like its *Eli's* birthday instead of Colt's. Paper streamers line the walls, colorful balloons proliferate in clusters all over the backyard. I half-expect a clown to walk through the door and offer to paint a butterfly on my face.

Kat and I make a plate for ourselves and head off to a table on the lawn where Stella and Eli run in circles trying to blow giant rope bubbles with the birthday boy himself. Janice invited Hudson and Candi because apparently she's certifiable as evidenced by the decorations. Thankfully they haven't shown yet. I'm sure things will get pretty interesting in a hurry if they do. Maybe they're the entertainment?

Kat leans in over her swollen belly. "Steve and I are downloading it tonight." *It* being Candi's sexcapades, the digital edition.

"Crap." Really, there are no other words. Once Kat has her brain wrapped around something there's no stopping her.

"What?" She takes a bite out of a cracker slathered with olive tapenade. "Who could resist? *A Night of Fine Whine.* I don't think your marketing department could have given it a better title. You gotta be diggin' the product tie-in. I'm

surprised Max hasn't died of a coronary yet." She takes a bite of her appetizer before shoving the rest in her mouth. "Come over in the morning, after you drop off the kids, and I'll let you sneak a peek."

"I'll pass."

"You know you want to. You coming?" Kat isn't above talking with a mouthful.

"We'll see."

She leans in secretively. "So how's the big guy upstairs doing in the matchmaking department?"

"I don't know. I sort of circumvented his decision making process and vomited out a conclusion of my own, albeit out of guilt and a bit impulsively." I don't have the guts to say anything else.

"What? *Who*?" Her eyes bulge the size of tennis balls.

"Stop it. You look like Sheila." A part of me feels bad that Max's mother is the only one in our extended family not invited. "Max rubbed Mitch's nose in our business, and I lost my head." My eyes mist over.

"So you chose Mitch to piss him off? How'd that go over?" She shovels in another bite.

"It didn't. Max wasn't in the room." My eyes roam over to where he's playing horseshoes with Colt and Mitch. "I'm not sure I meant it because I still desperately want Max." I close my eyes a moment, and an image of the two of them in bed with me quickly turns pornographic. "I can't deal with this." I try to blink the thought away but it sticks and replays on a loop. "It's making me insane. I know I belong with Mitch, but strangely I feel like I belong with Max. And not only did I tell Mitch I chose him, I told Max the same thing just a few days ago."

"Square one." She rounds her hand over her enormous stomach. I can't imagine how she'll explode in these last few months with an entire litter inside her. "You know, you should get married again no matter who you choose," she whispers. "You should have one of those huge over the top weddings—the

tacky ones they feature on reality TV. You're wealthy, so people are going to expect a lot from you. You'll have to serve mega doses of sushi. I hear raw fish cupcakes are all the rage in Europe. You might want to order extra because I plan on loading up. Man, I miss sushi." She takes a swig of her faux beer.

"Are you done?" My entire life is falling apart, and she's focusing in on imaginary fringe issues like the menu at my not happening next wedding.

I glance over at Max. He's sitting with Colt, each of them with a matching beer in their hands. He waves and blows me a kiss on the tip of his finger. His love used to be so freeing—buoyant, now it feels like I'm suffocating on the bottom of a lake filled with gasoline. It's Max who holds the match and doesn't even know it. God, help me, I really do love Max. If I hurt him, I'll light the match myself.

"Either way," I shrug, "I lose."

Kat follows my stare across the lawn. Her expression dwindles. "Max is a god." She looks up with heavy sadness. "You want Mitch though, don't you? You can't admit it to yourself out of guilt."

Moments bleed by, and I don't notice the sunset or the tiki torches that have taken over the landscape, dotting the shadows like roses of fire.

Hudson and Candi show up in a theatrical display of undress. She's wearing a crop top that leaves her bare belly hanging out, showing off the baby Shepherd she's incubating. A hot pink whale tail rises from the back of her jeans and when she bends over her nipples make their debut.

"She's got class that one," Kat says it from the side of her mouth as Candi makes her way over. We hug, and I introduce her to my forked-tongued sister.

"Look at you!" Kat pets her bare belly. "How far along?"

"Seven months."

Her bleached hair glows neon in this strange evening light. The dark trail of roots looks like someone took a magic marker and scribbled along her scalp.

Candi and Kat go over the finer points of cravings and nausea while I busy myself examining Mitch, who's examining me. He's just standing there sandwiched between Colt and Hudson. Odd. It's strange because I'm used to those men in different combinations and not necessarily together all at the same time. I've slept with all but Hudson and have no plans to in the future, real or imagined, to complete that little circle of fornication. Max catches my eye from the far left. With Max it's always been spontaneous combustion when we're together—with Mitch, too, but, dear God, I'd miss Max if I lost him. Suddenly it feels like I'm at his funeral.

"Earth to Lee." Kat fans her hand in front of my face. "You keep the placentas?"

"Oh, right." It takes all my strength to drag my eyes back to my sister. "Ate them for breakfast. They're great with eggs. Tastes like chicken."

They both echo a chorus of disgust.

"No, I didn't keep them," I say. "They're either in the landfill or the incinerator. I kept the kids. That's what counts, right?" I give a brief smile.

They continue on with the chatter about all things maternal, and I freeze for a moment as my brain clouds itself with menstrual mathematics. Holy shit. I was supposed to start, wasn't I?

"Watch out Lee, you're next!" Candi's teeth light up like lanterns.

Kat and I exchange looks. It's like she knows something I don't.

Colton whistles at me from across the yard. A dark-haired woman with bronze skin appears by his side, and two others, just as stunning, linger next to her. He motions me over, so I excuse myself.

From the corner of my eye I spot Janice helping Stella and Eli ladle punch from an oversized crystal bowl. We'll have to peel the kids off the ceiling tonight after she gets through pumping them full of sugar. Better yet, they can spend the night here. Then we'll see how easily the punch flows the next time we're together.

I step in close to Mitch, and our shoulders bump.

"Hello." I hold my hand out to Colton's flavor of the month. "I'm Lee."

"Hekili." She smiles. Her fingers clasp around mine, cold and light as a feather.

She's pretty, honey brown skin, long, dark hair with lots of body. Her friends say hello in unison like a matching set of speakers. The one with a crooked smile eyes Mitch as if he were dessert. Mitch is obnoxiously gorgeous, so I try to let it slide, but, in truth, it makes my stomach turn. It was as if all my hatred was pouring into this one gorgeous girl, ten years my junior—her milk white teeth, her glazed eyes that won't stop openly yearning for my Mitch.

I sling an arm over his shoulder and feel the heft of her gaze shift from him to me.

Colton clears his throat. "Maybe now's a good time for cake?"

Mitch

Lee places her arm around my shoulder, so I one up her and circle her waist. It feels like I'm finally breathing again, holding Lee out in the open. Colton leads his harem to the patio where Mom has a three-tiered cake decked out with a bouquet of frosted balloons. We make our way over, still interlinked, and stand off to the side.

"Is this what's been going on while I've been away?" I whisper into Lee like I'm blowing a kiss in her ear. "Throwing Colton birthday parties complete with ponies, clowns, and balloon animals? Although, technically, it was Colton making the balloon animals, and he's sort of a clown all in one—on second thought, the party works."

"If only this were the worst of it." Lee lets out a laugh. "Colt actually—"

Max comes up along side us, stopping Lee in her tracks before she can get another word out. He traces out our bodies, linked like a real couple, and his features drip into an honest to God state of depression. Hell, I almost feel sorry for the guy. Almost.

"What's got you going?" I ask as my smile expands. "Oh, right, the arm thing. I guess you should get used to it sooner or later."

"*Mitch.*" Lee tries to push me away, but I won't let her. "What are you—thirteen? Max has feelings."

"Sorry." Shit. "I just wanted to let him know you were free to hold me. I don't want him making you feel bad," I say, pulling her in and tightening my grip.

I catch a glimpse of my mother and choose to ignore the worried expression on her face. I bet she danced at their wedding—right after Colt pushed Lee in front of Shepherd like

an oncoming train. I wonder which lovely night that was for me? Isolation? Bring your whips and chains to work day? Maybe it was the time I was hogtied to a wall until I pissed myself?

Good times.

Mom starts in on a slow and dreadful version of *Happy Birthday*.

"Hands off my wife," Max barks.

"*My* wife," it comes out a growl, and Lee steps away.

Guess we're done playing nice for the night.

Max gets in my face like a juiced up gorilla—shoulders stretched back, nose to nose.

"Get the fuck away," I hiss lower than a whisper before propelling him back a good three feet. Max bumps the table and launches the cake off its stand. It does a cartwheel in the air, and half of it lands on Stella's dress, the other half on her toes.

"Squishy!" Stella screams as she and Eli proceed to stomp it out like a fire, their feet quickly transforming into a distressed rainbow of color.

Max comes at me with a series of violent shoves until I stumble onto the lawn. His fist flies in my direction, and I manage to duck before he knocks my teeth into my esophagus.

"Missed." I kick his feet from under him and land him flat on his ass. He lets out a hard groan, and his lungs deflate like a bad tire. In one swift move he knocks me over like a domino. We tumble like bear cubs until he pins me beneath him. He gives a swift knee to my balls and repeats the effort until I wish my head would explode.

China comes back in snatches—the inky darkness—the surprise of pain. Maybe this is all some twisted hallucination. Maybe Max Shepherd only exists in my worst nightmare, and I'll wake up in that cold sterile bunk—a bowl of food waiting for me on the floor, crawling with maggots. Isolation never felt so good.

He kicks my nuts in until they wish they could invert.

"*Fuck*," I shout into the night as my legs cinch up.

Screaming and chaos ensue. An army of legs prattle over in a frantic circle. Hudson and Colton pluck Max off while I roll around the lawn clutching my crotch, hoping to die.

"What the hell are you thinking?" Mom snaps at Max—at least I think so until she kicks me in the shin.

Shit.

"Busy dying." I recover enough to get up on my elbows. I'll feel this nagging pain in my balls until my deathbed. The bushes to the right look like a good place to sign off in peace.

"It's like a powder keg with you two." My mother shrills it out like an opera singer. "I saw you with your arm around Lee—*everybody* did. Apologize." She helps me up. Honest to God, I'm bracing for a slap in the face.

"Apologize?" Is she kidding? "I'm not apologizing." I'm not even entertaining the idea. "In the event you forgot, Lee is *my* wife."

Her eyes soften into perfect circles of apprehension. "Mitch"—she lays her head on my chest and whispers so the crowd won't hear—"oh, honey, Max feels the same way."

"I don't really care what Max is *feeling,* what bothers me is the fact he gets so much damn compassion from my own mother."

Colt makes his way over. He stands in front of the lights, and his face is swallowed up in a shadow.

"Free entertainment." He socks me in the arm. "Boys okay?"

"Super." I lie. They're still busy rioting like someone ripped the skin off and squeezed in a lemon.

I watch as Max wrangles the kids together, hosing the cake off their bare feet. Lee pops up behind me unexpected.

"Can I talk to Mitch?" She sounds curt—good and pissed for Max just like Mom.

Colton shuttles Mom off until it's just Lee and me here in the shadowed portion of the yard. I back up until we're hidden from the spectators, alone in the dark, with the whites of Lee's eyes glowing like flames.

"Sorry." My hands fly in the air defensively. "I'm crap. I handled everything like shit. Swear to God it won't happen again." I ramble out apologies for the next several minutes, taking the blame for third world hunger while I'm at it, the fact the moon is so damn hazy tonight, oil spills, ozone depletion, until finally Lee lands her cool finger over my lips to silence me.

"You didn't do anything wrong." She presses out an easy smile and my insides swim with relief.

Something in me loosens. "Thank you." I pull her in, brush my lips over hers and this time I don't give a flying fuck who witnesses the event.

"Come home," she says it soft, so achingly sweet my insides melt. "I'll calm him down." There's a genuine sadness in her eyes. It hurts to look. We used to be so happy, so full of life—enraptured. We walked on air for so long we forgot how to touch the ground—how cold and hard it might feel if everything came crashing down.

"You gotta tell him, Lee," I plead. A part of me wants to get on my knees like some sort of perverse proposal and pray to God she'll accept.

"You're making it hard," she says it a little more angry than I bargained for. "You're pushing us backward. Do whatever the hell Dr. Van Guard tells you. Do not veer left or right. You got it? There's a lot at stake—Max and his sanity—both of which I happen to care about, deeply." Her face pinches with grief. "That man would die for me—*kill*. You used to care about him. He talked about you, Mitch. He really missed those times. He's baffled about what happened. Just do us all a favor—open up and heal this wound already."

Here she is, begging me to breathe life into a relationship I chopped up and burned to ashes so long ago—one that I

ADDISON MOORE

would happily trade for table salt because of the horrible truths
I thought I buried with it.

Max calls out for Lee. His voice rises through the night
like a war drum, taunting me in the process.

"I gotta go," she whispers. "Come home, kay? But make
an effort. Do this for everybody—for *us*."

Lee takes off. She scoops up Eli on the way out before
glancing back.

Do this for us.

She's right. I need to shore this up and fast. I need to be
the bigger man. I knew holding Lee would set him off, and, at
the time, I wasn't really interested in the consequences—just
like I wasn't in high school when I cut him out of my life for
good.

Max would die for Lee—*kill* for her. What makes her
think I wouldn't do the same? Wouldn't that be the real kicker?
If I came back from the dead just to have Max Shepherd send
me off into eternity once and for all—so he can continue on
with the rest of my life.

I think she's got it wrong.

I don't think he missed me one fucking bit.

Max

Hudson slaps my shoulder on the way to the car. "You want me to call the clean-up committee?"

I don't make any eye contact with him, just watch as Lee struggles to get Eli into his car seat after the disaster that ensued. "I don't care what you do."

"Cool. I got your back, bro." He gives a quick sock to my arm.

"Stay away from the chips. I'm all out of cash, can't bail you out anymore. Clean up your life for me, will you?" I try to disinfect my mind of the insinuation he's flushed through it. The last thing I need or want is Mitch Townsend's blood on my hands. "Spend some time in the fields. We've got a big investors meeting coming up. Cut your fucking hair. That's what you can do. And stop knocking up chicks with a propensity for video cameras."

"Not a problem. I'll get you a copy. Autographed."

Perfect. It confirms the theory he hears all my words out of turn.

I get in the car and start the engine. Eli's eyes are already rolling to the back of his head. But Stella has her arms crossed tight over her chest, a pissed look on her face, and I hope to God it has to do with leaving before the gifts were opened and not with me.

"You hate Picture Daddy," she pouts. And there it is. I glance up at her in the rearview mirror as I get my belt on, her face streaked with purple and orange frosting.

"Do not." I don't put much inflection into it as I rev the engine. The last thing I need is for my wife and daughter ganging up on me. Thankfully, Lee doesn't offer her two cents. Then again, she's probably holding out until we get the kids to

sleep—letting the tension percolate while she polarizes further away from me emotionally.

We hit the open road, and I feel like I can breathe again.

"You do hate him!" Stella insists. "You hurt him in his area."

His *area*? Is that what we're calling it these days?

"And, I'm very sorry I did that." Not really, but for the sake of family unity I'll say just about anything. Truthfully, I'd like to destroy his *area*, incapacitate it until he's incapable of employing it in my wife's vagina. That ought to take all thoughts of copulating with Lee's 'area' off the table.

"You're not sorry," she continues. "You don't like, Picture Daddy. You wish he would leave and never come back!"

Great. Now I've got a mind reader on my hands. "Not true. In fact, I'm betting he'll show up tonight just in time to tuck you in." Because I can't catch a fucking break.

"Will you 'pologize to him?" Her eyes enlarge the same way Lee's do when she's upset.

"You bet. On all fours if it makes your mommy happy."

"*Max*." Lee shoves me in the arm, and I swerve momentarily. "You *should* apologize, and I think he owes you one, too. It wouldn't kill either of you to amp up the civility."

Grief from Lee is the last thing I need tonight. Getting back into her good graces should be a cakewalk—cake full of razor blades—bloody delicious. Maybe when Mitch gets home tonight they can take turns beating me with a baseball bat—twist my balls off and feed them to me for breakfast. It feels like that's been happening on a rotating basis since he's stepped back into the picture.

"I'm sorry, guys." I don't look at either of them the rest of the way home.

Lee helps put the kids to bed. She doesn't say a single word and barricades herself in the bedroom before I have the chance to kiss her goodnight.

Shit. It's like he's turning her against me without even trying. I head downstairs and switch on the comedy channel. Mitch strolls in about a half hour later, looking no worse for wear, even though I tried my hardest to shove his balls into his throat. He disappears in the guestroom for a few minutes before plopping on the opposite end of the couch.

"You want to finish what you started?" I mean for it to sound a little more sarcastic than it did.

"No. I'm through fighting with you." He looks exhausted as he stretches his legs over the ottoman.

"Great."

"What's it gonna take to make you happy, Max? Other than me taking off for good?"

Sounds like he's searching for some missing ingredient.

"Nothing."

"Fine. I'll let Lee impeach you on her own."

"On what grounds?"

"Moral corruption."

"It's completely moral for me to be with my wife." I stop from laughing. "You've got a lot of nerve touching her like that. I wish you'd respect the fact Lee and I are still together. I didn't come around pawing at her while the two of you were married." True story. And, honest to God, I thought about it. "What's it going to take to make *you* happy? I'm not going away, and neither is my marriage."

He gives an intense stare, examines me up and down for a minute. "Townsend. I want all of it back."

That piece of crap splinter in my side? "Sure. I'll let you take over the managerial duties. You can start tomorrow by tackling that irrigation problem." Crops will be dead in two weeks. "Good luck with that."

"You want to give me the name of the plumber you're working with?"

"I'm not holding your hand."

"Got it."

He took that well. It feels like a weight's been lifted off my shoulders, all those pressing nonsensical needs Townsend's been inflicting for years, vanished just like that.

"I've been thinking Lee and I should move," I offer. "We've outgrown the house—and that way you can have it back." I would take Lee and the kids and run off tonight if I had her blessing. I'd toss all our crap in a couple industrial strength trash bags and get us out in under fifteen.

"Where you going?" He doesn't sound the slightest bit concerned.

"Wherever Lee wants. I'm sure it'll be in town." Who am I kidding? I can't set foot in our bedroom, and I think Lee is going to move away with me? Nice. I'm sharing my delusions of grandeur with Mitch at midnight like some schoolgirl at a slumber party. It's all so bromantic I want to hurl myself out the second story window.

And since we're speaking without peppering our sentences with expletives, "What's the big mystery? What happened?" I let it hang out there several minutes to see if he'll take the bait.

"Your mother." He closes his eyes.

I don't think it was my mother. My mother happened months before he stopped talking to me. In fact, we had dozens of conversations regarding our parents' infidelities before 'it', whatever 'it' is, took place, and Mitch shoved me out of his life like I had the plague.

"You're lying, Mitch. Your dad was every bit to blame, and it never occurred to me to shut you out."

"You're right. I am lying." Mitch springs up and heads into the guestroom.

Really?

Now I want to know what the hell he's lying about, almost as bad as I want him out of my life.

If I'm lucky—and I always am, one will lead to the other.

16

The Incident

Lee

The clouds loom over Mono in heavy sheets, grey as pencil lead, and I expect a downpour any moment now. I sit and wait for Colton in the Rustic Cantina, where he said he would gladly buy lunch for his favorite sister-in-law.

All week long Mitch and Max have been going to their 'special' appointments with Dr. Van Guard together. Neither of them has said anything regarding whether or not progress is taking place, but the silence, the peace I feel around the house, is staggering.

They actually took a walk on the beach with Stella and Eli the other day while I indulged in a quick nap. I've been so damn tired lately that I'm scared as hell to take a pregnancy test. I made the mistake of asking for one of Kat's leftovers, and she's been harassing me ever since. Besides, deep down, I already know.

If that wasn't problematic enough, Max has suggested we move—somewhere, anywhere, far, far away from Mitch. That's not exactly how he phrased it. I believe he carefully chose the word *outgrew,* and when he finds out I'm pregnant, he'll prove himself right.

It's as if my nightmare has morphed into something bigger than I could have imagined, and now there will be maternity clothes and paternity tests to contend with.

I remember the days when Sheila would point out the fact Max and I normalized the Shepherd family. Now I'm sure she sees it for the sham it really was. How we've *abnormalized* it to the point of becoming tabloid fodder—how we turned it into a talk show worthy event. The I'm-pregnant-and-don't-know-who-the daddy-is edition.

A familiar baseball cap bounces through the shrubbery outside the window and enters through the front. It's about time. I've got to pick up Stella in an hour and a half.

I stand with a smile ready to greet my favorite pervert but it's not Colt, it's Mitch.

"Hi!" I lock my arms around his waist and hold him an unreasonable amount of time, take in his warm scent, feel his five o'clock shadow scruff against my cheek. All this hands off is making me miss him even more, Max, too. I hate the double-edged sword my heart has become.

"I intercepted my brother." He winces out a smile as we take a seat in the booth. "Hope you don't mind."

"Is Colt joining us?" A wave of guilt swells in me. If Max finds out, he might think I'm secretly seeing Mitch.

"No." Mitch gives a peaceable smile as if that were the plan all along. "He's not."

"Well, anyway, I'm more than happy to have lunch with you." My eyes widen momentarily. I have to keep reminding myself I'm not breaking any rules, self-imposed or otherwise.

"I miss you," he says with an intensity I haven't heard in a long while. It makes this feel like he might say something huge, like he's tired of waiting for me to come around or that he could never get along with Max.

"You can't miss me, we're living together." Any lighthearted feelings I might have had about meeting Mitch fade, and suddenly it feels like someone laid a boulder on my

back. I'm afraid he's going to cut to the chase—ask me to tell Max things I know I can never say.

"Dr. Van Guard wants to see us all together."

"When?"

"Friday."

Three days.

Dr. Van Guard would never push me to do something I'm not ready for. This is only buying me time.

"Lee, it's me, Mitch." He leans in as if I might have forgotten. "It's like you don't even recognize me anymore."

"What are you talking about?"

A tall, skinny girl comes over and takes our drink order, says she'll give us a moment to read over the menu, but her eyes linger on Mitch as if she wants to box him up and take him to go. There's not a woman on the planet who wouldn't want a bite out of Mitch Townsend.

"You know what I'm talking about," he whispers. "I want things back the way they were. They're never going to be that way again, are they?" He looks tired, desperate.

"They are," I whisper. Deep down I believe this. There's a film of moisture building in his eyes. "I swear to you. I'm not going to break your heart."

"What about Max? Can you break his?" His eyes elongate, making his features sag. "I don't think you can, Lee," he says it somber.

A stalled car outside the window catches my attention. Two strangers run over and help push it to the side of the road. *I* feel stalled. I feel like Max and Mitch are both pushing me in two different directions, and we're not getting anywhere, least of all forward. We're trapped on a dangerous road, and at any given moment something's going to ram into us, destroy us all for good.

The waitress comes back but we hold off on the order— just sit there feasting on our misery.

"Do you want to talk to him?" I ask. Maybe if I put this all off on Mitch he'll pull me out of the wreckage.

"I tell Max off routinely," he says. "It doesn't have any effect on him. He needs to hear the right words from you. If you say it, maybe he'll believe it." He gives a wry smile. "Maybe."

"What's that supposed to mean?"

"I don't think Max is going away so easily. He's more of a fight-till-the-finish kind of guy. The finish being death."

I take a deep breath. "Max would never hurt me. I know for a fact if I make a decision, and it doesn't involve him, he'd support me... over time." Not really.

"Are we talking about the same Max?" His eyes offer a smile all their own.

"Same Max," I say. Mitch's mood seems to have lightened. "I'm sorry I'm putting you through this."

"You're not putting me through this. I put us through this." He winces.

"You didn't put us through this." I collapse my face in my hands a moment. "Do you ever think maybe this was part of the plan?"

"Some master plan?" A dull laugh pumps from him. "If it is, God is going out of his way to prove how much he hates me."

"Mmm," I glance out the window, dismissing his theory. "It sure feels like some kind of weird sideline though."

"You think you're supposed to be with Max?"

I don't have the heart to say no. On some level, I've always felt Max would be in my life.

His features harden, his eyes dart out the window as he gets lost in the haze.

"We're part of the plan, Lee. Me and you." It sounds like a plea more than a fact.

"So *this*—this horrible thing was supposed to happen?" A watershed of tears breaks loose. I once thought heartbreak was a manmade misfortune. I never once believed God would dole it out by the spoonful.

Mitch swoops in and scoots next to me, drops a hot kiss on the top of my head.

"It'll all be over soon, I can feel it," he whispers. He pulls back and looks me in the eye. "We'll get through this. But it's entirely up to you how quick we get to the other side." He sinks into the booth as he takes me in. "Lee, I'd walk through fire for you. I'd jump over the moon, but I can't have Max warring over you for the next fifty years. It'll be the last nail in my coffin."

It's all coming to a head. I can feel the dam about to break. It'll sweep us all away in the current and in the end it'll be my fault.

I can't choose Mitch or Max—one over the other.

Something tells me walking through fire—jumping over the moon would be a hell of a lot easier.

Mitch

We're going old school tonight at Dr. Van Guard's office. Max and Lee are in there first, then Lee and me—then the grand finale—the smearing of Max Shepherd's heart over the walls.

I thump my fists over one another—stare across at the maroon walls trying to imagine what they could possibly be discussing. I don't like this. It feels like Lee is full of secrets all of a sudden. We shared everything before I left. Then again, she wasn't married to anyone else at the time. There were no privacy issues, not one ounce of intimacy she experienced outside of me.

Colton said Max came to my funeral. We hadn't talked in years, and he showed up with bells on. I bet. I'm sure he was gunning for Lee even then. I'm not sure why, but even with Lee's reassurance I can't lose this sickening feeling.

Max and Lee aren't sleeping in the same bed anymore, and yet that doesn't bring me all that much comfort. Although he did hint at the fact they didn't need a bedroom, that broad daylight sufficed as evidenced by their date a few weeks back. It feels like both Lee and Max are taking turns strangling me. That pretty much sums up how if feels when I open my eyes in the morning and remember who I am, where I'm at, and how in the hell I got there. Max—procreating with my wife—playing house. If I never came back it would have all worked out beautifully for him.

My foot thumps over the floor so hard and fast it tears through the silence like dynamite. I hop up and pace for a while until Max shows his face, and we trade places.

&OCB

ADDISON MOORE

Lee's been crying, nothing but two pools of vinegar where her eyes used to be. I can see Max has effectively worked his magic.

"Hey, it's okay." I wrap my arms around her and kiss her on the cheek. I'll just let the good doctor babble on while enjoying my time in the Max-free zone, comforting my wife.

"Mitch, we've just been discussing you." Dr. Van Guard offers his signature placid smirk. The building could be on fire, and he'd give that same deranged look.

"Really?" I don't let go of Lee. Instead, I lean in as she strokes my hair and keeps her head glued to my chest.

"Lee? Would you like to offer some of the concerns you and Max shared during our session?"

Concerns? Lee has concerns?

"No, thank you." She defers to him.

"Okay, I'll give you the basic run down of what was said, and you can surmise from it what you will." He butts his chair into the desk. "Lee and Max discussed the primary living arrangement the three of you share. Max mentioned this was never brought up for discussion—that you merely barged into their lives, and took up residence on the couch. Is this true?"

Why do I feel like I'm about to be strung up by the balls?

"True." Short, curt answers are always a good strategy.

"Were you at all concerned about the children and what they might make of this?"

If I say no, I'll look like a monster. "I considered it to the extent that one of them was mine, and I felt what better way to make up for lost time than to alleviate the distance between us."

He looks doubtful. "There was an apprehension between Max and Lee about whether this is the best solution for the time being. Lots of couples share custody, Mitch."

Lee stares wild-eyed at the doctor, as if he was about to enter the no-thrill zone, and she needed to brace herself.

324

He goes on, "Max mentioned, Stella was asserting the fact she has two 'daddies' at school. Now, in principle, that really isn't the problem, she keeps good company in that respect. However, she was emphatic that her two daddies live with her mommy—that they're both trying to put babies in her tummy."

Fuck. "Is she being teased?" It's like he fired a shot right through my chest. I'd die before I hurt Stella. I've turned her into some kind of freak without knowing it.

"No, no, Max didn't mention that. Just that her teachers were concerned for her welfare and wanted to be certain everything was going smoothly at home. Are you openly arguing with Max or Lee at the house?"

This is starting to sound like some social services audit, and I don't like it.

"No." God, am I? I'm not even sure that's the right answer, but I'm pretty sure it's my stay-in-my-own-damn-house-free pass. Had I said yes, he'd have me packing my pillowcase before sundown.

"Mitch, would you consider leaving the property? Surely you must understand this isn't a natural arrangement—for the children's benefit."

And there it is. Max found his loophole. He probably paid off the entire staff at Stella's golden elite private school to put it on record that I'm screwing with Stella's head.

"No. I won't move out." I don't need a moment to consider his absurd idea. "It's my house—mine and Lee's. We built it. Literally. Lee is *my* wife, and she wants to be with me. I think it's time everyone involved is apprised of the situation." Lee turns into me, but I don't bother trying to decode her expression. I can't help but feel like I'm about to sell her out. I think it's time we end the niceties and shore up the details of what's going to happen—today, at this hour, it all ends.

"Lee, do you think it's time?" Dr. Van Guard relaxes in his seat and waits for her answer with a pious level of patience.

Her body goes rigid. She doesn't say anything, just seizes up like a marble statue.

"Lee?" I can't say I'm shocked by her lack of enthusiasm. "Max isn't here. This is a safe zone. Don't you think it's time?"

She clears her throat.

Shit. What if she's been playing me? What if she's been saying the identical thing to Max for the last few weeks?

She leans in. "I *do* want to be with you." Lee wraps a delicate arm around my waist. "It's just this stuff with Stella—and if Max left it would be upsetting to the kids." It comes out stilted, rehearsed. Suddenly it feels as if I'm being tag-teamed by the Shepherds, Lee being one of them.

"Understandable." Dr. Van Guard nods into her line of thinking. "This might be a good time for us to initiate the final exercise in our homework series. This one involves you too, Lee. I'll wait for Max to come back in. But first, Mitch, I think you should really utilize this time with Max and try to formulate the kernel of a bond that Lee needs to witness between the two of you. Try to connect with him on a deeper level. Do you think you're capable of letting go of past grievances and starting a whole new relationship with him?"

"Of course." The words fly from my lips before I can evaluate them, before I can acknowledge if they were in the least bit true. I think I could. For Lee and Stella, and Eli. If Lee believes Max would walk through a fire for her, I need to prove I would too.

And I'm about to.

Max

Lee is practically sitting in his lap when I step back in. I smooth my hand over her back and restrain myself from reaching over and clocking Mitch square in the jaw. I'm not sure what good this therapy is doing for anybody. Lee is being twisted like a pretzel emotionally. Honestly, I think it's less harmful having Mitch loaf around the house all day, compared to giving her the grand tour of our psyches. I can only imagine what their sessions are like. Mitch masterfully dragging out the past, dunking her back into the ice bath of grief he put her in. They weren't even married for a year before he took off—

"Max. You seem to be lost in thought." Dr. Van Guard is starting to sound more and more like a smart ass as the weeks go by. "Would you mind debriefing us? What's on your mind?"

"Gladly." I bob my head over in Lee's direction. "I was just thinking how Mitch and Lee weren't even married for a year before he disappeared and how we were married for three."

"There's no statute of limitation on marriage," Mitch is quick to reply.

"There is when you're taken captive and mistaken for dead for a span of five years. She moved on." Really, I just wanted to remind Lee in the event she forgot. And the fact that we're all seated here proves she has. Either that or she regrets our marriage, and that's one scenario I'm not willing to face.

"Lee?" Dr. Van Guard seems unmoved by my argument. "Do you feel any less married to Mitch than you do with Max?"

"No. Not at all." She seems happy to answer.

"So, then, it would appear you're on equal footing again." Dr. V's smile broadens. Honestly, whose team is he on? "Right now I'd like to focus on your relationship." His pen flicks from

me to Mitch. "We need to dig a little deeper. We've done some skirting about the vineyards, the parents, Lee and the children, but something is missing. Max, I'm going to ask you point blank, when was the first time you had feelings for Lee? There is no wrong answer. It could be first grade, just be honest."

I look impassively over at Mitch. He's got his elbows resting on his knees, and miraculously now there's at least a foot between him and Lee.

"Maybe junior high." As soon as I hit puberty, I noticed she was practically naked in her bathing suit, but I leave that part out. "High school for sure."

His brows arch as though I've said something of significance.

"Mitch?" He postures in his direction.

"Same." Mitch doesn't mix words just rides my coattails, such as in life.

"Well, that leaves a full three years into your relationship that you both had an eye for the same girl. You must have discussed her at some point."

Neither Mitch or I say anything. It's not like we ever entertained obscene conversations about Lee, but we were teenage boys crushing from afar.

"Max?" He wants answers.

"Yes. We engaged in a few discussions."

"Mitch?" He wants a full accounting of what went on, I can tell.

"She was dating my brother," he says it quick like he's hoping it'll go away.

"She dated Colton briefly," I add. "Couple months, tops."

"Right. It was stupid," Lee shakes her head. "Colton dated everyone, I was just next on the hit list. It was over before it began. We hardly kissed."

Mitch looks over at her. I guess it's weird imagining your wife with your brother. She never looked in Hudson's direction

once or vice versa. But, then again, Mitch was more like my brother than Hudson has ever been.

A thought comes to me.

"You know"—I shake my head at how clear its all coming back to me—"that last year, Mitch and I hung out, we *did* talk a lot about Lee." A slow spiral of anger brews in me. "I talked about Lee. It was me who was clearly interested. I'm the one that had us down at the beach to hang out with her. It was me that made sure we ended up at the right parties—the *movies* I knew she'd be at. It was no secret to Mitch that I was totally into her."

Mitch doesn't say anything, just looks at Lee a few seconds too long before piping up. "I knew the second I laid eyes on her I'd never be with anybody else," he says, unmoved by my words. "I didn't keep that a secret from anyone. I thought you were just fantasizing out loud. Besides, you had three girls under your belt, calling you, going out with you. Who could take you seriously?"

"When I came back that summer, you had Lee. You wouldn't even look at me. It's because of Lee isn't it? This never had anything to do with my mom or your dad."

Mitch blinks off into space. "Are you accusing me of *stealing* Lee?"

"That last night at Brody Tomlin's party," I say, glancing at Lee first. Lee swears she never told Mitch about what happened between the two of us. "You left me stranded." After Lee took off, I had to hitch a ride with someone else because Mitch ditched me. That was the last night he ever spoke to me. "Something happened that night. We went into the party as friends then you took off." I try to lay off the aggression, but it comes barreling out like a train with no brakes.

Mitch stares long and hard at Lee, until she shifts uncomfortably.

"I wasn't planning on going here," he says, bowing his head a moment. "But for the sake of speeding up the process—if

you think the *kids* are going to be better adjusted adults." He
rises and starts to pace. "I went to the party with Max that
night." He shoots his words at me like poisoned darts. "Lee and
Colt just broke up. She wasn't with anyone, so I planned on
talking to her. I told you that."

"I was talking to her, and you were nowhere to be found."

"I was watching." Mitch hardens his stare. "I saw how you
made sure her beer never ran out—how you lured her to the
bedroom."

A sharp bite of heat explodes under my arms.

"I went back there to tell you that I thought we should
leave. That we should get her home before she got sick or did
something stupid." He cuts a hurt look over to her. "I went into
the bedroom, and you two were busy, so I left."

A deafening silence fills the air.

So Mitch knew. He knew I was with Lee. "You saw us?"

"Yes." Mitch looks freshly offended.

"Then you knew I was going to be with her, and you
waited until I left town before you made your move. You did
steal her from me."

"I'm not anybody's property, Max," Lee says it cool, but
her rage is layered just beneath. "Mitch, you never told me."

"Because *you* never told *me*. Why would I want to go
there? Obviously you regretted it. And, after that, we were
together."

"You kept us apart," I say just above a whisper. Fucking
bastard.

"That's right, Max." He locks onto me with a hostile stare.
"I knew you and Lee had 'chemistry,' and I wasn't about to sit
around and watch the fucking sparks fly. I didn't want you near
us—not for two seconds. I knew you would never let her go.
And to be honest? I didn't think it was going to be that easy.
But you never fought for her. You never once confronted me."

Lee's jaw goes slack. She stares over at him dumbfounded
as the color bleeds from her face.

"He confronted *me*," she growls. "Max talked to *me* on several occasions." Her voice shakes.

Mitch's face explodes, red as a turnip. "Were you seeing Max on the side?"

"No," she corrects. "He was looking for clues, for answers to why you were treating him like crap. I can't believe you had so little confidence in our relationship that you would throw Max away like garbage. You didn't think our love was strong enough to have him around as a friend."

"You *slept* with him." The words thunder out of him.

That's as good an argument as any.

"Doesn't matter." Mitch sits back down, despondent. "I thought I could keep you apart. Guess, life had different plans." It comes out mockingly, but it's the truth nevertheless.

Holy crap. Did Mitch just remotely insinuate that Lee and I were meant to be together? Is this Mitch, the supposed *great love of Lee's life* admitting defeat? I want to love it, but can't.

Lee picks up her purse and walks out the door. Looks like I'll have to catch a ride back with Mitch, or maybe he'll ditch me for posterity.

"Homework—final assignment." Dr. Van Guard slaps his hands together. "The both of you. For one solid month—stay the hell away from Lee."

Castle of Sand

Lee

I don't bother going home. Max and Mitch can pick up the kids. They can be the new Townsend-Shepherd couple of Mono. I'm going to hang out with someone far more mature and level headed than those two can ever be—Colt.

I give a hard knock over his door until the wood vibrates beneath my knuckles. It takes several minutes before a string of muffled expletives head in my direction.

The door swings open revealing a very rumpled, very freshly laid, Colton. His hair is sticking straight up, his bare-chest glistens with sweat. His boxers are pulled down to his pubic line. A woman, wearing nothing but his T-shirt, trots down the stairs, pausing a good three feet behind him.

"Sorry." I make my way over to the couch and fold into it.

"Sure, come in."

I don't bother acknowledging Colt's sarcasm. He mumbles something to the girl, and she scrambles back upstairs. He probably wants me to be quick, but I'm hoping it's her he'll evict.

"What's up?" He plunks down next to me, ripe with body odor.

"You smell funky—move."

"Any other pressing requests?" he asks, relocating to the recliner. "Have a sudden interest in yet a third husband?"

"I'm quite uncomfortable with just the two. Thanks for the offer."

"You're in a mood. You wanna pick up some food, and I'll get rid of... " He motions upstairs.

"No. I don't want to go anywhere, and for sure I'm not hungry." I want to cry, but the tears won't come. I'm all out of tears for both Mitch and Max. "What happened between us?" Now that Dr. Van Guard drew back the curtain, I can't help but feel maybe there's something more lingering behind the gossamer. Mitch's bombshell about keeping me away from Max leveled me. It wrung my heart out without warning, and I can't seem to get my footing.

"Us?" Colton scans the ceiling as though there never were an *us*.

"You were my first boyfriend. You gave me a hickey the size of an apple that warranted a turtleneck in the month of June."

"You want another?"

"No."

"Are we about to have an argument?" His head ticks back a notch, amused.

"Maybe." God knows I'm ripe for one.

"How long ago was this again?"

"Really? So I was just another face—nothing special? You don't even remember that we dated."

"I remember." He rolls his eyes. "Of course, I remember. I teased Mitch the first few years you guys went out. Told 'em I got the test drive. But you were good for a purchase, not so much a lease, and I wasn't buying. I handed you off to my little bro because I thought we should keep you in the family."

"Not funny." I'm completely unmoved by his allegorical confession.

"Glad you approve."

"What's wrong with you anyway?"

"As in wrong with me because I didn't choose you? I didn't catch Lee fever, so I must be damaged?" He gives a slight laugh.

"No, because you never settled down. You know—*family*, kids."

The floorboards creek from above, and he points up. "My version of settling."

"You like this one?"

"She's okay. I feel kind of bad I can't understand her, but that comes in handy sometimes."

"If it helps, I can't understand men—mostly Mitch." I shrug.

"So what happened? What perfect storm has you running for cover in my living room?"

"We went to see the doctor today. Mitch said he saw me with Max." I dig through my purse for a tissue. "It was high school, right around when you and I stopped seeing each other."

"You cheated on me?" He looks genuinely pissed.

"*No*. You had already been with like three other people simultaneously."

"Yeah, but that was expected. This is you we're talking about, and with Max? Wait, did you cheat on Mitch?"

"No, no—just you. In fact, I was drinking you away, and Max was there."

"Right place, right time. Best place to be." He winks. "So you never told Mitch?"

"Nope."

"He dropped the bomb on you today? He knew all along."

"All along," I nod. "And I feel like shit. All those years we were together—I never told him. He knew, and he never pushed me. And do you know why he hated Max?"

"To keep you apart."

"You knew?"

"He told me from the beginning, although, he omitted the little detail about you sleeping with Max. Makes sense, though. Max was after you, but Mitch wanted you more."

"You think so?"

"I know so."

"You're his brother, you have to say that. Max wanted me plenty. And in the end..." I wag my wedding ring in the air.

"But Mitch is back. This time you have to choose *him*." The smile melts from Colt's face. "He's running scared, Lee."

"I chose him before." A part of me wants to say *I'm going to choose him again*. But what if life is rectifying something that was meant to be in the first place?

"How do you really know you're with the right person, Colt?" I wait for him to answer, garnish it with some sage advice, but nothing.

"Lee." He lies back and closes his eyes. "I wouldn't know the right person if she walked up and spit in my face."

True. Who was Colton to offer advice on anything other than herding females into his bedroom by the dozen? He's a marathon womanizer, something less than a gigolo who has a woman stashed upstairs and probably ten more penciled in for the night. I'm not even sure he knows how to spell her name, let alone say it.

"I love Mitch." It comes out bland, so sad.

"And Max?" Colt wants me to say it out loud.

"I love Max."

"Thought so."

I take off from Colt's and sit in my car a good long while before starting the engine. Mitch ended his relationship with Max as some stupid game of keep away. What would have happened if Max *was* around?

My stomach turns with the possibilities.

How different would life be today if Max was in the equation way back when?

Mitch

"You want to hit Black Cove?" I ask as we maneuver onto the highway.

"Sure." Max flicks his eyes out the window.

Black Cove is technically the bluff above it. We used to hang out there with friends when we first started driving. I took Lee a few times to watch shooting stars.

The sun is still pretty high—summer sun. A slow trail of orange melts over the sky, making it look like someone left out a Popsicle too long. I pull into the lot and park against the overlook. Not a soul to be seen for miles. The fog rolls out over the ocean in sheets, taking the edge off the heat wave we've been sweltering in. If Lee were here she'd lose herself in the beauty of the clouds as they cover the shore. She'd rave about it, pull a notebook from her purse and start sketching. Those are the little things I love about her. The way she sees beauty in nature and doesn't hesitate to share it with others, sketch it out to appreciate later.

I roll down the windows, and the haze seeps in. Max leans back and closes his eyes.

I can't fucking believe I dug my grave today in front of Lee. That I told her what had really gone through my teenage mind at the time I booted Max out of my life. They say you should never let a girl get between you and a friend. But Lee was no ordinary girl. I needed to make sure what happened at the party never happened again. Didn't really succeed, though. I wonder what would have happened if I let them run their course. If Lee would have dumped him—hated him. Then years later, when I went missing, she would have stayed single or married Colt. Never mind the fact Colt is allergic to

commitment. He would have repelled from matrimony like an air bubble escaping the bottom of the ocean.

"So now what?" Max shifts in his seat. "You going to lure me to the edge and push me off?" He sounds resigned to pretty much anything right about now.

"Nope." Not that I wouldn't put it past him to lure *me* to the edge. "Just thought we could hang out for a second. Drink down the doctor's special brand of advice."

"Super." He turns his head toward the water.

"So are you going to do it?" I ask. "You going to keep away from Lee? A month?" I doubt Max could keep away from her for a solid day, let alone thirty.

"Wouldn't you love it."

"I'm doing it." If it only takes one more month before I can have Lee again, I'd stand on my head, douse myself in honey and let fire ants crawl all over me.

"I'll do it." It comes out disgruntled. "Lee gave that asshole her blessing to ratchet us however he wants. The sooner this is over, the better."

"It's the last assignment," I offer. Only Max has no idea he gets the boot in the end. No dating Lee, no touching, kissing, or undercover action for one whole lifetime. "I bet you feel like you're about to suffocate. At least you're not an entire continent apart. It's five weeks, not five years."

"I know, Mitch." He nods out the window. "Life fed you a shit sandwich, and now the whole world has to suffer because of it. And I damn well better be willing to cough up my wife."

"Lee gets to decide whose wife she is."

Max turns in his seat, switches off the radio. "You want her back?"

For a second I think he's going to give her to me, gift-wrapped—concede and call it a day.

"Stupid question," I say.

"If you do, you should know the way to get into her good graces is through me." The hint of a sly smile appears.

"Yes, you." I run my hand over the steering wheel. "I know." Lee's been saying, all along, the way to her heart is through Max. How fucking astute of him to realize. I doubt she clued him in. "I'm all yours, Max." I hold out my hands. "I want to fix this, make it right—for Stella and Eli. I want Lee, but I know you do, too. Aside from Lee, we need to parent these kids."

"You don't need to fake some bond with my son to get on Lee's good side."

"You fake some bond with my daughter?"

"I was there the day Stella was born," he roars. "I watched as she took her first step, her first word was daddy. I *named* her."

That last point takes the air from my lungs—siphons it out by way of my stomach. "You named her?"

"Yes. Lee wanted to name her Mitch, but I suggested Stella. You know, from the play."

Yes, I know. It was Lee and me who were in it. I was the one who got the whole school calling her Stella. I just assumed it was Lee who thought of it on her own in some serendipitous moment.

"Thanks. I like Stella." Still stunned.

"Lee was tired. She was alone and depressed—really scared."

"Sounds like a prime target."

"Nobody else was there for her!" His voice echoes through my skull. "Your nitwit brother couldn't tie his shoe if his life depended on it. Your mother had too damn much on her plate with the Townsend investors leaping off the nearest bridge every time she turned around. And, by the way, we're up the creek again thanks to your talk show circus. There's a meeting coming up in a few weeks that dictates whether or not we keep treading water or start inhaling to speed up suffocation. I'll have to pull the cord and attach it to the slush fund at Shepherd

just to keep it afloat." He pushes his head into his seat. "You take care of that leak yet?"

"I'm talking to the plumber." Slight exaggeration.

"You can't wait for him to get back to you, Mitch." He slaps his hand on the dash. "Get the hoses out tonight, let them run because half the crops are drying out. You're going to lose everything."

"I got it under control." The truth is, Max took better care of the fields. Where's my head been? I start up the engine. "Thanks for being there for Lee." I mean it this time. No sarcasm.

"You know"—he locks eyes with me—"deep inside I wanted to believe you would have wanted it that way. I didn't fight you for her back in the day." He looks past me at the open sky. "Maybe I should have. But then again, you can't fight what's meant to be."

I hope he remembers that when Lee brands her footprint over his ass.

Something tells me he won't.

Max

Lee took to the idea right away. It was almost as if she needed a mental vacation, and she agreed to the ground rules set up by Dr. Van Guard. Minimal contact. Avoid being in the same room together with the exception of shared family meals, no going out with either one of us, no extracurricular chit-chat, just hello and goodbye for one solid month. Mitch and I are to leave the house in the evening for a few hours—if possible together. It's been odd. The first week Mitch and I hung out on the beach teaching Eli and Stella how to throw a football, how to boogie board, and play a lousy game of volleyball.

And here we are again, building architectural testaments to the sandcastle. We've split into teams. Stella chose me, so Mitch and Eli are together by default. They're across the sand trying to outdo us by slopping together a fort that looks more like a trench or a moat.

Stella wants a princess castle. I wonder what this will all mean to her someday. If she'll look back and remember the time we built a castle together and wish she were building it with her "real" father instead. I wonder if by then Mitch will have stolen my daughter, wife, and son from underneath me like he thinks I did to him. It's the last thing I did to him. I never once thought about swiping Lee when we were in school. I gave in like the pussy he was hoping I was, but in truth I cared about Mitch as much as, Lee. They looked so damned happy. Who the hell was I to get in their way?

"We should name it," I say as we cut grooves into the towers with one of Eli's sand shovels.

"Chalet Shepherd." She gives a hard grin. She's so beautiful, just like her mother.

"Chalet Shepherd it is." Ironic. Mitch's daughter and so-called wife both bear my moniker. Stella only knows herself as Stella Shepherd—Townsend being her middle name.

"Look at me, Daddy!" Stella climbs up the mound of sand that supports the tallest tower. "I'm stuck in the castle, and I need a prince to save me!" She cups her hands around her mouth creating a megaphone, "Picture Daddy! Help me! Save me! There's a nasty dragon, and he's going to eat me!" She points in my direction.

Great. I've been relegated to the part of an overgrown reptile.

Mitch dashes over, swoops her in the air and she goes limp like a ragdoll. Stella laughs so hard she sounds like she's in pain. He lands her soft in the sand in front of me.

"That's no dragon." Mitch glances up and offers a wry smile. "He's a knight. He was just trying to rescue you."

Stella lunges into me with a death-grip. Her bony elbows dig into my shoulders as she wraps her arms around me.

"A knight, huh?" I shoot Mitch a weary look.

"Yeah. I guess it's easy to mistake a knight for a dragon from far away. Once you get to know them, you see the difference." He gives a slow smile before catching Eli as he launches into him like a missile.

"Nice knight." Stella pats my chest. "Just like when Picture Daddy was gone, you saved me and mommy. Then you put Eli in her tummy, so we can be a family. Did you put another baby in her tummy, so I can have a sister? Or is it Picture Daddy's turn?"

Mitch and I exchange glances. We don't say anything.

Eli starts destroying the castle, and we all join in.

$$\text{\large ဆ၀ၒ}$$

"She's fertile." I plunk my bottle down on the bar.

Took Mitch out to the Winding Rope on highway 39 just south of Shepherd. Smells like cologne and whisky. Every now and again a barfly lands between us, and campaigns for our attention with her tits.

Stella opened a whole can of worms with her awkward observation on the beach this afternoon which sponsored our drive to the bar to begin with.

"Maybe she's not." Mitch can't break his dead-on gaze to nowhere.

"Maybe." I knock back the rest of my beer.

The bartender offers another, but I pass.

"Not too many things pan out for us, though," I say. "If I had to guess I'd say it's true." Just another dart in the balloon of my life. Not that I wouldn't love the child, help raise it, but Mitch—he's not going anywhere. If she's carrying his baby it's just another point for team Townsend. "So congratulations." I tip my empty bottle toward him.

"Funny how we both wanted Lee, and now we both sort of have her."

"There's nothing funny about this quasi-polygamous arrangement." I pause a moment. "You know, I never thought about it—I mean *really* thought about it, but this has to be hard on her. To you and me it's black and white, but to Lee..."

Mitch doesn't say anything just swills his drink around in the bottle and watches it spin. "Lee's coming back to me," he says with the enthusiasm reserved for dental cleanings.

"You keep believing that."

"I know it." He doesn't bother putting any inflection into it. He's half-wasted, so I don't push him on the subject.

A hard slap lands on my shoulder. "Hey, hey the gang's all here." Hudson sings it out like it's his new favorite song. "Who's up for some pool? I got my boys in the back." He shoots me with his fingers.

"Sure." Mitch abandons his drink, and we follow Hudson down the narrow hall like a pair of prisoners on death row. "Is

this the part where you knife me and make it look like an accident?" He asks as we enter a large room filled with plumes of swirling smoke.

"Not tonight, Mitch." Hudson slaps both hands on his shoulders. "We're saving that fun for some other time." He gives a hard laugh and winks in my direction.

I wonder if Mitch thinks I'm capable of putting a hit on him. I've thought about it—hinted to Hudson, but the last thing I'll do is off Stella's "Picture Daddy." I'm not about to be hauled to prison for removing Mitch Townsend from the planet. Lee would never forgive me—hell, *I'd* never forgive me.

Hudson winks at me again when Mitch isn't looking and has me spinning through the Rolodex of every conversation I've had with Hud since Mitch returned. Shit. Who knows what miscommunication I've had with my brother. For all I know there could be a half a dozen "accidents" waiting to happen.

Mitch shoots, and the balls split in twelve different directions, none of them in his favor. That's Mitch all over. He plans life out one-way, and it crapshoots every which way but that. I almost feel sorry for him.

He steps aside, and I take over, call my shot, and it lands in the pocket like an obedient child.

Mitch arches a brow at me, feigns amusement, but you can tell he's impressed as hell.

I say Lee is pregnant.

Looks to me the odds are in my favor.

18

The Deception

Lee

In the middle of the second week, Kat drags me along to her OBGYN appointment.

"They're dating," I say to her as the technician leads us to the ultrasound room to view my sister's bundles of joy in triplicate.

"And you're jealous?"

"Extremely." I avert my gaze. "I want them to get along. I pray they'll get along. But now it feels like they're barhopping, picking up chicks on the side."

"And you're afraid they're going to leave you for one another?" She flags down a girl from the back office.

"I think they already have."

"Lani"—she squints into the svelte girl behind the counter—"my sister here thinks she might be knocked up. Could you possibly help us end this mystery? Pretty please?"

"Sure. It'll have to be off the record, though." She reaches into the cabinet and hands me a plastic cup. "You know the drill?"

I nod as I take the cup from her.

"Put it here when you're through." She motions to a plastic bin.

I give Kat a sharp look before heading into the restroom. When I come out I place the cup where she told me and follow Kat into the exam room.

"You're a troublemaker, you know that?"

"I strive." She hops up on the table and relaxes into the paper pillow.

"I hope they've multiplied and they find six in there," I say. "You know, I couldn't handle two of Eli. He was colic. Wouldn't it be something if all six of your babies were colic?"

"You don't like me, do you?" She winces as a small-framed woman pelts clear jelly onto her abdomen.

The frail looking tech starts poking around her belly with what amounts to a computer mouse while Kat and I struggle to see anything of relevance locked in the shadows up on the screen.

"I'm counting. There's only three," the technician says. She gives me a sharp look. "Healthy, though. I'd tell you the genders, but with three it's tricky. You could count someone twice and mess up the roll call, so I don't try anymore."

"How about just tell me if I've got a boy and girl. I'll figure out the logistics later." Kat grasps onto my hand and squeezes as if I should be campaigning for this as well.

The tech winces as she stares into the screen. "This one's a boy."

"A boy!" My fingers fly to my lips. "A little buddy for Eli."

The tech digs into Kat's stomach so hard it actually depresses. God, I think she's going to poke through with her wand. "And, you've got at least one other boy. Third one's shy which is fine by me."

"Another boy! Eli's going to be in heaven!" I hop up and down with Kat's unenthusiastic hand.

"Lee?" Tears stream down her face. "I don't know boys."

"Oh, stop. You know Eli."

"What if I have *three* boys?" Clearly she's petrified by the concept.

"Relax," I say. "Boys are way easier than girls. They turn everything into a gun, even toast. Girls just scream."

"Firearms? Are you telling me my children are going to be involved with firearms?"

Second thought, I'm not sure Kat being a mother to all boys is a very good idea.

"Maybe they'll be pensive and studious," I suggest. "We'll take them to the library every day. By the time they're three, it'll be their natural habitat. Those kinds of places practically train them to be quiet little geniuses." Unlikely, but I'll go with it.

"I have three brothers," the technician offers, wiping down Kat's belly with a towel.

"And I bet they're fine—doctors, or lawyers, or something," I offer.

"Two are in prison, and one is homeless somewhere in L.A."

I stare at her blankly as she gathers her stuff and heads out of the room. Kat's face bleaches out like she just saw the ghost of the triplets' future.

"She's a breath of fresh air." I help Kat down as she adjusts her dress, and we make our way back into the hall.

"I've got your results," Lani says, walking past us. "Congratulations. It's positive!"

"Well!" Kat's whole affect brightens. In fact, she looks downright vibrant. "I feel better about my budding little convicts now that I know you've confused the paternity of your precious angel." She pats my stomach with a beaming smile.

"I can't believe you. How can you joke about something like this?" Actually I can believe her, and, oddly, she's somehow managed to take the edge off my new predicament.

"Relax. Mitch and Max love you. They love Stella and Eli. This baby isn't going to change any of that. You can still choose Mitch or Max—Mix and Match. You can have a Monday,

Wednesday, Friday—Tuesday, Thursday, weekends arrangement." She winks.

"It's illegal to 'mix and match,' Kat." I glance out the window and watch as a bird dives off the roof of an adjacent building only to soar straight up again. I wonder when I'll start to soar again. Or will it be one long nosedive that leads to disaster. Feels like the latter. "If you can have three babies, why can't I have two husbands?" It comes out more of a spin on polygamy than I bargained for.

"You've lost your mind, Lee, nobody wants two husbands. One alone has the power to bring the misery of thousands."

I've compounded my misery with my spousal surplus— me and my husbands to the second power. I hate these cruel mathematics. I'll keep the baby low key until after I figure out how to shoot one of them through the heart. Still don't think I can do it. Where's God? I look out the window as though I might actually find him.

"I think this baby belongs to Max."

In a strange way I think I do, too.

❧❧

Corporate worship. That's what they call church these days. Sounds like fiscal records should be discussed—the budget—least of all the gospel. Mitch has been asked to speak today. I scoot into Max who oddly takes up my hand then drops it repeatedly as if it wades in and out of his mind that I have the plague.

"You can hold my hand," I whisper. "It's okay."

He picks it up again before redirecting his gaze back to the pulpit. The pastor introduces Mitch. He briefs the congregation in on the fact he left on a business trip, became a prisoner, and never wavered in his faith.

Mitch looks angelic. The light shines over him, and he glows. He lets out a supernatural smile before stepping up to the podium.

"I'm so glad I can be here today—be anywhere." His cheeks pick up a bright pink hue as he looks to the floor. "I want to share with you the story of how I came to be that prisoner, how I got here today, but first I want you to know I don't feel like a victim. I feel very much like there was and is a purpose being worked out for good—that even though I lost a tremendous amount of time with my family, I cling to the fact it was meant to be. Just before I was captured I asked God to please let me see my beautiful wife one more time—to let me hold her." He swallows hard. "That's one prayer I'm glad he answered." Mitch segues into his story, starting with the day he left. How he looked at me with an enormous feeling in the pit of his stomach that something was about to go wrong.

It's so hard to listen. Painful. I squeeze Max so hard, it's like labor all over again. All of this un-anaesthetized heartache stings like hell, leaving my soul in dust and ashes.

He details the beatings and for the first time I learn of the torture devices used to break him, to convey facts that were never his to begin with. Mitch was never a spy. He goes on to share the hallucinations he had of me, of his secret life with our nameless, faceless child. My effigy was always the trigger, always the release for a bottomless well of tears. He shares a beautiful story of paper roses. God's love notes, and his, all rolled into one.

Mitch wipes his eyes with the back of his hand as he brings it to a close. "I'm back, though. It's been a bumpy ride, but I made it. I'm not sure if I accomplished what he wanted me to. Perhaps I'll never know. I had two choices when I was going through it. To rely on the unpredictable cloud to govern my every move or build a golden calf in the desert—trust in government, man, myself. I chose the former. And, as confusing as my life's been ever since I've come back, I still

trust the unpredictable cloud. God is sovereign. I only need to learn that lesson once. Thank you."

There's a mild applause.

I'm in awe of Mitch—his bravery. Just knowing that the light that kept his sanity focused on the future was me—our family, makes me feel smaller than a flea. Mitch takes a seat on the other side of me and feels for my hand. He doesn't let go, and neither do I. Max shifts in his seat. It's all uncomfortable. If there were, or is, a purpose in all this, it makes no sense whatsoever. The tears I've shed over the last several years—*weeks* could fill fountains. I feel dizzy trying to decipher the code from this wordless cloud. I'm not picking up on any inner voice telling me when to pitch a tent—when to pull up the stakes. How exactly is anyone going to stop me from melting all of my resolve and forming it into some tangible, useless replica of my indecisive heart? I'm afraid I've already unwittingly fashioned the heifer. I can say I want Mitch, but I want Max just as much. I want to press them together until they form one person—and then I want to love them in that strange deformed way.

I stare with open anger at the monolithic cross before me.

I need a savior and soon.

Mitch

Mom and Colton take me to lunch after. It feels strange not having Lee with us. Not because she's been right by my side ever since I've come back as my loving, supportive wife, it's just that this was a big deal, and Lee and I have always shared our big deals together. I rattle the ice in my glass as I look at the ocean. I miss her. Old Lee—the Mitch and *Lee* version. I can't wait for this thirty-day standoff to come to an end.

"Hekili!" Colton jumps up and pulls out a chair for his girlfriend. I told him any woman with the reference to *he* and *kill* in her name was one to steer clear of. Another girl appears at her side, and I scoot over making room for one extra seat. Colton introduces her as Hana. They're both tall, dark and gorgeous, but I couldn't care less.

I tune out the conversation at regular intervals, consuming the interim with obsessive thoughts of Lee. My mind wanders aimlessly, wanting to get lost in the pressing details; what's she doing, wearing, eating, with or without whom? All of these things I want to know. I'm not really interested in the temperature difference between the California coast and the South Pacific. I feign a polite smile every now and again and wish to God I could transport myself anywhere but here—hell, I'd take China right about now. Sometimes I wonder if I ever really left.

I pull out my phone and text Max. Ask him where he is. I want an accounting of somebody for something, or I'm going to go insane.

A minute later my phone vibrates. **Townsend fields. Pipe burst. You're fired.**

Max. He's the one they called. I told the field manager not to bother him anymore, that I was in charge. I can see how far that went.

"What's wrong?" My mother extends her hand over mine.

"Pipe burst. Max is on it."

"Thank God for Max." She raises her glass as if she's toasting him. "Just enjoy your lunch. He'll take care of everything."

Colton and his girlfriends break out in a fit of laughter. Probably over something moronic he said, like I'm going to sleep with you both before nightfall. And I'm betting he will.

"Yeah, thank God for Max." I let out a breath. I'm so damn tired of everyone worshiping at the altar of Max Shepherd. With both Lee and Mom he can do no wrong—and I can add Stella to the worship team.

"Max cares about you, too," she offers.

"Really?" I'm amused by how this might work.

"Really." She leans in. "We had a nice heart to heart the other day when he came by to pick up the kids."

The thought of my mother having a heart to heart with Max guts me on some level. "So what'd you find when he ripped open his chest? Maggots? Necrotic tissue?"

"Stop. Max has a heart of gold. He loves Townsend like it was his own. Did you know he took out a second on Shepherd to keep it afloat for the first six months? He wasn't with Lee back then. I asked him the other day why he did it, and he said he did it for you, Mitch. He said your friendship meant the world to him, and he knew he could never tell you that again, so he stepped in and cared for you the only way he could."

Somehow I doubt Max said I meant the world to him. I wouldn't put it past my mother to sprinkle this conversation with her own special brand of euphemisms.

"Well, Max means the world to me, too," I say it mostly to get a rise out of Mom. She swats me with her napkin, and I give a lazy smile.

"You should make things right with him. Stella adores him, you know." She leaves out the fact he's her legal guardian, and although we're genetically bonded, I have about as much authority over her as the postman.

"I'm trying," I whisper. "Its taking Herculean efforts, but I'm trying."

"As long as you're trying, I'm satisfied with that. I could never accomplish that with Sheila. Lord knows I wanted to, but you're a better person than I am, Mitch."

Doubt it.

<center>ଛ୍ଞଓଷ</center>

Max and I decide to take the kids bowling. It's dark out, and Lee looks exhausted, but insists she's going to Kat's to watch a movie. I want to reach out to her, take her for a nice long walk on the beach, but it goes against the principle of leave-Lee-the-hell-alone month, so I resist the effort.

At the Mono Bowl O' Drome, Stella chooses a bright pink ball, and Eli gravitates toward the one with painted flames carefully protected by a square of glass—a gift to the establishment signed by a bevy of pro bowlers. A major meltdown ensues once Eli realizes the ball isn't landing in his hands, and Max stays behind to deal with it. Eli's next choice is the bright pink ball that Stella is busy cradling like an infant.

"Get your own," she barks.

"Stella," I say it soft, pleading with her on a subliminal level. "It's not a big deal. You can share."

"It *is* a big deal." She looks at me wild-eyed. "Sometimes I don't want to share. You shouldn't have to share everything, and bowling balls are one of them."

I want to add, *a wife, too,* but don't.

"Enough." Max plucks Eli off her. "You're sharing." He points hard at her. "It's done. Let's play."

Stella frowns into Max before getting distracted by seeing her name on the board.

I like how Max handles the kids, how he treats Stella as though she were his own. Who am I kidding? She *is* his own.

"Nice," I say. We watch Stella help Eli waddle down the alley and roll the ball between his legs.

"Yeah, well, you have to be firm. You'll catch on."

"I plan to."

"You should come with me in the morning and meet their teachers. They love—" He stops midsentence as he looks past me. "Crap."

I turn around to find Viv—Max's first ex-wife staring me in the face.

"I heard you were back." Her dark hair slips just past her jawline as she smiles at me. There's an evil beauty about her. That wicked gleam in her eye lets me know she's not above digesting a man for breakfast. "So, glad you're still in one piece. Look at you! Still the best looking guy in Mono." She cuts a look to Max to see if he's enjoying the dig. "You haven't changed one bit, Mitch."

"Neither have you," I say, looking from her to Max.

"So, Max, you ready to relinquish what's his?" She bares a halfhearted smile. "I'm still single, you know."

"And I know why." He doesn't twitch a smile.

"Oh, come on." She steps in and runs her finger along his cheek. "You can't tell me you don't think about me."

"Every now and again, in my nightmares."

"Sweet." She presses out a dull smile before returning her attention to me. "Rumor has it, you guys are all shacking up together. How does that work? Let me guess, she's got you on a schedule. Every other night—something like that?"

Stella runs up and hugs my legs.

"Hey beautiful!" Viv kneels down beside her. "Is it daddy's night out? Where's your mommy?"

"She's tired." She turns to Max. "Daddy it's your turn."

ADDISON MOORE

"You take it, sweetie." He directs her back toward the pins.

Viv stretches out. "I *bet* she's tired. If Lee needs backup, tell her to give me a call." She waves her fingers in the air as she struts on by.

I shake my head at him. "And which of her many redeemable qualities demanded you make her your bride?"

"You heard her, she's single." Max cuts his eyes across the way to make sure she's gone. "Why don't you find out for yourself."

"I'll pass. Lee is making her decision soon." A part of me wants to warn him that he's not the one she'll choose—spare him of a broken heart.

"I know." He looks down at his shoes as though he's resolved to whatever the answer might be.

For the first time since coming home, I realize that Max cares about Lee as much as I do. I didn't think it was possible, but the glint of pain in his eyes says it is.

Max

Another seven days stab by, and we're staring down the barrel of our final Lee-free week. Arduous, is a good way to describe this last month. We get to see Dr. V again once the reprieve is over. Him, I don't miss.

I head over to Archie's, a bar slash archery range, and meet up with Hudson. It was Hudson's idea, and that's never a good sign.

A bevy of waitresses run around in bikini tops, serving up beer at this ripe hour of the day. A short blonde winks at me as she heads in this direction with her nipples poking through like hat pegs.

It feels like I'm cheating on Lee just being here.

I slap Hudson on the back and pull up a seat next to him.

"TS spelled backward is shit," he says, holding out his hand for me to shake it. "What's going on?"

"Stocks tanked." I smack his hand away. "There's an investors meeting in the morning. I'm here to make sure you don't make a rare appearance." It's the nicest way I could think to keep him the hell away. I know he gets the company memos, so there's always the off chance he'd stroll in and hang me by the balls with his presence.

"Nope—can't make it. Got to take Candi to the doctor."

"Well, aren't you the devoted father-to-be. You ever hear from Jackie?" If I had a son somewhere out there in the world, I sure as hell wouldn't disconnect just because his mother moved.

"She's gone. I don't even try anymore."

"One day a kid is going to walk up and kick you in the 'nads. That'll be Joshua."

"She took him." He twists the amber bottle in his hand. "It's basically a kidnapping." He lets out a belch that scorches my eardrums. "You'll see. Once Lee and Mitch hook up again, they'll have to sell the land. The next thing you know, they'll want to move out of state." He takes a long swig. "Shit happens."

"I'm not letting shit happen. I'm odd that way."

"You gonna win this battle?"

"I win every battle."

He winces, closes his eyes like he's already had too much to drink. Probably has.

"It's because I have your back," he says. "That's why you win."

"You want to have my back at Townsend? I've got three faulty lines, and every plumber in the world is convinced you can't re-dig the pipes without killing every one of those crops."

"What are you doing?"

"Quick fixes. I fix one, the next day there's another leak. Some get water, some don't."

"Sounds like your house. Someone's getting some, someone's not. You'd better up your game, buddy. You know how she's going to judge this contest—beneath the sheets."

"Shut the hell up." I grind my palm into my eye. I'm sleepy. I miss my bed, my wife, my *life*. "All these problems, funny how they surfaced just as Mitch touched down on U.S. soil."

"The boy's always been bad luck."

"You're no horseshoe yourself." Did I just defend Mitch?

"Maybe I will come tomorrow. Bring my better half—hell, bring complimentary DVDs for everyone." He belts out a laugh. "You gotta have that you-can't-beat-'em-join-'em attitude in life. You watch it?"

"Are you nuts? She's like my sister-in-law. I'm not watching that crap, but I think Lee did."

"She pick up on anything? Notice anything new?"

I shake my head.

I'm not sure when we're going to rectify that either.

On a clear morning, at the polished offices of Townsend Shepherd, Hudson and Candi stride into the boardroom like they own the place. Candi has her assets on display for all to see, inspiring twelve dumbstruck foreign investors to rise to the occasion, followed by Mitch, Colton, and me. Lee cuts a look that doubles as a death threat as the two of them take their seats.

If I had thought there was any chance they'd actually be here, I would have made my protest crystal fucking clear. I would have *paid* them not to show.

I open with the niceties before I turn the table over to the PR team and watch them work their magic—their dry, out of practice, remedial at best—back of the cereal box hocus pocus.

An investor from the Emirates with a thin goatee, sharp, lively eyes asks about the steady decline in TS commodities. Mitch and I exchange glances.

"It's a hiccup." They've traveled over fifteen thousand miles looking for an explanation, and I tell them it's something akin to a bodily function? Just fuck.

"You have one too many hiccups." It comes from the other end of the table. By the time I look over, everyone is laughing, so it's hard to pinpoint exactly who the heckler is.

"Mitch." Johan Rewler. Our top man from France was raised in the states, so he speaks perfect English. "You've brought some financial dissention with your return. I'm glad you're back safe, but you've spooked the buyers, now I'm stuck with a shitload of wine. I can't push it off on the local drunk, let alone my vendors."

ADDISON MOORE

Before Mitch can refute his unintentional pocket poison, the rest of the crowd breaks into a soft hum of agreement.

"The Townsend Shepherd name has turned into a farce." It comes from a beady-eyed woman from the Netherlands. Her wiry hair sits on her head like a bird's nest. "I'd recommend you cease your attempt in fusing the two labels, but it's too late, the barrels of Shepherd have been tainted in the tabloids. No offense." She nods over at Candi. "You've officially dubbed Shepherd the porn wine of the 21st century. People associate your once good label with adult entertainment. What are you doing to cure the situation?"

Candi clears her throat.

She's the infection, and I guarantee the only cure is to cut both she and Hudson out of my life.

"I have a book coming out in the spring." She taps her chest. "While I'm not proud of what I've done, I do feel privileged enough to have built a platform to further myself and my new Shepherd family." She holds up her hand, sporting a nice pebbled-sized diamond.

Hudson never mentioned they were engaged.

"So you're making it official?" Lee juts her neck out nervously.

"Actually"—Candi looks over at Hudson—"we've done the deed. We're just keeping things low key for now until things, you know, die down."

"Did you have a prenup?" Johan asks as his forehead erupts with concern.

"Hell no." Candi is genuinely insulted. Her whole person ignites three shades of red, and she looks like she's been dipped in blood. "It's not true love in my book if you have to do that." She bats her lashes over at my sorry excuse for a brother. "What we got is gonna last forever."

The meeting turns somber as talk of buybacks of unsold shipments ensue, and my personal favorite, severing ties to decrease legal fees they might incur. It's a fuck fest, and TS is

358

taking it up the ass from every angle. It's a funeral. Everything Lee and I built, my father, Mitch and his dad—it's all been flushed away because of the rotten apple that fell from the Shepherd family tree. I tune out the rest of the meeting until one by one I shake their hands and thank them for coming as they scramble out the door. Lee sounds like she's giving a eulogy as she says goodbye.

I wait until I hear the last of their footsteps disappear down the hall before ramming Hudson up against the wall.

"You piece of shit." I jerk my knee into his groin so fast I send his balls clear up his throat. "Congratulations." I rattle him by the shirt. "You have single handedly dismantled a fucking empire it took Dad years to build. And you took it down in *minutes!* Is she worth it? Because I predict whatever little bit we do manage to hang onto, you're going to end up losing one day."

"You think you're *it* don't you?" Hudson's eyes bulge unnaturally before a surge of aggression spikes in him. "You never make a mistake, and nothing ever sticks." He twists his fists into my collar and gives a hard shove. "I'm gonna let you in on a little secret that everyone in this room knows but you. Your little princess—the woman you idolize like some kind of glass goddess—she slept with good ole' Colty boy the night before your wedding. You got that? She *begged* him to pretend he was Mitch." He smirks. "I bet she asks you that all the time." He hawks back a mouthful and sprays my face with piss-colored phlegm. He and Candi race out the door like the building were on fire.

I wipe down and catch a glimpse of Mitch as he shakes his head with a silent apology. He knew. I look to Colt, and he crosses his arms. He drops his gaze to the carpet while his face bleaches out.

Shit.

"Max." Lee comes up from behind with her eyes lit up like sparks, her lips trembling.

ADDISON MOORE

Fuck.

She did it.

I speed out into the hall.

"Max, wait," she calls, but I bolt down the stairwell so fast she can't keep up.

The truth spilled out as honest as a bullet.

Looks like nobody else wanted me in on their dirty little secret.

Carnal Affections

Lee

I want to close all the windows, make the light of the world disappear forever. Max took off after Hudson ripped into him, told him things I wish he never knew. But that look he gave me, it was a poison arrow—fire and acid, everything I've ever felt from him in reverse. In that moment he hated me, and, now, he probably always will.

I've no clue where Mitch went. I came straight home to an empty house and ran upstairs.

I pull out my wedding albums from the closet, both of them, side by side, and force myself to digest them for the rest of the afternoon.

I open each to the first page—Mitch and me—Max and me. I'm so happy in these timeless stills, so in love it's unfair. The only difference in those days was Mitch. His notable absence was the turbulence of my soul the day I married Max. But Max knew how to soothe me. He kissed me right there on the altar when my mind started to wander. I never doubted for a minute that I shouldn't be with Max. At that moment I didn't care if it would kill Mitch all over again if he knew I was with him. Max was what I wanted—what I needed. I knew he

wouldn't leave me—that he wouldn't go to another country if I asked him not to. Our lives were perfect in every way.

I thumb through the pictures of Mitch. Young Mitch. He looks aged now compared to all those years ago. Max, too. In the short time we've been married, he's taken on far too much. Townsend is enough of a headache on its own, let alone Shepherd. I dragged him down with all my dead weight. God knows his brother did him no favors. He must feel so alone, hated, maligned. We all did this to him, but I was the arrow that lodged in his heart.

I give him a call, but he doesn't pick up. Crap. I'll be lucky if Max ever speaks to me again.

I close the albums and slide them to the edge of the bed. Of all the people I knew when I married Mitch, the only person missing from the guest list was Max, and from the second wedding it was Mitch who was gone. There's a built-in irony in there somewhere, but I can't grasp it.

"Hey, beautiful." Max lights up the door like an angel—a savior. He gives a slow spreading smile as he comes over and sits besides me.

"You're home!" I fall over him with a tight embrace, just taking in his scent. "I never want to be without you. And I mean that."

"You know I love you." Max presses a heated kiss into my hair. "What's going on?" He nods over to the wedding albums, and his cheek slides up on one side, no smile.

"I don't know where Hudson heard that," I start. "But he didn't have the facts straight."

"Just tell me you were drunk, Lee," it comes out soft, broken, as if he had already considered all of the options, and he liked this one best.

I close my eyes. "I was drunk," I bury my face in his shirt and take in the warmth from his chest, feel the beating of his heart, quick and erratic. "God, I'm so sorry. And, I know—I

know there aren't enough apologies in this lifetime to convey how sorry I am."

"Come here." He pulls me up next to him and buries a kiss over my head.

"Can you ever forgive me?" There are so many things I need to beg forgiveness for. This is just the tip of the dirty iceberg.

"Of course, I forgive you." He presses his lips high up on my cheek and doesn't let go. He sighs into me like he's ready to fall asleep and bypass this insanity by way of a nap. "Lee, I know you went through something incredibly heartbreaking when you thought you lost Mitch. I know it's equally hard for you now. And I just want you to know I'm here for you. I really do want to support you. I want to help get you through this, Lee." Max bears into me with those cobalt spheres. "But I won't lie. I still want to be the last man standing."

I pull him in and nod. "Thank you so much for loving me the way you do." I tighten my grip around his waist. "And I wouldn't blame you if you hated me."

"I could never hate you." He drops another kiss on the top of my head.

"Have you missed me?" In every way I've missed Max. These past thirty days felt more like thirty years. Max is everything, and I need him. And I need him to be more than a friend in my life.

"Yes, I missed you. I missed you with an indescribable ache." He bows down and inhales the scent from my hair as his breath warms my scalp. I never want this moment to end. It feels safe, natural like this in his arms. "He tried to change things, Lee." His voice breaks. "He kept us apart."

"It didn't work, did it?" I glance up at him. "I'm sorry. I can't believe he did that."

"It was dirty. I should have played dirty. I should roll him in the dirt now for posterity."

"You know..." I place my hand on his chest and feel his heart thump over my palm. "Just between you and me, I felt something for you even after you came home from that trip. And when you didn't show any interest I figured maybe it was a one-sided thing, so I stayed with Mitch. But I've always felt something for you, Max."

He soaks in my gaze, absorbs my words like an elixir right into his cellular structure. "Always?"

"Always." I push a kiss just below his ear. "It could have been us from the beginning," I whisper the words like a secret as if I were somehow blaming everything that's happened on Mitch and his underhanded dealings with destiny.

"What's important is that it's the two of us in the end," he says.

I tighten my grip around him as if the house, Mono, the world were about to blow away.

That's exactly what I want—right along with Mitch.

"Come here." Max lands us on the mattress with our heads on the pillows. "Let me hold you, Lee."

I snuggle into Max and we fall asleep in one another's arms.

Just like old times.

Just like it's supposed to be.

ଚ୨ଓଷ

Max is still asleep well into the evening. The kids are spending the night at Janice's, where I assume Mitch has been all day, so I take Kat up on her dinner invite.

"I'm pulling an intervention," she says, before plunging a slice of pizza into her mouth. The restaurant is full, so we sit at the bar, but Kat has managed to amass a plethora of appetizers that keep coming at a steady pace. Kat's huge midsection acts as a barrier between us because, apparently, she can no longer

belly up to the bar. She holds out a slice of pizza toward me, and I shake my head at the offer.

"Look at us." I say, hovering over my virgin daiquiri. "Two pregnant women at a bar."

"We're the opening line to some really lame joke."

"That about sums up my life."

"Stop." Her mouth falls open with a mouth full of food, and I turn my head away to keep from puking.

"You ready for the whole baby shower thing?" I slide my daiquiri in her direction. They've already refilled her soda three times. They can't keep up with her. "I'll help you pick out whatever you need. And, I've got the entire town on speed dial. We can do a real blowout if you want."

"No blowout. The only thing that's blowing out is me. I look like a whale. The last thing I want is to be the center of attention. I'll just get what I need—as I need it."

"You sure?"

"Very. Although, I am open to accepting gifts from my wealthy sister."

"Done."

"So"—she glances down at her last slice of pizza—"rumor has it Max looked like he wanted to take a chainsaw to your head."

"Not true. Mostly he looked like he wanted a really long nap on the bed he hasn't slept on in over a month."

"Poor Max."

"Poor Max," I echo

"Lee?" Her eyes widen at something just beyond my shoulder. I try to turn, but she snatches me by the wrist. "I want to ask you something." She's intent on keeping my focus, so I play along. "What if they dated? You know, Mitch and Max."

"They are dating—each other." I struggle to turn, but she secures me with her newfound superhuman strength. "What's going on?"

"So what if they did?" Her eyes enlarge like silver dollars, and that's never a good sign. It takes a hell of a lot to shock the pants off my sister. "You know, meet friends for drinks?"

"I guess that'd be okay." Viv pops into my head. She'd swallow Max whole if he let her.

Her face contorts in a series of horrified expressions. "Um...Lee? Friends for drinks at three o'clock."

Friends for drinks.

I spin around and spot Mitch with one of Colt's hussies. Her amber hair falls like a curtain, and her lips shine like glass as she breaks out into a laugh.

Oh, God.

It's happening. I'm losing Mitch. He waited and waited, and now he wants nothing more than drinks with friends at three o' clock.

My insides pinch sharp as an ice pick—my intestines twist in a ball of fire.

How could he?

I'm going to kill Colt with my bare hands for facilitating the effort. The tramp and her lava-like hair, her thin arms slithering over his chair, his shirt. She runs her finger along the rim of his glass like a promise.

"Slow down, girl." Kat pulls me back in my seat. I hadn't even realized I levitated out of it. "You've got fire in your eyes and steam coming from your ears. Pull it together." She takes a breath before evicting me out of the barstool. "Now go kick her bony little ass."

My feet move swiftly without my permission. Every ounce of me wants to run and hide, but my body wants the exact brand of hostile revenge that Kat just prescribed.

It feels like a dream walking over to them. The little tramp slips her hand over his back and gives a light scratch like she's done it a thousand times before. The waitress sets down an oversized tray of drinks in my path, and I don't hesitate to knock it out of my way—filling the air with the violent sound of

shattering glass. I ignore the shout from the waitress, the gasp of the patrons, and just keep walking, garnering Mitch's attention in the interim.

"*Lee?*" He jumps out of his seat, startled by my destructive display. "What's going on? Everything okay?"

The girl springs up beside him, clutching at her purse in the event she needs to make a quick getaway, and I'm betting she will.

"I'm fine, Mitch." I stride past him and give her a nice hard shove in the chest.

"Lee," he barks it out with marked aggression and locks my wrists behind my back. "You're going to get yourself arrested." He pulls me in and holds me, but really he's restraining me, penning me in with all of his strength in the event the threat of a prison term meant little to me. "Hana are you okay?"

She shoots him a look that could slice through diamonds while muttering something in an unfamiliar language. In one swift move she sloshes a glass of water in my face before bolting for the exit.

"That went well," I say, wiping myself down with the back of my arm.

"Let's get out of here," he slips his arm around my waist and leads us out into the cool night air. Mitch waits until we hit the parking lot before he pulls me in, and his entire face explodes in a grin. "I think I like you jealous."

Kat appears, panting from the trek over. "Can you take her home for me? She's way more excitement than this pregnant woman can handle—for *any* pregnant woman to handle." She needles into me like she wants me to tell him about the baby right here in the parking lot in my soaking wet T-shirt.

Kat takes off without so much as a goodbye.

"Let's get out of here." Mitch washes me with his eyes, pauses when he hits my hips. It's like he knows, neither Kat nor

I had to tell him. He weaves me through the parking lot and into the passenger seat of his truck.

I guess we're breaking all the rules tonight. After the bomb Hudson dropped this morning, all of Dr. Van Guard's rules have been reduced to nothing more than debris on the war-torn landscape of my life.

Mitch and Max are in the heat of the battle.

War is hell.

I've got the battle scars etched over my heart to prove it.

Mitch

Lee and I drive down the ebony streets of Mono as the ground clouds roll over the boulders that line the side of the road.

"Swear to God, I was merely doing time when Colt's gal pal strolled up," I say as we round out the coast. I've already rehashed the story to her twice. The last thing I want Lee to think is that I was trolling for chicks in my spare time. In truth, I was mulling over my stint in China, trying to figure out whether or not this could possibly have fit in the hierarchy of plans that someone upstairs dreamed up for my life—the master plan that eventually revealed itself to be the disaster plan. I thought I'd be free once I left the detention center, but I can feel its looming presence in my life like shadowed wings that hover over me everywhere I go.

"She was all over you." Lee bites down on her lower lip, and I can't help but fight a smile.

"I never said she wasn't." I give a quick wink. "I'm teasing, Lee. You have to know the only woman I want all over me is you." Can't say I'm not impressed as hell by Lee's reaction though. I was just about to take off when Lee decided to castrate the furniture and break all the dishes. It must mean something. If she's that bent out of shape, she must still want me. "So, you were hanging with Kat in the bar?" I ask, never taking my eyes off the road. Kat looks as if she swallowed a pumpkin, hell an entire patch.

"Restaurant was full. You know how that goes." She gives a hard sigh out the window. "You want to go to the dunes?"

My adrenaline kicks in. Lee wants to go to the beach—*our* beach—the dunes. Maybe this is it. Maybe all Lee needed to fully commit was seeing another woman trying to dig her claws in my back.

"I can't think of anywhere else I'd rather take you." I flip a U-turn and head on up. The fog stretches over the beach, thick as a blanket. The sun set about an hour ago, leaving a tangerine sky in its wake. I park and grab the blankets still stowed in the back from our last adventure.

Lee comes around and wraps an arm around my waist as we make our way over to the sand.

I want to ask her about the baby. If she's having one, if she thinks it could be mine, but don't see any reason to inject more confusion into the situation.

"You're quiet." Lee props her head against my shoulder.

"Just content to be with you."

"You worried about breaking the rules?" There's a slight sarcastic edge to her voice.

"I don't like rules that keep us apart, Lee."

"I don't like rules that keep us apart, Mitch." She matches my tone but ends on a hard note when she says my name. "Or trips, or countries."

Here we go. "Looks like I get angry Lee—dishes-wielding Lee." I tickle her ribs trying to make light of it, but I think we both know I just landed us in a pile of crap.

She stops short and looks up at me. "You don't need to hang out with me, Mitch." She pulls away. "In fact, maybe you'd just better take me home. I'm all over the place. Hudson's outburst really fucked up my entire day."

I don't think I've ever heard an expletive fly from her mouth. I bite the inside of my cheek to keep a smile from blooming. Something tells me it's only going to piss her off.

"Honest to God, I was teasing." I land a kiss over her cheek. "I love all of your moods. Believe me, I'm just thrilled to be standing next to you." I pull her in close. "Holding you, seeing you. That's the prize Lee, and I already have it."

Her gaze dips to the sand. "This isn't enough, Mitch."

"It is for now. Next week it's all you. Send Max packing, and we'll have our lives back just the way they were."

Lee glances up. She spears me with something just this side of hatred before taking a full step back. "Send Max *packing*? You think that's all it takes? What about Stella and Eli who know him as their father? Should I send them packing, too, and we can just start over?"

"No." I reach down to take up her hand. "That's not what I meant. I know this isn't easy for you. And, I care about Max, too."

"Bullshit!" She spits it in my face. "You couldn't care less if he croaked right there in Townsend field. I don't like the way you've treated him since you came back when what you really owe him is a *thank you!* You know what else I don't like?" She jerks her hand away. I stare ahead not wanting to provoke anymore of her anger, although mine is picking up at a descent clip right about now.

"This conversation?" Because it's not my favorite.

"The fact you think I should have waited around in a giant black shroud, hoping my dead husband would miraculously show up."

"I never said that. I never even implied it." I never thought it for a minute.

"You wanted that. Admit it," she shouts into the wind.

"It's a pointless conversation. You want to go back to the truck? I'll take you home." I'll take myself to my mother's for the night—let Max deal with the fallout of Colton's ambush matchmaking.

She gives a hard shove into my chest. "Pointless?" I have a feeling she could snap my neck just for the fun of it.

"Don't do this." I back up. "I know your head's all over the place today. I know you wish you didn't have to choose. I *know* you love Max. Is that what you want to hear? There, I said it. I know you *love* Max!" The words thunder from me like a curse.

"I do love, Max!" Her voice rivals mine. I'll hear that echo in my dreams. "But it's *you,* Mitch! I want *you* back—our whole

life. And I can't figure out how to do this, and nobody in the world can help."

Lee melts to her knees and presses her hands into her face. I sink to the cold waiting sand and wrap my arms around her as she shakes from grief.

We've fallen into a well of deep emotions with nothing but heartache to greet us at every turn. We need the moon, the stars to let us know which way is up.

"I'm sorry." Her breath blooms over my face. Lee conforms to my body and I hold her like that. "When you came home everything changed," she whispers. "I thought about what would happen all the way on the car ride back to Mono. I thought everything in my world would change, but nothing did. I couldn't figure out what to do with Max, and I didn't want to leave him. He deserves better than this, Mitch I swear to you Max is good."

"I know he is." I press a kiss into her temple. "After getting to spend some time with him, especially seeing how great he is with the kids, I don't feel like Max was the worst decision you've ever made. It's the opposite, Lee. He was a good one." My stomach clenches, but I mean every word.

"You still wish I'd left him that night." She looks out at the ocean as a wave sweeps over the shore, white as a pearl. "You wanted that. I know you did, and I disappointed you."

I wish I could say that wasn't true—that I would never have wanted that, but I can never say it.

"I hoped." I barely have the nerve to whisper it. "I knew it would be complicated. And if it had been anybody else but Max"—I hang my head—"I probably would have backed off—for like a minute." I push my shoulder into hers and we share a stifled laugh.

"Do you still hate him?"

"No." I want to. It feels like self-sabotage to admit I have no more hatred left for Max Shepherd.

"You tried to keep us apart." It comes out drenched with disappointment. "You gave up your best friend because you didn't think you could trust me."

"I trusted you plenty. It was him I didn't trust. I wasn't going to make a big deal of what happened that night. But he wanted you, Lee. And there was nothing in me that was about to stand around playing third wheel. He slept with you. I had that small window, while he was away, to get your attention." The moon glints over her glossed features, and I brush my thumb over her cheek to wipe away the tears. "I thought if he wanted to play dirty, so would I. I thought I could control things, but I was wrong. I couldn't control losing my father. I couldn't control the inexcusable way he emotionally slaughtered my mother, so I vowed the day he died I would do anything to protect the ones I loved—that I would never hurt them, but I did. I hurt you, and I hurt Max. All along, I was trying to get my way. I was no different from my father after all. Turns out the selfish bastard didn't fall far from the tree."

"Mitch." She folds into me. "That was the end for Max and me, but not because of anything you did. It's because I chose to be with you."

"It wasn't the end." I shake my head. "Not even close. I'm being humbled. God is taking me down in grand style. He's showing me who's really in control. He put Max in your path once, and he did it again. I'm not the one who's in control, Lee, I never was." The detention center blinks through my mind in snatches, quick and haunting like clattering teeth. It's as if the entire universe is working in favor of Max Shepherd, and, if I'm not careful, I'll wind up right back in the dungeon where I came from.

Lee winces into me. "So you're trying to tell me, you think Max and I were meant to be together—that you were just some obstacle to our destiny? I don't think you believe it for a minute."

The ocean and its menacing thunder fills in the silence. We watch the waves collapse on the shore and pull out in a fury while trying to drag everything with it.

Max and Lee. It couldn't be right. *Mitch* and *Lee*, we were the super-couple. We were the great loves of our lives, weren't we?

"Max isn't going away," I whisper. It sounds like a betrayal coming from my own lips.

She pulls back. "And we're not going to arrange that." A fire ignites in her eyes. She's all hell and fury over the thought of me hurting Max.

"I think the bigger question is when is Max going to make *me* disappear? I still haven't ruled that one out. If I wind up in a ditch, don't be afraid to point fingers." I'm only half-joking.

"He would never hurt you." Lee pulls me in by the chin. A sad smile breaks loose on her lips. "Mitch," she whispers it solemn as a eulogy. Lee holds my face and offers a careful kiss over my lips, soft as air. I pull her down to the sand and cover her mouth with mine. It's an inventory of gums and teeth, nothing but the fire from our mouths to keep us warm. Deep, meaningful groans expel from our throats as we soak it all in. If my soul were required of me at this very hour I'd die a happy man in the arms of the woman I love.

My father and his philandering ways blink through my mind, and I lock him out. This is different. This is Lee.

She tugs at my shirt and pulls it over my head. Lee runs her hands over my chest, slow and easy as if she were committing it to memory. I think we're all done discussing Max and homicidal tendencies.

"You taste so good." She gives it in a heated whisper right over my ear.

I pull the blanket out and roll Lee and I over it. We spend a small eternity exploring the hot of one another's mouths until she lets me peel off her jeans. I slip my hand between her thighs and she gives a quiet groan of approval.

"Mitch," her eyes float to the back of her head as I plunge my finger deep inside her. She reaches down and frees me from my boxers, pulls me out like she's about to hold my cock for ransom.

"Do you want this?" I pull back to give her a moment to think.

Lee bites down on her lip as if she were unsure, as if her hormones overruled any rational thought she was capable of making.

Lee pulls me in by the back of the neck and dives her tongue into my mouth, hungry and needy. She reaches down and strokes me until I'm pretty damn sure I'm going to come right there in her hand. Lee guides me in, and I die from the sheer glory of the moment. I was starting to doubt this would ever happen again, and here we are, back in our own private paradise. I glide in and out determined to make it last. I plan on showing Lee exactly how much she means to me, how much I love every ounce of her, body and soul. And I plan on loving every last ounce, right here, until the sun comes up, then long past that into forever.

Tonight we're breaking the rules.

I don't mind breaking the rules with Lee.

Max

It's hard falling asleep when it's four in the morning, and your wife is still not home—and by some almighty coincidence neither is her ex. She's not answering her cell, neither is Mitch. Kat said she left the restaurant with him and apologized profusely as if she had shoved them into a hotel room herself.

The kids are at Janice's, and I'm holding out hope that Mitch is there, too—hell, I'd love it if Lee were there—if they were having one big family sleepover. Sure beats the alternative.

Wish I could fall asleep. Wish I could wake up and find Lee next to me—that it was months ago. I'd fly to China and strangle that son-of-a-bitch before he ever got a chance to set foot in an airport. He's taking advantage of her. Lee is too jacked up on hormones to notice. I'm sure she's hoping this will all somehow work itself out. Sex with Mitch on Tuesday—

The unmistakable rattle of the door sends me flying out of bed. I race down, and as soon as I see Mitch I jump the lower third of the stairs and crush him with my full body weight. The last thing I see is the surprise in his eyes. If I'm lucky enough to kill the bastard, I can always say I fell. I don't waste any time, just pummel him in the gut, hard and fast.

"You're *killing* him!" Lee screams.

I want to tell her I'm not that lucky, instead, I clock him in the face so hard I feel a satisfying pop beneath my knuckles. Mitch lobs me in the upper jaw, and I bite down hard on my tongue.

Shit!

The salt in my blood distracts me enough for him to blindside me with a fist to the chest. A blinding pain rips

through my body. My lungs deflate, and I struggle to take my next breath.

Holy fucking shit. He gave me a heart-stopper. I twist over him and shake him by his sweater.

"You trying to kill me?" I roar.

Mitch brings up his knee and lands another powerful blow to my gut.

"That's for Lee." Mitch jumps up and hobbles to the back room.

"Are you okay?" She pulls at my elbow until I rise unsteady on my feet.

Her hair is disheveled. Her makeup has been cried off, leaving long muddied streaks down the sides of her face.

It crushes me to see her like this, broken, coming home with Mitch.

I don't want to look at her. I want all of my rage focused in on the right person tonight. I speed over to the family room and find Mitch sprawled out on the couch.

"Get up," it comes out hoarse.

Mitch gives a slow blink past my shoulder. "Lee, end this bullshit right now," he groans, struggling to stand.

Lee doesn't say anything. Instead, she comes around and parks her body between the two of us like a barrier.

"It's your bullshit, Mitch." I knock a stack of books off the end table. "You keep throwing yourself at her, and she still hasn't left me. There's not a single document drawn up to take down this marriage. What does that tell you?"

His eyes dart over to hers. "End this." He moves to stand beside her. "Tell him right now."

"Tell me what, Lee?" I lock onto her. I'm ready for it. Whatever it is she wants to say, whatever she's been sharing with Mitch behind my back, I want all of it dumped at my feet like vomit.

She presses her hand into my chest and takes a step closer.

"Tell me." I lift my hands with the invitation. "That you slept with him again? I figured that out myself."

"*Lee.*" Mitch could slice tension wires with the desperation in his voice.

She gives a sad smile never breaking our gaze.

"Now," he urges, placing his hands square on her shoulders. "If you meant it at all, do it right now."

Lee doesn't move. She closes her eyes and presses her lips together to keep them from quivering.

"You lose, Mitch." I force a smile to come and go. "Now leave us the hell alone."

"Look at me." He spins her around with a crazed look in his eye. "What do you find so difficult about the truth? Say it, Lee. Say it *right now*," he barks within an inch of her face.

Lee's entire person seizes.

"Let go." I free her from his grip. "Keep your hands off my wife." I pull Lee toward the door and broaden my chest in the event he feels the urge to charge—hell, I'm inviting it.

He circles around me and steps into her line of vision.

"I can't do this anymore." He's pleading with those algae-riddled eyes. "I thought I could take it. I thought that you'd eventually come around. But it looks like I've just stepped in your way." A single tear tracks down his face. "You know what it feels like?" His voice jumps up an octave, his lips twitch. He's shaking, trying to keep his emotions in check. "It feels like I'm some guy you have on the side. Like you're having an *affair* with me. It feels wrong. And if I feel that way maybe you do, too." His voice reverberates off the walls. I don't think I've seen him this angry before, not even at me. "I'm sick and tired of trying to saw your family in half. This should have been black and white, Lee. It would have been for me. But, then, I guess I don't really know you. I guess we were never who I thought we were." He turns and heads into the guestroom—nothing but the slam of drawers, the pump of hostile footsteps. Mitch reappears

with his backpack slung over one shoulder as he makes his way past us, marking his exit with the quiet click of the front door.

Lee stares at me wild eyed. She looks lost, abandoned.

The roar of his engine fills the night as Lee and I make our way to the living room. We watch his headlights back out of the driveway before disappearing down the street.

It feels final. I'm not sure how it feels for Lee, but in my gut I know he's not coming back. He'll always be in our lives as Stella's father, but it's looking like hurricane Mitch is finally starting to dissipate.

Love like a Bullet

Lee

The days bleed by, black—somber as a funeral.

Mitch won't pick up the phone. He's steered clear of the house. Janice says he's laying low with Colt.

Max is happy enough to fill the void. He's resumed the role of faithful, loving husband, and the rhythm of the house has returned to just this side of normal.

On Thursday, Max asks to take me to Dr. Van Guard's office, just the two of us. It feels off, like we walked backward into couples counseling, not that we didn't need it.

"Mitch has maintained contact with me." Dr. Van Guard's smile retracts when he says it.

It's the first topic of conversation, and my spirit soars just hearing his name. It makes Mitch feel real again, not like some dream I accidentally dragged Max into.

I struggle to read Dr. Van Guard, what he might be trying to tell me on a subliminal level. I'm desperate for a glimmer of hope that Mitch might be coming back here—to *me*—but Dr. V. offers nothing more than his elastic smile.

"Lee"—he leans over his glasses, looking at the two of us— "Mitch shared that you had another indiscretion with him. He also informed me that Max is aware of what happened."

I hold my breath a moment. Indiscretion sounds like code for mistake, and I hate the thought of being with Mitch as a mistake.

"I'm very sorry," I say. I'm mostly sorry I couldn't tell Mitch what he needed to hear, but there's no point now.

"Do you understand why I asked for the trial separation—the breathing room? You're living in a boiling cauldron of emotion. Something like this was bound to happen without time apart."

He should have taken me aside and pointed this out in private. *Keep the fuck away, or you might accidentally sleep with Mitch.* I give him a sharp look. I know he's the least to blame. But I'd love to point the finger.

"Are you willing to rectify your marriage?" His eyes wander from Max to me.

So that's it? He's giving up on Mitch just like that?

"I am." Max turns toward me.

"I am, too." I don't know who owns my mouth anymore. I smile hesitantly at Max and pull my lips back even further for the doctor.

A part of me dies in that moment. I can feel a literal death, taking place inside me. It feels so wrong not to mourn it, to feign happily-ever-after here with Max and the witchdoctor. I'm still hopeful, deep down inside, that Mitch and I will work things out.

I'm so desperate to believe the delusion.

Blatantly choosing Max feels like the biggest betrayal.

⚜

In the evening, Max and I review email after email from our foreign investors as they jump ship like a herd of wild lemmings. They pull out, one by one, and before dinner we

manage to lose every one of our overseas distributors. The door has closed—bolted shut by foolish decisions and circumstances.

Max is lost in an expletive riddled tirade. I shuttle Stella and Eli upstairs and tell them to watch a movie in my bedroom. It's such a treat for them, you'd think it was Christmas. It helps take the sting off of Mitch's notable absence, which did not go unnoticed by either of them. It turns out "Picture Daddy" is quite the hit around here, and a huge disappointment when he's gone.

"Lee." Max looks up from his patchwork of spreadsheets.

I take a seat beside him, afraid to ask.

"It's not good." He leans in. "We're going to have to leverage Johnson's."

"Sell it."

"No." His eyes darken. "It's my gift to you. It's not going anywhere. Besides—the market's dead. It's depreciated since escrow closed—considerably."

"This isn't right." I shake my head in disbelief. "We made sound decisions. We've never lost our shirt once."

"It's not us. It's Mitch coming back and—"

"You're so quick to blame him." It comes out in snatches.

"And I was going to add—my *family*. My brother and the pornographic diva didn't exactly help the situation."

"You're right, it was your brother." My voice rises to unnatural levels. "All Mitch ever did was survive, and he gets nothing but crap for it. It's a wonder he doesn't regret coming back."

"Maybe he does." Max opens his laptop once again.

"Did he say that?"

"No." Max doesn't bother looking at me anymore. He's trying to evade conflict by sinking us back to the task at hand.

"I miss him. I need him." Everything in me freezes at what's managed to escape my lips. Truth is, I'm too emotionally exhausted to care.

"You ready for the zinger?" Max blinks up at me unmoved by my confession.

"Ready."

"We need to take a second out on the house—hell, I'd take a third if they'd let us. If things don't pick up, we'll lose the roof over our heads."

I narrow my eyes in on him. Wouldn't he just like that.

"Sell your mother's house," I seethe. "Sell your brother's dump and every damn car you own, but you're not touching my house."

"We're in this fifty-fifty, Lee," he bites the air with his words. "I have as much to lose as you do. This isn't some Mitch-inspired vengeance. I haven't wasted the last five years trying to figure out how to pull the rug from underneath him by way of you or this house. It's simple math. It doesn't matter if you accept it or not." He picks up a file and tosses it in the air, spraying the kitchen with a shower of paper.

It's a battlefield in here.

It's a battlefield everywhere we look these days.

Mitch

Colt throws in another movie, third one in a row, while I listen to Lee's message over and over again on the phone. I try and decipher her tone, try to figure out how desperate she may have felt when she made the call. I doubt that her desperation can ever begin to rival my own. If I call her back she'll probably just offer more false hope. Not that I'm accusing her of it. I just happen to know for a fact she's incapable of detaching herself from my worst nightmare. Maybe a break is exactly what she needs—what we both need.

Colt dives down on the couch across from me. He lets a belch rip from his throat and nods over to me as if daring me to top him.

I shoot him a look. I don't like staying here. The constant stream of foreign women coming and going at all hours of the night makes it feel like a covert United Nations summit or something just this side of human trafficking. Another reason I hate it is because he bathes in proportion to their arrival and departure. Anything in between is up for hygienic dispute. It's becoming painfully obvious he's comfortable with his own special stench—ode to ass crack. It reminds me of prison. Funny how olfactory senses can work for or against you. I remembered Lee and her scent when I was there. I miss how much I longed for Lee, and now I can't be near her because it brings everyone so much damn pain.

"Dude, wake up," Colt snaps. "I've asked like six times for you to get up and hand me the remote." Colton grates it out like he's about to thrash me if I don't comply. He hasn't exactly been thrilled to share the amenities here at his carnal castle.

"Chill out." He's just lazy.

I get up and swipe it off the table before beaming it at his chest, torpedo style.

"You almost shot my nuts off!"

"If I was aiming for them, I would have," I say, landing back on the couch.

"Get over yourself."

"What did you say?" I lift my head just enough to get a look at him.

"You need to get over Lee and move on."

"I'm not listening." I settle my head in the pillow, annoyed.

"I'm telling you, if she wanted to dump Shepherd, she would have done it by now. You need to realize there are other women out there that would kill to have a chance with you. Stop letting Lee and Max shred you to pieces. Man up and move on already."

Man up and move on. The words pulse through my head like a heartbeat. The detention center blinks to life in my brain, and I feel like a bat trapped in the dark tunnel of isolation, thrashing its wings trying to get the hell out. But the joke is on me—somehow they've implanted that hellhole into my mind, and, now, I can never get out—never fly away home like I thought I did.

Fuck this. I roll off the couch and snatch my keys off the counter.

"Dude, get back here and sit down." He's softer now—afraid I might ruin his viewing experience if I don't comply.

"No thanks." His words burn through me like battery acid. He's right. Lee has moved on. "I'm going to run out and get some food."

"Hekili's coming over. She's bringing Hana."

"All the more reason to get the hell out of Dodge." My brows peak at his insanity. "Look, Colt. I appreciate you looking out for me, I really do. I wish I knew what was best for me right now, but I don't. There's not a woman in the world who can

cure what's going on inside my head." Except Lee, but I don't say it. There's no point.

I'm not in the mood for my brother's misguided matchmaking. He's the one who let Max move in on Lee in the first place.

I'm done with Colt in general. It was nothing but a bad idea to detour here.

I head for the door.

"See you later." Or not.

ഏഗ്ദ

A boil of soot-covered clouds lay over the hills. They hug the trees, mingle in their branches cloying and uninvited. Everything looks sinister—hollow and gothic in this early evening light.

I get in the truck and just start driving. Up the coast, down, whichever light is green is how I end up playing it. Up wins—toward the dunes—the mother of all beaches. It's where I made love to Lee for the very last time, and now it'll forever be the marker of my misery.

I'm disoriented without Lee. I'm dying again—hell I'm already dead without her. Death is simply having its way with me, and, now, here I am, angry and bitter. All this pain, it just highlights how deeply I cared. In a way, I've dragged Lee down to the grave with me—the death of Mitch and Lee Townsend. That sounds about right. Death left a haunting void in my heart, knocked me off balance while on the brink of a steep, unknowable abyss—nothing but a raging sea of emotions waiting below to strangle the shit out of me. Death gave me a broken compass, turned out the lights, and made me try to grope my way out of a room that never stops spinning. Death still wants me. It wants to finish what it started all those years

ago. It has never freed me from its clutches, just gifted me one fucking long day pass.

My foot falls heavy on the gas. I don't even look at the water as I pass it, just keep a firm grip on the wheel and glance at the rearview mirror from time to time.

They say you can never go back. Never go home. I never would have believed it if they told me Lee was happily married to Max Shepherd, having his babies, having the time of her life trying to weld Townsend and Shepherd together at the hip. I would have laughed in their faces. Not my Lee. My family wouldn't let Max *near* Townsend let alone, Lee.

Bull-fucking-shit.

It was all some figment of my prideful imagination. What you fear the most and what you need the least will happen to you—Mitch's law.

My eye snags on an old grey convertible, tagging me about three cars down. It's been in my sights since I left Colt's. I thought it looked odd in the neighborhood since it's just my mother's property and two others on that road. But here?

My fingers fumble with the radio. The song Lee and I danced to at our wedding blares from the speakers with its macabre undertone. I switch it off like it might start an engine fire.

Strange. It's not a popular song—not in this decade. Anyway, I don't want to hear it. It depresses the hell out of me, makes me miss Lee on an unnatural level. It's time to end this misery. I'll stop by the house tonight and try to make things right with her—let her know I'll give her and Max some space while I move back in with Mom. It's time to start taking control of my life again and stop trying to control everyone else's. Maybe at the end of the day, that was the lesson in all this.

Maybe I'll head back to China and pay a quick visit—come home with some peace in my heart like I should've in the first place. Maybe then the entire damn country will stop hovering over me like a sickle waiting to finish the job it started.

I make a few odd turns in an effort to lose the beat up Chevy and curb my paranoia. It seems I've been paranoid about a lot of things lately. Sure, most of its been directed at Max and involves wild theories of him hijacking my life, but that set of paranoia seems to be panning out.

I cross over to the old road that runs along the farmland. It's off the grid, so no one uses it. The lanes are too narrow, too many unloved potholes ready to swallow your tires.

I glimpse in the mirror just as the Chevy takes the corner.

Son of a bitch if he didn't take that turn with me.

Its just one guy, no passenger—looks older, skinny with a wife beater on. Maybe he's lost his way home from the bar and thinks I'm leading him through the desert like some magical prophet in a white pickup. I pull over to let him pass. There's just the two of us now kicking up dirt. I might as well eat his dust. I eat everyone else's.

He slows when he reaches me, stalls his car right in the middle of the road, and hops out.

Maybe I left something dangling on my bumper? A body. Max's body would be nice.

My mother left a pair of scissors on her bumper once, and an old man followed her for miles trying to help her get them back. Spooked the shit out of her.

I roll down the window as he makes his way over. Lanky, not too tall, looks like he was attacked by a Sharpie, both arms inked up solid to his neck. I'm memorizing him for the police report.

"What's up?" I give a bleak smile.

"You Mitch Townsend?" A gold tooth catches what's left of the light.

Something in me loosens. He knows me. He's probably a hand in the fields or someone who's heard about me through the PR circus Kyle sucked me into. He might want an autograph. I stifle a laugh at the thought.

"Yup. What can I do for you?" I lean out the window.

"Eat this."

A loud pop explodes from nowhere. A spear of fire rips through my shoulder. I look down as a bloom of crimson spreads over my shirt.

Shit.

His tires scream as he rushes from the scene, leaving a plume of smoke in his wake.

My fingers magnetize over the warm stain. I hold out my trembling hand, glossed in a viscous dark slick, and it takes a second to register.

I've been shot.

Call Lee.

I scramble for my phone and twitch it in my palm until I hear it ring the other line.

Max picks up, then it occurs to me I may have called Max.

Great. I'm dying, and I've just given Shepherd a front row seat.

"Hello?" He gruffs. "Mitch, I know it's you. Lee's busy."

The world starts to vanish in a sea of grey. I try to choke out a word, but my vocal cords are on lockdown. I try to get out a coherent thought, a sound, anything, but I can't catch my breath.

Blood is everywhere. A warm river streams from my body.

It's done. God answered my prayer and brought me back to Lee, and now he's bringing me home.

I close my eyes. Lee smiles at me from behind my lids just before everything fades to black.

Max

He's still on the line—I think.

"Mitch?" He's probably putting in an order for a triple heart-stopper—doesn't want to interrupt his flow, so I hang on a minute. The unmistakable sound of moaning comes through.

"Mitch?" It sounds sexual, but knowing Mitch, it's not. For one, Lee is upstairs, and two, he'd never call to gloat.

"Mitch, can you hear me?"

Without thinking I shout up to Lee that I'm going to the store. I grab my keys, and head for the truck. If I told Lee there might be something wrong with him she'd lose herself in a tailspin, and I don't want anything happening to that baby. *Nothing* can happen to that baby—might be the last one I ever have with her.

"*Mitch?*" I scream into the phone while I back out of the driveway. "Tell me where you are, damn it. I can't help you if I don't know where the hell you are." I start making my way toward town. Major intersection? Maybe there's been a crash. That doesn't make sense. He wouldn't be alone. Mono's full of tourists. He's obviously not at Janice's, Lee and I left there an hour ago. Not at Colt's because Colt's most likely at a bar.

I pick up the phone again. Faint moaning this time. It sounds bad. Whatever it is he can't breathe too well, sounds like he's jonesing at the bottom of a cup with a straw. What if he tried to off himself? Fuck. He's probably belly up at the base of a cliff somewhere.

"Last chance, Mitch. Pull your shit together and tell me where the hell you are, or I'm turning around!"

Nothing but silence, then the faint sound of whining— sirens come through on the other end of the line.

I roll down the windows to see if I can hear anything. Mono's big but not that big, and there's no wind tonight.

A light wail ignites in the distance.

I hear them. The unmistakable cry of sirens. I see the lights sawing through the night, rippling over the sky in flashes of crimson and blue. They're headed toward the old river—it flooded out a few years ago, so no one bothers with those backward arteries—apparently no one but Mitch.

I race through a stale red light, honking my horn like an idiot. I cut through the overpass just this side of the river and find the strobe lights stopping up the air with their seizure of colors—a manmade rainbow of death.

Dear God, not tonight. If Mitch dies, Lee is going to crack a hatchet through my skull.

I park next to a fire truck blocking all access to the road up ahead. No sign of Mitch, but I get out and head over to a group of firemen to get some answers.

"What's going on back there?" I try to sound casual as if I were simply making chitchat with the silver-haired firefighter.

"Accident. Road's closed."

I glance past him to find three firefighters working over a body lying limp on the ground.

Then I see it, Mitch's pickup on the side of the road with the hazards on.

"I know that guy." I push past him. My adrenaline kicks in, and for a second I think I'm going to pass out. I'm not exactly a hero when it comes to blood and gore. Not sure what to expect as I circle the front of the truck. My heart starts racing. It beats so damn fast it creates an echo in my throat.

Two EMT workers kneel over Mitch while one of them shines a giant flashlight onto his chest. I stagger over and find his bright red shirt sliced open, and I've got a sick feeling his shirt wasn't that color to begin with. An oxygen mask is glued to his face, and his eyes track up to mine. He gives a hard blink before lifting his fingers toward me.

I drop to my knees. "It's going to be all right, buddy." I tremble the words out while trying to hold back a river of tears. I think I just lied, and I pray I didn't because suddenly I want Mitch to live out a very long existence. "What happened?" I glance up at his truck. "Did he get hit?" I'm met with narrow gazes.

"Sorry, sir, it's family only."

"He's my brother." It comes out so fast I hardly have time to process the lie—only I don't think it is one. I've always thought of Mitch as family, always. I lean in toward him. "Mitch, look at me." His eyes roll back into his head, and he passes out momentarily before struggling to open them again.

"Sir, you need to back up. Your brother was shot. He's losing a lot of blood."

His words are drowned out by the blare of a siren. I wobble over Mitch, and his vulnerable body. A long yellow arm reaches up and pushes my head between my legs, tells me to breathe.

I don't need any other explanation. I turn my head and vomit.

I have a feeling I know exactly what happened.

<p style="text-align:center">⁞ℂ⃣</p>

The EMT's try to convince me to come along for the ride, but I assure them I'm fine. They need to take care of Mitch, not my pansy ass. As soon as I heard the word surgery it made me sway again.

I pull one of the EMT's aside before he hops into the truck.

"He's going to make it, right?" I'd die in his place for that to be true.

"We're doing everything we can."

I watch in horror as they scream away. His words didn't sound too promising. I get on the horn and call Colt and fill him in, tell him to get Janice and Lee and head to Mono Bay Memorial, then call Mom and ask her to watch the kids.

I jump in the truck and head in the opposite direction.

There's one person I'm guessing who won't want to visit Mitch on his deathbed anytime soon.

<p style="text-align:center">ℬℭ</p>

All of the lights are on at Hudson's. I can't help but note how cheery everything looks inside. Just throw my life in the shitter and get on with yours like it's fine and dandy. I haven't spoken to him since he slammed me into the wall and filled me in on yet another one of my wife's indiscretions. I try pounding my fist through the door and wait for someone to answer.

Candi swings it open, and the smell something burning in the kitchen blasts over me like a necrotic heat wave.

"Where is he?" I barrel past her, grazing over her belly in the process.

"He's in the shed."

I bolt out the door, hurdling a dozen rotting tires on my way to a suppressed beam of light shining through the old tool shed. He builds million dollar garages for rundown pieces of shit and refuses to knock down this glorified outhouse. That's Hudson in a nutshell.

I peel open the door to a fog. The stench of stale pot stagnates in the air. Hudson is lying back with his eyes partially closed as he blows smoke over at me. I reach down and pluck him off the floor, limp as a ragdoll.

"Someone shot, Mitch. You know anything about this?" I squeeze my hands around his neck until his eyes bulge from the pressure. He claws at my arms until I relent.

Hudson breaks out in a coughing fit, spitting in the dirt behind him. "I'm not qualified to say anything until I have an attorney present." He gives a goofy grin.

"*Shit*," I bark in his face before knocking him into the grass. The sound of his laughter lights up the night as I sprint back to my truck.

Stupid. I'm so *fucking* stupid to have anything to do with my brother—let alone speak to him—insinuate criminal activity. I bang my hand against the driver's side window.

"Everything okay?" Candi shouts from the porch.

I don't bother answering. Instead, I burn up the dust on the back of my tires as I leave Hudson's metal graveyard for what I pray is the very last time.

Tears blur my vision.

I put this whole thing in motion. I think I finally did it—killed Mitch.

Please God—don't let him die. I swear to you I didn't mean it.

Mitch, who I would trade a thousand Hudson's for, we would have been good brothers. We were at one point, but we let a girl get between us once.

Still do.

The Dreamer

Lee

Peppermint moon.

Those were the last words my mother whispered as she ran out to the soon-to-be wreckage of my father's hatchback. *Peppermint moon.* It hangs bright over the hospital as Colt speeds me in by the arm, but I'm resisting. It happened this way that night—my sister and I were taken to the emergency room by the sitter to see if there was a chance my parents had survived.

That's what we're seeing tonight—seeing if Mitch has a chance.

Colton scrambles out a word salad to an orderly behind a big gleaming desk and he points a crooked finger upstairs to the ICU.

My heart races as we stumble down the hall. Colt leads us in a panic until we land in front of a nurse's station that greets us with a bevy of women huddled around a patient's chart.

Mitch is still in surgery, and we're forced to wait in a small, crowded room that holds the odor of stale coffee and crisp newspapers.

"We're not going to lose Mitch." I say it to myself, but Janice moans in agreement.

Colton tucks his head between his legs, until his face swells, red as vinegar. The veins in his neck plump like cables.

I close my eyes and busy myself with the task of begging God to let Mitch live. There's no way I could lose Mitch—not after everything I've been through. I can think of a thousand things I'd like to say when he finally wakes up. I'll rectify this entire situation with Max and Mitch, right here in the ICU. I refuse to let Mitch go. I'll be his dutiful widow if I have to. I just need him to hear the words he longs for, coming from my lips.

A shadow darkens the doorway, and Max comes barreling in like a dark knight in shining armor.

"What happened?" Colton snaps.

"I don't know." Max pulls me in tight and lands a hard kiss on my mouth. I can feel his lips trembling over mine. He's just as frightened for Mitch as I am. Max runs his hands over my back warming me. It feels good, safe to be held by him like this. "I got a call—it was from his phone. He never said anything. I didn't want to worry Lee, so I took off looking for him—heard a siren and followed it." He swallows hard and his Adams apple rises and falls. "They said he was shot."

Max looks bewildered, his eyes dart around the room as if he were still trying to piece it together, but there's something layered beneath his concern. I could always tell when Max was trying to stretch the truth... Oh God.

"We need to talk." I drag him out the door, not waiting for an answer.

We head down the hall and behind a brick wall leading toward a staircase.

"What the hell is going on?" My hands tremble uncontrollably. I can hardly hold onto his fingertips.

"Nothing." His jaw clenches. Max cuts a look out the blackened window and his eyes go dark as if God himself turned the light out in his soul. "By the time I got to him, he was already being worked on." He grits it through his teeth, his eyes glossing with tears.

"You know something." It comes out breathy, disbelieving that he would hold anything back from me. "He's not going to make it is he? Was he—*is* he gone? Are they trying to revive him?" The world slows to a crawl. The walls warble in and out, and my voice comes back to me as a demonic echo. I spin around and try to run, find him, break into the room they've locked him away in and speak to him—kiss him one last time.

Max pulls me in by the waist and smooths my hair back as if he were comforting a child.

"No, Lee. I swear he's going to live." Max exhales hot into my hair. "He was conscious when the ambulance left. They had the wound taped up to stop the bleeding."

I pull back and examine him. His eye twitches, his jaw pops as I inspect him.

"You're acting strange. You know something." I try to pull my arms from his stranglehold but Max is holding on for dear life. "I can read you like a book, and you're not telling me everything. Did you see something?"

His gaze shifts to the floor. Max shakes his head, but his cheeks light up like flames refuting his actions.

"Who would do this to Mitch? Where was he?"

"Old road, south of the riverbed."

"That's practically abandoned." My heart throbs in my throat like a fish out of water. "You don't think he ran into a drug deal, do you? Or maybe—"

I take in a breath that never ceases. I forget how to breathe altogether. The dim hall fades to cold, grey steel.

"*You*—" I try to jab him with my finger, but it wags in the air like a stranger to my body.

Max bears into me. He doesn't even bother to deny it.

"You *bastard*." My hands slap over his chest as I try to push him away, but it comes out weak. Max restrains me by the wrists with no real effort.

"I swear to you. I had nothing to do with this."

"That's because you had your moron of a brother do *this*. You think your hands are squeaky clean, but I can see the blood on them thick as gloves—Mitch's blood." I spit in his face. "I fucking hate you, Max Shepherd. I *hate* you!" I scream it out for everyone to hear, and mean every last word.

ಬಬ

Two hours slog by slow and meandering like a glacier drift. Max sits stoically by my side as though he wanted to be there, as though he cared, but he can't fool me. He'd just as easily sit next to Mitch's casket—dig his grave if we let him. I'm an idiot to have trusted him. I let the wolf in my life, and now Mitch is going to pay with his.

A surgeon enters briskly, half masked, dressed in powder blue from head to toe.

"He's going to be all right." His silver eyes crease into a smile as he gives the news. "There was a clean exit—no vital organs were harmed. It narrowly missed the scapula, but he's pretty banged up. It took a lot to stop the bleeding."

"Where is he?" Everything in me exhales with relief. Mitch is alive.

"In recovery. You can visit, one at a time."

I don't wait for him to finish, just speed past him on my way to sweet, gorgeous Mitch who I've tortured endlessly since he's come back.

A nurse leads me to a man lying on a gurney with wires and tubes hanging out of his every part, and in no way does he resemble my precious husband.

It takes my breath away to see him like this. I'm horrified at what I've caused. I lean in toward him and pat his forehead with my fingertips. He's bloated, his eyes glossed over with a thin seam of liquid.

"Mitch." I take his hand, and I swear his fingers move. "Can you hear me? Squeeze my hand if you can hear me."

Slight pressure builds around my fingers. Real or imagined I can't tell, but I run with it.

"Mitch, I'm so sorry I brought this plague into our lives. I swear I never thought..." I let the words hang there. I don't know how to finish the sentence. I could have never known. I would never have even dreamed Max would do something like this.

Max comes up and lands a hand on my shoulder. I hope he heard every word.

"I swear to you"—he whispers heavy in my ear—"I had nothing to do with this." Max leans in and inspects Mitch. His lips tremble from the sight, and he crumbles.

Max pushes in close to his ear. "I will find the bastards that did this. And I promise you, I will kill them myself."

My knees quiver with the heft of our new reality.

I place my hand over Max's cheek and wipe away his tears.

I can read Max like a book. These are real tears. Max didn't do this. He couldn't have.

Could he?

Mitch

It takes several minutes of pleading with my body for my eyes to peel open. Long slow blinks, that's all I get. I can make out Mom and Colt in a blur, then Max with Lee tucked under his arm.

I try to wipe my forehead, but my arm is secured, tied down to the bed and I'm wrapped like a mummy from the neck down. For a brief moment I'm reminded of a torture technique they used back home. I think I just called China home.

My eyes stay open long enough to process this isn't the guest room back at the house. I try to sit up and my body won't follow orders.

That's right. *Eat this* turned out to be a bullet with my name on it. The convict with the golden tooth grins at me from inside my eyelids. It all comes to me with perfect clarity.

A strange dream comes back to me—a beautiful dream of Lee in a windblown wheat field. She promised if I woke up she'd leave Max—tell him right there and then.

I give a placid smile over at her. Too bad you can't play back dreams—show them to people. I'd love for Lee to see how bad she wanted me—how she demanded that I live and blamed this whole nightmare on Max.

"Don't strain yourself," Mom says, laying the cool of her hand over my forehead. It feels so damn good. It forces me to close my eyes in appreciation.

"Are you in pain?" Lee's voice.

I shake my head and blink up at her. Her face is swollen and blotchy around her eyes but her beauty shines through, and a knot the size of a softball swells in my throat.

"Hey, buddy." Max pats my hand. "They've got you on Dilaudid. It's ten times stronger than morphine—makes heroin look like baby aspirin."

"Nice," I manage. My voice sounds as though I've been sucking on gravel.

Colton crops up, and for a second I think it's me looking down on myself. "When you're up for it, the police want to swing by. They said they'll check in with you tomorrow."

Max shifts into Lee. He looks uncomfortable—*guilty.* Who else would want to blow a hole through my heart? I press my lips together. I'll have to invite Max to the big meet and greet with the cops, see if he wants to offer up any info or maybe just turn himself in and save us all the effort.

The nurse asks everyone to leave, says I need my rest. One by one they say goodbye, but Lee stays, inspiring Max to linger by the door and listen.

"I love you," she whispers through a broken smile. Two long black tracks mark where her tears have been.

"I know." Still can't get the words out.

"If you died, I would die." It comes out as a fact. She looks dazed, unsteady.

I close my eyes trying to escape this nightmare. "Don't say that."

"It's true. I can't do this earth thing without you. I thought I could, but I was wrong." She swallows a laugh. "The nurse said I could spend the night."

"No. Be with the kids. Come back, though." I offer a lame smile. Everything feels off, and for the first time I notice I'm able to track the scenery with my eyes and have it linger with an optical echo. "Go and kiss Stella and Eli for me. Tell them I love them."

"I'll be back"—she leans in and presses her lips to mine, hot and wet—"first thing in the morning." She drifts to the door and blows me a kiss. "I love you deeper than the ocean, Mitch Townsend."

My heart soars—makes me forget all about pain and bullets.

❧❧

That night I dream in parchment—stacks and stacks of paper—white, red, blue, pink, yellow, brown. People with dark carpets of hair bustling around me like a river of humanity, folding paper—writing—prison bars. Someone calls my name, and I turn around. It's Gao. He holds his hand out to me—tells me to come back. He's got one more thing for me—wants to show me something, then I wake up.

A sharp pain ignites in my groin and my lids fly open. A heavy boned nurse has her hands over my crotch. She's either trying to make sure I have a very good morning or my balls are about to get knifed off.

"Catheter is backlogged." She doesn't bother looking up at me. She might as well be talking about someone else entirely. "I've done it without waking a patient before." She yanks at my dick like it's a nozzle of some broken down appliance.

"Shit!" That fucking hurts. Burns like hell, too. She twists it like a cork and extracts the air bladder, holding it up for me to see with a victorious smile.

"We'll get you to go on your own today." She jots this down in my chart as though it were pertinent information. It's nice to see my overpriced insurance money hard at work—tracking my bodily functions, jotting them down with the same intensity as a scientific equation.

That dream comes back to me. Gao—China. Maybe if I did go back, on my own terms, I could finally get out from under this black cloud I've been living under. People go to different countries all the time and they come back no worse for wear. Maybe if I go and come right back I can start feeling a little more in control of my life. It's as if all those years hijacked

so much more than my time, they took my sanity and put it under house arrest. Maybe I can flip the switch. Go over and come back—let the big guy show me it was all a part of the grand design, and I don't have to fear an entire country.

Mom walks through the door and gives a little wave. I'm a little disappointed it's not Lee, but then she's got Stella and Eli to contend with, not to mention Max who'd put up a minefield to stop her from getting to me—or more accurately a firing squad pointed in my direction.

"How you doing?" She presses her cool cheek against my forehead and I feel all of six again. Mom smells like a sweet memory, some floral perfume I recognize from an entire lifetime ago.

"Better."

"You look better. Doctor said it missed your vital organs. He said you must really have important things to do here." She gives a stifled laugh. "Isn't that the truth?" Her eyes sparkle. She can't stop smiling.

I feel bad looking over her shoulder. Waiting for Lee to show, but I know she'll be here.

"I had a strange dream about China." It unnerved me— hell, it rattled me.

Her face darkens. "It's over, hon. You're safe." Her eyes drift down toward my scars as if she were reliving the torment right along with me.

"I know. But what if there was something I was supposed to finish?"

"Like? The housing project?"

"I don't know. Something. Maybe a lesson I didn't learn the first time."

My mother shudders. Her entire body sags in defeat.

"I've had this tugging since I got back—since I left—that something was...I don't know." Really I just want to know I didn't waste five years—that something so damn meaningful took place but I forgot to notice. The egomaniac in me wants to

think I made some vital difference—that if I came back on my own terms Lee and I wouldn't be such a fucking mess anymore.

"What's going on with Lee?" She tries to change the subject but lands us from one frying pan to the next.

"Things aren't clicking. Like it or not, it looks like it's Max's time to shine."

She shakes her head. "I can't image how you feel and how overwhelming this all must be for you." She plucks a tissue from her purse and blows her nose.

Lee appears and illuminates the entire room with her beauty.

Mom gives a weak smile. "I'm going to run downstairs to get some coffee. You want anything?"

"No."

Her heels click out of the room as Lee makes her way over. She's got her hair pulled back, a red scarf around her neck and a black and white striped T-shirt on. She awakens all of my senses, and I take a deep breath as I take her in. Lee could wake a dead man, she's so stunning.

"Hey." I can't help but smile. I'm not sure if it's because I cheated death or the fact I feel strengthened and renewed about the standing of our relationship, drug-induced as it might be, but I'll take it.

"Hey sweetie." She plants a soft kiss over my lips and feathers my hair away from my face with her fingertips. "I talked with the nurse. She says you slept great. And you have no signs of infection. Are you in pain?"

I hold up the medication pump. "Use it whenever I want it. Great stuff. I'll need about a gallon to take home."

"I don't think they have a to-go menu." She makes a face and shows me that natural sarcastic beauty I've loved for so long.

"I had a wild dream." I tell Lee about my nocturnal wanderings and watch as her reaction mirrors my mother's.

"Interesting. I have news for you." She changes the subject.

"You do?" I want her to tell me about the baby.

She nods. "Stella made something for you." Her eyes glitter with tears. "A picture. I was going to bring it, but I was in such a hurry to get out the door I forgot."

My heart drops like a stone. "I thought you were going to say you were leaving Max." I try to laugh it off as though it were a joke, but it comes out forlorn, so damn pathetic I want to hide under the sheets and die.

"Mitch," she whispers, leaning in. Her full lips just an inch from mine but she won't give the kiss I'm craving.

"I thought I heard you." I shake my head. "Must have been hallucinating." I try sitting up and wince into a sharp bite of pain.

"I just need time." She exhales a shaky breath. "It's going to kill me, but I know you'll help me through it," she says it uneven as if she's trying to go along with my delusion.

Lee fills me in on the investor exodus that took place last week—Max and his run in with Hudson.

"Max didn't do this on purpose, Mitch."

"Figures. Thought he was doing his brother a favor." Good old Hudson. I still think Max knew on some level, but I don't share the theory. Max and I have grown leaps and bounds the last few weeks. It almost felt like old times—pre Lee.

"I don't want you to rock the boat with Max," I whisper. "Don't evict him just yet."

Her forehead creases as if the thought never crossed her mind. "You want me to wait until you get back from the hospital?"

"No." I press my lips together a moment. "I want you to wait until I'm back from China."

Max

The officer and I walk shoulder to shoulder on our way to pay Mitch a visit. We make small talk about what happened—sum up Mitch and his brush with death in dollars and change.

His badge gleams with pride under the harsh fluorescents. It makes the vomit rise to the back of my throat without even trying. I'd bet a solid grand he sees right through my sweet talk. It's all my fucking fault for not putting the ax on Hudson's self-appointed clean-up committee. Hell, I wished, *willed* this to happen. I'm so sick I might actually introduce my breakfast to the officer's shiny black shoes.

I don't have a murderous heart—what I felt for Mitch was more like the kind of hatred you feel toward someone in grade school—the kind that makes you say stupid things like *I wish you were dead.* Hudson just so happened to pick up on my Morse code, and took matters into his own hands. Now we're both up a creek, and Lee knows the longitude and the latitude of it all. I'm sure Mitch has his theories about my role. As soon as the tabloids find out I put a 'hit' on Mitch—my rival—my wife's supposed ex-husband, I'll be lucky to sell rubbing alcohol to a hospital.

We step into the room. It's all downhill from here, I can feel it.

Lee gives me a brief hug. She looks happy—downright joyous. I haven't seen her looking like this in a long time. Like something inside her has lightened and she can finally breathe again. I wrap my arms around her and pull her in as the cop asks Mitch a series of rapid-fire questions.

"There was something about him..." Mitch searches for clues. "He had solid tattoos, and a gold tooth or teeth, right up front. He was skinny."

"You know what kind of car he was driving?" The officer takes notes before Mitch can answer.

"Old, beat up grey sedan, Chevy, I think. I remember thinking it looked out of place."

"You get a look at the gun?"

"Just the barrel." Mitch relaxes into the pillow, closes his eyes for a moment. "I heard a loud pop, and my chest felt like it caught fire. I tried to call my wife, but I got Max instead." His gaze wanders over to me. "Thanks. You don't know how much it helped to hear you on the other end. I didn't know if you'd find me, but I knew I wasn't going to die alone."

I get over the *my wife* part pretty quick. A lump the size of a tractor gets lodged in my throat, and I bite the corner of my lip to stop from bawling like a baby. I wipe a quick tear from the corner of my eye.

"That's Max," Lee says, putting her head down over my shoulder. "He's always there when you need him."

"Thanks, Lee. You make me sound like a golden retriever." I give a placid smile.

"She's right." Mitch looks me dead in the eye. "You're always there when we need you. Thank you, and thank you for what you've done for Lee and Stella."

I blink a smile over at him. I'm not sure I like the way he's speaking for Lee. I'm back to not liking the way he referred to Lee as his wife a minute ago.

The cop steps in and tries to shake him down for more details.

Lee stands on her toes and whispers directly into my ear. "Something's wrong."

"What?"

"He wants to go back." She pulls away with a genuine look of terror in her eyes.

"Back *where*?" I whisper.

"China," she mouths the word.

I look over at the poor bastard lying all beat up with his chest taped up in gauze, his left arm lying in a sling across his stomach.

Hate to say it, but it feels like the best news I've had in a good long while. And I wish to God it didn't.

<p style="text-align:center">ফওনে</p>

Mitch finally manages to stabilize. Lee takes the kids to school before heading back over to him. It's discharge day at the drive-thru hospital. I pour myself a cup of coffee and pop open my laptop to see what bills TS is running behind on. Usually Lee and I comb through the killing fields of our debt together, but I let her off the hook this morning. I knew she'd want to be with Mitch, bring him home herself, talk him out of the delusions she claims he's having that include travel plans abroad. He never did bring it up again.

He was probably just high. They had him on some serious shit. Stuff like that messes with your brain. Maybe she misunderstood him. Maybe he said *I* should go back to China. Now that's more than a little plausible.

I click into the general account. The numbers look off by a digit, so I squeeze my eyes shut and blink into the screen.

Fourteen thousand?

I click into the history for an explanation. My body spikes with heat as I break into an instant sweat.

"Sweet fucking mother..." Four different withdrawal transactions for twenty-five thousand each over a forty-eight hour period. "What in the hell?" I pull out my phone and get on the horn to Lee.

"Hi!" Her voice squeals in my ear, chipper as a blue jay in springtime. No edge in her voice that even remotely suggests she pilfered our account. Not that she's my prime suspect. "Something's up."

"What?" Her tone sharpens.

"I'm looking at TS. It's missing a hundred grand." We were low to begin with. What we had was barely enough to cover the bills.

"*What?*"

I can hear Mitch in the background asking questions, and she murmurs away from the phone to fill him in.

"It shows four withdrawals, and you and I are the only two authorized on this account."

"It wasn't me. What about the siphons?"

There's a reason we've nicknamed Colt and Hudson "the siphons." It's like taking two hoses and hooking them up to our checking account.

"I don't know. They're on stipend. They can't control how much we give them. Isn't that how we set it up?" I scan my memory, but I'm pulling up blanks.

"I'll talk to Colt," she offers.

"Great. I doubt I can get Hudson to pick up the phone. In the meantime, I'm freezing them out."

"At least temporarily." I know she's vying for Colt.

"Lee, we have no money to pay the freaking bills. Without little things like electricity and water, we can kiss our paycheck goodbye."

"Crap."

Perfect. I've managed to stress out my already stressed out pregnant wife. "Look, never mind. I'll pull us out of it. Don't I always?"

"Yes." She exhales hard. "Thank God, you do. If there's one thing I can count on, it's for you to save the day."

"How's Mitch?" I ask in an effort to calm her nerves.

"He's doing great. Janice set up the couch downstairs."

"Good. Tell him I'm glad he's doing better. I'll see you soon?"

"I'll pick up the kids on my way home."

I hang up and stare at the screen mystified. How could I have ever underestimated my junk-heap loving, hit-man hiring, fucking bonehead of a brother?

And Lee. I just lied to Lee for the very first time. There's no way I'm going to be able to pull us out of this. This is the big one. No one is getting out alive. Not Townsend. Not Shepherd.

I pray our relationship survives.

Stay with Me

Lee

Janice's house is quiet as a tomb. It takes everything in me not to take the bottles of Townsend and Shepherd that Janice has artfully displayed and smash them to pieces until there's nothing but glass crushing beneath my heels. They might as well be filled with blood the way Max and I toiled to save Townsend when we thought we were doing it all for Mitch and the false god of posterity.

It's just Mitch and me taking up space in the living room. Janice stepped out to pick up some groceries, and I glower over at him because I can't find the words to properly tell him off.

"I don't expect you to understand." He compresses a smile.

I thought after all this time, China would be the one place he would never set foot again, and to go back on his own volition? For what?

"Are you suicidal?" It only makes sense.

"No." He arches his head back frustrated as if my question had the power to piss him off. "I've been thinking— dreaming about it. I swear to you, Lee, I need closure. I just need to go and come back on my own terms."

"Then I'll go with you." It comes out an empty promise.

"It's not happening." He rubs his eyes as if the idea were absurd.

"See? It's *dangerous*. Why in the world would you want to go?"

"People go to China all the time, Lee. It doesn't mean they get swallowed in some black hole. What happened to me was an anomaly. I don't want to live my life in fear of an entire country. I'll be quick."

"That's what you said the last time." I slit the air with my words.

"This time I..." He trails his gaze out the window.

"You can't say it can you? You made a promise to me all those years ago that you'd be back, and now you won't because you know you can't guarantee anything." I don't think I've ever felt such disdain toward him, such outright seething borderline hatred.

"I'm not taking any risks this time."

"You're leaving Stella again." My eyes flood with tears. "You are not the man I married." My voice shakes as I make my way over to where he's laying. "You would never have done this if you knew what was going to happen. My parents would never have gotten into that car if they knew they were going to die." It all comes full circle. The people I love most have a way of dying while trying to get somewhere. "You board that plane and you run the risk of never watching Stella grow up. You are going to break that little girl's heart, *twice*."

"You're overreacting." Mitch can hardly get the words out. He's locked in emotionally, denying himself the privilege of tears.

"Something is desperately wrong with you." I pace over to the large bay window and turn my back on him like he's doing to me. I can't even look at him anymore. "This is why you don't want me 'rocking the boat' with Max. In the event you don't make it, I'll have a matrimonial backup plan."

Mitch doesn't refute the theory, just stares at me with those sea glass eyes.

It feels like the whole world is shouting, and I cup my hands over my ears. There's so much grey noise fogging up my brain I can't filter it out anymore. If Mitch leaves I'll splinter, lose my mind for good this time.

I take hold of the marble table set under the window. I need an anchor, and neither Mitch nor Max will do.

There's a click at the door, followed by footsteps.

I expect Janice, but Colton materializes in her place.

"Kick the crap out of your brother," I hiss.

"Nice." He glides past me and makes his way over to Mitch. "You ready for your scheduled beating?"

Mitch is stoic, unmoved by my plea. "She's not happy right now."

"He's going back to China," it comes out accusatory.

Colt's eyes widen. Even Colton sees the impending danger, the doom written all over the great wall in Mitch's own blood. "Dude—I don't think that's a good idea."

"Come with me," Mitch counters.

I let out a little laugh. "Sounds like you have five years to kill, Mitch. That is, if they don't burn you alive first." I hope I scared the crap out of Colt in the process.

"Good point. We're not going." Colt plops on the couch like it's no big deal.

"Maybe you're not—I am." He doesn't meet my eyes. Mitch and his unmitigated resolve, he's turned into something unrecognizable—a man on a suicide mission.

"If you're going, I'm going," Colt says.

Janice walks into the room and holds out a bag of prescriptions as she makes her way over.

"Mitch is going back to China." It strings from my lips like a haunted lullaby.

Her face bleeds out all color. "Mitch?"

"Colt's coming with me." He's quick with the false assurance.

An unsettled laugh gurgles in my chest. "I feel better already." You can taste the sarcasm. "You need to recover. You can't even go to the bathroom without pain, much less another continent."

He gives a slow blink and nods. I can tell he's not dismissing the notion. He's simply quieting the conversation, shelving any potential drama for later.

An entire bevy of erratic thoughts swim through my mind. I need to update my passport. I need Max to take care of the kids and—my baby. My hand rises to my abdomen. I can't risk losing this baby. I can't risk getting trapped in a prison for five minutes. I can feel my skin rising in welts, replicas of the scars that Mitch wears. I can't die over there hoping Mitch will come back and stay safe. Stella and Eli need me. Townsend and Shepherd need me. Max needs me.

Janice drops the bag on the coffee table and speeds out of the room. He's going to kill his mother, both of them will.

"When we leaving?" Colt seems serious, too serious. If I didn't know better, I'd swear he looks downright frightened.

"Soon. I want to get this over with."

"What about Stella?" It comes out hollow. I'm no longer in the equation. I can feel it.

"Bring her over tomorrow." Mitch meets my gaze for the first time, earnest and apologetic. "I'll say goodbye."

I don't want any of his miserable apologies. The only thing I want to bring is a frying pan down over his skull and make him forget about every other country on the planet, the same way he's forgotten to stay home and love me.

Mitch

I wait until Lee takes off to pick up the kids before asking Colt to help me upstairs. Mom won't even look in my direction.

"Grab a carryon bag from the attic," I instruct as I pull a few shirts out of the drawer of my old bedroom. Nothing but a couple of plain white tees and one that reads British Columbia that belonged to my dad—most likely a bad omen. I sling it on the bed anyway.

"Here." Colt unzips a small duffle bag. "So, how long will it be before we're taken captive? Can I choose between electrocution or gas? Electrocution's sort of on my bucket list— near the bottom, but nevertheless."

"Three days."

"Three days? Great."

"That's how long I plan on staying."

"So, if you left last time with the intention of staying two weeks and landed your ass in prison for five years, lets see... this time we're looking at a year and a half max?" He pins me with a look. "Is my math off?"

I knock my sling into the door and let out a groan.

"Hurt much?"

"Only when I move it, smart ass." The physical therapist wants to see me every other day, but that'll have to wait. She threatened it might freeze this way without therapy. I almost wouldn't mind as long as I could get back to Stella and Lee. But everything in me knows I have to go. The entire country has a stranglehold on me, like some giant prison guard is holding me up by the neck and won't let go. Scenes from my internment play out in the back of my mind like a constant mocking that I can't shut off.

"So why we going? You didn't get to see the wall?"

"That's right. I didn't get to see the wall. Good fences make good neighbors. Bring a camera, I hear that thing's huge." I toss my deodorant and toothpaste into the bag.

He plucks them back out. "Too bad, you can't bring this crap on board anymore. Are we going knockoff shopping? I hear we could make a fortune on eBay." Colton glares at me while demanding a better answer.

"How about I sell *you* on eBay?" I take a seat at the wooden ladder-back chair I used to log time in while still in school, reminds me of the notes I used to write Lee. "I need to go and come back. It's going to eat me alive if I don't. And when I get back, I'm going to ask Lee to marry me again. You up for best man?"

"You're delusional, dude." He shakes his head, looking desperately sorry for me. "She's already married."

I glare over at him. "I may not be able to hit you, but I can sure poison your food."

Colt starts reorganizing the suitcase.

"You're a nutcase, Mitch. I'm going with you, but the second our plane touches back down on U.S. soil I'm locking you up and giving Max Shepherd the key."

"I don't see why the fuck not. You gave him everything else."

<p style="text-align:center">☙</p>

It's late, but Lee calls me over to the beach house, so we can talk. She asked me to come around back, so I wouldn't wake the kids. I was assuming it'd just be the two of us, but it's the white of Max's eyes I see first.

It's cold out as the salty fog licks against my skin. The moon hides beneath a white veil, just a sliver tonight—a thumbnail moon.

I can't get my arm in a jacket, so I didn't even bother. I thought maybe Lee could keep me warm—guess I was wrong.

"What's going on?" I take a hard sniff of the thick night air.

"Lee's grabbing a sweater." He leans back in his seat and takes a sip from his steaming mug.

I don't like the feel of this, the tension—the mystery. Who knows what Lee has planned.

Lee steps out with her hair pulled back in a ponytail, her face fresh scrubbed. Lee looks all of sixteen, and it sends my dick knocking at my Levis.

"Hi." She's all smiles as she makes her way over, as if the three of us were getting ready to make S'mores by the fire. Lee slips an arm around my waist and kisses me openly on the lips in front of Max. I look nervously over at him. If Lee's big plan is to incite him into beating the shit out of me, it's going to work brilliantly.

"Lee says you're headed to China." Max seems indifferent.

"Just a few days."

"Do they still mark days in twenty-four hour intervals?" His features darken. "You know how upset Stella will be when she gets wind of this?"

"I'll tell her," I offer.

Max doesn't say anything. He just shifts his gaze to Lee.

"I think it's better if I told her." Lee rubs her hands over her arms. "But I'm not really looking forward to it—just like I'm not looking forward to this." Her gaze falls to the sand and lingers. "I wanted you both here because I need to share something."

I hope this is about the baby. I've been waiting for Lee to tell me. To give me the slightest hint that she thinks it might be mine.

"I've made a decision about my life." She looks mournfully over at Max, her lids heavy with grief.

Shit. Not this.

"Lee." I try and garner her attention, but she won't bite.

"It hasn't been easy." She presses her lips together until her face is pale as the moon. "I'm always going to be Stella and Eli's mom, that's a title I'll never have to give up. I never thought I'd have to stop being your wife, Mitch, but when you were gone, and we didn't know..." She shoots a look over to the black ocean. We sit and listen to the waves tumble over one another while Lee's mind splinters from the pain I've caused. "I never would have imagined giving up being your wife, Max. It seems like we've been through everything together—you're a better husband than I could have hoped for." Her eyes dart to mine. "But I don't want you to go to China, Mitch. I want you to stay, right here in Mono. A small part of me feels like you're punishing me for not leaving Max. I know you're going to deny it, and that's okay, but I think somewhere in the back of your mind—"

"Not true." I shake my head emphatically. "I would never do that." It never crossed my mind.

"You're doing it," Max interjects. "You're manipulating Lee into making a decision before she's ready."

"I *have* made a decision," the words speed out of her. "I'm sorry, Max. I can't do this with either of you anymore. I never meant to break your heart. I hope you don't hate me, but I'm filing first thing in the morning." She can't say the D word—she can't say divorce.

He rests his elbows onto the table and examines her as if they were playing poker. "So if I tell you I'm going to hurl myself off a bridge are you going to retract your statement? You're operating under fear, Lee, you know that?"

"That's not true." She glances back at me. "Mitch, we can go back to China together when the kids are older." The desperation in her voice proves his point. "But right now, we need more time to focus on piecing our lives together—to focus on us."

"Lee," I whisper, pulling her in. "I'm still going. I have to. This is something for me. I need to break this mental hold it has and come back on my own terms."

Her lips part as if she's about to say something then aborts the effort. Lee is willing to rearrange the ladder of her existence, and I've just removed the ground beneath her. I hate this. I hate this feeling. I hate destroying Max, Lee, Stella, and my mother.

"You're nothing but a fucking bastard, Townsend." Max gets up from the table. "You've got her right where you want her. Hope you're happy. If you do have the misfortune of rotting away in some detention center again you can always look back on how you cracked Lee's heart in two just for the hell of it this time." He knocks back his chair and heads inside. Lee and I watch as he snatches his keys off the counter. A few moments later the front door slams like a gunshot.

"I'm going after him." I give Lee a quick kiss before pushing through the sand and heading into the darkness.

I need Max to be there for Lee again.

I want him to.

Max

Headlights trail me all the way to Hudson's. It's either Mitch, or Mitch and Lee, either of those two in combination or without. I pull onto the weed-laden front yard and dig inside the dashboard for a flashlight.

Got it.

I click it on and off, but it's dead. Figures.

A truck pulls alongside me. Its just Mitch, and I'm a little relieved by this. I'm not ready to deal with Lee and her unpopular decision. My gut wrenched just listening to her. I almost hurled as I got up to leave, and I should have—projected it all at Mitch.

I roll down the passenger window. "You got a flashlight?" I ask before he has a chance to get out of his truck. It looks like a major deal, the way he's barely moving. He dives into the center console and plucks one out.

Score two for Mitch tonight.

I hop out and snatch it from him, don't wait for him to crawl out of the truck. He'll catch up eventually.

Lights are on inside the house. Hudson's truck is parked high on the driveway. Glad to know he's home, but I'm not up for any brotherly bonding unless, of course, he's in the shed, high as a kite.

"Where we going?" Mitch struggles to keep up. I think he's limping now, too. Perfect. I'm sure Lee will want to coddle the hell out of him, kiss all of his mother fucking boo-boos so long as he stays on U.S. soil.

"Keep it down. You in a hurry to show my brother his handy work?"

"Knew it."

I crack open the door to the shed and hold it open while Mitch gimps in.

"Is this where you're going to finish the job?" Mitch settles inside as I do a clean sweep of the counter and spot a tall, metal canister.

I pluck off the lid and take a sniff.

"Bingo." It's filled to the brim with dehydrated crap—nothing but the best. "He's such an idiot. He doesn't even bother to hide this shit." There's a small plastic bag near the bottom with a few fat rolls inside. I hand one to Mitch and grab a lighter off the ledge.

We settle in a pile of old blankets on the floor. I don't want to think about Mitch or Townsend or the testicular history this crumpled up blanket beneath us might have met up with. I just want to numb myself from the world—from Lee.

We don't say anything. The haze breaks through the window as the stars wink down at us.

"I never hated you, Mitch." The entire room fills with a veil of Hudson's illegal dealings as we choke and toke ourselves into a mind-numbing nirvana. We're entranced by the soft swirl, the slow lethargic circles that evaporate to nothing.

"You hated me a little," he says it low as if he didn't mean to.

"A little." It's easy to admit it here in the dark, with the noxious fumes hacking away at our brain cells.

"I never hated you either," he says. "I lied to myself, and said I did—believed it too. If I didn't want Lee, I wouldn't have cared if the two of you got together—hell, I would've rooted you on. I knew it was you or me, though—and I needed it to be me."

"So you have balls after all," I say. "You hide them well."

"I do what I can." He takes a long, slow hit and seals it in his lungs, expiring it into a white tornado aimed at the ceiling.

"You're a control freak, you know that, Mitch?"

"I know—and the funny thing is, the more I tried to hold onto things, the further they slipped away. I think, right now, I

just need to close a few wounds. Come back as a new man—one that doesn't try to navigate other people's emotions."

"You did a great job of navigating Lee's emotions tonight."

He pulls a bleaks smile and shakes his head before taking another hit. Somehow I believe he's not doing this to sway her.

"So you're really going back there?"

"Bought my ticket this afternoon. I leave six in the morning, day after next."

"I'd go with you, but I'm too busy pulling your company's ass out of the shitter."

"Mmm." A pale fog evaporates from his lips. "Colt's going. And, thanks by the way. I'd do the same if the roles were reversed."

"You'd gladly steal Lee?"

"I've done it before."

"Yes, you did." At least he's honest. "It's more complicated now, though. Kids and stuff."

"We're going to be dads together."

"Yup. Joined at the hip for life. I'm sure you're loving it."

"No, it's good. I like being connected to you. I think of you as a brother. Used to anyway."

I take in a smooth, long drag—hold my breath until my lungs burn, then blow it from my lips like a white-hot tornado.

"That's good," I whisper. "I'm not through with Lee, though. I plan on several affairs. She can't resist me. Always know when you can't find her, I'm off somewhere entertaining her with my body." I nod into this reality as though it were the most banal thing in the world.

"Perfect." He tosses his joint on the floor and stomps out the glowing ember.

"She tell you she's pregnant?" I ask.

"Nope. She tell you?"

"I don't know." I've been on information overload these past few weeks. I can't keep it straight anymore. "You got any money stashed away?" I doubt it, but I'm hopeful.

"Nothing, why?"

"We're broke. I put another lien on the house, but I still can't scrounge enough cash to pay the bills. You might come back from China with nothing, Mitch."

"Wouldn't be the first time."

"So if this whole wine thing doesn't pan out, you want to go into construction?"

"Are you kidding?" He's finally absorbing what I've been trying to tell him.

"No, I'm not kidding. I'd like to send our kids to college one day, buy them new clothes once in a while, and keep a roof over their heads. Food might be necessary now and again."

"You and me?" A laugh gets stifled in his throat. "What about Colt and Hudson?"

"Maybe Colt. I'm pretty sure Hudson's got room and board covered for the next ten to twenty years."

"You turning him in?"

"Hell, yes, I'm turning him in." I don't bother telling him about the mass pilfering of the company's bank account. I feel like an idiot for having trusted him in the first place.

"You think he'll get a refund, now that I'm alive?"

"Nah, he's probably onto plan B. If I were you, I'd watch your back."

He nods. "It's always nice to be wanted."

"Yeah, well, tell me how it feels sometime."

"It feels insane. The best part is knowing that there's a plan in all this—a purpose."

"Is that why you're still here?"

"Without a doubt. You've got one, too."

"Oh, I know it," I say, rolling a blanket into a pillow. "It involves misery and humiliation, breaking my back in thankless

Townsend field. In fact, I think I'll rename the damn place just that, hang a giant sign out front for everyone to see."

"I want it all back, Max."

"All yours." I slap my hands together, wiping them clean. "Get back in one piece, and I'll sign anything you want. Just get my name off it."

"Shepherd going to be okay?"

"No, Mitch. You managed to drown out whatever profit I was making a long time ago. It feels like I'm serving penance for what my mother did."

"She wasn't alone. My father had his hand in it."

I look over at him. "It was some other body part, but I appreciate the olive branch."

Mitch closes his eyes. We laugh until nothing but our voices linger in the air. I fall asleep and dream strange dreams. Mitch and I are young again. It's the night of the party, and this time we decide not to go.

23

Paper Roses

Lee

Max never came home. I take the kids to school and pretend it's just another ordinary day, not some hellish rendition of my worst nightmare, the last day Stella might see her father again. I apprise Kat of the situation over lunch. She looks amused while consuming mass quantities of fries drenched in every available condiment until her food swims in a dull orange mess.

"You want some?" She pushes her plate into me, and my stomach does a revolution.

"I should be with Mitch," I say it like it's a chore of gargantuan proportion. "I can't, though. I don't know how I'm going to survive this."

"Wish I could be there." She shovels fries in by the forkful.

"Max and I are going after we pick up the kids. He said he was with Mitch all night, wouldn't say where."

"Mitch still alive?"

"Not sure I care at this point."

"*Lee.* You know where he's going, that's bad juju."

"I don't believe in juju, Kat." I sharpen my eyes at her. "I think Mitch is insane. I'm not even sure I should have left Max. I thought about what he said all night long—about Mitch

manipulating me. What if he was right, and this is all a ploy to get me to hurry up and take a sledge hammer to my marriage?"

"It worked didn't it?"

"Indeed." I run my finger over the rim of my glass, mesmerized by how fast I can travel in one uncomplicated circle. I've been spinning in one dizzying circle ever since Mitch came home, and now he's leaving again. I let my finger nosedive into the glass—let it sit there until it goes numb from the ice and burns.

"Neat," Kat says, slurping down her malt. "You got any other tricks, or you saving them for the asylum?"

"Just the one." I pluck my finger out and warm it in my mouth. "I can't let him go, Kat. Tell me how to stop him."

"Lock him up."

I nod over at her, actually considering this. "He's stubborn, though. He's not the old Mitch I knew. This is the new, unimproved version."

"Maybe you can stir up some trouble?"

"Like?"

"Fake an illness. Or get lost and have them look for you."

"And worry the kids? No thanks. I'm just going to have to let him go." I can't believe the words that just sailed from my lips.

"He's coming back, Lee. He did before."

"It took five years." I blink into the tears. "I won't take him back if he leaves me."

"You don't mean it." She fills her mouth with fries.

"I wish I did."

I sit and watch Kat consume food at an alarming pace, not to mention two whole shakes, mine and hers. She's not afraid of carbs or calories or cholesterol, and I envy her for that. I envy her for her one husband, her three children all at one time. I've always admired her carefree attitude toward life, and, now, I wish I could trade places with her.

"I'd give anything to be you," I say, looking past her at the crowd blooming on the street. "So normal."

"Boring?"

"So phenomenally boring."

ଚ୦ଔ

"Picture Daddy is going on a short trip," I say to Stella and Eli as we drive through town. "We're going to wish him good luck at Grandma Janice's."

Max and I shuttle the kids through Mono. Everything feels tragic—final as a funeral.

Stella gasps at the idea. "Where's he going?" A rise of fear sounds in her.

"China." Max shrugs over at me like it was no big deal. "Business."

"Isn't that where Picture Daddy died last time?" Her forehead erupts in a series of worry lines.

Max and I exchange glances.

"He's going to finish up some work, then he'll be back." I can't help but feel like I've just lied to my child.

Stella starts in on a slow sob that builds to a piercing crescendo. Max carries her into the house that way and lets Mitch get an earful before anyone says a word.

Mitch takes her from him, and I'm surprised she didn't kick him in his area, or his injury—both would have been nice.

He takes her into the family room and tries soothing her by whispering something into her ear. Stella perks up and nods at whatever he's filling her head with, then Eli starts in like some delayed reaction, crying for the simple reason Stella is.

"Come on, buddy." Max scoops him up. "Let's go raid Grandma's fridge."

Stella and Mitch kneel in front of the coffee table together. It's only then I notice it's covered with odd sized

papers and pens. They busy themselves writing something before he starts folding the sheets into complex geometric shapes. I take a seat on the couch as Max and Eli come back.

"Where's your mom?" Max asks through a mouthful of cookies.

Mitch looks up before returning his gaze to the task at hand. "She's busy."

Figures. He's either locked her in a closet, or she's taken off for the evening. I can't blame her for not wanting to participate in Mitch's newfound madness.

"And your brother?"

"Saying goodbye to his girlfriend."

"Uncle Colty's going?" Stella cocks her head up at him.

"Yup." Mitch affirms as if it's a good thing. "You want me to bring you back anything? A doll? Something for you and Eli?"

"I want firecrackers." Max knocks his elbow into me. "Big, illegal ones."

Mitch raises his brow. Something about the way Max and Mitch are interacting feels different tonight.

"Here." Mitch holds up a paper bird and places it in Eli's tiny hand. Of course, he unwraps it in less than two seconds. Mitch hands a paper rose to Stella. "For you, my love."

"Should I open it?" Stella who can't stand seeing a wrapped gift seems to need permission—*want* it from Mitch.

"Can you wait until tomorrow morning? Because if you can, I'll have two more for you."

She nods eagerly. "Yes!"

"They're numbered. Each day I'm gone I left you a special message. And when the roses are all gone, I'll be on my way back."

He gets up, stretches his spine, and winces.

Mitch walks us out, gives both Stella and Eli a monster hug with his free arm.

428

I wait until Max ushers the kids into the car before turning to him. "You're an asshole, Townsend." I can hardly get the words out.

Mitch holds back a smile. "You really want those to be the last words you say to me?"

"I'm positive."

"I'll be by later. Around midnight," he whispers with those sad citrine eyes. "Meet me downstairs and say goodbye to me, Lee. I need that."

Max comes over and gives him a man hug. "I meant it about those firecrackers."

"I'm sure you did. You think I'll have a hard time getting explosives through customs?"

"Not if you swallow them first." He offers up a knuckle bump. "Take care man."

I don't hang out for the love fest. I just get in the car and wonder how the hell we landed in this scary place once again.

<p style="text-align:center">ℂℂℂ</p>

I'm not sure if Mitch chose midnight because he hoped Max would be asleep, or he was hoping the moon coupled with my fatigue would romanticize the situation. I make my way onto the back porch just as Mitch comes up through the dark. The moon captures his hair and outlines him in a phosphorescent glow. It illuminates him like a thing of beauty, like a being from another world.

He gives a slow spreading smile as he takes me by the fingers and lures me onto the sand.

We walk for a while, ignoring the chill, and amble close enough to the water until our feet sink into the cold, wet shoreline.

"Max okay?"

"He's fine—sleeping in our bed." I hope it stings.

He dips into a reluctant nod. "All right."

"I find it strange you find anything all right with that."

"Don't. I'm over hating him. When I come back, we'll fix this mess." He jostles my hand.

"Maybe there won't be a mess to fix. Maybe I don't want you back if you leave."

"Don't do this, Lee."

"I'm doing it." I pull him to an abrupt stop. "Get on that plane tomorrow, but know if you do, it's over. You tore me to pieces the first time, and now you want to play Russian roulette like you're begging for it to happen again."

"I know what you're doing."

"Is it working?"

"No. I'll be there three days, five with travel. You won't miss me. You'll be too busy being mad, and, trust me, anger makes the time fly by real fast. I know."

"You don't care what this is doing to me. You don't care that I'm carrying *your* baby. What if you miss this child's delivery—hell, miss its life? Or *mine* or *Stella's!* Where's the fire, Mitch? Who's pushing you to hop back on that plane?"

"You're having my baby?" A grin slides up his face.

"Yes." I can barely breathe the word. I leave out the fact it could belong to Max—that it probably does.

"I'm thrilled." He stares at me lovingly before digging into his pocket and plucking something out. "Made this for you," he whispers.

He hands me a small paper flower like the one he made for Stella. "I don't want it." I shove it back at him. "Keep your stupid roses. I want *you,* Mitch. What don't you get about that? I'm your wife, damn it! Listen to me. Do not go. I *forbid* it!" The wind steals my voice, and all of my aggression is lost in its soft roar.

He tries pulling me in but I give a hard push, accidentally knocking into his left arm.

Mitch lets out a groan that could be heard for miles.

"Is that what would make you stay?" I shout. "If I hurt you? *Shoot* you?" I give another hard shove to his bad shoulder, and he explodes in a dull scream before dropping to his knees. He staggers back up again and charges at me. With one swoop he restrains my wrists behind my back and pushes his lips against mine, hard and aggressive.

It all melts away. We shared our first kiss here. I told him I was having Stella under a paper moon just like this one. This is where he proposed. I dig my toes into the sand as I pull him down and lose myself in these black magic kisses.

We watch the moon round out over the sky as the hours tick by. Colt eventually appears.

"Love you, Lee." Mitch pulls me into a one-armed embrace.

"Love you, too." I press my lips to his.

"I'm coming back to you," he whispers. His eyes lock over mine like a vice. "I promise."

I watch as the two of them grow small as ants, never taking my eyes off Mitch until he disappears into a blip on the horizon.

That paper rose catches my eye and I pick it up, unfold it to see what it might say.

I love you deeper than the ocean, Lee Townsend.
Remember that always.
Mitch

Mitch

Colton hasn't been on a plane since our dad took us salmon fishing in Alaska. I'm reminded of this as the plane thunders into the air.

He squeezes his eyes shut and clutches onto the armrests until his fingernails are pressed white. I wait until we hit a decent altitude before jabbing him in the chest, startling the crap out of him.

"Relax, would you?"

"Can't." He grits it through clenched teeth as he looks cautiously out the window. "You can see everything up here."

"Yeah, well, soon you'll just see clouds. Home will be a memory."

"No angels with harps?"

"Not where you're going." I close my eyes and try to remember details from last night on the sand with Lee.

"So why are we doing this again?"

"Just want some closure. Maybe figure out if there was a purpose in all this. I can't explain it. I need to do it." I need to know every move I make doesn't turn to shit.

"Is this you getting back on the horse?" Colt doesn't look too impressed with the idea.

"That's it."

"So what's it like there?" He settles his head into his seat. "Chinese food on every corner?"

"Don't know. All I ever saw was the inside of a detention center." That's not entirely true, but that last day with Kyle was a blur. My eyes spring open.

"What?" Colton hones in on my panic.

"Nothing." I burrow my head into the seat. Shit. I forgot to tell Kyle I was headed back—meant to have him on standby

in the event circumstances boiled down to the worst-case scenario. Life has a way of doing that—especially mine. Which reminds me, "You have any money saved?"

"Some. Why? You want that, too? Taking my life in your hands isn't enough?"

"I talked to Max. He said the business is broke. I don't think you'll be getting a draw for a while."

"Really? I talked to Lee about finances a couple weeks ago. She said things were stable."

"They're not."

"And you think Max is telling the truth because?"

"Why would he lie?"

"Why wouldn't he?"

The plane jostles for the next fifteen seconds. Colton expels a string of expletives while writhing like he's about to have a baby.

"You're bad luck, Mitch, you know that?"

"So I've been told."

"What's on the itinerary? You book a hotel?"

"I'm not worried about the hotel. I'm sure they'll have room." I don't fill Colt in on the fact I plan on making a beeline to the detention center to talk to Gao and Mei if she's still working. Tie up my loose ends then scoot out of China my way. I want to let it culminate the way it should have the first time, nothing to fear, no scars, no dramatic lapse in time, no children born without me front and center to witness the event.

"Lee's pregnant." The words feel foreign on my lips.

"You the daddy?"

"Maybe."

"Awesome. You know I never thought your life would turn out this way, Mitch."

"Me either. You know that old saying we make plans, and God laughs?"

"Yup."

433

"I'm not trying to manipulate things anymore. Just let them happen and trust that the chips will fall where they're supposed to."

"What if they fall where you don't want them to?"

"It's happened before."

ಐುಅ

Turns out the hotel I stayed in with Kyle is booked six weeks in advance. The manager gives me a list of other prospects, and one of them is a youth hostel, which Colt refuses right out the gate.

Outside the air is humid, smells like gasoline and bad engines, the whole city seems to have a bad case of exhaust pipe breath. I manage to get a taxi, and both Colt and I file inside.

"Where to now, genius?" Colt stopped panting like a woman in labor once we touched down.

"Reeducation for labor center." I instruct the driver. Colt's face bleeds out, pale as rice paper.

It's strange to observe the scenery from this vantage point. Small pushed together shacks, long colorful strands of laundry hanging by a wire, a business district that looks metropolitan in nature, streets brimming with merchandise. A rainbow of kimonos drape an entire city block as far as the eye can see.

We pull up to a tall looming building and slow to a halt. The cab driver doesn't bother warning us not to go in there, instead he extends his hand for payment and I hand over U.S. currency. He doesn't mind, but offers no change.

"So they gonna let us out?" Colt hesitates before stepping out of the cab. "Is it even legal for us to go inside?"

I'm too stunned to answer.

Here it is. The place that still holds me caged within its walls even though I was thousands of miles away. It's time to

say goodbye once and for all, leave all of my tragic yesterdays behind so I might be able to enjoy every one of my tomorrows.

I hold the large glass door open for Colt. I don't know the answers, but I don't plan on spooking him either.

A young woman at the desk glances up. "No tourists." She doesn't bother to smile as she nods toward the exit.

"I'm here to visit one of your prisoners. His name is Gao." I knock my knuckles against the counter. It occurs to me I have no idea what his last name might be.

"You family?" She picks up the phone and punches a number.

"No."

"Then you cannot visit." She replaces the receiver.

"How about Mei? She's on staff."

"You know Mei?" She hoods her eyes at me suspiciously.

"Yes. I know her very well."

"What is your name?" She picks up the phone again.

"Mitch Townsend."

<p style="text-align:center">⁊❧</p>

"Crazy Mitch!" Mei wraps her arms around me.

"She does know you." Colton offers his hand and introduces himself.

"You fat now!" She pats my belly as we stand in the lobby of the glorified torture chamber.

"Thank you, I think. How's Gao?"

"Gao not here." Her expression darkens.

"What happened?" My chest pinches. I'm not sure I want to know. That last day crops back into my mind. He tried slipping me a "Master Work" which equates to the book ban of the century in some of these parts. Maybe they found it on him? People left this place in body bags for far lesser offenses. It was the fastest route out of here and often taken by choice.

"He go home. He finish."

"That's great!" I'm filled with relief. "Where can I find him?"

She gives rudimentary direction to the harbor. Then it all comes back to me, the story of how he shared a junk boat with his ailing grandfather, how he was imprisoned for trying to feed him.

"How's everything else?" I ask her.

Mei eyes the girl at the desk and pulls us toward the exit. "You remember Tosa and Jun? Brothers."

"The little boys." I nod. Ironic, I spent day after day elbow-to-elbow with them and I'm not sure I ever knew their names. The vocal cord ban had been pretty effective.

"Yes," she nods. "They make paper flower and shapes from book Gao leave. But now different, you need be careful. After read paper..." She motions with her hand as though crumbling a piece of paper and eating it. Wipes her hands of it. "Gone."

"Excellent." The word of God nourishes in more ways than one. Wish I would've thought of that. Bet its more palatable than the stuff they pass off as food.

I thank Mei and give her a deep, long hug.

She points to my arm. "What happen?"

"He did it." I jab my thumb at Colt. I don't bother telling her they tried to kill me back home—that there was nowhere safe on earth after all. I leave out the fact I was haunted and needed to see things from a different perspective, that my wife married a man from my nightmares. No point in sharing, really. It's all going to work itself out the way it's supposed to. I can feel it.

At least I hope it will.

Colt and I don't have any luck finding a taxi down to the harbor, so I pay a young boy on a rickshaw to pedal us out. He seems to struggle a bit—hell, he's downright straining, but most of the way is downhill and makes for wild ride, so I tip him well at the drop off.

"Reminds me of your driving." I smile over at Colt. He's out of his element until a group of beautiful women walk by, and he springs into action, following them. "Wrong way." I spin him toward the water. Hundreds of tiny wooden vessels wobble on the tide, knocking into one another creating a symphony of clattering chimes. An oil slick congeals over the top of the water, creating a patina of lavender and blue.

The boats clank together, bobbing in rhythm. Each one is occupied two to three times overcapacity. I start asking around if anyone knows Gao. The first three ignore me, but eventually someone motions to the other end.

It's getting hot, we're thirsty, tired, and I'm trying not to remember that we'll need to eat more than paper to survive for the next three days, not to mention find our way back to the airport. That alone might take a day.

"Gao?" An old man turns around.

He motions to himself, says a whole string of words I can't understand.

"I think I got the wrong guy."

"Mitch?" A familiar voice booms from behind. "Crazy Mitch!"

"Good God, they all know you," Colton marvels.

ЄÞᏟᏲ

We keep our passports and wallets with us but leave our bags on Gao's boat. It's surprisingly small with a miniature hole that sleeps one uncomfortably beneath. Looks like we'll be camping up top, and we'll barely fit at that.

We head into town and hit a restaurant. Colton eats enough for the next week in the event this is his last meal.

"I have new group." Gao smiles as he says it. His dark hair is shorn close to his scalp, greying at the temples. Crow's feet have taken over in the corner of his eyes. He looks as if he's aged a good twenty years since I last saw him. "I take you tonight. Meet friends." Gao can't stop smiling—calls me *Crazy Mitch* every few seconds and shakes his head in disbelief.

"I didn't expect you to get out so soon." I'm not sure I ever expected him to get out—me either for that matter.

"Grandfather die. I finish."

"I'm sorry, man. They let you out for his funeral?"

"No. He drowned. I come out."

It takes several seconds for me to absorb this. He took his own life to get Gao out. Damn. No easy exit out of that place ever, except maybe mine, and, of course, all hell broke loose in Mono once I arrived just like Kyle Wong predicted. I've no idea what really went down with Gao's grandfather, but I'm not prying for details either.

"Mei says you gave the book to the boys."

"They do good."

"Yes. They might have a high fiber diet, but they're doing good."

<p style="text-align:center">⁋ʘ⁊</p>

Gao takes us on a hike into unrecognizable hillsides, dusty streets under a bleary-eyed moon—same one Lee sees. I look back at Colton who's huffing to keep up.

"He's taking us to the woods to hack us to pieces," Colt whispers.

"Yeah, they call it nutritional tourism. What'd you think you were eating?" I blink a smile over at him.

Twenty long minutes later, we arrive at a house up on joists, built into the hillside. People are sardined in the living room, about twenty or thirty at the least. No sitting room, so Colt and I stand near a wall to the back as Gao introduces us.

Colt leans in. "Is this illegal?"

"I'm pretty sure." The gospel meet and greets usually are.

It's Gao they were waiting for. He speaks softly as they bow their heads in unison before sitting down and engaging with them for hours, passing out hand written papers with longitudinal characters like it was chocolate.

Maybe this is why I was here in the first place, for Gao, for this, for these people—to share a little hope.

Colt and I sit and listen. Even with the language barrier, you can feel the joy, the peace that flows through each living soul like a conduit straight from above.

I lean into Colt. "I don't know about you, but I'm feeling pretty damn lucky to be here."

A sharp knock erupts at the door. It explodes open, and bodies fly everywhere.

And, in typical Townsend fashion, I think my luck just ran out.

Max

In the heat of the afternoon, while Lee is out picking up the kids, Hudson appears in the kitchen, about as wanted as a burglar. He twists the chair around and takes a seat as if he were an invited guest. If Lee catches him here, she might brand his ass by way of a frying pan.

"Remind me to start locking doors," I quip. "I hear there's a murderer on the loose. You missed, by the way." I save the document I was pecking at and close the laptop.

"I got me some problems." His lips pull into a line. His tries to run his fingers through his shaggy mane and they snag every few inches. Hudson looks like a wooly mammoth—hell, he's an insult to wooly mammoths everywhere. He looks bedraggled, unkempt even by Hudson's standards.

"You got problems, huh? You *think*?" I clench my jaw at what a liability he's become this past year alone.

"I got three different guys after me, and they all want their dough. Plus, Candi's missing."

"Missing? I suggest you check the mall."

"She's been gone three fucken' days bro."

"Sorry about that." Not that I'm surprised. Hud's got a history of women taking off on him. "Look, I don't have anymore money to give you because you sucked it all out of my ass. Or have you conveniently forgotten that?"

"I don't know what you're talking about. I didn't suck money out of anything."

We sit and stare at one another a good long while. Hudson and his wide-eye appeal—honest to God, I think he might be telling the truth. But I'd be a fool to believe him.

"How much did she take?" He looks genuinely disturbed by the idea.

"Hundred grand."

He knocks the chair over as he bolts up. "She told me she was going to kill me—now I know how."

"Look, I don't even want to know why she wants to kill you, but I can assure you, you'll be plenty safe."

"Where?"

"Behind bars. I'm turning you in for what you did to Mitch. That's Stella's father you almost offed. You're damn lucky he's up and running, and not a vegetable or, God forbid, a coffin dweller."

"I'm not going to prison." His eyes glaze over. "It was your fucking idea."

"*That* was never my idea!" I let the words reverberate off the walls.

He jabs his finger into my chest. "I offered to clean up the mess, and you never told me not to."

"I don't know what you're talking about." Holy shit. I thought it, may have implied it—*strongly* in fact, but never wanted it to actually happen. Did I? "What's with Candi?" I change the subject. "She find someone else to leech off?"

"She caught me with some chick. We were fucking, and she came home."

"In your house? You're so damn *stupid*. You've got all the money in the world, and you couldn't take her somewhere discrete? No wonder Candi took off. How'd she get access to the account?"

"I put her on. Changed the title to the house." He lets out hard exhale. "Put her on that, too. She said something about suing for the vineyard."

"Mark my words she'll be back for that one, but not before we lose it. You know it's not even considered theft what she did? She cleaned us out, front and center, and the law is on her side."

"So you can't spot me anything?"

"I could spot you a busted jaw."

441

He scratches at his chin before heading toward the door. "Got some tricks up my sleeve."

"Good luck with that."

"When you calling the cops?" He calls from the door.

"Soon as you piss me off."

"Good to know."

Debt collectors are after him, his wife is leaving him, and he's banking on party tricks to keep himself alive. What I want to know is how in the hell did my life become a mirror image of my brother's?

<p style="text-align:center">😊)C3</p>

It's hot as a skillet in a fire out in Townsend fields. Thermostat reads over a hundred in the shade, and it's nearly three in the afternoon.

"Hey!" Lee waves from the parking lot.

I flash the shears in my hand at her and watch as she ambles down the walkway to the tool shed and emerges with a pair of gloves and a rusted pair of clippers.

"You going to cut my hair with those?" Everything in me soars. I'm damn happy to see Lee. Her blonde hair glints like gold in the sun, and her soothing smile cools me.

"Nothing like teamwork." She lunges at me, wrapping her arms around my waist.

"You're so beautiful." I press my lips over hers, and she doesn't slap me silly so I take it as a good sign. "You here to help or cut my limbs off?"

"Help. What are we doing?"

"Pruning the branches. I called off the gardeners." I pause to look past her shoulder as Townsend field commits suicide right before our eyes, much like Mitch. "I put everyone on temporary leave this morning."

"What a disaster." She slips from my grasp, despondent. "I really hate this."

"Come on." I point over to the vine with the least dehydrated leaves. "Let's get her done."

It feels good working side by side with Lee. Watching her move, sneaking glances at me from the other side of the branches. I reach through and grab her wrist, listen as she squeals and breaks free.

"We've got miles to go," she says, getting back to the business of severing dehydrated twigs.

"We'll never get done." It would take an army to cover these endless acres. We're just trying to make ourselves feel better so that at the end of the day we can check off the box that reads we did everything we could. Which isn't true. I wish I cut my brother out of my life ages ago, at least then I'd still have a nickel to call my own and Mitch wouldn't have a bullet hole in his body.

"The Max Shepherd I know isn't a pessimist."

"You're right. He's a realist. I see things for what they are." And right now, they're not good.

We continue our vain effort, cutting and snipping until we reach the end of the row. At this rate we'll have Townsend pruned by next July.

"Look." Lee points at the strawberry sky. Sunset over Townsend never lets you down. It echoes off the leaves, turns the whole world into a reflection of burning fire. It dances off Lee's hair, mixes pink with gold, and I want to remember her like this.

"I love you." I swipe a kiss off the side of her cheek as she presses into me.

"I love you too, Max." It comes out with a smile, but you could taste the grief.

For a moment I envision a plane nose-diving into the Pacific, and it gives me a small ray of hope—not that I want

that. I shake the thought away. I really need to stop murdering Mitch in my spare time.

"So you're leaving me?" I twist my lips at the idea.

"Nope. He left me—told him not to go. You'd never leave me, Max," she whispers, running her fingers through my hair with a look of inescapable sorrow. "I can never desert you. I'm too far in. You're the anchor in all this madness. You've always been my rock. I'm not going anywhere, ever."

She wraps her arms around me tight and lays her head over my chest.

I swallow hard as I try to digest her words. Lee just said what I've been dying to hear from the beginning.

"You're just ticked," I whisper into her ear as a dry laugh rumbles through me. "You'll be back on the fence by the time he gets back." I bow a kiss over her temple.

"You think he's coming back?"

"He'd better." I toss the shears into the field. "He's got a hell of a lot of work to do."

We take a seat right there in the crimson-colored dirt and watch the sun slip behind the hillside. I snap off a small bunch of concords and feed them to Lee, one at a time, dripping them into her mouth like purple gold.

"You really know how to love me." She nuzzles into my chest.

"As opposed to that fake stuff Mitch passes off as affection?" I tease.

She makes a face. "Sour grapes?"

"We are at Townsend." I examine the meager offerings and pitch them back into the field. "They're sweeter at my place." True story.

"I bet. And who's pruning Shepherd? Hudson?"

"Hudson's pruning our banking account." I tell her about Candi. "Looks like having him arrested will be doing him a favor. I should just let him run around scared for a while. It might knock some sense into him."

"You think those people he hired to kill Mitch will come back?"

"Not unless they work for free. I'm pretty sure it was a onetime deal. They couldn't care less that he's not dead. Besides, it's Hudson's gambling debts that have him running for the hills. He's got all the wrong vices."

"And you?"

"You're my vice, Lee." I pull her in.

"*Ouch.*" She doubles over slightly.

"Is it the baby?"

She doesn't say anything just breathes her way through it. Please God, no.

This week could not possibly get any worse.

24

Ghost Twin

Lee

Under the sterile illumination of florescent lights, a nameless ER doctor presses into my stomach while conducting an ultrasound. He breathes over me with his shock of grey hair and squints as he rolls the device over my abdomen.

"You're hurting me." I hesitate before giving a generous squeeze to Max's poor hand.

"Sorry." The doctor replaces his instrument with a mild sense of disappointment. "I'll have to do this internal." He pulls out a wand and throws a condom over it. I push my feet into the stirrups and wince as he slips it in. "That's better."

"For *you*." I spear him with a look.

"Here's what we got." He points up to the screen. "See this?" A pulsating being—my baby. No bigger than a bean. I bite down a smile. "Everything looks great," he confirms.

"Thank God." Max leans over, brings his cheek next to mine as we marvel at the monitor. It brings back all those memories of doing this with Eli. Max never missed an appointment. He never complained, he *volunteered* to come with me. We made a routine of going to lunch afterwards, built memories like any normal husband and wife. I bring his hand over my mouth and touch my lips to him.

"But this one." The doctor moves to a different location. "The sac is empty. It's been reabsorbed."

"There were two?" I get up on my elbows. I've never had twins, never even knew I was capable.

"Looks that way. Happens more often than you think. Sometimes the second baby vanishes without anyone noticing, especially when it takes place so early. I'm sorry." He takes the chart off the table. "You can get dressed and come out when you're ready." He pulls the curtain shut on his way out.

"Twins." Max shakes his head. "I'm sorry."

"There's still one healthy baby." I reel him in, hugging the trunk of his arm.

There were two, and now one is gone. Reminds me of Mitch and Max. But Mitch came home to me, the first time. I look up at Max. I wish I could tell him this was his baby without a shadow of a doubt. Max who is always there for me—here for me now—who would never, ever leave for China if I begged him to stay. I pull him down and kiss him full on the lips.

"Thank you," I say.

"For?"

"Just being you."

<p style="text-align:center">ℎℎℎ</p>

Max and I go out to dinner before heading home, just the two of us with lobster and candlelight. By the time we get to the house Janice has the kids already tucked in and sleeping. We don't tell her about the phantom baby—probably Mitch's, that one. Instead, I assure her the baby is fine, false alarm, and send her home happy knowing that the heart of her grandchild is beating strong.

"Maybe Stella and Eli were twins," I say as Max crawls under the covers. A thin seam of moonlight tacks over his body like an ethereal highlight.

"We shouldn't go there," he whispers. "It'll just mess with our heads. They're here. That's all that counts." He pulls me into him and hooks his leg over mine, warm and inviting. Max is a balm as always. "We're pretty lucky. Two healthy kids."

"Another on the way." I place his hand over my stomach, and his eyes squint into a smile all their own.

"Another on the way," he parrots, kissing my eyelids in turn.

The moon washes out his features, taking ten years off his age. They should bottle moonbeams, best anti-aging remedy yet.

"What?" He slides in close before relaxing over his pillow.

"Nothing," I whisper. "Just looking at how handsome you are."

"Feel free to stare." He closes his eyes with his arms securely wrapped around my waist.

"You going to sleep?" I trace the outline of his lips with my finger, soft as a feather.

His eyes spring open. "Not if my services are needed." His lips curve into a devilish grin. "You're worried about the baby, aren't you?" He rubs slow circles in the small of my back.

"No, it's not that."

"Oh." It comes out measured like he knows. He doesn't say his name, neither do I, but Mitch lingers on the bed with us like a phantom, like he always has, only I'm too much of a coward to admit it.

I run the pad of my finger over his ear, tug at his lobe before tracing the outline of his brows, the bridge of his nose, his soft, full lips.

"You're a masterpiece," I whisper. God can be very proud of this one. A Davidian beauty. David was flawlessly beautiful, perfectly handsome, and it's so true of Max in every possible way.

"No, Lee, I believe that would be you," he teases, pulling a kiss off my lips like he was stealing the moment.

I tug on his shirt before he helps evict it from his body. Max lifts my dress over my shoulders, and I hold my arms up as he slips it off.

I need Max to scrub these inescapable thoughts out of my mind. I need him to scour Mitch off my heart once and for all. Mitch who tried to keep us apart, and here we are, our stomachs fusing together at the touch.

"You're mine, Max Shepherd," it strings from me with a quiet laugh. "How did I get so lucky?"

"Maybe you didn't get lucky." He pushes in a heated kiss. "Maybe this is how it was meant to be all along."

"Maybe it was." I outline his lips with my tongue and try to forget the last few months, the last few years, and pretend it was that night at the party once again—just Max and me in some strange bedroom with no history of grief chasing us down like a sickle but I can't. There's no scrubbing this stain from my soul. You have to own the past or else it owns you.

I fall over him with an urgent string of kisses. His hand floats down to my stomach and warms the baby. I roll back on the pillow and hang onto his unbreakable gaze. His eyes glow translucent in this light, inhuman, like fractured glass. His hands track up, cupping my breasts, and I give an audible groan. Max slips his knee between mine and dips his hand between my heated thighs. I'm ready for Max. I'm ready for a future with Max and all it might bring. I'm not sure how we're going to get there, but if I just keep breathing, if he does, I think we have a fighting chance.

Max offers solid kisses. His heart beats against my chest like a primitive war drum. It lets me know that he would never leave me—that an arm's length is almost too far.

He trails his lips down my chest and licks a fire line all the way to my belly. He pulls my knees over his shoulders and buries the hot of his mouth between my legs—nothing but an explosion of lust and wanting. His passion detonates as he wrenches an aching groan from deep inside me.

Max loves me with his tongue, his fingers, with his entire body until the sun rises—threading his existence into mine once again as husband and wife.

We don't take the kids to school the next morning. We shut off the alarm and hold one another, binding each other up with our flesh.

Long after the sun rises, Stella and Eli flop into bed with us and we all fall asleep again until noon in a beautiful tangle of limbs. It's familial bliss, something we haven't known in so long.

I love Max and our family. I submerge myself in a world of dreams where only those two things exist, and there is never a choice to make, never a baby to lose.

A thunderous pounding emits from downstairs and the four of us jolt from a dead sleep.

"What the hell." Max jumps into his jeans, buttons them as he races downstairs.

A pulse of alarm races through me as I spike up in bed not ready for the dizzy rush that follows. Eli starts in on a wild cry that picks up in volume as I pull him toward me.

Deep inside I'm hoping Mitch has miraculously returned.

Max shouts my name, and I hop out of bed.

Mitch

The vibration of footsteps dashing in every direction rattles the tiny house like an earthquake. The lights go out—screaming ensues from all angles. Gao pulls Colt and I out a window near the back. We climb down the backside of the hill and fall into a row of dense bushes that line the property.

"It's okay," he offers his false assurance. "Happening all time."

I meet with Colt's pissed off expression.

"Reminds me of high school," Colt says. "But the cops didn't come armed with assault weapons."

Gao's last words hit me like a rock.

"All the time?" I ask.

His dark eyes glint in the night. "Yes."

We watch as the police patrol the area while speaking to a group of women in the distance, and things seem to calm down a bit. Gao motions for us to stay put and hightails it over to them.

"What's he doing?" Colt fills in the space between us.

"Self-sacrifice?"

"Admirable," Colt flat lines. "Now let's get the fuck out of Dodge."

"No." I bring my finger to my lips. Gao is getting animated, distracting the officers while the others slowly back away. No one seems too interested in them anymore, all eyes are on Gao and the clap of thunder emitting from his mouth. The officers laugh—pat him on the shoulder as if thanking him for the show.

A sharp poke in the center of my spine causes me to take a quick breath. I swing my arm into Colt and groan.

Shouting ensues. A man in black, armed with a rifle, motions for us to get up. Colt and I hold our hands in the air and make heavy strides toward Gao and friends.

A look of panic sweeps over Gao's face. "He gone take us for ride, Mitch." He says it matter-of-fact before they stuff us in the back of a microscopic patty wagon. It's pitch black inside, can't see my hand in front of my face if I tried. We hear the distinct bolt of the door, the truck rattles, and we start to move.

"So at what point will they tie me up and whip the shit out me?" Colton's voice cuts through the darkness. "Because I'd really like to fucking know. You think they take requests on design formation? People actually pay to have their flesh carved out back home. Personally, I think a dragon would be fitting."

"Shut up." My mind is racing. Lee and Stella—I'm doing it to them all over again.

It's happening.

This is what I get for believing I could ever come back and leave on my own terms—that there was a hole in my destiny that needed to be shored up like a ripped pair of blue jeans. Deep down I thought if I controlled how it all went down that I could go home and put my house in order, starting with Lee and me back in our old bed with the roof I built firmly over our heads.

Fuck.

This is what I get for believing I could ever have a conversation with God—that there *is* a God. I asked to see if this would be safe, to see the mark I left on people—to stroke my own ego and believe for a minute that I ever made a difference—that I could go back home in one piece like a normal person—that I have any control over life at all. I'm so fucking stupid to have a conversation with my own fucking mind—and to land myself in hell twice in one lifetime. Max would never have been so stupid.

I was right, give a fool enough rope, and he'll hang himself, and, ironically, I'm the fool.

A part of me still wants to believe it was destiny though. That God loves me—that He's still in charge and this is just a part of the plan.

"Where are You, and why did *You* bring me back?" I roar into the void.

A beam of light slivers in through the crack in the door. Without hesitating I grab a hold of Colt and Gao and kick the back open with both feet. I haul them out as the truck makes a hairpin turn and we roll onto the waiting concrete below with nothing but a veil of fog to buffer us. We watch as the doors latch themselves shut again, polite as a whisper, and the car disappears down the road without us.

"Freaking *A*." Colt laughs as we dust ourselves off. He points to a death drop to my right. If I had hesitated one more second, we would have rolled into a ravine and either plunged to our deaths or twitched ourselves into paralysis.

"Crazy Mitch." Gao belts out a laugh so loud that it echoes clear back to the States. I'm not sure I ever heard him laugh in all the years I've known him.

We run off into a thicket and make tracks north.

I hope Gao knows where he's going.

I've got an airport to hit in less than forty-eight hours.

❧❦❧

Turns out Gao knows jack shit. We spend the greater part of the night arguing over what direction we should head in.

"Let's spend the night here." Colt crashes next to a tree and kicks his feet into the ground trying to get the mud off his soles.

"First good idea I've heard in a while."

A loud booming voice vibrates through the woods. Flashlights fill in the void between the branches. An army has arrived, and it wants its prisoners back.

Colt and I jump up as Gao pulls us further up the trail. This time I don't argue, just keep running until my feet feel like they're about to fall off.

Trees rush by like shadows. An entire fleet of strange wooden beings create obstacle after obstacle. We hear the voices boom all around. Colton and Gao bolt on ahead while I struggle to keep up. I trip over a rock, slicing my jeans open, and a trickle of warm fluid tracks down my shin.

"Mitch, stop!" Colt's command cuts through the forest. "Go back—" A dull thud lights up the night followed by a muffled cry.

Shit.

My heart pounds erratic as I propel through the woods, faster and faster until all I see are the black outlines of branches defined against a lavender sky.

"Think of *Stella*, think of *Lee*." Colt's voice booms across the expanse then the distinct sound of a slap.

Nothing but labored breathing stems from up ahead, sounds like thunder, like the loudest noise in the world. I peer around the burnt trunk of a pine and spot Colt and Gao in the clearing. Four men are on standby with rifles pointed at their skulls. They could kill us right here if they wanted. We'd be a feast for wolves—bones by morning.

Gao and Colt get on their knees while one of the soldiers binds their hands.

Stella and Lee—I've made another grave mistake. But this is no time to be a coward. If anyone has the motivation to get us out of this it's me.

I glance up past the starry hosts into the nebulous eternal realm where I still believe there's a throne and a higher being who uses the earth as a footstool.

"It's gonna work out, right?" I whisper.

Go.

I hear it clear as day. I don't put a lot of thought into it just thrust myself into the open with my hands in the air.

Colt looks up at me and shakes his head. "Crazy fucking, Mitch."

Max

The house is quiet once I get the kids to school.

After the assault Kat carried out on our front door this morning—her violent incessant urge for a "mall crawl" with Lee—I thought it might be time to spend some quality time with my own sibling. Maybe get some details on the bonehead he hired to carry out the hit.

I park adjacent to the Cadillac graveyard and head toward the house. The sun rides hard over Mono, searing the top of my head like a furnace.

Lee and I set the sheets on fire last night. It felt so damn good, my dick feels like writing her a thank you note. I think we're finally hurdling Mitch and his last resurrection. Not really looking forward to the next one. I won't lie. I'm a little partial to his disappearing act. It's his best trick yet.

A beat up Chevy with the trunk popped open sits in front of Hudson's unkempt abode. A buffed out man with a long goatee gives me a hard look as I make my way up the driveway.

Candi streams out of the house with an armful of clothes, some of them still on the hangers as she creates a trail of fabric from the door to the car.

I punch a quick text over to Hud and tell him to get here quick before he misses all the *f-u-n.*

"What's going on?" I try to sound friendly—*harmless.* The dude with the goatee is quick to lift his shirt, exposing a piece of metal that makes my balls shrivel to the size of dimes. Nice to be warned when someone's packing. I take a step back. "Just looking for my brother. You see him?"

Candi comes scrambling out once again, more erratic than before, losing half her loot on the porch.

"What's the hurry?" I shout over.

"Hi Max." She waves before dashing in for another run.

"You mind telling me what's going on?" It's clear as crystal what's going on. I'm just trying to make nice with the pistol packer before he lodges a bullet in my brain.

"Moving day." There's something in his mouth. Metal. My adrenaline spikes. It's the fucking guy who shot Mitch. At least it might be, if the gold tooth fits, but I let it go for now. I'd hate to help him with his target practice by picking him out of a lineup just yet.

"I'd better get going" I take a few steps back.

He whips out his gun and starts tossing his head around like he's having a seizure. "You don't know when to shut up!"

"Shit," I whisper. Running sounds good, but bullets are faster.

"Duane!" Candi screams, dropping another load into the overflowing trunk. "That's my brother-in-law," she says, struggling back up the porch with her pregnant belly and scooping up the leftovers.

"Going to be ex-brother-in-law," he corrects.

"Help me shut this," she says as she dumps the final load into the trunk

"He's gonna call the cops. I can tell by looking at him."

"He ain't calling nobody. He's a good one."

"Thank you, Candi." I give a slight wave, still making my way down the property.

"Get the hell back here." He waves me over with the barrel, and I pull forward like a magnet. I should have run. I should have ditched behind one of those monuments to the god of rust and let him empty out his cache, so I could drive the hell out of here.

"Listen," I say, holding out my hands. "I don't even *like* my brother. You can rob him blind. I really don't give a shit. I'll help you hoist the safe in the backseat if you want. But I've got a wife and kids, and I just want to get the hell out of here right now.

He twitches his fingers. "Gimme your phone."

I pluck it out, and Candi snatches it from my hand. He flashes his gun and waves it around with a greasy smile. "It's just for fun." There it is, that gold tooth, front and center. Knew it was him. "Get in the house until we take off. Crack open a cold one on your dear old bro."

I don't resist the invitation. Instead I mock him internally as I make my way into the well air-conditioned mini mansion.

"Max?" Candi tosses me my cell, and he groans at her stupidity as if there weren't a phone in the house to begin with.

"Yeah?"

"I'll have my lawyer contact you 'bout the ranch. You're not mad, right?"

"No, honey, it's okay." I take a breath. "My brother drives people to do interesting things." What ranch? I'm thinking she means vineyard but with the way Townsend has turned into dirt overnight I can see the loose connection.

"Glad you understand." She blows me a kiss.

They argue over who gets to drive as I shut the door behind me. I look out the window in time to see a plume of dust burn up on the horizon. They jump out of the way as it barrels right for their car, exploding into it without mercy—head-on.

Looks like Hudson finally decided to show.

25

Birthday

Lee

The sky above the outdoor mall is a pretty windswept blue. The clouds dot the atmosphere in a series of feathered wings. It makes me feel safe as if the angels themselves were observing us. Max dropped the kids off for me, freeing up the entire afternoon.

Kat and I bicker whether or not to go into the bookstore or eat.

"We can have nacho pretzels first, then go in for coffee," she points out.

"I love how every move you make these days has less than six degrees of separation with your digestive system," I say, following her to the concession stand. "You've got—"

She snatches at my shoulder and gives a hard squeeze. "Lee?" Her face fills with worry as she cradles her stomach.

"What's wrong?" I lead her over to a nearby bench and dump our packages onto the floor. "Is it a contraction?"

"I just felt a knife dive bomb my stomach," she pants into her words.

I sweep the hair from her forehead, her lips are so blood red and full I think they're going to burst. "It's probably just Braxton Hicks." God, I hope it's just Braxton Hicks.

"No, this was real. I've had those before, and I could hardly feel them. This was bad, scary bad." Her face glows a bright pink. "Shit!"

"Oh God," I whisper as a million thoughts fly through my mind. A horrible sense of fear sweeps over me. I know triplets usually come early, but I think it's a little too early.

"It's okay, just breathe through it. We'll get you to the hospital—they can always give you something to stop labor." I'm pretty sure seven months is a danger zone. Even if its not, I'd hate to take any chances. I help her back to her feet and saddle up with all the bags, trying to hoof us to the nearest the exit.

We make it a few short steps before she grips the railing and heaves her chest over the balcony. Kat lets out a howl that rivals wolves in heat everywhere.

"*Kat.*" I snatch her back like pulling her out of a fire. "What the hell are you doing?" A whole slew of frightened bystanders stare up at us from the first floor.

"I'm in *pain.*" She squeezes her eyes shut before falling to her knees.

"You are causing a scene," I grit it through my teeth as I try to drag her to the exit. "Women have babies all the time. Get it together. Use those fruit-loop breathing techniques you promised would see you through Armageddon, and let's haul ass to the car." I force her up by the elbow. I'm hoping my impassioned plea to get her into the passenger's seat worked and we won't have mall security shooting Tasers into us before the hour is through. We continue another few steps before she plants herself on a piece of random mall art that she's decided to use as a stool.

"Hey, Sweetie." I try and soften my tone. She's crying into her hands muttering obscenities. "What's going on?"

"I'm having my babies at the mall," she blubbers.

"No, honey." I rub her back. "Nobody has their babies at the mall. We need to go. We need to get to the car, right now. Come on, get up."

She nods and steadies herself against me as she rises.

"Oh. My. God." It comes from her deep and controlled yet equally panicked. "My water just broke."

"Shit."

I speed dial 911 as a crowd amasses around us.

"Another one's coming." Kat breaks out into an all out shriek, throwing a nearby toddler into hysterics.

"God, you sound like a Yeti," I tease, trying to calm her with her own brand of humor.

Kat shoots me a death stare clearly letting me know there is no brand of humor strong enough to pull her through this moment.

"Breathe, sweetie!" I help her pant her way through the next several contractions, which happen to be right on top of one another—always a good sign when you break out in spontaneous labor at the mall.

"Lee?" She tips her head back and squeezes her eyes shut. "I take back everything I ever said about natural childbirth." It speeds from her lips like only the truth can. "I don't want it. Get it the hell away from me. I want a mountain of drugs. What do you have in your purse?" She holds out her hand as if I'm actually going to drop a fistful of aspirin into it.

"You're having a C-section remember?" I'm quick to remind her.

"Yes," she pants. "But *before* that I want something fucking illegal to take the edge off." She spits it out like venom. "Powerful sedative shit that offers the benefit of mass delusions—like you had with Stella."

"I had Stella natural remember?" It was the birth from hell, but I leave that part out. "You don't want drugs, Kat. You made me promise. You can totally handle this until the doctor

straightens things out. I'll even buy you a huge box of chocolate as a reward."

Her eyes spring wide. Her panting all but ceases. "I can trace every damn yeast infection I've ever had back to a box of chocolate." She hisses at the offer as if it were vile, and her hands twist around the front of my shirt quick as a ninja. "You make sure I get the best damn drugs available. And I don't need you or Steve interfering with my new plan of action!"

"You picked a lousy time to turn into the exorcist. What about that verbal contract you made me agree to? You threatened to make copies of my high school diary and give both Mitch and Max a copy for Christmas if I didn't comply. I'm not messing with you."

A siren screams up to the entrance, and two men in white rush over.

"Great news, Kat!" I place the cool of my hand on her forehead. "No mall babies for you." I pull the bags off the floor and get up.

"Lee, quick!" Kat holds out her fingers. "Drag me to Macy's. Imagine the discounts my children will have!"

<p style="text-align:center">‽∰∛</p>

I meet Kat over at the hospital just as they're wheeling her to the maternity ward.

The smell of this place has always reminded me of ketchup, and it inspires a thin rail of nausea in me.

"I called Steve," she croaks the words out. "He's two hours away, but I told him to take his time."

"You really don't want him here do you?" Her face is rife with perspiration as I push the tendrils of hair from her cheeks.

"Not if he's going to interfere with my pressing pharmaceutical needs," she pants.

"Please, it's not like you're doing anything illegal. Women take stuff all the time to take the edge off. Labor's no fun, that's why it's called *labor*—not fun."

"Right." Kat snatches at my wrist, a look of wild determination shoots through her. "Get something, *now*. Make friends with the nurses. Tell them you'll supply them with a year's worth of free wine—hell, make it a lifetime. Throw in that box of chocolate you were going to get me."

"Now, Kat..." I pick up my pace, trying to keep up with the gurney. "I'd hate to be responsible for all those yeast infections."

They wheel her into a private room, and the nurse turns on the television as I help her change into a pale yellow gown. I hold out the sleeves. I don't bother securing the back, just help her under the thin sheet and sit on the edge of the bed.

"Tell her." Kat nods at a nurse in the corner. "Get the good stuff, or I will not forget this, Lee."

"Excuse me?" I get the nurse's attention. "She'd like something to take the edge off."

"Oh sure, hon." The squatty faced nurse winks over at Kat. "Soon as the doctor gets here. Should be about twenty minutes." She speeds out the room without waiting for a response, probably due to a history of unfavorable responses.

"Twenty minutes?" Kat whimpers into my shoulder.

It goes by like twenty years.

<div align="center">ଓଓଔ</div>

The doctor is a small-framed woman who speaks too fast for me to understand, so I just nod while Kat thanks her profusely for the shot she had the nurse administer.

Kat is relaxed—toasted to be exact, with her head moving in slow lethargic circles. She's completely unaware of the fact the nurse is prepping her for emergency surgery. And, all

things considered, it's probably for the best. Kat is lost in her own reality. That may not be what she wanted, but it's damn sure what she needed. I'm guessing she'll wake up tomorrow and slap me silly for not cheering her on while she chewed her arm off in pain.

The nurse hands me a blue paper uniform, and I pull it on with booties to match over my shoes. Steve is an hour away—defying all traffic laws to get here.

An entire medical team dressed in paper suits helps wheel Kat's bed into the OR. I follow behind into a well-lit room with a table laden with surgical supplies that can double as medieval torture devices.

The over-bright lights, the people dressed as aliens, the thick orange paste they paint over her burgeoning belly in haste, it all sends me swaying on my heels.

A nurse slides a stool over to me and stuffs my hand with cotton-shaped rods.

"Smelling salt. Easy breaths," she barks. "Only if you think you're going to pass out. Take in a sharp breath, and you will."

"Right." I study the team as they build a tent around Kat's stomach. Thank God. I can't see a thing from this angle, and I'm more than relieved.

"Don't just sit there! Get your phone out and record this!" Kat is quick to morph into a director.

"It's going to be gory," I warn.

"It's going to be beautiful. I'm going to be a mother, Lee. This is my one shot, and I want to see it, please?" Her eyes glitter with tears, and it's becoming clear Kat is cognizant once again.

I wait for the doctor's signal then slide my stool over. If I stand up I'm going to black out, and nothing will piss Kat off more than me landing face first in her gaping belly.

Gah!

I cover my mouth as I take in the sight and subject my phone to the horror.

Her flesh is neatly sliced open, exposing layers of flesh. A wall of yellow fat leads to a pocket of bloodied muscles. Four gloved hands reach in and dig around at the same time. I see a foot, then a back, before I know it the doctor fishes out a beautiful bloody baby.

"It's a boy!" He passes it off to a waiting nurse before plunging his hands back into her stomach. The next one comes out more readily. "Another boy!" Cheers erupt from behind the masks. He reaches back in and fishes out the last baby—at least I hope it's the last baby. It's smaller than the other two—already crying, this one. "Girl!"

I can hear Kat bawling from the other side of the curtain. I move the phone up over her face. She sort of does look like the exorcist, but I mean that in a beautiful way.

"How does it feel to be a mommy?"

"Feels good, Lee." She sniffs through the tears. "Real good."

Mitch

Never let an abductor take you to a second location. Heard it a million times.

The car thumps along as the night stretches out indefinitely. It's damn hard to argue with someone holding the barrel of a gun down your nose. Colt kicks me in regular intervals as we crouch in the backseat. Gao's in another car, at least I hope he is. I'd accept that rather than him dying in a ditch—although—he might prefer the ditch.

His last words were, *this is good.* Maybe we had this whole crazy thing backward—maybe it's been Crazy Gao all along. Obviously, I'm insane for coming back here—expecting a different outcome—expecting to be in control for once. That's just like me. I tried to keep Max from Lee and that's not exactly what I got, and now here I am as a testament to my own stupidity. I wouldn't blame Lee for setting up a conservatorship if I manage to get back alive. Hell, I'd beg her to do it to keep me from making such magnificent mistakes.

What in the hell did I think was going to happen? That I was going to tie everything up in some nice, neat bow? That the guards who made my life miserable at the detention center were going to apologize? Maybe throw in a little dance number? I fog up the window with a huff. I don't stop Colt from knocking into my bad arm either. I deserve far worse than that for taking our lives and screwing up the hell out of them. I'm the master of disaster. Maybe that's why God sent me here the first time—to protect Lee and Stella. He knew what He was doing when He put Max into her life. He was just putting the puzzle pieces back where they belonged. Max is the anti me—a superhero in blue jeans.

It takes another half-hour before we arrive. A building materializes from the night and stretches skyward like a cinderblock palace.

We're back. I'm home and not in any good way. I blink in disbelief. I've landed myself right back at the detention center and brought my brother with me. I bet my father is rolling in his grave at what a fool he raised—although I could always point a finger and say I learned from the best.

They hustle us in through the side door, up a familiar stale yellow hall and into the infirmary. Gao comes in last, his face bloodied, his lip swollen on the side. We hear the distinct sound of a bolt penetrating the wall once they leave.

I pull my lips into a bleak smile over at the two of them.

"Looks like more work." Gao nods as if he's accepted his fate.

Funny, I'm not feeling so charitable with my life this time.

"You don't seem to mind," I say, trying to free my hands, my arm feels like a knife is stabbing through it with every move.

"I teach, I die, live real life." He's still smiling like a loon, and it weirds me out until I realize what he's just said. He lives then dies—then his real life begins. It's as if all of the horror, the grandeur of life were simply a prelude to something bigger.

That's what I pumped in his head for years, and now he believes it. Not sure if I do anymore.

"You're a good guy, you know that?" I sag into my words.

"You still crazy."

"You've both got a few bolts loose," Colt says with a level of defeat I've never heard in him before.

The door rattles before two men enter with rifles, then the familiar round face of my sweet friend Mei.

Her cheeks pucker in a series of wrinkles then loosen as if she expected this on some level. Her hands fold into her hips as she shouts something at the armed guards. They lower their

weapons and look over at us uneasily. She makes her way over, pokes at my scuffed knee.

"*Shit*," I hiss.

"You baby. Nothing wrong." She looks over at Colt and surmises the same minus the name-calling. She invokes her singsong tone once again as she speaks to the gunmen and points toward the hall. Mei pulls a scalpel from her pocket. In one swift move she creates an incision along her forehead.

"Stop," I bark.

A seam of crimson trails down her check and corrupts her crisp, white uniform by way of red flecks. She does the same to the arm of one of the guards.

She speeds out something to Gao then turns to me. "Get out! Nice see you. Now go. No come back!"

Gao leads us out the hall until we come upon a door held open with a bucket. Mei must have known the floor was being cleaned—either that or she planned our escape like a prison mastermind. We run into an alleyway before Gao slows down out of breath.

"I go back. Goodbye, Mitch. Mitch brother." He gives a half bow to each of us.

"Why?" I try pulling him with us.

"More work. Thank you for beautiful thing. I see you." He points skyward, squeezes my hand with both of his.

The sound of footsteps, clutter the night. An entire army is about to materialize at any moment. This is it, fight or flight—prison or Lee.

"Gao, no!" I try to latch onto him, but he breaks free from my grasp.

"Goodbye, Mitch," he shouts, bolting back in the direction of the detention center.

The area explodes with shouting.

"I have to get him," I start to take off just as a shiny black shoe steps out from beyond the bushes—stops me dead in my tracks.

"Are you fucking nuts?" Colt pulls me back by the shirt, but something in me stalls.

Out from the brush emerges the familiar frame of a man. He wears a navy suit, slick gold tie, patent leather shoes—I know that face.

"Dad?" My heart races as I take a step forward.

"Dude, let's go!" Colt's voice elevates with panic.

"He can't see me, Mitch." My father gives a placid smile. "It's over now. Lee needs you at home. There's no reason for you to be here." He nods with a touch of sadness in his eyes. "Go on. Get out of here. Go home on your own terms. Lee needs you to save her, one last time."

Colt rains down expletives around me, but my ears are stopped up with the wonder of seeing my father. I'm immovable as stone. Tears flood my vision. My lips twitch out of control as a baseball-sized lump of grief lodges in my throat.

"Why did you hurt us?" I whisper. Of all the things to say, I suppose it was the least productive.

"I'm afraid I don't have a good answer for you—just know that I'm sorry. If I could do it all over again, I'd do it different. But I wasn't offered a second chance, a chance to ask forgiveness—to forgive, a chance to say goodbye. I wasn't one of the lucky ones."

"Let's do this," Colt drags me down the dirt path as my chest heaves from holding back tears.

My father fades into the scenery, until he becomes clear as velum.

"I forgive you," I try to shout the words, but they come out less than a whisper. Something tells me he still heard.

Colt whisks me down the road without my permission as my father's words siren through my skull like a warning, a salve.

Colt and I run through a series of narrow alleys. We climb over a chain link fence until we hit the general population. Colt

finds an abandoned water bottle, and we wash our wounds before ambling along slowly as if nothing ever happened.

We finally hit the harbor, sacked and rundown like a couple of glorified carcasses. My father's image is still fresh in my mind. I forgave him. It felt like a boulder moving off my chest just like it did when I made amends with Max after all these years.

"Shit," Colt hisses as we hit the junk boat. There's not a sign of our luggage anywhere near Gao's boat.

"That's why we took what matters," I say, pulling him back up the pier. Colt and I still have our wallets, our passports—*ourselves*. We don't hang around. We walk until we find a cab and head for the airport.

It's time to get home to Stella, to *Lee* if she'll have me. And, after the stunt I just pulled, it feels rather doubtful.

Max

Hudson and gold-tooth-Duane participate in a shoving match, exchanging a few words before Candi removes the keys from my brother's pocket, and she and Duane take off in Hudson's car. That should teach my brother for disabling a getaway vehicle.

Hud doesn't put up much of a fight. He simply kicks his way into the house, cussing at jet engine decibels.

I walk out and meet him in the entry.

"What the hell."

"Came looking for you," I say, holding up a beer. "This is better than cable. You should sell tickets next time. So who's the asshole with the gold tooth?"

"Some shit she's been seeing."

I don't say anything about Mitch and his description of the bastard that shot him. But something doesn't make sense.

"You friends with that guy?"

"Why would I be friends with him?" He picks up the piano bench and hurls it at the mirror, sending glass shards raining down with a crash. He speeds off down the hall in a tirade.

There's something odd about Hudson—something more brewing here than just Candi's Hollywood exit.

"Are you high? Dude, what are you on?" I quicken my gait and track him down to the kitchen where he's on his belly digging in a cabinet next to the dishwasher.

"You're not gonna help, so I gotta help myself." He pulls out a wad of bills in a plastic bag with duck tape securing the middle. "Bingo." He waves the money at me like he just caught a trout. "My secret stash."

"I can't help you because I can't help *myself*," I bark. "In fact, you should hand over every damn dollar you're hoarding, so I can pay the electric bill over at Shepherd." I leave out Townsend. Although, the idea of Hudson helping out either of my businesses is a joke at this point.

"Now..." He holds up a hand. "I recall you threatened to call the cops on me."

"Might not." I'm pretty sure Lee will once I tell her about my new friend Duane.

"Might. That's a loaded word, little bro." He picks himself up off the floor. "One day you're going to look back and remember all the things I did for you."

"Like?"

"Like giving you Lee on a silver platter." He pulls out a pocketknife and examines it in a stream of sunlight.

I don't even ask the question.

"When Mitch came looking for you at some party back in high school, I pointed him in your direction. Personally, I was sick of listening to the two of you jawing over her, but when I saw you take her to the room, I was damn proud of you buddy." He slaps his hand over my shoulder. "Too proud to keep it to myself. Had to find Mitch and share the big news."

Hudson.

I close my eyes a moment. "That didn't give me Lee."

"Nope." He glances up from polishing his knife. "You were too stupid to hold onto her."

"I got her back."

"Until Mitch showed up again." He blows hard against the blade.

"She's still with me." I'm not cluing him in on the big powwow the three of us had the other night—or my borderline pleasure of watching Mitch walk off the plank on his way to China.

"We'll see." He shrugs. "I tried taking care of things for you. The guy's got some nether-world missile shield around him. Impenetrable—he's an immortal or something."

"He's mortal all right. You jacked him up pretty good. He's got a banged up arm to prove it."

"I'm no more guilty than you are." His brows rise as he settles those red-laced eyes over mine. "We didn't pull the trigger, now did we?" His lip curls on the side.

Shit. "I gotta go." I make tracks for the door.

All those years—all that torment of losing Lee—losing *Mitch*, it was orchestrated by Hudson and his backward intentions—all to hurt Mitch and exalt me in the process like some fornicating frat hero.

Stupid.

That's Hudson in a word.

26

Fields of Fire

Lee

Steve arrived late.

The babies are tucked safe and sound and, more importantly, healthy in the NICU. Each one of them is thriving and breathing on their own. They're beyond adorable, each wrapped like a burrito with their pink and blue caps pulled over their little blonde heads. Kat is passed out for the night, so I take off.

The sun melts over the horizon, leaving trails of burnt orange lingering in the sky. Instead of veering toward the coast, I head over to Townsend field to see if Max is still there, maybe surprise him with a little more than a kiss.

I glance back up at the ever-darkening sunburnt sky. There's something odd about it, ominous even. Everything about the stale, silent world outside my windshield is reminiscent of the last time we lost Mitch. I'll never forget the horror of hearing how they found him. How a fire had ripped through the car he was in—*supposedly* in. I wonder what it'll be this time. A bullet? A plane crash? A knife to the throat? They all feel like real possibilities—nefarious promises. Something doesn't feel right. All these unsettled feelings, the unexpected birth of Kat's babies, the fact Max and I haven't talked since

this morning, which isn't normal for us. Something is definitely off. The charred sky knows something, and for once I want in on all its damn secrets. A warning siren goes off in my belly, and I want to know just what the hell this impending doom is. I don't like not knowing, I don't like suspense or decision-making. I was never a fan of those chose-your-own-destiny books in school.

I glare up at the invisible eye of God. "That's what we pay you for," I hiss. We pay in trust and honor and all those noble things my parents taught me before You snatched them back. I glance at myself in the rearview mirror. There I am. Haggard. Older—tired beyond measure. I'm rattled—unsettled by something mysterious that hangs in the air like a sickle.

I pull into the empty lot that lends an incredible view of the fields.

No sign of Max, but that doesn't stop me from getting out of the car and taking on the angry sky in a shouting match.

"Where are you?" I bark it out at the red-faced universe, but really it's the creator of all this madness I'm pegging with my anger. It feels good to scream—cleansing on some level. "I told you I couldn't make a decision!" My entire body starts in on a series of convulsive shivers, despite the molten heat permeating me like a membrane. All of this vitriol brewing inside me, it wants to spew from me like vomit—it demands to. I've become a kettle, the lid rattling just before it blows. If I leave all of this toxicity in my bloodstream for another second, I'm going to die from the poison, right along with my child. "*You* were supposed to be in control!" My voice echoes off the fields like a song. "Where are You?" It comes out shrill, a scream rising in octaves that never lets go. "You failed me because you're nowhere. Get down here—do something if you're real. I'm so tired of breaking everybody's heart. I want some action. I want it *now*. You hear me? Do You fucking *hear* me?" A hollow whisper pulsates through the air. My voice reverberates off the landscape as if mocking me, so I fill the

silence once again. "Answer me, damn it. Right this second. I *demand* an answer!"

A roar erupts from behind. A loud rush of wind ignites to my left, and I look over in disbelief. Row after row of vines light up like torches. A line of fire races along, swift as a stream, taking down the crops like dominos. In less than ten seconds, Townsend field is in flames all around me. It burns with vigor, with a vengeance that only the danger of a fire can provide. A choir of dancing flames thunder and snap, all in my honor. I had the audacity to take on God, defame Him with my insolence, and the punishment is proving swift.

The heat permeates my clothing, sends my adrenaline into overdrive.

Dear God Almighty.

I've damned the whole place to hell.

Mitch

The souvenir kiosk is bustling as I sift through the mediocre offerings just prior to boarding. A small snow globe with the great wall encapsulated in a plastic bubble garners my attention. Looks odd yet amusing, so I clasp it in my palm. I think Eli might like it. He can hurl it at Max every now and again, probably me, too. I move over to the dolls—tall ones, small ones, porcelain, plastic. I hold up a bright red geisha for Colt's opinion.

"I'd do her." He's thumbing through the x-rated postcards, to use as a "bookmark" he claims. The fact he hasn't picked up a book in a decade doesn't seem to factor into the decision-making process. In his defense, he might have meant picture books.

A plastic kabuki doll garners my attention—all the inconspicuous drama locked in her face, her sideways secretive glance, it lends a sense of mystery—but it's the paper rose she's clutching in her hand that has me mesmerized. It has so much meaning. I have to get it. I don't ask for Colt's opinion, just pay for my trinkets.

The overhead speaker goes off and announces the boarding for our flight.

"We're headed back to Mono." I pat Colt on the back.

We move along like cattle until we step on board.

Almost home. Home on my terms, sort of. I fight tears as we find our seats. I'm so ready to put this living hell behind us. I'm anxious to watch the earth dissipate—so glad to rise into the sky still wearing my coat of flesh, and not as some ethereal floating soul.

I settle into my seat and smile banally as the stewardess flirts with Colt—life in all of its normal glory.

I take a nap and wake to the plane already in the air.

Clouds stream by in vapid haste. I look through the murky expanse and try to snatch a glimpse of the great beyond, catch God on the throne surrounded by heavenly hosts—a wink from an angel, but nothing.

It's over now, right?

I give a grim smile. I think I made a difference—the whole pebble in the water deal. God touched me, I touched Gao, the boys, Mei, its all a chain that leads back to the sky. It hurt like hell, but I made it through to the other side. It was all for a reason—everything in its season. I close my eyes again. Someway, somehow it worked out. But why Max and Lee? Why twist our lives together in an eternal pretzel? I wonder if there was ever any great plan for them or if this was some big scheme to teach me a lesson for even thinking I could be in control, that I could control others in the process. But in my defense, all I ever wanted was Lee.

I glance out the window, trying to find an answer in the clouds. I hate to remind God, but Lee is mine. He might want to double-check the system—because there is definitely a glitch. Hopefully the bugs get worked out before I hit U.S. soil. I only get one shot at happily ever after. But it's all a bit more complicated now—especially after I stopped hating Max.

I look out at the blank, open sky.

You out there? You're gonna fix this mess and make sure I end up with Lee, right?

The plane dips a good ten feet.

I'll take that as a yes.

My father's words come back to me like a bucket of water thrown in my face. *But I wasn't afforded a second chance, a chance to ask forgiveness—to forgive, a chance to say goodbye. I wasn't one of the lucky ones.*

Maybe this is the part where I forgive China—*Max.*

Colton locks his fingers over my bad arm, and I let out a groan.

"Was that turbulence?" Colt's face bleeds out as he chokes on the words.

"Maybe." I look out at the sky with the blood pumping through my veins a little faster than before.

I forgive them. I forgive an entire country—and Max Shepherd, the man who became both Stella and Lee's universe in my absence. It's done. Over. No more fear or outright hatred left in my bones for anything or anyone.

Lee comes to mind. She's such a gift. I wonder if she'll ever fully understand how much she means to me.

A pen peers from the seat pocket in front of me, and I pluck it out and write her a letter telling her exactly how I feel. Of course, I'd much rather say it in person—but just in case things don't work out for me. I'll give it to Colt to hang onto once we get home. I fold it up and hold it in my arms as if it were, Lee.

I close my eyes and dream of castles in the sky. Lee and Stella and Eli are with me. Max is the knight galloping in the distance. I can't tell if he's coming or going as the scene fades in and out. It rolls on for hours as I dream my way to my beautiful wife.

Lee and me—we're going to happen.

We have to.

Max

When I get home, there's a note on the door from Lee, and it sends me bolting back to the car.

Shepherd field. I race through three stale red lights, honking like a jackass. Lee's note said there was trouble—to get here quick. I put in a call to her, but she doesn't pick up. She probably misplaced her phone, thus the note.

The fields look peaceful, the parking lot's empty. She's probably on her way with a picnic basket and a bottle of bubbly. The memory of her body writhing under mine comes back to me. We've christened the sheets the past few nights with the anthem of our love.

I head into the office and pour myself a stale cup of coffee left over from this morning, looking out at the leaves waving in the night breeze, pale as butter. Nothing says peace and quiet like this place. And for sure there's not one sign of trouble. Sounds more like a proposition from my very hormonal wife. Not that I mind. Hell, I'm more than pleased. Having Lee beats Christmas morning every single time.

A strange glow in the distance catches my attention. Then like a bolt of lightning it races through the fields, igniting in a fire line that maps out like a square.

"Shit." I knock my coffee over before heading out the door.

A wall of fire—an entire fortress of flames engulfs every single acre.

"Fuck!"

I dig for my phone in a panic and call 911.

"There's a fire at Shepherd field. The whole thing's lit up. We're going to need several trucks."

"You mean *Townsend*?" The female voice asks from the other line. "The field fire at Jenson road has already been called in sir."

The world stops. Gravity digs its lead claws into my shoulders, and I sink into another dimension. I tuck my head between my knees a moment before hanging up and calling Lee, but there's no response.

I stagger over to the edge of the parking lot and take the view in full. The blaze riots into the sky. The flames fan out. The fire roars and laughs, dark like a demon. It expands its molten wings over the entire field, all of Shepherd soil is baptized in this fire. The flames taunt me. They rise like lions, bear their pointed teeth and lunge at me with the wind as if I was their target all along.

"Shit."

I jump in the car and speed down the road as the sound of sirens scream through the night. Mono is lit up like a jack o' lantern. But right now, all I care about is Lee and our baby.

The sting of tears blurs my vision. Headlights come at me and I breathe a sigh of relief at the familiar looking car.

"Lee!" I scream stopping in the middle of the road as we both get out. I pull her in and crash my lips to hers. "You okay?" Ashes fall in my mouth as I shout over the noise. I'm eating Shepherd field, literally.

"It's gone." She grips my shirt as if she were in pain.

"The baby?"

"*Townsend*." Tears track down her face like an oil slick. "It's burning."

I glance back at Shepherd, at the hurdling flames that stretch to the sky.

She rattles my shirt. "Who did this?"

"I have an idea." I coax her back into her car and have her follow me home.

We ride through town under a cover of embers, salt grey pillars rising from opposite directions as Mitch and I burn

together. It was as if our fathers had roused themselves from the grave to teach us a lesson from the great beyond. It's over now. No more worrying, all the backbreaking, the financial tap dancing up in smoke—ashes to ashes, dust to dust. Maybe Mitch wasn't the bad luck charm after all. Maybe it was me all along.

I look back up at the remnants of sky.

Somehow, someway, Townsend Shepherd needs to survive this nightmare.

A rolling black cloud boils up above. Nothing but soot and fumes clotting up the sky.

Lee sees me as some kind of savior. I need to pull this off to help keep her sanity.

I'd do anything for her—and the truth is, I'd do anything for Mitch, too.

Abduction

Lee

"Whoever did this, set us up." Max glares out the kitchen window. The orange sky is lit up like a flame, mocking us as we sit idle while everything we worked for is reduced to cinders.

"Nobody knew I was going to Townsend," I say. "*I* didn't even know until I made that turn."

"Maybe they saw you and decided it would be serendipitous of me to do the same?" He tries to explain away the note. "Don't you get it? We're on the security tape in the parking lot. Insurance will never cover the claims if they smell arson, and believe you me they will smell arson. I let go every damn person that runs the fields indefinitely *three* days ago. That left us plenty of time to gas those fields."

"I don't get it." I blink into him. "We would never do something like that. Everyone would vouch for us. We breathe, eat, and live for our business."

"I don't get it either." He comes over and wraps his arms around me, solid and stable. "You want to hear something scary? If it was just the twin burns, I almost would have been fine with it. No more headaches, the bills, the drama— everything would have been swept away neatly. But for someone to do this? It just got personal. Who hates us so much

that they'd not only want to imply we were somehow involved—but Lee, they could have killed us."

A set of tiny footsteps make their way down the stairs.

It's well past two in the morning, and I can't even think about sleep. We spent the last four hours lost in a flurry of police reports not to mention dealing with a distraught Janice and Sheila who actually embraced for the first time in years right here in our living room.

"I'm thirsty." Stella twists her fists into her eyes.

Max gets up and pours a cup of milk. "Just a sip."

"Is Picture Daddy home?" Her mouth cinches up, and she looks like a twin to her father. It guts me just to take her in.

I had forgotten all about Mitch, quite possibly the only time I've completely dissolved him out of my mind.

I squeeze my eyes shut for a moment. God, I miss Mitch. He's the secret scent I long to inhale.

"Not yet." I pat her on the bottom and shoo her back upstairs. "I guess he should know as soon as his plane lands," I say. "I'll let Janice tell him." God knows I won't be the one to deliver the blow.

"He'll think I did it." Max looks resigned to this.

Sadly, he's probably right.

His mouth rounds out to a perfect O before he snaps it shut abruptly.

"What?"

"Nothing."

"You were going to say something. No room for secrets, Max. What is it?"

"I had this crazy afternoon with Hudson and Candi." He exhales hard. "There was this guy helping her get her stuff, and he fit the description of the guy who shot Mitch." He taps his lips.

"You saw him?"

"I'm pretty sure it's the same person. I doubt Hudson knows too many people sporting a heavy metal smile."

"Max," I whisper. "We need to call the police."

"Tomorrow." He lands a kiss over my forehead and lingers. "Let's get to bed and try to forget the world for a while." He rides his hands over my back. "Tomorrow has got to be a better day."

"It will be."

It's a lie.

We both know it is.

Once we crawl into bed, Max glides his hands over me, slow and soothing. I let him kneed his fingers into my flesh, working out the kinks in my back, my thighs, my most intimate part until I'm groaning with pleasure. Max pulls himself over me and I guide him in. He glides in and out with slow, easy thrusts, and I convince myself it's months ago and Mitch never came back. We still have Townsend and Shepherd, and everything is back to normal, at least the normal we bought the idea of—the one we thrived in for five long years.

Max pulls me up until I've wrapped my legs around his waist and we rock steady into the night with our mouths fused together. Selfishly I never want this night to end. I try to memorize the way I feel, dizzy and heady with Max buried high inside me, loving me with his hot lashing kisses. A thread of excitement rails through me, and I don't fight it. A cry escapes me as I seize over him, my fingernails dig into his back in a fit of pleasure. Max clasps onto me and presses me into him so hard, a moan rips from my throat.

"Fuck, Lee," Max pants with a laugh into my ear. "I'd die for you, you know that?"

My eyes spring open in the dark as I try to steady my breathing.

"Don't die, Max. I couldn't handle it." The truth is, I'd rather die myself than lose Max, and seeing that I've lost just about everything else, it sounds a hell of a lot like a bad omen right about now. "Just love me, forever," I whisper.

"I'll always love you forever." He digs his fingers into the back of my hair, still holding me secure over his lap. "No matter what."

ഇൗ രൂ

In the morning, as soon as Janice leaves to take the kids to school, I head back to bed. I watch Max lying there with the look of perfect peace on his face—not one note of despair in his slumber. Every now and again he reaches over and pulls me in.

After what feels like hours of tossing and turning, I scoot out of bed. I need to assess the damage in the light of day with my own eyes.

In the late afternoon, I head outside without bothering to shower. The stench of the charred landscape fills my lungs with the bittersweet warmth from the fire. Both our cars are covered in ash so thick I can write my name in it. The driveway, the lawn—they're both buried beneath this hellish grey snow. All of Mono is suffering from the effects, coughing up pieces of Townsend and Shepherd, choking on them in and out of their sleep.

I drive to Townsend first. It looks suspiciously normal until I crest the hill and catch the blackened fields, caustic as a slap in the face—so many memories, dreams, and dollars, up in smoke. Nothing but necrotic decimation as far as the eye can see—pitch and tar, final as death. I'm frozen, staring out at the carnage. So complete is the damage it looks as if someone laid a charcoal blanket over the area.

It all feels surreal. I wonder if it's all a dream, hope it is. I cruise over to Shepherd totally unaware of how I arrived.

Same scene. Evening is quickly casting its pall on the soot-filled rows of once supple, fertile vines. Shepherd was the crown. We begged Townsend to be its shining jewel, but it could never forgive me for merging with the enemy. I flash my

brights over the carnage as I spin in a circle to soak it all in. So much lost, so fast. Who could hate us this much?

Then, without hesitation, I drive over to Hudson's.

Mitch

No huge reception to greet us at the Bradley terminal this time, which doesn't really surprise me. Colton has a shiny new ticket slapped on his windshield when we get back to the car for not renewing his registration. We don't say much on the way home. Colt calls Mom, tells her we're on our way, and I can hear the relief in her voice as if she were in the truck with us. He keeps it short, not wanting to let her in on all the fun details just yet. I fall asleep about halfway and enjoy a nice long nap until I feel a hard smack on my bad shoulder.

I bolt up nauseous from the explosion of pain.

"Smell that?" The whites of his eyes glint out the driver's side, examining the landscape for clues.

"Fire." I roll down the window to get a better look. Smells like the whole damn town went up in smoke. Ashes blow into the cab of the truck, and we both start to hack as our lungs lock up from debris. Nothing but soot and darkness governs the world.

"What do you think happened?" I ask.

"Brushfire."

"No brush around here, genius," I muse.

"Unless." His head rolls east.

"Crap." I close my eyes as Colt makes a beeline for Townsend.

We hit the top of the ridge, and the air smells like an incinerator. I think I see it for what it is, but don't run with the idea until I get out of the truck. I head down past the parking lot and jump into the dirt I grew up playing in, cultivating—*inhaling*—and the soles of my shoes give way to an unfamiliar crunch.

There's nothing but onyx ash as far as the eye can see. Every single row, trimmed of its beauty. The moon casts a harsh glow over the barren field that was once my family's pride and joy—*Lee's*. I crush the remainder of a burnt out vine with my heel, turn around, and find Colt's face glossed with tears.

"Looks like my bad luck precedes me," the words press out of me the way only the truth can.

We get back into the truck and don't say a single word.

<div align="center">⊱⊰</div>

I call Lee three times, but she won't pick up, so Colt and I head over to the house. Max comes down fresh from the shower.

"You're back." His face pales at the sight of me. "Where's Lee?" he asks, zipping past us into the kitchen.

"Her car's not out front." I glance over at Colt. "I tried calling, and she wouldn't pick up."

"I just called her and nothing." Max swallows hard. "I think I might know where she went. We'd better hope I'm wrong."

Max drives us over to Hudson's. He fills our heads with what happened last night, the fire at Townsend, the fire at Shepherd. It's like we've landed in some alternate universe, a bad dream that's opened its jaws and swallowed us whole. I try to shake myself out of it—to wake up on the plane and have it be five years ago.

Why the hell isn't Lee picking up? What now? I look out the window into the deep, purple sky.

What fucking now?

ဆဉလ

Fourteen. I count fourteen once-upon-a-cars littering the entry, and that doesn't include the ones cleverly camouflaging themselves among the weeds that sprout up like bushes. Looks like that whole landscaping thing never panned out for him. Funny, you'd think the haul Shepherd took in would afford him the luxury of having his home not look like a litter box. Nope. Just take and squander. It reminds me a little of my own brother. I look over at Colt. He's scanning the vicinity, looking for signs of Lee, but there aren't any—then I see it.

"Her car," I say, pointing at the carport near the back of the house. There's another car tucked behind her, blocking her in. "You think if Lee was coming here she'd park there?"

"Nope." Max pulls in close to the front door, and we get out.

The air is thick, still smells like acres of charbroiled vineyard. He gives a brisk knock, and we wait.

A light goes on downstairs then a shadow appears on the other side of the murky glass before it swings open. Some guy in a cowboy hat invites us to step inside.

Max brushes past him, "Lee?" His voice booms off the walls, echoes as if the house were devoid of any furnishings.

Colt and I make our way in, and the door shuts rather abruptly behind us just before the lights go out.

"Shit." I hear Max hiss.

A hard blow to my neck knocks me to the ground. Someone wrangles me out of my sling and ties my hands behind my back, and I scream out in pain.

The familiar click of a gun reduces the room to silence.

"Get up." A voice wills us from the dark.

We don't argue. I'm hoping they'll lead us to Lee, unharmed. Maybe we can ride the coattails of those miraculous

escapes from the past few days and get out of here with our lives intact.

The idiots brandishing weapons herd us outside toward the shed that Max and I bonded in while whittling down Hudson's stash. They hogtie us together, back-to-back, and stuff a pile of kindle in the small space between us. When they're done, one of the guys holds up a match and lights it mid-air. He pulls his lips into a crocodile smile. Then I see it—the glint of a familiar gold tooth.

He blows the flame out and leaves the room.

Max

"He said he was in trouble." I've been making excuses for Hudson the Horrible—the *terrorist*—for the last fifteen minutes while we struggle to break free. The scum he sold his soul to have taken over his home, his wife, the fields—God knows what they've done to Lee. I bet he's hightailed it halfway to Vegas by now to cash his car in and lose what's left. "How did we turn out so different?" I say it mostly to myself. I can't really see Mitch or Colt unless I strain my neck, and then it's too dark anyway.

"I know what you mean." I can feel the vibrations of Mitch's voice crawl up my spine.

"What the hell are you talking about?" Colton pipes up. "We're exactly the same."

"You would die trying to be me," Mitch shoots back.

Colton skips a beat before refuting the idea. "You're right. I almost died trying to be you, *Crazy Mitch*. I would never want to *be* you. Although, before the trip I thought you were a little boring."

"And now?"

"Now I think you're a bit of a bad ass, and I'm proud to call you my brother—that goes for you too, Max."

"Thanks." I exhale. "Let's get the hell out of this makeshift dungeon. We can hug it out later." I try freeing my hands from the plastic ties they've tethered us with but it's like they're made of fucking steel.

"Hey, you mind?" Mitch quips. "It hurts when you do that."

"I wouldn't have to do that if you honed in on your 'bad ass' superpowers and got us the fuck out of here."

"All right, all right," Colt interjects. "Focus. Let's use anger to our advantage."

"How are we going to do that?" I know I'm beat when Colt starts making sense. Anger is all I have to lean on at this point.

"Think of Lee," he says it like a command.

"Lee doesn't make me angry," I say. "You're making me angry."

"Go with it," Colt grunts. "I slept with Lee." He annunciates for my benefit. "Although, technically, you had the facts wrong. It was the week before your wedding, and yeah she was drunk, but I don't think she was wasted—that girl wanted me in the worst way if you know what I mean. She really knows how to work it."

"All right I'm pissed." I manage to stomp his foot and grind it into the ground until he lets out a satisfying yelp. "I'm going to flatten your balls as soon as we get out. You happy now?"

"No," he groans. "Happiness fits nowhere in the equation. I want you to take it a step further. Think of Lee again. Think of her in that house with that group of mangy primates, and what do you think they're going to do to a beautiful woman like her?"

A simultaneous snap goes off as Mitch and I break free from our plastic cuffs. It takes three more seconds for us to untangle ourselves from the mountain of rope. No sooner do we stand then the door swings open and a burnt breeze rushes in.

"Where the hell you going? I got one more to add to the party." Gold tooth pushes Hudson in. "I'm right outside"—he shakes his rifle at us—"ready and willing to blow your heads off." He steps back out and bolts the shed, tapping the window with his impressive long carbine. I've got a million questions, but, for now, I just glare at my brother.

28

Rescue

Lee

"Isn't this fun?" Candi bounces on her bottom sitting Indian style on the floor. Her enormous belly takes up the space between us like a shelf you could place an entire set of encyclopedias on.

"We are *locked* in a closet." I fold the cards in toward my chest in disbelief.

"It's a walk-in," she annunciates each word. "And we're playing games." She waves a straight flush of spades in my face as if I should be grateful. The only thing I'd like to flush around here is Hudson for even entertaining the idea of entrapping me in a glorified laundry basket.

Stupid, *stupid* me. I close my eyes and mull over how I got here. Looking for Hudson was incredibly stupid. Following Candi upstairs so she could show me her "maternity wedding gown" for a wedding that already happened, and to which I was never invited again, stupid.

"So that guy, you called him Duane?" I say it measured and her eyes sparkle when I mention his name. "He tried to kill my husband." I try cluing her in on the gravity of the situation, to my own peril, I'm sure.

"He did?" Her brows arch unnaturally like a pair of overgrown fishhooks. Candi is beautiful in a made up, pageant queen kind of way but dumb as a doorpost. "Which one?"

I blink into my frustration. "Mitch." His name bites through my chest.

"No kidding?" She snaps her gum and rearranges her deck. "He likes doing stuff like that on the side." She tilts her head and gazes at the ceiling as if deep in thought. "You know— I'm kinda like you in that respect."

"What respect?" Other than the boobs and the vagina, I doubt we have much in common.

"Having two husbands and all. I've been with Duane six years. We're on and off like you and Mitch."

My gut cinches. Mitch and I are not *on and off.* He was captured. Held prisoner. His fierce undying love brought him back to me, but something tells me this concept will transcend her single brain cell, so I don't bother.

"So which one do you think you'll choose?" I ask. "You know, you can only have the one." I wag my ring finger in the air.

"True. But lucky for me, I get to choose whenever I feel like it. They don't mind. It could be Hud one day, Duane the next. We're gonna move in together like you guys."

Great. I'm a shining example in the worst way possible. Stella probably dreams of her wedding day, walking down the aisle with two men beaming back at her.

I toss down the cards, trying to stave off tears, but I feel them coming up behind my lids, angry and violent like a prison riot. A knot swells in my throat, the size of a fist.

"I love them both," I whisper.

"I know"—she reaches over and strokes my cheek—"and they love us."

"I'm pretty sure they don't love you, Candi," I say, gazing at a stray, black stiletto. "They locked you in a closet. You're sitting on the floor, very, very pregnant. They didn't give you

food or water. Have they asked once if you need to use the bathroom?"

A fire blooms in her eyes. "You're right." She struggles to rise before staggering to the door.

Candi pounds against the wood with relentless baby-like tremors, and it doesn't come across as that urgent or impressive. "Du-*ane* get your ass up here right this effing minute and let me out! She don't need me to calm her anymore."

"Maybe you should try calling on your cell?" They took mine, but hers has been peering from her pocket the entire time. If she wasn't with child I would have knocked her out hours ago.

She presses into her phone feverishly and listens, but they don't pick up.

A sharp stench lights up my senses, and I crawl to the door. "You smell that?" It's the distinct odor of smoke. I've been inhaling it for the last twenty-four hours. It's tattooed inside my nostrils, but this is different, it's fresh.

"Smells like barbeque. Whole damn town's been on fire—makes me crave some good old fashioned baby-back."

A puff of smoke curls from under the door and waves its necrotic finger.

It gives away all its deadly secrets in one soft whisper.

Mitch

It feels like hours drone by, but, in reality, it's been less than five minutes. Hudson fills our ears with stories of pool, football, poker debts, and, for once, I'm proud to have Colton—the Count of Clitoris—as my brother.

"You fucked up real good this time." Max bows his head.

Here we are sitting around, waiting, anticipating anything and everything.

The door cracks open, letting in a rush of cool night air. It takes the stench of four sweaty males out in a rush.

A tall guy with a shirt pulled over his face, pokes in. "Time to go."

"They here?" Hudson glances up as if he's caught off guard.

"There's a problem," he gruffs through his T-shirt. "It's time to make tracks."

Hudson moves to the door. "All right boys, change of plans."

"What plans?" Max growls at him.

"Some of my old buddies are about to pay a visit." Hudson sidesteps over to the talking T-shirt. "Told them I had all the money they needed. I'll leave you jokers to tell them where to find it. Pay up boys"—he gives a wink— "your lives are at stake."

"Pay with what?" Max barks.

"With whatever it takes. Just thought it up, too. You can thank your old lady for dropping by. Playing the part of Candi ain't easy, and who knew you'd stop by to play the part of me and my good friend Duane."

"Aren't you glad," it comes from me with an edge of grief because I see where this is leading, and I hope to God I'm

wrong. "You want them to kill us, so you won't have to look over your shoulder anymore."

"You always were the smart one, Mitch." He winks. "Time to roll." He steps out and turns around. "Thank Lee for heading to Townsend. We never did think to make it look like you set the fire yourselves. But it was Candi who thought we should send you to Shepherd. Never in a million years did I think you'd fall for it."

"Why'd you do it?" Max steadies his voice.

"I would have died in prison, buddy. A life for a life."

"You couldn't milk anymore money out of me. If you can't get anything out of someone, you desert them just like you deserted Joshua. Let me refresh your memory. That's your son."

Hudson spits in his brother's face, full throttle, leaving curdled phlegm that webs between his nose and eyelashes.

Hud and his buddy scuttle out and labor to secure the door shut. I'm already eyeing the small window near the ceiling as I listen to the sound of shouting followed by the roar of an engine.

"They're rushing Candi out." Colt says, while peering out of a hole from the distal corner. "She's puking—*choking*."

"Any sign of Lee?" I try to push him out of the way, but he won't budge.

"Nope, just Candi."

The sound of a car speeding away fills the night.

Colt pushes a metal shelf under the window, and cans of paint come crashing down with a clatter.

Max jumps up and peers out. "The house." He knocks Colt out of the way, easy as a chess piece, and breaks the window with his fist.

"What?" I struggle to look out the tiny hole. All I see is smoke filling in the driveway. "That's exhaust, right?" It strangles out of me because I know it's not.

Holy shit.

I can't help her. I can't climb out that window or move fast enough to save Lee.

Fuck this.

I use Colt as a springboard and burst through the window, run through the smoke and into the house with its walls on fire.

"Lee?" I choke it out as I stumble in the white haze.

Shit.

Max skids in beside me.

"I'll go this way." I point to the right, and Max takes off in the other direction. I pull my T-shirt up over my nose and trip on the staircase. A rhythmic thumping comes from the wall, and I touch my hand to the plaster all the way up the stairwell.

She's calling for help the only way she can. That has to be Lee. I follow the heartbeat until I land in an oversized bedroom filled with a thick veil of smoke.

"Lee?"

The pounding intensifies as I come up on the closet. A chair sits tucked under the knob, locking it from the outside. I throw it open and shut myself in—dizzy, struggling to catch a fresh breath.

Lee presses into me, her face cool and wet against mine as the smoke curls in. I run my lips over her hair, her eyes, her lips.

"Hold your breath." I instruct through a series of hacking coughs.

I take her by the waist and lead her into the room already engulfed in flames. The heat sears over me, and I can feel my shirt trying to melt onto my flesh. I spot the balcony and head over, scalding the skin on my palm as I let us out and slam the door behind us.

A blast of cold night air hits us, and we gulp down the fresh night air.

Lee sobs into me. Her hair falls over her face as she molds her body to mine.

"God, I love you," I whisper, pressing my lips to the top of her head.

The house burns around us as we take shelter on the small balcony overlooking the driveway.

We sputter and gasp as the smoke stings our eyes.

"You okay?" I ask, touching my hand down over the baby.

Lee looks up at me with her beautiful face and nods.

"Down here!" Max shouts up from the driveway. His clothes are blackened. His arms are covered with blood. "Lee!" He waves a hand over his head to get our attention.

The balcony jolts—a wall of glass explodes from behind, and I push Lee into my chest until it's quiet again.

The fire extends over the frame of the door, licking the roof like a blowtorch.

"I love you," I squeeze the words from my throat. We're only two stories up, we can do this. "It's been more than a gift to be your husband, Lee."

She looks at me with those ocean blue eyes, and the peaceful look on her face startles me.

"You're the universe to me, Mitch. You have to know that." Lee presses her lips over mine, and the entire world stops spinning. The fire, the fields, it all fades away. It's just Lee and me locked in our love—this kiss is the only event on the horizon.

"I'm glad you think so." I scoop her into my arms and hoist her over the railing, ignoring the pain that's electrifying my shoulder.

"No!" Lee lets out a curdling scream as her fingers claw at the ledge. "Don't do this. I'll hate you. I will *hate* you, Mitch!"

"We've run out of options." I press another kiss over her lips. "*Max!*" I watch as he steadies himself beneath her. He holds his arms out, open and waiting, and he damn well better catch her.

Dear God, let this work.

"I love you, Lee." I drop a kiss on her forehead and let her go slowly—watch her fall into Max's waiting arms, safe and sound.

"*Yes.*" I let out a sigh of relief. Lee is safe—out of danger, away from the Townsend curse we've been held under for so long.

It's done. Lee and the baby are going to be fine.

The fire licks at my scalp before biting down over my shoulder.

"Mitch!" Colt comes speeding toward me with the truck and parks beneath the balcony.

I flip my legs over the rail and stand on the ledge, my shirt smolders in flames as I ready myself to jump.

The smell of gas intensifies. An enormous roar rips through the night as the house detonates from behind. The earth shakes. A blinding light ignites the sky like the Fourth of July as I catapult off to the left—I try clawing my way back to the truck—to *Lee*. I can hear the sirens—see the horror on my beautiful wife's face as the stone driveway fast approaches.

I think of Stella and Eli, the baby that I know is mine. I think of what Lee and I have, what we've had for so long and how God smiled and let me see her again one last time. I think of Max—how we came full circle in the end and how I love him more than a brother.

Life happened. It came apart at the seams and sewed itself back together the way it was supposed to.

Somehow I know this to be true.

And the world claps to darkness.

My father comes to me, and this time it's not a dream or some trauma-inspired hallucination.

"You ready, Mitch?" He holds out his hand.

I look around unsure of this new hazy world. "Is it really my time?"

"Your time was up five years ago, son. You were meant to die in that car fire along with the others—but you managed to

garner one final act of mercy. Not too many people have a chance to make things right with the ones they love—to make peace with people and places." He gives a little wink.

So this is it. I pan the chaos breaking out on Hudson's driveway—my body lying motionless in the corner.

"Do I have a say?" I glare into my father because I already know the answer.

"Not this time." He pats my back and tries to move me from the scene. "You were one of the lucky ones, Mitch. Don't deny the gift you were given."

I take a hiccupping breath as my gut pinches with grief, and marvel at how normal I still feel—and, yet, nothing will ever be normal again. Not for any of us.

"I guess I am one of the lucky ones, and so are Stella and Lee." I look over to Max and offer a little smile. "They're in good hands." And this time I approve. I know he'll take care of my family—love them just as much as I would.

Max and I somehow managed to fix things, and maybe, in a sense, it was a gift to do just that. I knew in my heart that everything was better between us. I could feel it there those last few weeks. It had all turned around, right back to how it used to be, with each of us hoping Lee would choose us—stronger than blood brothers. If I could change one thing, it would be to make things right with Max a whole lot sooner—hell, never to let them go wrong in the first place. We could have had so much more. But in the end, I'm glad I had a chance to come back and make things right.

I glance back down at Lee. "I love you deeper than the ocean, Lee Townsend"—my voice breaks as I glance at her beautiful face one last time—"Max, too."

I guess you could love a lot of people deeper than the ocean.

Life is short.

You should.

Inescapable Sorrow

Lee

The house dissolves into flames. Mitch flies over the truck and lands with a thud on the other side.

"Hold onto her." Max pushes me into Colton before taking off.

"Oh my, God." I close my eyes and lock out the world for a brief moment before kicking free from Colt.

Mitch lies on his stomach with a trickle of blood coming from his nose. Max falls down next to him and speaks directly into his ear. The sirens stop screaming, the flash of red and blue lights slice through the night as an entourage of men in uniforms storm the grounds. I drop to my knees and lean over his beautiful face.

"Mitch," I breathe his name, but not a sound escapes my lips. Max backs up for the medics to tend to him. They take his vitals—lift his wrist, limp as a ragdoll. I push my lips to his ear. "I have *always* loved you, Mitch Townsend." It strangles out of me with tears. "You will always be mine. Come back to me, Mitch." A painful knot ties up my vocal cords, but I push the most important words through. "I will love you forever."

ADDISON MOORE

The days melt by in snippets—the race to the hospital—
Mitch in a coma for weeks.

He never woke up.

The funeral is small and private. The whole world has
inverted. It turned its ugly side out and made us suffer. There is
a familiarity about this horrible hour in my life, but this time
every new memory we created these past few months gouges at
me with its jagged shards.

Stella and Eli are locked in the tempest. Nothing could
ever quell this sadness—take away the pain from this needle in
our eye. There is no more light in the universe, no more oxygen.
Mitch took it all with him. There is nothing left to look at
without him here beside me. Every part of me wants to crawl
into his casket and beg the world to cover us both with warm
Mono soil. I just want to be near Mitch. I miss his touch, his
voice, his strong body pressed against mine. I'm smothering in
this indescribable ache. My heart has shattered. Mitch took it
right along with him.

Max and I share our grief—a suffering so great, I'm not
sure it will ever end.

I never could choose between the two of them.

Sometimes God chooses for you.

Sometimes even He can find no good solution.

Then at the end of a long harrowing day at the cemetery,
after lowering a black slick casket that holds the remains of my
sweet husband and tossing soil over it with my own hand,
Colton brings me a gift.

"He wrote this on the plane, just in case. He didn't think
he'd need it."

I take the envelope from him, gingerly, as if it were Mitch
himself.

Max and I read it together.

Dear Lee,

If you're reading this things didn't end well for me. I was sort of hoping this was just a way to kill time on the flight back home but something in my gut said do it just in case. You see, the last time you lost me I didn't leave anything behind for you to look at or hold that would tell you how much I love you. I guess what I'm doing now is covering all the bases.

I wasn't sure why God had me in that hellhole for so long, but, now, I think I know. I think there was a purpose and that purpose was his and his alone. I'm also pretty sure that five years apart gave you enough time to establish a new life, it let me see what your world would have really been like had I been gone for good. I'll be honest I wasn't too impressed with the choices you made at first, well, choice, and that being Max. But now that I've had time to see things from all angles, I have to commend you on a job well done. Since I wasn't there to be a husband to you, I'm glad it was Max. In fact, now that I've made a more permanent relocation to the hereafter, I hope the two of you will live a very happy life together. I mean that from the bottom of my heart. If it can't be me, I'm glad it's Max Shepherd.

Please tell Stella I love her as often as you can. I don't want to weigh her down with my death, but somehow I'd still like for her to feel like I'm a part of her life.

I'll be watching down over our family every single day. When the kids hit all their highlights in life you can bet I'll be right there beside you and Max, cheering them on.

As for the sweet baby you're carrying, I wish I could have been there to see you through this, hold your hand when it comes time. I know that if that child is mine, and I really feel in my heart it is, that Max will still love her or him as fiercely as he does his own, like he loves Stella.

I can't say I'm not sad to be there with you, to make love to you each night, to feel your hair, your soft kisses, but I know that if God did choose to take me, it was my time to go.

Don't cry for me, Lee. Don't grieve me. It kills me to think that I could bring one more ounce of pain to your precious life. Smile when you think of me. Laugh. Talk about the good times and cherish them. I'll see you again, Lee. I'll be the first one waiting to greet you when you come home—Max, too. We'll all be together again, and maybe you and I will get that private time as husband and wife we missed out on down there. It was a privilege and an honor to be your husband, and, if I had my way, we would have lasted another sixty years at least. I'm guessing eternity won't start feeling like heaven until you arrive, and, when you do, I plan on making up for lost time if you don't mind.

I guess it's hard to tell what the future holds in so many ways, but I know with Max there beside you there is nothing for you to fear. I know with Max in your life, I'm leaving my family in the best hands possible. Tell him I love him. Tell Stella, and Eli, and the new baby, too. I love you all deeper than the ocean.

I will see you again someday.

Love,
Mitch

Max
One Year Later

"Go right!" I shout to Eli. It's hazy out, but the sand is still warm under our feet. "No—your other right." I laugh, tossing the ball anyway.

"Daddy—*me!*" Stella jumps and squeals.

"You're next." I turn toward the house. Lee catches my eye. She waves from the porch and pauses to grasp the baby's fingers, and the two of them wave together.

A sharp pain flares in my gut as Eli pins me with a power throw. "Nice job, buddy." I hike the football over to Stella before glancing back at Lee. Hard to believe the baby is seven months.

Baby Mitch is quiet and pensive—a twin to Stella in male skin.

They caught Hudson. He confessed to the field fires, so insurance paid up after all. But it's been Johnson's almond farm that's kept us afloat. It turned out to be a saving grace. We've already decided to replant the fields. Vines are on their way from Italy and France—should be here in a few weeks. We're dedicating an entire field to Mitch as a memorial— Mitch's reserve. He'll get his own line. God knows he deserves one and then some.

Lee kicks off her shoes and makes her way over with the baby. Stella thinks he's great, but she's still holding out hope for a sister. We told her we'd try again in a couple of years.

"Hold your fire," I shout to Stella. She tosses the ball to the side and runs in and out of the waterline with Eli.

I take the baby from Lee and bounce him off my chest until he smiles. He has the same serious gaze as his father, and

he holds me with it as if it were Mitch looking right at me through his son's eyes.

It brings me back to that night we lost him, how I told him he would always be my brother, to hang on, that it would be all right, but it wasn't. I knew in my heart, though, that everything was better between us. I could feel it there those last few weeks.

I'd like to think there was a higher purpose at play. In the midst of heartbreak, when things don't make sense, I plan on remembering that—remembering Mitch, letting him live on through me, and Lee, and this beautiful family he's given us. We gave each other strange gifts. We were the curators of our own misery, but it all spun around, turned into a thing of remarkable, absolute beauty. We were family once, and, now, we are again in so many ways.

Stella and Eli run over and clasp onto my knees for a moment. I pull Lee in and land a careful kiss over her lips. I like this chaotic unity, this buzzing circle of children that surrounds us, but it feels like someone is missing from our circle, and I know for a fact it always will.

"Can I throw in Daddy's flowers?" Stella snatches the pale yellow lei off the sand.

"Yes." Lee manages the word, but you can see how much it hurts.

Today marks one solid year since Mitch went home.

I watch as the flowers sail through the air only to drift back to shore. Stella tries two more times before launching it out about five feet. Lee and I take a seat in the sand and watch as the flowers drift over the surface of the water. She circles my waist and rests her head on my shoulder.

"He'll always be a part of us," she gives it in a broken whisper.

"I know." I land a soft kiss over the top of her head. "I wouldn't want it any other way."

Mitch and I had made amends. We righted all the wrongs at the last minute. I hope he's okay with the fact I'm here with Lee—that I'm going to love her and the kids until the day God rips me from this earth. If the situation were reversed, I know I'd be more than content. For so many months I struggled with why God would let him come back only to take him away again so tragically. But Mitch had a chance to meet Stella, to kiss Lee one more time and create a beautiful new being with her. He got to say one hell of a good bye, and I'm glad he did.

He saved Lee from the fire. I didn't find her. Mitch did. He gave her back to me and to the kids. He was the guardian angel that needed to help her out one more time.

I'm damn glad he came back from China. He promised Lee he would, just like he did the first time, so he had to.

I give a wry smile.

Mitch always kept his word.

I lean in and kiss Lee on the lips, slow and lingering.

She pulls back with a loving smile. "We had him for a while." She blinks into her tears. "In that sense it was good."

"Then that's what his labels will say—a good year."

"More like a good year for heartbreak." She lays her head on my shoulder.

"Let's just call it a good year." I sweep a kiss off her cheek. We had talked about that once—adding *a good year* to the labels—about it representing how strong we were, and now it means so much more because it brings Mitch into the fold—the three of us like a team. "I love you, Lee."

"I love you, too." She wraps her arms around the baby and me.

Every year you spend with the ones you love is good.

In the end, what Lee, Mitch, and I shared was good.

And it always will be.

Acknowledgments

To my husband, you rock my world. No more falling from rooftops, please.

A special thank you to my wonderful team of betas, proofreaders, and my fab editor, without who my books would still be sitting on my hard drive. Christina Kendler, you are kind beyond words to endure my torment! Thank you for all of your patience, and thank you for pushing me to make this the best book it could be. I *really* appreciate your hard work. Delphina Miyares you have gone above and beyond! A million thank yous for your valuable input! Diane S., what can I say other than you have the eyes of an eagle. Bless you for that. I owe you dinner. Preferably sushi. Tamara Beard you are amazing and sweet and I thank you from the bottom of my heart for all of your valuable and thoughtful suggestions! To the wonderful Heather Smiddie, you saved my butt! You truly are a "Supa Gurl." Thank you for taking the time to go over the manuscript, and for letting me harass you at all hours of the night. And, last, but definitely not least, Sarah Freese who endures all my insane emails, and Facebook messages. You have spoiled me unreasonably with your kindness. I love you for that.

To my wonderful readers, you bless me every day. Thank you for making my dreams come true. I hope you enjoyed Lee, Mitch and Max as much as I did. This is a story that has stayed with me for years, and it's a privilege to share it with you. I love to chat with you online, please feel free to message me whenever!

To Him who sits on the throne; worthy is the Lamb. Your word is manna for my hungry soul. I owe you everything.

About the Author

Addison Moore is a *New York Times, USA Today,* and *Wall Street Journal* bestselling author who writes contemporary and paranormal romance. Previously she worked as a therapist on a locked psychiatric unit for nearly a decade. She resides on the West Coast with her husband, four wonderful children, and two dogs where she eats too much chocolate and stays up way too late. When she's not writing, she's reading.

Feel free to visit her at:

http://addisonmoorewrites.blogspot.com
Facebook: Addison Moore Author
Twitter: @AddisonMoore
Instagram: @authorAddisonMoore

Made in the USA
Lexington, KY
09 April 2018